At the Threshold of the Image

Translated by John Eaglesham

with Margherita Fontana and Sofia Pirandello

At the Threshold of the Image

From Narcissus to Virtual Reality

Andrea Pinotti

ZONE BOOKS · NEW YORK

2025

© 2025 Urzone, Inc.
ZONE BOOKS
633 Vanderbilt Street
Brooklyn, NY 11218

All rights reserved.
No part of this book may be reproduced, stored in a retrieval system, or transmitted in any form or by any means, including electronic, mechanical, photocopying, microfilming, recording, or otherwise (except for that copying permitted by Sections 107 and 108 of the U.S. Copyright Law and except by reviewers for the public press), without written permission from the Publisher.

Printed in the United States of America.
Distributed by Princeton University Press,
Princeton, New Jersey, and Woodstock, United Kingdom

Originally published as *Alla soglia dell'immagine*
© 2021 Giulio Einaudi editore s.p.a. Torino.

Library of Congress Cataloging-in-Publication Data

Names: Pinotti, Andrea, author.
Title: At the threshold of the image : from Narcissus to virtual reality / Andrea Pinotti ; translated by John Eaglesham, with Margherita Fontana and Sofia Pirandello.
Other titles: Alla soglia dell'immagine. English
Description: New York : Zone Books, 2025. | Includes bibliographical references and index. | Summary: "This book invites us to linger on the threshold that both separates and joins the real and the iconic world" — Provided by publisher.
Identifiers: LCCN 2024050016 (print) | LCCN 2024050017 (ebook) | ISBN 9781945861024 (hardcover) | ISBN 9781945861031 (ebook)
Subjects: LCSH: Image (Philosophy) | Visual perception. | Aesthetics. | Art — Philosophy.
Classification: LCC BH301.I52 P5613 2025 (print) | LCC BH301.I52 (ebook) | DDC 111/.85 — dc23/eng/20250203
LC record available at https://lccn.loc.gov/2024050016
LC ebook record available at https://lccn.loc.gov/2024050017

Contents

 Prologue 7

I *The Two Narcissuses* 17

II *Alice's Mirror* 43

III *Pygmalion in Westworld* 69

IV *The Environmental Image* 103

V *The Subject in Question* 135

VI *In/Out* 153

VII *Empathy Machine?* 189

 Epilogue 217

 Acknowledgments 219

 Notes 221

 Index 267

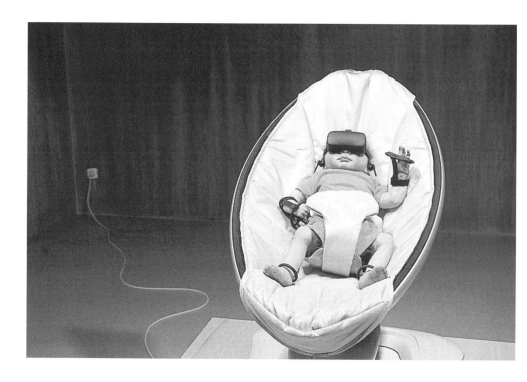

Figure P.1. *NurturePod*, a project by Stuart Candy, 2017 (photo: © Stuart Candy).

Prologue

Unframedness. Presentness. Immediateness. It is under these three titles — intimately related — that we now experience the image by means of those devices that constitute image-making strategies: virtual immersive environments.

A first feature that strikes the user of virtual reality headsets is the fact that the field of vision is saturated to 360 degrees by the image. In other words, it is no longer possible to perform an operation that, although it may seem trivial, is actually crucial: focusing one's gaze on what is not an image, on the off-image, an operation that could be carried out when the image was a mosaic or a painting, a sculpture or a photograph, a film projected on the cinema screen or shown on a television or computer screen. This circumstance leads us to reflect on a traditional property of the image — its being framed, its framedness — which consists in occupying a cut-out of the visual field within which there are spatiotemporal laws, syntactic rules, and semantic contents different from those in force in the extraiconic world, in the field outside the image. The cut-out image is a presence in the real world (it is still an object, supported by a material medium: canvas or paper, marble or glass) that introduces us to a kind of unreality. While I can say that I am two meters away from the painting hanging on the wall of my room, it makes much less sense to say that I am twenty meters away from the man depicted in the room represented in perspective in that same painting.

In the experience I have once I put on the virtual reality headset, however, I am no longer *in front* of the picture or the screen that offers me an image. Rather, I am *inside*, immersed in an environment that solicits actions and movements, offers me affordances and possibilities of agencies (and in the case of interactive environments, offers them to me as concrete practical possibilities), as if I were present in a real space. I lose one measure of freedom: the possibility of looking outside the pictorial field, offscreen. And I gain another: precisely because I am immersed in a condition of *unframedness*, I can autonomously give myself the frame, free as I am to focus on what I please in the visual field.

Of course, one can immediately object that the experience of framing is not canceled at all in the virtual reality experience, but only reformulated: I decide to put on the headset, I enter the virtual world, I end the experience, I take off the headset. It is a specific temporality that is cut out of the real temporal flux, and it is a time, in addition, during which I feel the weight of the headset itself on my head. But if we consider the rapid developments in the fields of nanotechnology and biotechnology, we can easily expect the devices to become increasingly lighter in weight, together with a correspondingly progressive "innervation" of them: from wearable devices that we still place on our heads, they will evolve into biotechnical prostheses that we will assimilate into our bodies, with the consequent further weakening of our ability to distinguish a virtual environment from a real one by relying on those markers that still offer us a foothold to make this distinction successfully.

A second characteristic, directly related to unframedness, is *presentness*, the strong sensation of presence, of being there, elicited by virtual immersive environments. This presence is to be understood in the double, correlated sense of the presence of the user (now, by virtue of the multisensory implications of such environments, more of an overall experiencer than an observer or spectator looking on) in the virtual environment and of the presence of the virtual objects in the real environment. Once the threshold separating image and

reality has been weakened and, ideally, annulled, what was previously a boundary becomes a gateway through which take place passages in both directions by virtue of the establishment of a common and shared space-time continuum. Already with illusionistic painting, the elements depicted were perceived as an integral part of the real world environment. With immersive virtual reality, there is created, as an alternative to the real world, a simulated world that aims to present itself as equally complex and convincing. In augmented reality, the possibility of an integration between virtuality and reality is opened up, and the digital entity emerges in the environment with the aim of exerting an increasingly effective prosthetic grip on it.

The property of presence (the effect of "presentification," of making the environment present to the experiencer and the experiencer to the environment) seems to undermine the foundations of a paradigm that has underpinned the main theories of the image since antiquity, evolving and articulating itself in numerous variants right up to the present day: the paradigm of representation. In its classical formulation, which can be traced back to Plato, the image is a mimesis, a more or less faithful imitation of a reality that preexists and is superior to the image both ontologically and gnoseologically. The representationalist model underlying the theory of mimesis, typically instantiated in the example of the portrait as a re-presentation that stands in place of the represented subject, would find endless variations over the following centuries until it reemerged with unspent force in contemporary theories of the image: C. S. Peirce's semiotics, Edmund Husserl's phenomenology of image consciousness, Erwin Panofsky's iconology, and the theory of depiction elaborated by analytic philosophers. Without prejudice to the specific differences of these approaches, what they have in common is precisely the conviction that the image is an "image of," the representation of a reality that preexists and exists independently of the image that represents it—a conviction that immersive virtual environments, precisely due to their power of presentness, seem, on the other hand, to challenge openly.

This challenge launched by virtual immersive environments to representational referentiality leads us directly to their third fundamental property, perhaps the most paradoxical one: *immediateness*, the appearance of immediacy, of nonmediateness, which is obtained by means of the employment of technological mediations of a complex nature. The access to presence that immersive environments allow us appears to be immediate: we feel immediately in the presence of entities in the flesh, so to speak, and not with their representations. Moreover (and this is the most problematic aspect), immediacy is understood as the "transparency" of the medium, which denies its own opacity, dissimulating itself to the advantage of what is exhibited by the medium itself.

Also in this respect, it seems difficult to align immersive virtual environments with the representationalist paradigm defended by the main Western theories of the image. In fact, these theories have variously sustained the assumption that, in front of an image, the user always has the possibility of focusing their attention either on what the image represents or on the material support that concretizes it as an object in space (e.g., either on the landscape that appears to me in the painting or on the canvas and on the pigments that are painted on it; now on the face that appears to me in the photograph, now on the grain of the photographic paper). The summer breeze that stirs the curtain of the open-air cinema, at the same time deforming the faces of the actors; the ray of sun that hits the computer screen while I am watching a film on the train, offering me my own face reflected in the glass. These are moments in which I am forced to take note of the support and consequently to realize the iconic status of what I am looking at. It is precisely this awareness that the virtual reality headset tends to make ever more difficult.

Husserl's distinction between image-thing and image-object, the distinction between preiconographic and iconographic stage introduced by Panofsky's iconology, the figurative/plastic pair in Algirdas Julien Greimas's semiotics, Richard Wollheim's twofoldness, Gottfried Boehm's iconic difference: mutatis mutandis, it is always

a question of safeguarding the possibility of distinguishing between image and support. On the contrary, virtual immersive environments aim precisely at obfuscating, ideally to the point of annulling, our ability to orient our gaze on one, rather than the other level, rendering them indistinguishable.

The powerful effects of immediacy and transparency produced by virtual immersive environments bring with them a series of implications that are not only theoretical, but also political: by virtue of those effects, what is promoted is the belief in a direct and unmediated access to reality, free of manipulation and interference, guaranteeing an unfiltered openness to truth itself. In the case of historical forgeries, while manipulative interventions in photographs (indexical images par excellence, whose role was to document the evidence for the historical veracity of an event) could be unmasked precisely by investigating the alterations to which the supports had been subjected, now this possibility of demystification seems to be radically reduced.

While previrtual images, such as icons, were characterized by their being framed, representational, and mediated, the fact that virtual images tend to deny these characteristics by virtue of their unframedness, presentness, and immediateness suggests that we recognize them as "an-icons," that is, as images that, in a completely paradoxical way, strive to negate themselves and deny their status as images in order to present themselves to us as if they were the reality of which they are the representation. Although widely abused in contemporary philosophical terminology, the hyphen "-" in "an-icon" is necessary in order to clear the field from the outset of the doubt that the intention here is to deny the iconic and representational nature of these entities and to welcome, or stigmatize, the definitive disappearance of the distinction between image and reality: they are, of course, images that in their own way, as we will see in the following chapters, are definitely framed, representational, and mediated. In other words, it is the effect they aim to produce on the viewer (their phenomenology) that is "an-," but their nature (their ontology) remains "icon."

"An-iconology" as an exploration of this tension between the phenomenology and ontology of self-denying images must be integrated with media archaeology. VR does not come out of nowhere, nor are "an-icons" the exclusive preserve of our present. Quite the opposite: the current an-iconic condition has been prefigured by a centuries-long history in which, from time to time, with the representational and media technologies available (from trompe l'oeil painting to 3-D cinema, via animated statues, participatory theatre, and precinema projection devices), each era has aimed at producing images that deny themselves. Or it has dreamed them up: in myths, anecdotes, fantasy literature, the various forms of externalization of the imagination. Situated at the crossroads between the an-iconic and media-archaeological approaches, this book pays as much attention to the an-iconic devices actually constructed as to the fantasies that have variously imagined them — if only because, as we will see, the latter have not infrequently heuristically fertilized the ground from which the former have been able to emerge.

Starting from the legend of Narcissus, the protoimmersive subject who plunges into his own reflected image, this book stretches an arc up to our virtualized times. It traverses myth and history, arts and techniques, in pursuit of a peculiar desire that seems to be anthropologically universal, thanks to its transcultural and transhistorical nature: the desire to linger on the threshold that separates and at the same time connects image and reality, to blur our ability to distinguish between the two dimensions, forcing us to reflect on what they have in common and what divides them.

In extending this arc, am I running the risk of embracing a naive, teleological linearity? That is, to present the contemporary virtual immersive environment as the ultimate outcome and the (for now) most sophisticated accomplishment of a strategic objective focused on in ancient visual culture (or perhaps as far back as Paleolithic caves) and passed from hand to hand just as in a relay race through the centuries without interruption? It is difficult to deny the problematic nature of the slippery logic based on precursors and precures; it is

just as difficult, however, to resist the temptation to recognize an an-iconic impulse in ancient pictorial illusionism or in the 360-degree *camerae pictae* of the Renaissance, in the nineteenth-century panorama, or in stereoscopic cinema.

Furthermore, I am not proposing a general theory or a general history of the image tout court. The an-icons certainly do not exhaust the iconic experience. And there are classes of images that, so to speak, do everything in their power to be recognized as such, proudly affirming — if I may express myself with a crude personification — their nature as images. We need only think of the adventures of so-called abstract (better defined as "nonobjective") art, which abandons any evocation of an external referent in order to assert its full autonomy: in this image (and only thanks to it) there comes into the world for the first time a certain sense that does not preexist and cannot be expressed otherwise.

Having said this, it is still the case that the class of an-icons in their multiple historical manifestations occupies a not-inconsiderable place in the human experience of the image, a place that today the new immersive virtual reality technologies encourage us to recognize in all its scope and to frame theoretically and historically, taking on board their double value, which is both aesthetic and political. An aesthetic value, not so much in the sense of a philosophical reflection on art or beauty, but rather in the etymological sense of the term, as an investigation of the implications of an-icons for the *esthesis*, the sensory experience. In other words, we need to ask ourselves what impact the new immersive virtual technologies are having and will have on our way of being in the world as bodies, of perceiving and acting.

In the 1930s, Walter Benjamin — one of the first philosophers to deal with what were then the new media — characterized the advent of photography as a form of progressive tactilization of the image, its becoming "in the hand," manipulable. What might have seemed a bizarre observation at the time (after all, a photograph is still an object to be looked at with the eyes) takes on a prophetic

farsightedness today if, with hindsight, we read those pages in the light of the digital revolution (to be understood first and foremost in the etymological sense, from the Latin *digitus*, or finger) and the spread of touch screens. Today, experiencing an image means both looking at it and touching it, and an image that cannot be rotated, zoomed, reduced, and modified with the fingers is no longer an image for us. In the space of a few years, we have become touch subjects, and the younger generations have been touch natives for some time now.

We must raise the same question with regard to immersive virtual environments: How will they transform (they are already transforming) our experience of images and our experience tout court? If we consider the remarkable number of hours we spend today in front of a screen (be it a TV, a computer, a tablet, a smartphone, a big screen at the station or at the airport), we have to ask ourselves what will happen when, in a not too distant future, during these hours and maybe even for longer, we will no longer be in front of that screen, but inside it. In other words, how will our sensorium change if the touch native evolves into an immersive native (fig. P.1)?

The aesthetic value is accompanied by a political value, again to be understood in the broad etymological sense of the *polis*, of living in common, of being together. For some time now, social platforms have been introducing immersive versions designed for headsets in which to interact with contacts in a virtual space. The announcement of Facebook's evolution into Metaverse is a clear symptom of this trend. Avatars (our digital representatives in the virtual world) are creating new forms of intersubjectivity and conquering increasingly significant spaces on the political scene. What is the significance of these phenomena? How will they transform (are they already transforming?) our conception and experience of politics and communal living?

These are clearly issues that unequivocally suggest that the question of how we relate, by modifying them and being modified by them, to the new technologies of production and consumption of

images is by no means an abstract or merely theoretical problem, but allows us to glimpse a very concrete practical and existential horizon—a horizon for which it is urgent to prepare ourselves critically. Distancing itself from both the apocalyptic technophobes (who fear the dissolution of the real in the virtual) and the euphoric techno-enthusiasts (who hail in the virtual the definitive resolution of the anxieties that afflict the real), this book lays the foundations of an an-iconological critique in the sense of an examination of the possibilities and limits of images that deny themselves.

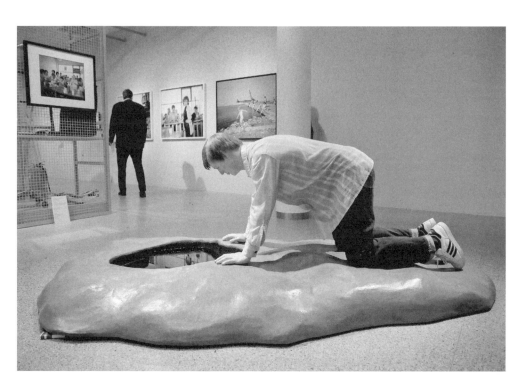

Figure 1.1. Olaf Nicolai, *Portrait of the Artist as a Weeping Narcissus*, polyester, textiles, water, electronic pump, 2000. Courtesy Galerie EIGEN + ART Leipzig/Berlin, Installation view, Bundeskunsthalle Bonn, 2020 (© Olaf Nicolai, by SIAE 2024; photo: © Oliver Berg/dpa picture alliance/Alamy/IPA Images).

CHAPTER ONE

The Two Narcissuses

The Naive and the Self-Aware
"It is sheer folly to suppose that a person who has reached the age of falling in love should be unable to distinguish between a man and his reflection."[1] Thus, bluntly, Pausanias branded the legend of Narcissus as folly — a story that perhaps is folly, yet has been capable of deeply molding the imagination of the West for many centuries: a myth in which at stake is not only the question of the origin of the image, but also the transgression of the boundaries between reality and representation. This is how Leon Battista Alberti evokes it in a famous passage from *De pictura*, a treatise that marks the beginnings of modern reflection about the image:

> I have taken the habit of saying, among friends, that the inventor of painting was, according to the opinion of poets, that [famous] Narcissus who was transformed into a flower. As the painting is in fact the flower of all the arts, thus the whole tale of Narcissus perfectly adapts to the topic itself. To paint, in fact, is what else if not to catch with art that surface of the spring?[2]

Returning today to this myth on which so much has already been written may allow us to unleash its unexpected potentialities: regarding not so much the origins of painting (many times proclaimed dead, and yet in some ways more alive than ever), but its extreme outcomes, which we experience today in the form of

immersive virtual environments—in the form, that is, of environments in which the transgression of the boundaries between reality and representation is configured, as we will see, as a peculiar kind of narcissism.

In its most famous variant, as popularized by Ovid's *Metamorphoses*, the handsome young man, born of the violence perpetrated by Cephisus on the nymph Liriope—first indefatigable in rejecting the amorous offers of persistent suitors and then exhausted from failing to possess the object of his own unquenchable desire (himself)—"On the green grass / He drooped his weary head, and those bright eyes / That loved their master's beauty closed in death." Even death could not end his passionate scopic obsession: Ovid points out, "Then still, received into the Underworld, / He gazed upon himself into the Styx's pool."[3] From the decomposition of his body on the bank of the spring sprang the beautiful white and yellow flowers that bear his name.

Several variants have developed around the figure of Narcissus and his tragic end. Before Ovid, Konon had preferred the suicide version.[4] After Ovid (and this is the solution that most interests me for the argument I intend to develop), Plotinus will opt for drowning: without even naming him explicitly, in his treatise on the beautiful, in accordance with Neoplatonic ontology, he warns those who rush after bodily beauty without understanding the actual nature of bodies as mere "images, traces, shadows":

> For if a man runs to the image and wants to seize it as if it was the reality (like a beautiful reflection playing on the water, which some story somewhere, I think, said riddlingly a man wanted to catch and sank down into the stream and disappeared) then this man who clings to beautiful bodies and will not let them go, will, like the man in the story, but in soul, not in body, sink down into the dark depths where intellect has no delight, and stay blind in Hades, consorting with shadows there and here.[5]

The variant of the fatal immersion would later be revived by Severus of Alexandria: "He was a beloved without a lover, but casting himself

upon the spring he took to loving his shadow as if it were his beloved, and, seizing himself from himself, he plunged into the waters. Thus, seeking comfort from passion, he found death."[6]

In an interesting article, Pierre Hadot[7] compares the version of Plotinus—later revived in the modern age by Marsilio Ficino[8]—to other variants, noting that Ovid's is the only one that introduces the element of self-recognition in the transition from naive falling in love with another who mirrors the gestures he himself makes to the realization that that young man is none other than himself reflected in image. At first, in fact, Narcissus addresses the object of his love as an otherness to whom he first speaks in the third, then in the second person:

> "My joy! I see it [*et placet et video*]; but the joy I see
> I cannot find (so fondly love is foiled)
>
> Come forth, whoever you are! [*Quisquis es, huc exi!*]...
>
> My looks, my age—indeed it cannot be
> That you would shun...."[9]

This is an equal and opposite error to what would catch Dante in Paradise (3, 17–18) and make Beatrice smile: "I fell into the contrary error to that which kindled love between the man and the fountain." While Dante looks at souls, mistaking them for "mirrored faces"[10] of bodies and turns to see their flesh and blood models, Narcissus mistakes the mirrored reflection for a real person.

But then the bitter awareness of the reflected self takes over, and the discourse, completing the "game of pronouns,"[11] switches to the first person: "Oh, I am he! [*iste ego sum*] Oh, now I know for sure / The image is my own; it's for myself / I burn with love; I fan the flames feel."[12] After all, the reader already knew this, because Ovid had pointed it out (today, we would call this a spoiler) about thirty verses earlier, calling Narcissus naive [*credule*]: "You see a phantom of a mirrored shape [*imaginis umbra*]."[13] Such self-recognition decrees his

death, reversing the prophecy that the seer Tiresias, when asked by Narcissus's mother, utters: "and of him she asked the seer, / Would he long years and ripe old age enjoy / Who answered 'If he shall himself not know.'"[14]

The *self-aware* Narcissus who ends up recognizing himself in the reflection (and thus at the same time recognizing that he is facing the image of himself, thereby becoming aware of the medium water-as-mirror) is contrasted with a *naive* Narcissus who, as Pausanias sums it up, grasps neither that he is the object of his own desire nor that he is the object of an image: "Narcissus looked into this water, and not perceiving that what he saw was his own reflection, fell in love with himself unaware."[15] By branding such naivety as "folly," however, Pausanias shows that he no longer understands (when he writes in the second century AD) that Narcissus's inability to distinguish image and reality is not a defect, so to speak, in his perceptual and cognitive abilities, but a dulling caused by Eros, who thus takes revenge for the conceit of a young man who had rejected all his suitors out of *hybris*.

In terms of contemporary media theory, we could reformulate the polarity between the naive Narcissus and the self-aware Narcissus as the antithesis between the *transparency effect* and the *opacity effect* of the medium.[16] The naive person fails to grasp the aqueous mirror as a material medium that allows the image to manifest itself as precisely an image and therefore believes that he is in front of a presence. By contrast, in the moment of self-recognition the self-aware person takes note of precisely the relation between that support and that image, simultaneously realizing that he is in front of a representation, an image that represents him, that is, that makes a sign, unveiling the dimension of semiotic reference: "After many frustrations," notes Julia Kristeva, "Narcissus gathers that he is actually in a world of 'signs.'"[17] In the transition to image consciousness, the importance of tears should not be overlooked, and this Ovid promptly emphasizes:

> Distraught he turned towards the face again;
> His tears rippled the pool, and darkly then
> The troubled water veiled the fading form,
> and, as it vanished, "Stay!," he shouted, "stay!
> Oh, cruelty to leave your lover so!"[18]

The perturbation of the watery mirror caused by the tears makes clear the opacity of the medium, exposing its function as a support for the image and consequently the iconic nature of the love object.

Iconographic Polarities

In a Warburgesque study focusing on the language of gestures, Paul Zanker effectively shows how the antithesis between the naive type and the self-aware type is also reflected in a specific modulation of bodily postures peculiar to one and the other, accurately documented by ancient and modern iconography (with the chronological priority of the naive type and the predominance of depictions of the self-aware mode from late Hellenism onward).[19] The naive type is often depicted in the act of raising an arm, marveling at the gesture that the "other" repeats in the reflection. The self-aware type is frequently associated with the depiction of the naked body of Narcissus, corresponding to the gesture of stripping himself naked described by Ovid immediately after the handsome young man's realization that he is both object and subject of the mirror reflection: "Then in his grief he tore this robe and beat / His pale cold fists upon his naked breasts."[20] In the development of this iconographic line, the intensely dramatic moment of Ovid's verse is softened into a quiet pose of complacent self-contemplation of the naked body, not infrequently depicted in the posture with arms raised and crossed above the head: what Zanker designates as the *Narzißgebärde*, Narcissus's gesture. Hence it is possible to pursue a history of the effects of this gestural pattern, which, passing through depictions of the Callipygian Venus, reaches the twentieth-century representations (e.g., in Matisse or Picasso) of the painter's model, who displays her body in all its beauty to herself and to her portrait painter.

Among the most consciously narcissistic artistic genres, it is of course the self-portrait that stands out. Those who have reconstructed its cultural history observe that "it seems perfectly justified to regard Alberti's advocacy of the 'Narcissus-painter' as the seminal celebration of self-portraiture."[21] The use of the mirror and catoptric reflection as a condition of possibility for this representational practice is evidently constitutive, as we will see more fully in the next chapter. The modern genesis of the self-portrait would be made possible by a narcissistic process of separation and autonomization of the individual from the supraindividual sphere of the sacred,[22] a process in which the process of self-awareness is fundamental. Paradigmatic of this line, because it makes it patently explicit, is *Portrait of the Artist as a Weeping Narcissus*, a life-size polyester sculpture made by Olaf Nicolai in 2000 (fig. 1.1). The artist, kneeling in casual clothes and sneakers, leans weeping over the mirror of water that reflects his image to him — his tears soon reveal the transparent medium in all its opacity.

If, as has been aptly observed, "every age forms its own Narcissus,"[23] it would be impossible to do justice here to the history of his iconography, which from the paintings in Pompeii, through the medieval miniatures of the *Ovide moralisé* and the Renaissance, mannerist, and baroque variations, is indeed characterized by the prevalence of the self-aware type, but will never definitively erase the polarity between naivety and image consciousness: the naive *Narcissus at the Fountain* (ca. 1600) leaning fatally deceived by the reflection of his beloved, attributed by Roberto Longhi to Caravaggio and preserved at Palazzo Barberini in Rome, and the *Narcissus* sculpted by Benvenuto Cellini (ca. 1548–1565) in full awareness of his beautiful nudity, preserved at the Museo Nazionale del Bargello in Florence, eloquently represent this polarity in the art of the second half of the sixteenth century. Later, Nicolas Poussin, Claude Lorrain, Bertel Thorwaldsen — to name but a few major masters — would engage with the figure of the scornful youth indifferent to love, and nor would he be spared the desecrating irony of Honoré Daumier

published in *Le Charivari* in 1842. In the second half of the nineteenth century, Gustave Moreau stands out among the artists obsessed with Narcissus; Claude Monet's passion for watercolor reflections (think of the cycle of some two hundred and fifty *Water Lilies* painted during the last thirty-one years of his life) has also been read in the light of the myth of the immersive young man.[24] Among the surrealists, André Masson repeatedly returned to this motif, and Salvador Dalí even wanted to show his oil painting *Metamorphosis of Narcissus* (1936–1937) to Sigmund Freud at their first meeting in London on July 19, 1938, hoping to spark a discussion with the father of psychoanalysis about narcissism and his own "paranoiac-critical" method.[25]

Even in contemporary art, as a whole characterized by a high level of reflexivity, the type of the self-aware Narcissus seems to predominate unchallenged: body art could be interpreted as an incessant and tireless commentary on self-aware narcissism: "Narcissus protests (and thus finds gratification) through the agency of himself."[26]

In his polymorphous masquerades of self in guise of other, Luigi Ontani has very often varied his interpretation of the topos of Narcissus: in *tableaux vivants* such as *NarciGiuda* (1993–1995) or in ceramics such as *BellimBusto NarcisEco* (2018). The work that inaugurates the series in 1970, *NarcisOnfalOnan alla SorGente Del NiEnte* (fig. 1.2), makes clear from the title its place in the self-aware typology: omphalocentrism and onanism, concentration on one's navel and autoeroticism.

But the naive type endures, peeping out for example in Roy Lichtenstein's *Look Mickey* (1961) (fig. 1.3): rod in hand, Donald Duck looks excitedly at the mirror of water, convinced that he has caught a big fish, not realizing that the hook is snagged in the back of his jacket and that — making a self-aware Mickey Mouse snicker — it is his own reflected body that he mistakes for a fine catch.[27]

The element of water plays a fundamental role in the art of Bill Viola: consider the series of "water portraits" (e.g., the 2013 self-portrait *Submerged*, donated by the artist to the Uffizi Museum, which

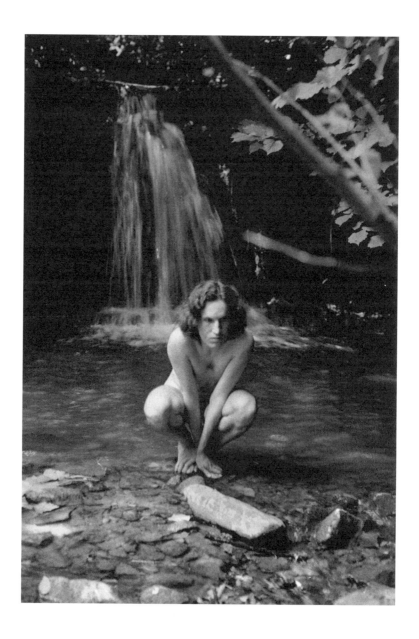

Figure 1.2. Luigi Ontani, *NarcisOnfalOnan alla SorGente Del NiEnte,* blowup/enlarged color photograph, Tuscan-Emilian Apennines, 1970 (courtesy of Collezione Ontani).

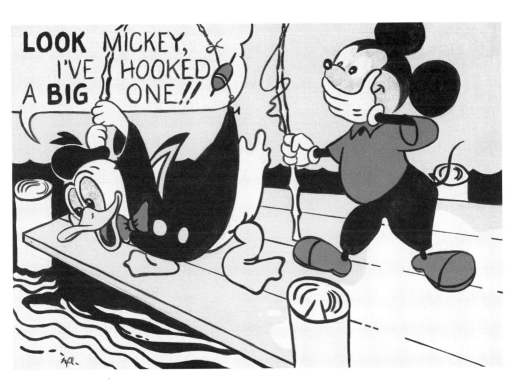

Figure 1.3. Roy Lichtenstein, *Look Mickey*, oil on canvas, 1961 (courtesy © Board of Trustees, National Gallery of Art, Washington, and © Estate of Roy Lichtenstein, by SIAE 2021).

received it as the first animated work in its permanent collection), or the videotape *The Reflecting Pool* (1977–1979), all playing on the paradoxes of the reflected image. But it is especially in the video diptych *Surrender* (2001) that the call of Narcissus is most strongly felt (fig. 1.4). Part of the *Passions* series, which explores emotional extremes, the work consists of two vertical plasma screens placed one above the other. On the top screen, a man dressed in red appears, while on the bottom, a woman is shown dressed in blue. Both are seen in half-length, positioned as if they are each other's mirror image. They bow toward the edges of their respective screens, seemingly attempting to kiss. However, as they move closer, their faces meet the surface of a mirror of water. When they rise, drops of water—evoking the tears of Ovid's Narcissus—fall back, distorting the figures. At this moment, it becomes clear that the figures are merely reflections. The embrace they seek is unattainable; ultimately, they must surrender, as the title suggests.[28] This diptych seems to allude to the transition from the naive type to the self-aware type: the difference in the colors of the clothes and of gender emphasizes the naive falling in love with the Other. In contrast, the dripping of water on the liquid mirror, which reveals (as was the case in Ovid's version with the tears of the handsome young man) both the medium of reflection and indeed the mirrored nature of the object of love, embodies the self-aware type.

On that note, we may recall that lesser-known variant of the legend of Narcissus according to which the handsome young man is said to have fallen in love not with himself, but with a twin sister, who resembled him in every way, both in appearance and in the way she wore her hair and clothes. This is how Pausanias reports it, pointing out that in this variant, Narcissus was not so idiotic as not to recognize that the object of his vision was an image but nevertheless wished to contemplate it as a representation commemorating his beloved: "Narcissus loved his sister, and when the girl died he used to haunt the spring, knowing that what he saw was his own reflection, but finding solace in imagining that he was looking, not at his own reflection, but at his sister's likeness."[29]

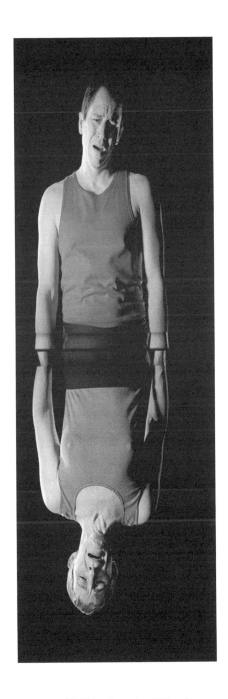

Figure 1.4. Bill Viola, *Surrender*, 2001, color video diptych on two flat panel displays mounted vertically, one over the other on wall, 204.2 × 61 × 8.9 cm, 30:51 minutes; performers: John Fleck, Weba Garretson (photo: Kira Perov © Bill Viola Studio).

Narcissisms

The polarization between the naive type and the self-aware type is, moreover, not the exclusive preserve of the Narcissus myth. For the naive mode, we recall the legend of the madwoman Acco, reported in the collection of Greek proverbs attributed to the philosopher Zenobius, who taught rhetoric in Rome in the second century under the emperor Hadrian: "Acco was a woman renowned for insanity, and it is said that in looking in the mirror she spoke to her own image as if to another person. Hence the saying 'To be mad as Acco.'"[30] As is shown by the comparative exploration of the European tradition and the Chinese and Persian, Indian and African folk traditions undertaken by fairy-tale historian Albert Wesselski,[31] numerous crosscultural examples can be found regarding the lack of self-recognition in mirror reflection. To recall but one instance, we can cite a story included in the commentary to the *Dhammapada*, one of the canonical Buddhist texts of the Theravadan school. In preparing to attack the palace of the treasurer Jotika, Ajātasattu sees the image of himself and his own escort reflected by the jewels set in the palace walls and mistakes it for the enemy army: "Seeing his own reflection and that of his retinue in the jeweled walls, he concluded, 'The householder has armed himself for battle and has come forth with his host.' Therefore he did not dare approach the palace."[32] In the authoritative treatise *De re rustica* (6.35), Columella also considered an animal version of the same theme: mares afflicted with rabies, "if they have seen their reflexion in the water, they are seized with a vain passion and consequently forget to eat and die from a wasting disease due to love.... This delusion is dispelled if you cut off her mane unevenly and lead her down to the water; then beholding at length her own ugliness, she loses the recollection of the picture which was formerly before her eyes."[33]

As for the self-aware mode, it appears in the form of an ancient superstition, found in numerous cultures, that holds that those who look at themselves and recognize their image reflected in a mirror or pool of water are destined to an imminent demise. In *The Golden*

Bough, James George Frazer collected many instances in which the reflection in the mirror is equated with the soul: according to the Zulu and Basuto in Africa and equally to some Melanesian peoples, mirroring oneself in a pool of water exposes one to the risk that ferocious beasts or evil spirits may take possession of one's soul: "We can now understand why it was a maxim both in ancient India and ancient Greece not to look at one's reflection in water.... This was probably the origin of the classical story of the beautiful Narcissus."[34]

In a fascinating pioneering investigation at the intersection of anthropology and psychoanalysis taking into account Frazer's reflections, and with extensive references to the myth of Narcissus, Géza Róheim parallels the notion of removal and that of taboo, examining a wide range of instances from European and non-European folklore relating to the prohibition of looking into the mirror and the fear of one's own mirror reflection (eisoptrophobia or spectrophobia) as a fear of self-recognition.[35]

The type of the self-aware Narcissus, as originating with Ovid, has almost unilaterally fed into the mainstream story of the effects of this myth,[36] decisively reinforced by the psychoanalytic conception of narcissism, which then became the standard in common parlance.[37]

The psychoanalytic elaboration of narcissism is preceded by psychological and psychiatric literature in which references, albeit marginal, to the figure of Narcissus occasionally crop up. This is the case, for example, with Alfred Binet, who in a note to an article on fetishism calls to mind the "fable du beau Narcisse" about "ces tristes perversions" in which the fetish consists of one's own person.[38] The explicit elaboration of the concept, however, is mainly due to the studies of Havelock Ellis and Paul Näcke, exponents of the intense period of research on sexuality, *psycopathia sexualis* (according to Richard von Krafft-Ebing's famous designation) and the so-called perversions (exhibitionism, autoeroticism, coprophilia, fetishism, and, of course, homosexuality...) that flourished in the second half of the nineteenth century. As early as 1898, Ellis had sketched

out a predominantly female type of autoeroticism, designating it as "Narcissus-like": "I may briefly mention that tendency which is sometimes found, more especially perhaps in women, for the sexual emotions to be absorbed, and often entirely lost in self-admiration. This Narcissus-like tendency, of which the normal germ in women is symbolized by the mirror, is found in minor degree in some feminine-minded men."[39]

Taking a statistical approach to the subject of sexual deviations in a sample of more than fifteen hundred male and female patients admitted to the Heil- und Pflegeanstalt Hubertusburg in Leipzig, Näcke adds the suffix "-ismus," adopting the term "authentic narcissism [*echter Narcismus*]" to denote the extreme (albeit in his opinion rare) form of "auto-eroticism" described by Ellis, that is, the form that includes full sexual satisfaction resulting in orgasm, while reserving the notion of "Pseudo-Narcismus" for less intense forms, mostly consisting of self-admiration and intensive contemplation of one's body in the mirror.[40]

In the more properly psychoanalytic context, with an approach that combines the examination of clinical cases together with ancient and modern literary and philosophical references, it is to Isidor Sadger whom we owe the first clinical discussion of what he calls "Narzismus": an attempt to turn toward one's own body those attentions and care devoted to it by one's mother during childhood, ultimately therefore a kind of "Identifikation" between maternal and filial instance.[41]

According to the interpretation, later to become canonical, finally offered by Freud in the 1914 essay "Introduction to Narcissism" (which draws on the work of Ellis, Näcke, and Sadger), "an antithesis between ego-libido and object-libido" is produced that corresponds to a relationship of inverse proportionality: "The more of the one is employed, the more the other becomes depleted."[42] While primary narcissism is consubstantial to infant life, in which the child (from the womb onward) assumes itself as a love object before investing in external objects, secondary narcissism consists of a later adult

regression to that stage, successive to withdrawal of object investment. The possibility of directing one's libido toward an other and external support (i.e., anaclitic attachment: for the child, typically the mother as the original source of pleasure) is replaced by the choice directed toward one's own self. Which version of the myth Freud was referring to, that of Ovid, is clearly revealed not by this major essay, but by a passage from the famous study "Leonardo Da Vinci and a Memory of His Childhood" four years earlier in which the male homosexual is described as having slipped back into the autoeroticism of early childhood:

> The boys whom he now loves as he grows up are after all only substitutive figures and revivals of himself in childhood-boys whom he loves in the way in which his mother loved him when he was a child. He finds the objects of his love along the path of narcissism, as we say; for Narcissus, according to the Greek legend, was a youth who preferred his own reflection to everything else and who was changed into the lovely flower of that name.[43]

This consolidates the general idea that narcissism consists of a general ineptitude for libidinal object investment, resulting in regression to early stages of undifferentiated autoeroticism and mother-child identification processes, together with homosexual inclinations. The issue crucial to our argument of the beclouding of image consciousness (i.e., the inability of the naive Narcissus to realize the iconic nature of what he perceives in the mirror reflection) fades into the background.

For this very reason, on the other hand, the analysis of a narcissistic dream elaborated in 1911 by Otto Rank appears to be particularly significant precisely because it addresses the image experience. It bears recalling here in its basic outline. A young woman, once infatuated with a man who initially reciprocated her attentions and then gradually distanced himself from her, dreams that she receives three letters. The first is a love letter in which "W" (an initial that during analysis the patient would later actually refer to the name of her lover) declares that he is always thinking of her and constantly

looking at the oil painting of her that she had given him as a memento, envying the man who can instead look at her in the flesh. He also confesses that he is already married and encloses a photo of his wife. The second letter is entitled "In a dream" (thus a kind of *mise en abîme* in which the oneiric planes seem to split): the intensely poetic tone of the writing makes her think of a reverie, a daydream. The third and final letter contains only images: leafing through it, she first comes across half-length portraits, then the image of a very beautiful woman (it is not, however, his wife, since the surname written below is different: a surname known to the dreamer, who cannot, however, recall it), and finally the picture of his spouse, complete with surname. Her unattractiveness makes her realize why the man confessed to always thinking of the protagonist of this dream adventure. The patient then returns in the dream to the image of the more beautiful woman, and here it is opportune to report the account in detail:

> I go back flipping backwards until I find the beautiful image again, sinking [*vertieft*] into her gaze.... Above all, I am struck by her face, and primarily by her hair and hairstyle, with a ribbon running through it: I thought it was just the way I style myself. Her eyes reminded me of my own as they appear in my own portraits, and so the shape of her face looked like mine. Then I noticed her beautiful legs and lower body, which also reminded me of my own. I liked this image very much, and I immersed myself [*versenkt*] in its vision as if falling in love with it. I looked at it again and again for a long time, thinking that maybe Rubens might have painted it (maybe he actually painted it). Then it occurred to me that maybe I had talked to W., but I don't know for sure whether I really did and in what way: whether I was there or he was here. I could only see his face, his head in front of me.[44]

The dream scene reported by Rank appears particularly suggestive because it seems to eschew the stark alternative between self-recognition and nonrecognition, opting for a strong *resemblance* (and not a simple identity, precluded according to Rank by self-censoring intervention) between the dreamer and the image of the beautiful

woman portrayed. For the rest, the experience of deepening and immersion (suggested by the verb forms *vertieft* and *versenkt*, respectively) and the dulling of proprioception (her uncertainty regarding the position of her body: "whether I was there or he was here") appear as unmistakable signs of that transgression of the threshold between image and reality that the legend of Narcissus in its naive type articulates as a mythological topos.

Media Narcosis

We said: *beclouding* of image consciousness, *dulling* of proprioception. This is a further reason that warns us against quickly dismissing the naive Narcissus as an idiot, as Pausanias would have it. It is again Hadot[45] who reminds us of the crucial role played by the narcissus flower, the etymology of whose name has been traced by several authors to *narkè*, numbness, narcosis: we read, for example, in Pliny that "it has received its name, from *narkè* [torpor], and not from the youth Narcissus, mentioned in fable"[46] or in Clement of Alexandria that "there is the narcissus, a flower with heavy perfume, whose name itself suggests that it acts as a narcotic [*narkan*] on the nerves."[47] It is thus its narcotic power that establishes that dimension of consciousness at once auroral and crepuscular through which the failure to distinguish between image and reality, between the body and its representation, is made possible.

Marshall McLuhan did not fail to note the connection between the legend of Narcissus and the effects of *numbness*, making explicit its mediological repercussions in a way that is crucial to our discussion. In chapter 4 of his landmark work *Understanding Media*, significantly titled "The Gadget Love: Narcissus as Narcosis," the Canadian mediologist evokes from the outset the etymology that would see the young man's name derived from *narkè*. And he advances in his own way a critical reflection around the Ovidian question of self-recognition, which, as mentioned earlier, has become mainstream:

> The wisdom of the Narcissus myth does not convey any idea that Narcissus fell in love with anything he regarded as himself. Obviously he would have

had very different feelings about the image had he known it was an extension or repetition of himself. It is, perhaps, indicative of the bias of our intensely technological and, therefore, narcotic culture that we have long interpreted the Narcissus story to mean that he fell in love with himself, that he imagined the reflection to be Narcissus!⁴⁸

The recourse to this myth is not ornamental; on the contrary, it appears crucial in the economy of McLuhan's argument, aimed at describing the essential ambivalence of the media as *extensions of man*: "When the spell of the gimmick or an extension of our bodies is new, there comes *narcosis* or numbing to the newly amplified area."⁴⁹ The enhancement of the organic-natural performance of the human body is inseparably accompanied by a corresponding numbing of the corresponding organ: presumably to preserve a state of balance between the hyperstimulation caused by the prosthetic extension and the numbing that compensates for it. The invention of the wheel (this is McLuhan's own example) exponentially increases human capacities for movement and transportation, but this prosthesis ends up causing an atrophy of the foot, which has delegated to the wheel a whole range of functions that it was previously performing itself. In the case of the handsome young man at the spring, the prosthesis constituted by the reflecting mirror of the water offers him an extension of the self, except that it then (in the non-Ovidian variants) prevents him from recognizing himself since the extension of the sense of sight constituted by the mirrorlike medium entails at the same time a dulling or, as McLuhan sometimes prefers to put it, a *self-amputation*: "Self-amputation forbids self-recognition."⁵⁰

Esthesiology is the study of sensations, and proposing an analogy between the human being's central nervous system and the electricity-based technology that extends and externalizes it into the world, McLuhan advances an esthesiological reading of this correlation, believing that the introduction of each new technical device entails an overall redevelopment of the relationships among the particular senses and of the human sensorium as a whole: "Any invention or

technology is an extension or self-amputation of our physical bodies, and such extension also demands new ratios or new equilibriums among the other organs and extensions of the body."[51] By serving the machine, the human being becomes in turn — dialectically — its relative servomechanism.

Returning to what he calls the "Narcissus narcosis" syndrome in an interview with *Playboy* a few years later, McLuhan significantly associates this syndrome with the question of media awareness and the relationship between the transparency and opacity of the medium, resorting to a metaphor destined to become famous, that of the rearview mirror. As long as they are immersed in a medium, the human beings are as little aware of it as is the fish of the water in which it swims. Only at the moment that medium is superseded by a later medium can it be retrospectively focused on and grasped precisely as the medium in which the experience took place: "Thus we are always one step behind in our view of the world."[52]

A similar categorical framework also seems to be referred to by the historian of ideas with a sociological orientation, Christopher Lasch, in a series of works published between the late 1970s and the 1980s dedicated to the analysis of the narcissistic personality of contemporary American man. Directly tying such a style of behavior to the phenomena of media spectacularization, Lasch is among the first to identify the "imaging" of existence in its every minimal and private recess as one of the fundamental causes of this process of the overall narcissification of life, due to the uncontrollable proliferation of images intended for recording and broadcasting: such pervasive iconic mediation means that "we cannot help responding to others as if their actions — and our own — were being recorded and simultaneously transmitted to an unseen audience or stored up for close scrutiny at some later time."[53]

Returning to these themes in a subsequent essay in *The Minimal Self*, Lasch is keen to distinguish the narcissistic personality from the concepts of egocentrism and egoism with which it is often and willingly confused: "As the Greek legend reminds us, it is this confusion

of the self and the not-self—not 'egoism'—that distinguishes the plight of Narcissus." The minimal or narcissistic self presents itself as a self uncertain of its own boundaries (those that determine the typically contemporary preoccupation with individual "identity"), which originates from a radical transformation: "The replacement of a reliable world of durable objects by a world of flickering images that make it harder and harder to distinguish reality from fantasy."[54]

As was already the case for McLuhan, for Lasch, what essentially constitutes the essence of the Narcissus fable (insofar as it can help illuminate the pervasive transformation of the contemporary world into an image) thus has nothing to do with self-recognition and self-eroticism at all, but rather with "naivety," that is, the difficulty or rather impossibility of distinguishing between reality and its iconic representation: "Narcissus drowns in his own reflection, never understanding that it is a reflection. He mistakes his own image for someone else and seeks to embrace it without regard to his safety. The point of the story is not that Narcissus falls in love with himself, but, since he fails to recognize his own reflection, that he lacks any conception of the difference between himself and his surroundings."[55]

Slightly subsequent to Lasch's reflections, Régis Debray's mediological considerations, also engaged in an attempt to reconstruct the history of the Western gaze, identify in the media narcissism of the contemporary technological stage designated as "visual" a self-reflexivity and circularity of referrals between media that is sealed in a self-referential bubble devoid of effective connections to the real: "In a culture of subjectless gazes and virtual objects, the Other becomes a species in danger of extinction, and the image, an image of itself. Technological narcissism, that is, corporate 'communication' as mere navel-gazing. . . . The visual communicates itself, no longer desires anything but itself. Vertigo of the mirror: more and more frequently the media tell us about the media."[56]

Apnea

In the light of these considerations, which we might well call dialectical mediology, we are now in a position to assign to Narcissus a fundamentally archetypal role in the genealogy of immersive environments that we propose to delineate: a role that is all the more crucial insofar as it is rooted not in the chronology of prehistory, but in the undefined mists of myth. The reconstructions of media archaeology that have attempted a history of the precursors of such environments—discerning them, as we will see, in the illusionistic paintings of Pompeian villas, in panoramas, in iMax cinemas—have not gone as far as Narcissus, who instead can be included in the genealogy of immersivity and indeed must be recognized as its eponymous hero: Narcissus is the proto-immersive, the archetypal *experiencer* who grasps the image as if it were reality itself and not a mediation of it (immediateness), relates to it as a presence relates to another presence, and not to a mere iconic representation (presentness), and finally, corresponding to a specific *affordance*, immerses himself in it (unframedness) traversing its threshold.

And it is precisely by turning to the timeless past of this proto-immersive myth that we can begin to glimpse the sense of the seemingly ineluctable drive toward immersiveness that distinguishes our contemporary media landscape and seems to direct its near future.[57] Although, as we will see more extensively in later chapters, while "immersion" refers *lato sensu* to an experience of total involvement in an iconic environment, its meaning *stricto sensu*, which ties it literally to the liquid element, exhibits its status in a paradigmatic way.

Early cinema had already made a pact with this literal sense of immersiveness:[58] the shot from the train of the Whirlpool Rapids in *Panorama of Gorge Railway* (Edison, 1900), which seems to want to draw the viewer into the swirling waters, offers an early example of this. The pact would later be reaffirmed and strengthened by subsequent developments in a cinematography aimed at what has been called a true "enwaterment" (water + embodiment) of the viewer, who is incorporated into a liquid and fluid dimension.[59] Think—to

mention but a few successful titles — of the cases of *Cape Fear* (Martin Scorsese, 1991), *Titanic* (James Cameron, 1997), *The Truman Show* (Peter Weir, 1998), and *Saving Private Ryan* (Steven Spielberg, 1998).

In the context of video art, the video environment *The Swimmer (going to Heidelberg too often)* (fig. 1.5), made in 1984 by Studio Azzurro (a group of artists who were among the first to experiment with digital technologies), appears particularly significant for our discussion since it stages in an exemplary way the dialectic between framing and unframing. Arranged side by side, twenty-four monitors scan separate spaces horizontally. But this discontinuity is systematically negated by what the monitors themselves display: a swimmer who, gliding from one screen to the next, bursts, as it were, from their frames and imposes the establishment of a continuous space.

Nowadays, when immersiveness seems to have become a buzzword, we should ask ourselves whether the future of virtual reality will be underwater. In 2020, Pierre "Pyaré" Friquet, an artist who creates immersive virtual environments, presented at the Sundance Film Festival the work *Spaced Out*, to be experienced by swimming underwater with a waterproof VR headset designed by Ballast Technologies, a liquid journey from the Earth to the Moon that, as the press release states, allows for full immersion: "Floating in the water with VR goggles becomes a space simulation as the absence of gravity immerses all the senses."[60]

With *Aquaphobia*,[61] a 2017 VR installation, Jakob Kudsk Steensen stages a watery world in which nature has now taken over from humans, uniting the post-Anthropocene future with an archaic, prehuman Brooklyn. The title makes direct reference to psychotherapeutic treatments aimed at curing water phobia and alludes to a perspective in which, due to climate change and rising sea levels, the submerged condition promises to become not the exception, but the rule of existence (the perspective foreshadowed by the film *Waterworld*, directed by Kevin Reynolds and released in 1995).

Immersion in a virtual reality environment that simulates a world alternative to the real world could well be compared to a condition

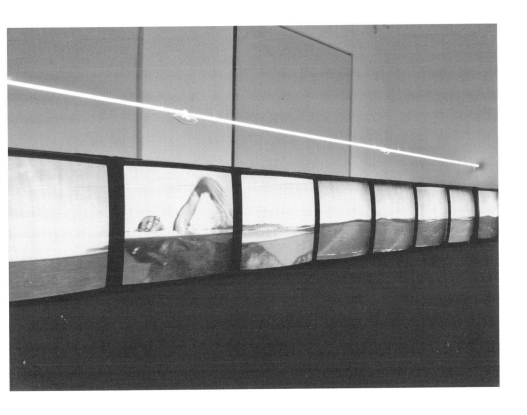

Figure 1.5. Studio Azzurro, *The Swimmer (going to Heidelberg too often)*, video environment, 1984 (courtesy of Studio Azzurro).

of apnea, in which the so-called breathing rhythm that governs our usual interactions with the real world is suspended and replaced with a different rhythmic pattern in which we must learn new gestures and new sensorimotor performance.

Apnea[62] is a VR video game published by MephistoFiles in 2015 in which the player embodies a Soviet diver who must retrieve the prototype of a nuclear missile from the US submarine *Scorpion*, which sank in the waters of the Atlantic in May 1968. But *Apnea* (fig. 1.6) is also an immersive installation combining virtual reality and interactive documentary, created in 2016 by Vanessa Vozzo and dedicated to the tragic shipwreck in the Mediterranean off Lampedusa on October 3, 2013, in which at least 368 migrants perished: passing through three distinct moments (an exhibition room where photographs, videos, and documentation related to the shipwreck can be viewed; an interactive projection; and a 360-degree video that immerses the viewer in the waters off the coast of Sicily), the viewer is invited to share a disturbing threshold experience: "In *Apnea* the sea is a boundary where everything disappears, a real border, but also a representation of the limit that separates life from death, from solitude, from void."[63]

We will have to return later to the (controversial) use of virtual reality in humanitarian documentary filmmaking as a device capable of triggering in viewers feelings of empathy and proactive participation. For now, we can observe that this installation leads us directly back — uniting history and myth — to the figure of Narcissus as proto-immersive and in particular to the watery death that we have seen reserved for him in the version embraced by Plotinus. By immersing himself in the image, Narcissus dies by drowning: the deadly danger of immersion. By immersing themselves in the image, the viewers of *Apnea* are invited to identify themselves, albeit asymptotically (like the famous parallel lines that meet, yes, but only in infinity), with those drowned in the Mediterranean: through such an immersive experience of identification, users are urged to empathize with the victims and to develop a prosocial attitude toward

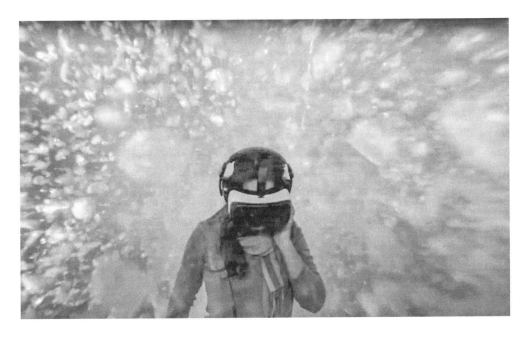

Figure 1.6. Vanessa Vozzo, *Apnea*, interactive and immersive documentary about migrants and the sea, 2016 (courtesy of Vanessa Vozzo [Officine Sintetiche]).

the migrant crisis and a participatory understanding of this tragic phenomenon.

We are here faced with what Walter Benjamin calls "telescoping [*télescopage*] of the past through the present," a telescoping or collision of different levels of temporality (like a spyglass closing up on itself) by which the contemporary reactivates the meaning of a past, a past so archaic that it blurs into the mists of myth, leading it to new "legibility" and "recognizability."[64]

Thus, the ambiguous profile of immersiveness as a true two-faced Janus begins to emerge: on the one hand, as a destiny of death and loss of the boundaries of the self in the indistinguishability that fuses together reality and image and nullifies the experiencer's ability to assume a critical distance from the situation that envelops him or her.[65] (The *hikikomori*, who practice an almost total social withdrawal and isolate themselves from the world by sealing themselves inside a digital bubble, could be contemporary embodiments of this form of narcissism.)[66] On the other hand, as an opportunity of involvement in and participation in the situation, which transcends the traditional position of the subject standing in front of the object and opens up unprecedented experiential and cognitive horizons: an occasion that, just like a free-diving experience, is delimited in time and destined to resurface but that also promises to transform those who experience it.

CHAPTER TWO

Alice's Mirror

Perturbing Reversals

As seen in the previous chapter, the myth of Narcissus contemplating his reflected image at the spring is inextricably linked to the theme of the mirror and its complex symbolism. The mirror is in turn inseparably linked to the question of the origin of the image, an issue on which the condemnation pronounced by Plato in the tenth book of the *Republic* hangs heavily. In this denunciation of the image makers, it is precisely the device of the mirror that is evoked as a mimetic instrument of illusory reproduction of the real: "You could do it quickly and in lots of places, especially if you were willing to carry a mirror with you, for that's the quickest way of all. With it you can quickly make the sun, the things in the heavens, the earth, yourself, the other animals, manufactured items, plants, and everything else mentioned just now."[1] Ernst Cassirer and Panofsky[2] showed that the concept of *mimesis*, viewed negatively by Plato but now elevated to a positive value by passing through a variety of transformations, would be the mainstay of theories of the visual arts for centuries to come: imitation would constitute the supreme task of the artist. Something similar could be said for the mirror, adopted as a formidable ancillary tool by painters and then becoming both object and metaphor for subsequent techniques of image production, from photography to cinema to virtual reality.[3]

An inherently ambivalent device, the mirror, as Michel Foucault observes, is an "in-between experience"[4] combining utopia (the unreal

virtual space in which I see myself over there, there where I am not) and heterotopia (an unreal counterspace that returns me to the place I actually occupy in the world). In the mirror, as Jurgis Baltrušaitis has well shown, we dialecticize the polarity between faithful reproduction of the real and deformation that alters it.[5]

In the treatise *On Painting*, to which we have already alluded in connection with the myth of Narcissus, Alberti thus advises those who wished to be good painters, "certainly, a mirror will be an excellent judge to examine this result. And even I do not know how objects depicted without errors become pleasing in a mirror. It is surprising, moreover, that every imperfection of a painting appears more deformed in a mirror. Let, therefore, [objects] taken from Nature be corrected through the control of a mirror."[6] In his reflections, later collected by his pupils under the title of *Treatise on Painting*, Leonardo da Vinci makes more explicit this cognitive and corrective function of the mirror image, emphasizing the capacity for estrangement inherent in the effect of contralateralization: "I say that when you are painting you ought to have by you a flat mirror in which you should often look at your work. The work will appear to you *in reverse* and will seem to be by the hand of another master and thereby you will better judge its faults."[7]

This effect of estrangement of mimesis achieved by means of specular reflection — consisting of reproducing, yet at the same time of metamorphosing — thus occurs not only by resorting to deforming mirrors (such as that exploited by Parmigianino in his famous *Self-Portrait in a Convex Mirror* of 1524), but also by employing simple flat mirrors. In the splitting produced by the mirror, a kind of *Verfremdung* takes place, an estrangement or alienation that is accentuated in nonideal environmental conditions, such as low light. Freud not surprisingly refers to precisely this in his essay on the concept of the uncanny (*unheimlich*), recounting an episode that had happened to him firsthand:

> I was sitting alone in my sleeping compartment when the train lurched violently. The door of the adjacent toilet swung open and an elderly gentleman in a dressing gown and travelling cap entered my compartment. I assumed that

on leaving the toilet, which was located between the two compartments, he had turned the wrong way and entered mine by mistake. I jumped up to put him right, but soon realized to my astonishment that the intruder was my own image, reflected in the mirror on the connecting door. I can still recall that I found his appearance thoroughly unpleasant.[8]

Far from being an alienating effect reserved for artists, then, its uncanny capacity is a constitutive quality of the mirror experience, which sits at the intersection of identity and otherness and plays on the possibilities of mutual reversal between the Self and the Other.

Essential contributors to such a perturbation are not simply the fact that in the mirror I am facing myself, but also that this myself is inverted with respect to me so that if I raise my right arm, my counterpart in the mirror raises the left one, and vice versa.

The issue of inversion *in counterpart* was well known to Plato himself, who observes in the *Timaeus* that in mirrors, "what is left will appear as right."[9] However, the idea that mirrors reverse right and left has found authoritative opponents. Investigating the relationship between catoptrics (the branch of optics that studies the phenomena of specular reflection) and semiotics, Umberto Eco emphatically rejects it:

> A mirror reflects the right side exactly where the right side is, and the same with the left side. It is the observer (so ingenuous even when he is a scientist) who by self-identification imagines he is the man inside the mirror and, looking at himself, realizes he is wearing his watch on his right wrist. But it would be so only if he, the observer I mean, were the one who is inside the mirror (*Je est un autre!*). On the contrary, those who avoid behaving as Alice, and getting into the mirror, do not so deceive themselves.[10]

This argument is raised by Eco in a section of his text on mirrors entitled "A Phenomenology of the Mirror." But it is precisely our phenomenological experience as naive subjects who identify with the character inside the mirror that makes us notice the contralateralized inversion. And this is precisely because, as Eco himself

indeed observes, despite the fact that the mirror has no "inside," the observer perceives what he sees in the mirror *as if* he were placed there in a space with its own depth analogous to that possessed by the space that presents itself in front of the mirror, a trait that determines its virtual quality, defined as follows: "As for the virtual image, it is so called because the observer perceives it as if it were inside the mirror, while, of course, the mirror has no 'inside.'"[11]

Who can really, by looking in the mirror, behave not like Alice, but like a physicist who is not naive? "I'll tell you all my ideas about the Looking-glass House," Lewis Carroll's heroine tells her kitten while holding it in front of the mirror, "First, there's the room you can see through the glass—that's just the same as our drawing-room, only the things go the other way.... Well then, the books are something like our books, only the words go the wrong way."[12] Certainly many other strange things happen in the world beyond the mirror: for example, the traditional distinction between humans and non-humans vanishes, and new, perfectly legitimized ontologies appear.[13] But the contralateral inversion remains the most striking aspect.

The consequences of this inversion were well noted by an admirer of the author of Alice's adventures such as Jacques Lacan, not, however, in the *hommage* expressly dedicated to him in 1966,[14] but in the famous essay on the mirror stage. Inspired by Freudian reflections on primary narcissism, Lacan recognizes the powerfully configuring function in the child's experience (in a period ranging from about six to eighteen months) of the reflected *imago* of his own body in the mirror, obtaining for the first time instead of a fragmentation of *disiecta* bodily limbs a meaningful ("orthopedic") image of its own totality, which will later condition its social relations.

However, this "virtual complex" does not lead to full recognition of the self-image as seen by others. A "fictional direction," a "discordance" is created, essentially due to the fact that the *Gestalt* of one's body that the child receives from the mirror necessarily falls "under a symmetry that reverses it."[15] The contralateralization effect produced by mirror reflection—whereby what is on the right

is reversed to the left, and vice versa — thus introduces an unassailable gap between an individual's self-perception and the public and intersubjective perception of that individual to which others accede. It is a phenomenon (singularly overlooked by otherwise astute readers of Lacan, such as Maurice Merleau-Ponty himself)[16] that invests those small asymmetries of our bodies, and particularly of our faces, that we can easily experience when, while driving, we look in the rearview mirror at the face of a person who is familiar to us, detecting small, yet *unheimlich* formal and physiognomic inconsistencies.

Doubles and Simulacra

But that is not all. Although only *en passant*, Lacan hints at an aspect of the mirror image that seems particularly relevant to our discussion of the threshold, connecting the reflection of self to those "correspondences" and "projections" — the statue, the automaton, the double — that extend and multiply it:

> The specular image seems to be the threshold of the visible world, if we take into account the mirrored disposition of the imago of one's own body in hallucinations and dreams, whether it involves one's individual features, or even one's infirmities or object projections; or if we take note of the role of the mirror apparatus in the appearance of *doubles*, in which psychical realities manifest themselves that are, moreover, heterogeneous.[17]

In the context of psychoanalysis, before Lacan, Sadger[18] and Rank[19] had already hypothesized that the inclination toward narcissism, which we have seen to be constitutively bound to the mirror image, could go as far as *Doppelgängerei*, that is, to the production of a look-alike or double. Rank, not surprisingly, considers the lesser-known variant of the Narcissus legend reported by Pausanias (which we mentioned in the previous chapter) according to which the handsome young man fell in love not with himself, but with a twin sister similar to him in every way.

The twin, the doppelgänger, the double (and, as we will see below, the avatar) represent a constellation of kindred figures that

mythologies in different cultures and the history of world literatures have incessantly interpreted in a variety of ways.[20] In our own cultural tradition, German literature in particular has focused on the theme of the doppelgänger, as in the cases of two short stories, "Peter Schlemihl" (1814), by Adelbert von Chamisso,[21] in which the protagonist sells his shadow to the devil, and —particularly significant for our catoptric theme — "A New Year's Eve Adventure" (1815), by E. T. A. Hoffmann, in which Schlemihl himself appears as a secondary character, among many examples that could be cited. In the latter tale, in the episode titled "The Story of the Lost Reflection," the tale is told of Erasmus Spikher's adulterous love for the beautiful and mysterious Giulietta, who at the time of their separation asks her lover to leave her his reflected image (*Spiegelbild*) to remind her of him: "Erasmus saw his image step forward independent of his movements, glide into Giuletta's arms, and disappear with her in a strange vapor."[22] After various vicissitudes, and the revelation of Giuletta as the devil's emissary, Erasmus returns to his wife, who, however, is unwilling to take him back until he is reunited with his own mirror image. The forlorn wretch then sets off on his travels and ends up meeting Schlemihl: "They planned to travel together, so that Erasmus Spikher could provide the necessary shadow and Peter Schlemihl could reflect properly in a mirror. But nothing came of it."[23]

The fantastic tales of Chamisso and Hoffmann constitute two of the direct sources for one of the earliest German art films, *The Student of Prague*, directed in 1913 by Stellan Rye, scripted by Hanns Heinz Ewers, set to music by Josef Weiss, and starring Paul Wegener. Here we find the penniless student Balduin, who, a novice Narcissus, plays at dueling in the mirror with his own image, boasting that he is the most valiant swordsman in all of Prague. It will be that same image that the old adventurer Scapinelli (yet another incarnation of the Faustian Mephistopheles) will take away from him, compensating him with a hundred thousand gold florins. The mirror reflection will be invited by the old man to leave the mirror and embark on an autonomous existence, detached from its model (fig. 2.1).

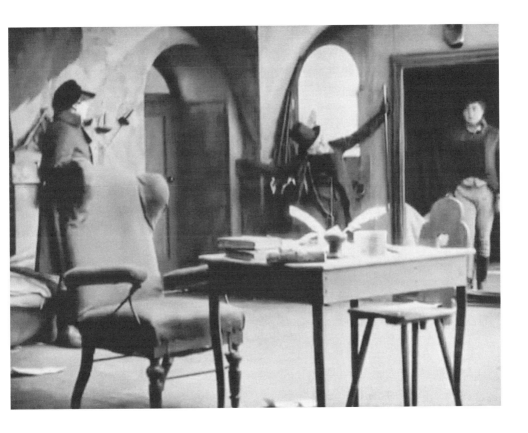

Figures 2.1. Film still from *The Student of Prague*, 1913, directed by Stellan Rye (Deutsche Bioscop).

But the reflection takes to tormenting Balduin, haunting him in several appearances, even to the point of substituting himself for the young man in a duel with the contender for the hand of the beloved Countess Margit. The death of the challenger, which the student had vowed to avoid, leads to the tragic denouement that results in a suicide-homicide: Balduin resolves to get rid of his mirror double once and for all by shooting him with a pistol, realizing in the end that he has shot himself.

It is precisely with *The Student of Prague* that Rank's essay on the double in literature and folklore opens. Here, hot on its heels, as it were (the book was published the year after the film's release), the Austrian psychoanalyst notes the peculiar effectiveness of the filmic transposition of that literary motif, "the uniqueness of cinematography in visibly portraying psychological events": not only can "cinematography, which in numerous ways reminds us of the dreamwork, express certain psychological facts and relationships—which the writer often is unable to describe with verbal clarity—in such clear and conspicuous imagery that it facilitates our understanding of them,"[24] but it can also allow for the resurfacing in modern days of very ancient layers of meaning buried in the mists of tradition.

Rye's film—partly due to its two remakes in 1926 (directed by Henrik Galeen) and 1935 (directed by Arthur Robison)—caught the attention of many media theorists.[25] Siegfried Kracauer points out that the film introduced "a theme that was to become an obsession of the German cinema: a deep and fearful concern with the foundations of the self," the question of "split personality."[26] This would have been, in Kracauer's sociopolitical interpretation, a metaphor for the collective split personality of the German bourgeoisie itself, resentful of the ruling feudal class. For his part, Friedrich Kittler spoke of a veritable "doppelgänger boom"[27] inaugurated by *The Student of Prague*: Balduin seeing the image of himself moving autonomously would ultimately be nothing more than the allegory of the film actor witnessing the representation of himself on the screen, a kind of film within a film.

But it is with Jean Baudrillard's reading that we reach a crucial point for our discussion. Baudrillard repeatedly returns in his work to *The Student of Prague* (referring not to the first version, but to the 1926 remake). In *The Consumer Society*, the loss of the mirror image in exchange for money is read as the commodifying alienation of a part of the self in the consumerist logic of exchange value; that part, however, is not simply surrendered, but returns as an avenging specter to haunt the subject who has alienated it.[28] In *Simulacra and Simulation*, Balduin's specular reflection is evoked along with Schlemihl's shadow as a perturbing symbol of the impossibility of establishing a priority relationship between model and image, appearance and reality.[29] In *The Perfect Crime*, the film is called to mind as an illustration of the "precession of simulacra," that is, of the precedence of the image over its own model: "Like the double of the Student of Prague, who was always there before him."[30] It is the last chapter of this book — significantly, entitled "The Revenge of the Mirror People" — that makes explicit the implications that we might call "political" of that precession, which asserts the irreducible otherness of the mirror image with respect to the subject mirrored in it:

> Every representation is a servile image, the ghost of a once sovereign being whose singularity has been obliterated. But a being which will one day rebel, and then our whole system of representation and values is destined to perish in that revolt. This slavery of the same, the slavery of resemblance, will one day be smashed by the violent resurgence of otherness. We dreamed of passing through the looking-glass, but it is the mirror peoples themselves who will burst in upon our world.[31]

Two-Way Road

Inspiring Baudrillard for the hypothesis of this catoptric revolt is "Animals of Mirrors," a short story by a grand master of mirrors, Jorge Luis Borges, included in the *Handbook of Fantastic Zoology*. Here is found the account of an event that took place in the time of the Yellow Emperor:

> In those days the world of mirrors and the world of men were not, as they are now, cut off from each other. They were, besides, quite different; neither beings nor colours nor shapes were the same. Both kingdoms, the specular and the human, lived in harmony; you could come and go through mirrors. One night the mirror people invaded the earth. Their power was great, but at the end of bloody warfare the magic arts of the Yellow Emperor prevailed. He repulsed the invaders, imprisoned them in their mirrors, and forced on them the task of repeating, as though in a kind of dream, all the actions of men. He stripped them of their power and of their forms and reduced them to mere slavish reflections. Nonetheless, a day will come when the magic spell will be shaken off.... Little by little they will differ from us; little by little they will not imitate us.[32]

In Borges's fantasy, mirror mimesis (which in any case already in itself involves the alteration of the counterpart) thus turns out to be a derivative and provisional situation, preceded and followed by a condition characterized by two fundamental elements: otherness, the dissimilarity between the mirroring and the mirrored; and osmoticity, the traversable threshold between the real world and the mirror world.

A fundamental theme is announced here to which we will return several times in the chapters that follow. Compared with the legend of the proto-immersive Narcissus — who plunges into his own image in a *unidirectional* movement leading from reality to its representation — in the mythologies that have developed around the mirror, a *bidirectional* movement unfolds that allows the entry from the real world into the virtual environment as much as the leaking of elements from the latter into the former.

While the exit scene is effectively portrayed by *The Student of Prague*, the entrance scene finds its natural place in our imagination, so to speak, at the moment when Carroll has his heroine pass through the mirror (fig. 2.2):

> Let's pretend there's a way of getting through into it, somehow, Kitty. Let's pretend the glass has got all soft like gauze, so that we can get through. Why,

 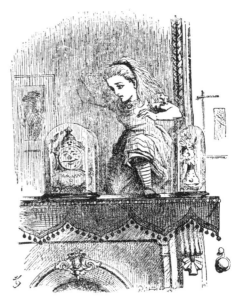

Figure 2.2. John Tenniel, *Alice Through the Looking-Glass*, illustrations from Lewis Carroll's volume *Through the Looking-Glass* (1871, first edition, London: Macmillan Company, 1907), Henry W. and Albert A. Berg Collection of English and American Literature, The New York Public Library (photo: NYPL).

it's turning into a sort of mist now, I declare! It'll be easy enough to get through—" She was up on the chimney-piece while she said this, though she hardly knew how she had got there. And certainly the glass was beginning to melt away, just like a bright silvery mist. In another moment Alice was through the glass, and had jumped lightly down into the Looking-glass room.³³

As was the case with the earlier and more famous novel *Alice's Adventures in Wonderland* (1865), the sequel *Through the Looking-Glass, and What Alice Found There*, published six years later, would also inspire various transpositions and remediations: think of the animated short film *Thru the Mirror* in the Mickey Mouse series, directed for Disney by David Hand and released in 1936, or the video game that was based on it, *Disney's Magical Mirror Starring Mickey Mouse* (developed by Capcom and released by Nintendo and Disney Interactive in 2002), or the more recent film *Alice Through the Looking Glass* (2016), directed by James Bobin.

Early cinema was quick to learn how to exploit the idea of bidirectionality by employing the mirror as a passageway transitable in both directions with remarkable special effects. In *Les hallucinations du Baron de Münchhausen* (1911) Georges Méliès presents us with the baron, who falls asleep after a drinking spree and in a dream enters (albeit stumbling) and exits the large mirror above his bed, actively participating in his own nightmares and hallucinations (fig. 2.3).³⁴

The mirror-crossing topos later proved an irresistible attraction to Dadaists and surrealists. Lord Patchougue, the literary alter ego of the Dadaist dandy Jacques Rigaut and protagonist of the short story of the same name that came out posthumously in 1930, enters a mirror only to find nothing but more mirrors to cross, in a classic *mise en abîme*.³⁵ The chapter that recounts this passage, "Passage dans la glace à Oyster Bay," is, moreover, strictly autobiographical. One evening in 1924, during an exclusive party on Long Island, Rigaut himself had shattered a mirror with his head in an attempt to pass through it.³⁶ As for the cinema, Jean Cocteau, whose work is obsessively characterized by the mirror device, explored the theme in

Figure 2.3. Film still from *Les Hallucinations du Baron de Münchhausen*, 1911, directed by Georges Méliès (Star Film).

Figure 2.4. Film still from *Le Sang d'un poète*, 1930, directed by Jean Cocteau (courtesy © Jean Clement Eugene Mar Cocteau, by SIAE 2021; photo: © Hulton-Deutsche Collection/Sacha Masour/Stinger/Getty Images).

two memorable films: *Le sang d'un poète* from 1930, and *Orphée* from 1950. In the former, a statue of an armless woman (Lee Miller) comes to life and invites a poet (Enrique Rivero) to cross the threshold of a mirror (fig. 2.4), while in the latter, Heurtebise (François Perrier), a kind of guardian angel, invites Orpheus (Jean Marais) to pass through a mirror so that he can reach the afterlife and bring Eurydice back.

It is what Cocteau himself defines — in Heurtebise's words — as the passage through the "zone," a marginal, threshold territory between life and death, present and past, reality and imagination:[37] a zone that many years later would inspire those depicted by Andrei Tarkovsky in *Stalker* (1979) and David Lynch in *Twin Peaks* (1990–1991).[38]

The passage of Orpheus and Heurtebise through the mirror represents a highly evocative sequence, which Cocteau achieved through the use of four hundred kilos of mercury, a substance indispensable to create the required effect "because [it] shows only the reflection and not the part that has penetrated into the mirror, as water would have done."[39] It is hard not to think of the scene in the Wachowskis's *The Matrix* (1999) in which Neo, after swallowing the red pill, is about to learn the truth, interacting with a mirror whose glassy surface is transformed into mercurial liquid and becoming that mirror himself. After all, Morpheus warns him with an explicitly Carrollian admonition, "You take the red pill, you stay in Wonderland and I show you how deep the rabbit hole goes." Had Neo ever had a dream so realistic that he could not distinguish it from reality, Morpheus urges? And if he could not wake up from that dream, how could he distinguish the dream world from the real world?

Alice's entry into the world beyond the looking glass had ultimately turned out to be a dream interrupted by the child's awakening. But in the last chapter entitled "Which Dreamed It?" Carroll left his protagonist (and the reader with her) in doubt: "You see, Kitty, it must have been either me or the Red King. He was part of my dream, of course — but then I was part of his dream, too!"[40] In our cultural tradition, the link between dreams and mirror images has been close

at least since the time of Aristotle (in the *Parva naturalia*, we read that "dream images are analogous to the forms reflected in water"),[41] and the difficulty or even the impossibility of discerning between the realm of the real and the dream realm constitutes a transcultural topos that would be impossible to reconstruct here. We need recall only that Borges himself includes it in *The Book of Fantasy* in the Chinese variant collected by the Sinologist Herbert A. Giles: "The philosopher Chuang Tzu dreamed he was a butterfly, and when he woke up he said he did not know whether he was Chuang Tzu who had dreamed he was a butterfly, or a butterfly now dreaming that it was Chuang Tzu."[42]

Christopher Nolan provides a powerful cinematic formulation of the interconnection between mirror and the dream dimension in his *Inception* (2010), played on a *mise en abîme* of different levels of dream within a dream that fit one into the other like Chinese boxes: maze builder Ariadne (Elliot Page) creates before the eyes of Dom Cobb (Leonardo DiCaprio) an illusion of infinity by juxtaposing huge mirrors between the uprights of the Paris Bir-Hakeim Bridge. Nolan's film is, after all, but a recent chapter in a long and complex love affair between cinema and mirrors: one may consider, to give but a few paradigmatic examples, the labyrinths of mirrors in Chaplin's *The Circus* (1928) and Orson Welles's *Lady from Shanghai* (1947) or the monologue before the mirror in Martin Scorsese's *Taxi Driver* (1976). We might also add John Woo's *Face/Off* (1997), in which the exchange of the faces of the two antagonists triggers alienating mirroring effects: "It's like looking in a mirror. Only... not," says John Travolta to Nicolas Cage, who beholds his own features on his opponent's face.

Not only are mirrors objects beloved in cinema—which employs them in "mirror shots" with peculiar subjectification effects[43]—but they have also been a powerful metaphor for it, competing very early on with other equally influential metaphors such as those of cinema as frame or window.[44] In *Photoplay* (1916), one of the earliest theoretical studies of cinema, psychologist Hugo Münsterberg compares

depth perception in the mirror and on the movie screen.[45] In *Visible Man* (1924) Béla Balázs advances a physiognomic reflection on the close-up of Asta Nielsen's face that reflects as in a mirror the expression of her interlocutor.[46] From these early insights there unravels a complex tradition of film theories, inspired especially by psychoanalysis, that have resorted to the analogy between film projection and mirror reflection. We recall, among many names, Baudry (for whom cinema would promote a regression to Freudian primitive narcissism)[47] and Metz (who worked on specular processes of identification),[48] but also Eco, who proposes a "magic experiment" in which cinema should be understood as a mirror that first freezes images (as in photography) and then dynamizes them.[49] More recently, cinematic mirroring has received support from neuroscientific research into those processes of embodied simulation capable of triggering the particular population of neurons in the premotor cerebral cortex that "discharge" both in the case of me performing actions myself and in the case of my seeing them performed by others: "mirror neurons," precisely,[50] which are activated in me when I observe another human being perform an action in both the real world and the representational world that appears on the screen, demonstrating that the threshold between the two dimensions is not a rigid barrier, but an osmotic membrane.

The Reflective Medium

The screen understood as a catoptric surface has found a particular mode of application in video art. Here, we are immediately brought back to our starting point: Narcissus in the mirror. In analyzing a series of videos made between the late 1960s and the first half of the 1970s (in which artists such as Vito Acconci, Richard Serra with Nancy Holt, Bruce Nauman, and Lynda Benglis employ the medium of video as a self-reflexive mirror), Rosalind Krauss explicitly refers to an "aesthetics of narcissism," going so far as to state that "the medium of video is narcissism" itself.[51] In these videos, the artist's body is sandwiched between two machines as if between two

brackets: the camera that shoots it and the screen on which the shot comes to manifest itself.

In *Centers* (1971), Acconci films himself as if in a mirror while pointing to the center of the screen for more than twenty minutes. In *Air Time* (1973), Acconci again sits between the camera and a large mirror facing his own reflected image to which he simultaneously corresponds and does not correspond:

> I'm sitting here, looking into a mirror, not to see myself but to see myself in relation to a specific person I've been involved with for an extended time: I look at the mirror as if she's in here with me, as if I'm looking at her, as if I'm talking to her through the crowd: recreate incidents we've been through together: see myself the way she's seen me, hear myself the way she's heard me.[52]

What Krauss calls a "self-encapsulation" is produced, "a situation of spatial closure, promoting a condition of self-reflection."[53] In Serra's *Boomerang* (1974), Holt speaks and hears her own delayed voice in headphones, so that there is asynchrony between emission and reception. We listen to her own words without being able to hear/perceive the sound effect (we could say an echolalia, that is, a form of sonic pendant to the visual narcissism that, indeed, Ovid had already been able to integrate into the legend of Narcissus thanks to the figure of the nymph Echo):

> I can hear my echo.... I have the feeling that I am not where I am.... I feel that this place is removed from reality although it is a reality or already removed from the normal reality... boomeranging back... which makes me think about the difference between instantaneous time and delayed time... instantaneous time is an immediate perception, whereas delayed time is more like a mirror reflection... a mirror reflection.... I am surrounded by me.... There is no escape.... It is a constantly revolving involuting experience.... I am reflected back into my ear and into your ear.... You are hearing and seeing a world of double reflection and refractions.[54]

In *Revolving Upside Down* (1968), Nauman is filmed by an upended camera, and while as if upside down, he rotates for sixty minutes on

one foot—a sort of parody of the fact that mirrors reverse left and right, but not up and down. Of all these examples, perhaps the most telling is Benglis's *Now* (1973): The artist is filmed in close-up in profile as she turns to a screen in which she herself appears, as if in a mirror, while uttering the same repeated words, "Stop recording now."

Where does this kind of self-reflexive loop around which these videos in various ways revolve actually lead? According to Krauss, the catoptric image aims at surpassing the separation between subject and object, between reality and image, between mirroring and mirrored. And it is a surpassing that is achieved by *submergence*: "The result of this submergence is, for the maker and the viewer of most video-art, a kind of weightless fall through the suspended space of narcissism."[55]

But the appeal of specularity exerts its fascination on contemporary artists far beyond the medium of video art. Since the 1960s, artists from different backgrounds have found themselves converging with increasing persistence on the medium of reflective surfaces in general (stainless steel, Plexiglas, Mylar...) and the mirror in particular in order to question the separateness on the one hand between work and environment (the environment is reflected in the work), and on the other hand between artist and viewer (the viewer finds himself reflected in the work, involved in it, participating in the production of its meaning)[56]

The specificity of the *reflective* medium can be grasped in the dialectical comparison with its opposite, the *transparent* medium. Opting for a transparent material means employing/choosing a material that does not hold the gaze on itself but leads beyond it, to the world behind it, a world that, however, does not appear to us as if it were perceived in the flesh, directly, but rather as transfigured by traversing the medium. Employing a reflective material entails, for the same and opposite reason, the use of a substance/material/medium that denies itself as such to perception, rejecting the gaze to grasp not what lies behind it (as in the case of transparency), but what lies before it. That, too, is not grasped by our gaze as if it were caught

Figure 2.5. The interior of the mirrored dome of the Pepsi Pavilion, Expo '70, Osaka, where the reflection of the floor and visitors hangs upside down in space (photo: © Fujiko Nakaya. Courtesy of E.A.T. and the Daniel Langlois Foundation).

directly, but is rather seen/observed in the mediation of the reflection, of the mirror image.

Among the very many examples that could be cited, we can mention Michelangelo Pistoletto's *Mirror Paintings* series (started in 1961), Robert Morris's *Mirror Cubes* (1965–1971), Yayoi Kusama's *Narcissus Garden* (1966), Lucas Samaras's *Room No. 2* (commonly known as *The Mirrored Room*, 1966), Smithson's *Yucatan Mirror Displacements (1–9)* (1969), Joan Jonas's *Mirror Pieces I* and *II* (1969, 1970), Bruce Nauman's *Corridor with Mirror and White Lights* (1971), Dan Graham's *Performer/Audience/Mirror* performance (1975), Nanda Vigo's mirror performances in the 1970s....

Francesca Woodman's mirror self-portraits, and in particular the Roman *Self-Deceit* series, can be read from a narrative perspective as a slow and cautious progression toward becoming aware of the reflected self and the mirroring function of the device: the artist behind the mirror, above the mirror, beside the mirror, and finally in front of the mirror, or rather in the process of crawling inquisitively up toward the sight of her own face, which can be seen only in the reflection.[57]

Special consideration, if for no other reason than a matter of architectonic scale that further enhances the narcissistic-immersive aspect, is merited by the Pepsi Pavilion presented at Expo '70 in Osaka, Japan, and designed by Experiments in Art and Technology (E.A.T.), a group founded in 1966 by two electronic engineers, Billy Klüver and Fred Waldhauer, and two artists, Robert Rauschenberg and Robert Whitman (fig. 2.5). From the moment they approached, visitors were literally beclouded, exposed to a huge cloud of fog (created by artist Fujiko Nakaya) enveloping the entire structure. Then, penetrating a dark tunnel, they reached the interior of the "mirror dome," featuring a 210-degree spherical mirror vault twenty-seven meters in diameter made of aluminized Mylar and designed by Whitman. Thanks to the reflection, visitors saw images of themselves upside down hovering above their heads from the ceiling. Complementing the environment from a multisensory point of view were

the sound system designed by David Tudor (thirty-seven speakers mounted behind the mirror) and the lighting system designed by Tony Martin, which gave effects of spatialization to the reproduction of electronic music.[58] It was an experience that Gene Youngblood did not hesitate to qualify as "a world of expanded cinema in its widest and most profound significance."[59]

From these early experiences in the 1960s and 1970s, the fortunes of the mirror medium have grown to become more recently established in the large-scale works of artists, often engaged in public art, such as Anish Kapoor (*Sky Mirror*, 2001 in Nottingham; *Cloud Gate*, 2006 in Chicago), Olafur Eliasson (*The Weather Project*, 2003 at Tate Modern in London), Ken Lum (*Pi*, 2006 in Vienna), Doug Aitken (*Mirror*, 2013 in Seattle), and Jeppe Hein (*Mirror Labyrinth NY*, 2016 in Brooklyn).

In line with the constitutive polarization of the mirror experience, which we emphasized earlier, all these catoptric works can be distributed along a line whose extremes are marked by faithful mimicry and perceptual distortion. The invitation that such reflective works address to the viewer to "reflect" on their own perceptual processes and on the interpersonal dynamics established during the experience constitutes their most exquisitely phenomenological quality. It is a true "mirror effect"[60] in the broadest sense, embracing not only those works based strictly on the mirror medium, but also those objects that, by resorting to sensors or other forms of live feedback, entail—just as in the case of mirrors—catoptric interaction effects triggered by the living presence of the viewer before the work (or rather of multiple viewers involved in an interpersonal experience, in which the act of observing/seeing/looking and more generally of feeling and behaving is reflexively folded back on itself). A threefold interpretation of mirroring thus comes into being: observing one's own reflections in relation to those of other spectators; behaving (intentionally or unintentionally) in such a way as to mirror the actions of others; and imagining oneself in the place of others.

Yet as Claire Bishop observes in a section of her study of instal-

lations significantly titled "Through the Looking Glass,"[61] works based on reflective effects can in some cases give the impression of engulfing the viewer within themselves in a mixture of seduction and menace. This is what happens, for example, with the gloomy lake of waste sump oil employed by Richard Wilson for his work *20:50*, which opened in 1987 at Matt's Gallery in London. No wonder the work's press release carried precisely the quote from Carroll regarding Alice's passage through the looking glass.[62]

Virtual Alice

The task of reconstructing the impressive history of the effects of Alice's adventures (in general and through the looking glass in particular) could itself be the subject of a separate study. Periodically, an attempt is made to take stock of these remediations in the field of visual arts and visual culture in the broad sense by a number of exhibitions, such as that held at the Mart in Rovereto in 2012[63] or the recent exhibition at the Victoria and Albert Museum in London in 2021,[64] which also featured an interactive virtual reality experience. After all, the press release notes, "Wonderland is the perfect world to explore in virtual reality"[65] — a comment made today, but one that sums up the irresistible attraction that the vicissitudes of Carroll's heroine has exerted since the since the early faltering steps of VR.

Indeed, the inventor of virtual reality headsets and one of the pioneers of interactivity, computer scientist Ivan Sutherland, claimed as early as 1965 that a display connected to a computer could enable us to familiarize ourselves with phenomena of geometry and physics that are outside the everyday experiences to which we are commonly accustomed. It would be necessary, Sutherland observed, foreshadowing the multisensory ambitions of later developments, for such a device to involve the greatest number of senses and to be able to be "kinesthetic," that is, to correspond to the movements of the user and the related perceptual changes, including by means of joysticks capable of simulating all the "degrees of freedom" allowed to the human arm. "With appropriate programming such a display could literally

be the Wonderland into which Alice walked," the Harvard computer scientist concludes.[66] Within three years, Sutherland would add the effects of three-dimensionality to the ensemble,[67] the same ones we appreciate today in the 360-degree virtual immersive environments I will discuss later. Carroll's fantasy thus provided from the outset an effective metaphor for the emerging virtual technology.

Another pioneer of VR, indeed, the one to whom we owe the very coining of the term "virtual reality" itself back in 1987,[68] Jaron Lanier, remembers the early experiments at VPL Research (Virtual Programming Languages) with designer Ann Lasko as follows: "Ann was the absolute mistress of whimsy. She made a funny and spectacular Alice in Wonderland world, for instance. You could run into the White Rabbit's mouth."[69]

Again under the aegis of the Victorian poet and photographer, a few years later, one of the first art exhibitions was mounted in which works made with virtual reality technologies were shown. Curated by Janine Cirincione (herself a multimedia artist) at the Jack Tilton Gallery in New York in 1992, the exhibition was entitled *Through the Looking Glass: Artists' First Encounters with Virtual Reality*.[70] Not surprisingly, critics, repeating the skeptical attitude that had characterized the early days of photography, questioned the actual artistic value of such works.[71] Instead of publishing the usual catalog, the curator, together with Brian D'Amato, organized a volume in which artists (including Peter Halley and Jenny Holzer), VR pioneers (such as Lanier), and intellectuals (such as Donna Haraway) were invited to answer the question, "What types of cultural futures should we create with digital technology—specifically, virtual reality?" It was Haraway herself who took up the Carrollian provocation of the title, reporting her own impressions during her first experience in a VR environment. Realized in a closed and confined laboratory space similar to a cell, it had turned out (this was the early 1990s) to be a disappointing experience, the American philosopher confessed, when compared with the powerful immersive effects of cinema.

Yet, Haraway acknowledged, while often reducing itself to three-dimensional graphic effects achieved with two-dimensional screens, virtual reality operates a transformation of consciousnesses on the imaginative and ideological level—promising multisensory experiences and real-time feedback—beyond its actual capacity to produce such concrete experiences. The reality effect, the "realism" of such experiences, would have to be progressively learned as a new convention at once perceptual and stylistic, capable of impacting "common sense," just as was the case in the past with the style deemed realistic or becoming accustomed to linear perspective in the history of painting. One would thus learn to inhabit new worlds and to experience in such environments "a particular kind of 'Alice in Wonderland' effect: a scaling issue, so that you can become very large or very small, and either inhabit a world at a different sense of scale, or surround a world."[72]

The Netflix series *Black Mirror*, created by Charlie Brooker, is peppered not only with references to VR devices, but also with echoes of Carroll. *Black Mirror: Bandersnatch*,[73] the controversial interactive film written by Brooker, directed by David Slade, and released in late 2018 recalls with its title the mysterious fictional creature that appears in *Through the Looking Glass*. Alice, already on the other side of the looking glass, stumbles upon it in the nonsense poem "Jabberwocky" (written backward, of course, and thus to be read in turn in mirror reflection).[74] Carroll will also take it up in the poem *The Hunting of the Snark*, published in 1876.[75] Both the form and the content of Slade's film, so to speak, is interaction: its protagonists are young interactive game programmers, and as the story unfolds, viewers can for their part choose between two options that bifurcate the narrative, branching it. The play resonates with Carrollian allusions: the already famous game designer Colin Ritman (Will Poulter) teaches neophyte Stefan Butler (Fionn Whitehead) how to pass through a mirror to travel through time and back to the traumatic moment of his mother's death. After all, as the White Queen had explained to Alice, how poor would be a memory that only works backward. The

things she remembers best are the things "that happened the week after next."[76] In an interview in 2019, Brooker announced that he would consider a VR remastering of this film and other episodes.[77] It remains to be seen whether this version will succeed in reconciling opinions of this work, which so far are quite discordant.

VR not only stages experiences à la Carroll, but also allows itself to explore virtualities not actualized by the Victorian writer. Such is the case with *Down the Rabbit Hole*, the "immersive diorama" directed by Ryan Bednar and presented in 2020 at the "Venice VR Expanded" section of the Venice Biennial.[78] In this prequel, the player is transported to Wonderland at a time before the arrival of Alice and must guide a girl in search of her pet, Patches, who is lost in that mysterious land, by discovering secrets and solving puzzles.

As the trail from the first experiments attempted by Sutherland in the 1960s to the VR works of our own day shows, Carroll's fantasy has exerted a powerful effect not only as a thematic motif and narrative content, but also — and perhaps above all — as a heuristic metaphor that has guided the shaping of immersive virtual technologies and the conceptual models that interpret them. The fact that this fantasy was specifically dreamlike, as we have seen, helps to clarify from a genealogical point of view those recent readings that have compared VR with the dream experience.[79]

CHAPTER THREE

Pygmalion in Westworld

Agalmatophilia

In the *Metamorphoses*, Ovid tells us that the nymph Echo, rejected by Narcissus, wasted away until "only her voice and bones are left; at last / Only her voice, her bones are turned to stone."[1] Even the handsome, indifferent youth who chose to ignore her ended up turning to stone, not, however, through pains of love, but through the action of a sculptor. In his *Ekphraseis* (also known by the Latin title *Statuarum descriptiones*), written in the fourth century AD, the Greek rhetorician Callistratus describes a splendid marble of Narcissus beside a spring of clear water. His attire was so skillfully modeled that it let his body shine through in all its splendor. The sorrowful expression hinted at the tragic fate that awaited him:

> He stood using the spring as a mirror and pouring into it the beauty of his face, and the spring, receiving the lineaments which came from him, reproduced so perfectly the same image that the two beings seemed to emulate each other. For whereas the marble was in every part trying to change the real boy so as to match the one in the water, the spring was struggling to match the skillful efforts of art in the marble, reproducing in an incorporeal medium the likeness of the corporeal model and enveloping the reflection which came from the statue with the substance of water as though it were the substance of flesh. And indeed the form in the water was so instinct with life and breath that it seemed to be Narcissus himself.[2]

The situation of a statue mirrored in the spring producing its own mirror portrait thus involves an iconic doubling: the image of an image, an image to the second power, whereby the relationship of dependence of the representative on the represented, of the figure on the model, is lessened, and instead a mutual imitation is established between signs that attempt to "emulate each other," Callistratus says. The liquid element, by virtue of its essential mobility, ends up animating the statue, as if it were Narcissus in the flesh, the very one from whom water, in the immersive version of the legend, had taken his life. The classical topos of the animation of the inanimate is here subtly reformulated in an intermedia mode. Thanks to its own intrinsic dynamism, it is the liquid medium (water) that mobilizes the solid medium (stone).

This procedure proposed by Callistratus seems implicitly to hark back to the myth of Pygmalion, described by Ovid in the tenth book of the *Metamorphoses*. The bachelor sculptor, out of disdain for the dissolute female sex, fashioned himself a marvelous woman from a block of ivory, so beautiful that only shyness seemed to prevent her from coming alive. Inflamed with love for that "body he had formed [*simulati corporis*]," Pygmalion, "with many a touch... tries it — is it flesh / Or ivory? ... Kisses he gives and thinks they are returned," adorns her with gifts and jewels, and garbs her in finery. "In nakedness no whit less beautiful," and the sculptor takes her to bed with him, calling her his darling. Until, during the feast of Venus, he makes up his mind to ask the gods that this young woman may become his wife. Venus magnanimously grants his wish, and on returning home, the sculptor "at last / His lips pressed real [*non falsa*] lips, and she, his girl, / Felt every kiss, and blushed."[3]

At the same time, with his marble and "Pygmalionized" Narcissus, Callistratus seems to prefigure the polarization between Narcissus and Pygmalion that would characterize centuries later — and in an exemplary manner in the *Roman de la rose* (fig. 3.1) — what Giorgio Agamben characterizes as "an erotic itinerary that goes from the mirror of Narcissus to the workshop of Pygmalion, from a reflected

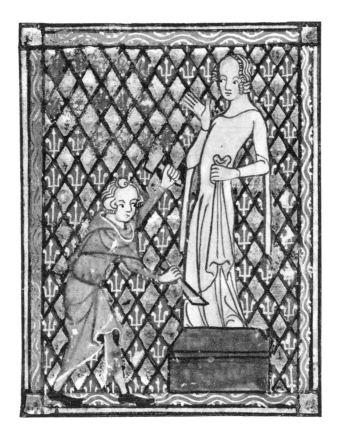

Figure 3.1. Guillaume de Lorris and Jean de Meun, *Le Roman de la rose*, detail of miniature (ca. 14th century), unknown artist, British Library, London (photo: © British Library Board Archive. All Rights Reserved / Bridgeman Images / Mondadori Portfolio).

image to an artistically constructed one," both the object of an uncontrollable erotic passion and both proof that "every genuine act of falling in love is always a 'love by means of shadows' or 'through a figure,' every profound erotic intention always turned idolatrously to an *ymage*."⁴ With one fundamental difference, however, underscored by the verses of Jean de Meun, who puts this comparative consideration into the mouth of his Pygmalion:

> But I do not love too foolishly, for, if writing does not lie, many have loved more dementedly. Didn't Narcissus, long ago in the branched forest, when he thought to quench his thirst, fall in love with his own face in the clear, pure fountain? He was quite unable to defend himself and, according to the story, which is still well-remembered, he afterward died of his love. Thus I am in any case less of a fool, for, when I wish, I go to this image and take it, embrace it, and kiss it; I can thus better endure my torment. But Narcissus could not possess what he saw in the fountain.⁵

While Narcissus's mistake had originally been not to fall in love with himself but to mistake the image for reality, in the transition to the making of the statue, Pygmalion is from the outset aware of the iconic nature of the sculpture he himself carves. By what account, then, must Pygmalion be evoked in the context of the discourse I am conducting? This is not about the naive Narcissus, who confused an image with reality (as discussed in Chapter 1), but rather about the transformation of the image itself into reality. This transformation—where an image becomes real—reflects a chronological and cultural evolution that begins with the Ovidian legend and extends through the centuries, ultimately encompassing the androids of *Blade Runner* and *Westworld*.

In reconstructing the history of the effects of Ovid's fable, Victor Stoichita has appropriately insisted on the peculiar nature of Pygmalion's statue. Far from being a representational image that mimetically reproduces a model external to it (and prioritized over the image in terms of both ontology and gnoseology), according to the line of interpretation that we might call Platonistic, insofar as it

is expounded in exemplary manner by Plato in the tenth book of the *Republic*, the image of Pygmalion instead presents itself as a *simulacrum*: "An artificial construct, devoid of an original model, the simulacrum is rendered as existing in and of itself. It does not necessarily copy an object from the world, but projects itself into the world. It exists." In this sense, the story of Pygmalion is the founding myth of the simulacrum as a "myth of excess and the obliteration of limits" between reality and its representation. What makes his story special is that "the statue is not imitating anything (or anybody). Pygmalion's statue is the fruit of his imagination and of his 'art,' and the woman whom the gods gave him for a spouse is a strange creature, an artifact endowed with a soul and a body, but nevertheless a fantasy."[6]

Ovid had certainly not been the first to tell of this strange couple. From the accounts of Clement of Alexandria and Arnobius (Christian authors who seized onto the legend of the sculptor in love with a statue to lash out against idolatry), we know that the Greek historian Philostephanus of Cyrene in the third century BC already spoke of it.[7] Nor was the statue sculpted by Pygmalion the only one to ignite irrepressible lust. In his *Eikones*, speaking of the *Cnidian Aphrodite* sculpted by Praxiteles, Lucian of Samosata relates that there was a story circulating among the inhabitants of Cnidus that "someone fell in love with the statue, was left behind unnoticed in the temple, and embraced it to the best of his endeavours."[8] The motif became so widespread that it merited rhetorical exercises and orations, such as one written in the second century AD by the sophist Onomarchus of Andros, "The Man Who Fell in Love with a Statue."[9]

The topos is multicultural; variations of it can be found in Islamic and Indian visual culture, for example in the fifth story of the collection *Tales of the Parrot* (*Śukasaptati*), written in Sanskrit and dating back to the twelfth century. Four men—a carpenter, a goldsmith, a tailor, and a hermit—decide to spend a night in the desert, taking turns watching over each other's sleep. During the first vigil, to cheat sleep, the carpenter carves a wooden statue of a woman. At the second watch, the goldsmith adorns her with jewelry. At the third vigil,

the tailor makes her wedding clothes to cover her nakedness. Awakened last, the hermit stands before that marvelous statue and prays to God to grant her life and speech. After the night has passed, all four find themselves desperately in love with the maiden, each claiming to be her exclusive owner. A fifth man arrives, who is invited to settle the dispute. He, however, claims that the woman is in fact his own bride whom the four have treacherously kidnapped. He then takes her with him and brings her to the town commander, who as soon as he sees them recognizes the woman as his brother's wife and accuses the five men of murdering him in order to take possession of the woman. When the woman is led into the presence of the *cazy*, a civil judge, and this latter identifies her as his own servant who had gone missing after stealing a large sum from him, which he now demands be returned to him by the group. The quarrel escalates, attracting several onlookers, including an elderly man who suggests that it be resolved before the "Tree of Decision," which is capable of settling those disagreements that human beings are unable to resolve. Once they go before the tree with the woman and their reasons, the seven see the trunk spread wide open, swallow the woman, reassimilating wood to wood, and close again straight after. A voice from the tree utters these final words, "everything returns to its first principles," leaving the men to steep in shame.[10]

In 1919, Paull Franklin Baum collected a number of variants revolving around the theme of a man becoming engaged to a statue (of Venus or, mutatis mutandis, the Virgin Mary), spanning from the twelfth century[11] all the way to nineteenth-century tales such as Joseph von Eichendorff's "The Marble Statue" or Prosper Mérimée's "The Venus of Ille" (brought to the screen by Mario and Lamberto Bava in 1981).[12]

But the motif continues all the way into the twentieth century.[13] In 1903, Wilhelm Jensen's novella *Gradiva* was published, a "Pompeian fantasy" about archaeologist Norbert Hanold's falling in love with a female figure depicted on an ancient bas-relief and characterized by a peculiar gait of the step (hence precisely the name, Latin for

"she who walks"), accentuated by an unusual posture of the foot, bent at a right angle in an almost unnatural way: "The left foot had advanced, and the right, about to follow, touched the ground only lightly with the tips of the toes, while the sole and heel were raised almost vertically."[14] Obsessed by this image, Norbert ends up hallucinating and dreaming about it repeatedly until on a trip to Pompeii he realizes that the bas-relief is nothing more than the sculptural transfiguration of Zoe Bertgang, a childhood friend who had always been infatuated with him. The transition from love for the image to love for the flesh-and-blood woman will finally cure Norbert of his delusion.

Made famous by Freud's analysis in 1906[15] and then by its adoption by the surrealists and Roland Barthes,[16] Jensen's Gradiva/Zoe undoubtedly represents the most emblematic literary case in the history of the metamorphoses of the Pygmalion legend and related derivations in psychopathology. As we have seen happen with the myth of Narcissus, which ends up naming a psychological and psychopathological complex, namely narcissism, the Pygmalion fable has in fact played a similar function for so-called "Pygmalionism," otherwise defined as "agalmatophilia."[17] Basing his findings on the cases described by Paul Moreau concerning the type of aberration of the *érotomane* who falls in love with inanimate beings,[18] among the perversions that Richard von Krafft-Ebing contemplated in his famous *Psychopathia Sexualis*, was the type of the violator of statues (*Statuenschänder*), which is significantly interpreted as the precursor stage of necrophilia and corpse desecration.[19]

In juxtaposing statuophilia and necrophilia, Krafft-Ebing thus highlights the possibility of a dual and dialectical directionality of Pygmalionism: by lingering on the threshold between image and reality, one can proceed not only in the direction of the animation of the inanimate (the path taken by Ovid's tale and its manifold variations), but also in the direction of the "inanimation" of the animate. Let us take a closer look at this twofold movement.

Animation of the Inanimate

The myth of Pygmalion, along with the stories from cultures all across the globe that tell us of love for statues, fits into the magical realm of images believed to be alive or capable of taking on life investigated by Ernst Kris and Otto Kurz in their classic study of the legends that developed around the figure of the artist.[20] The archetype in ancient Greek culture is represented by the mythical sculptor Daedalus, of whose statues — as Plato recalls in the *Meno* — it was said "that they too run away and escape if one does not tie them down but remain in place if tied down."[21] Aristotle even imagined them as examples of an instrument that "could do its own work, at the word of command or by intelligent anticipation."[22]

But behind Daedalus, we glimpse the magician of the gods, the crippled Hephaestus, whom the *Iliad* presents to us not only as the goldsmith of splendid jewels and the forger of invincible weapons, but also as the craftsman of android servants: "His maids ran to help their master. They are made of gold, looking like living girls: they have intelligent minds, and speech too and strength, and have learnt their handiwork from the immortal gods."[23] Callistratus himself, from whom we have taken our starting point in this chapter, tells us of a maenad carved from Parian marble by Skopas around 330 BC "transformed into a real Bacchante": "When we saw the face we stood speechless; so manifest upon it was the evidence of sense perception, though perception was not present."[24]

While Kris and Kurz trace these variations back to "magical thinking, and the meaning of effigy magic in particular,"[25] equating the picture and the original it depicts, they nevertheless incline to relegate this belief to the behavior of the *other* (primitive or infantile, or the result of individual or mass delusion), thus making this kind of experience essentially inaccessible (because safeguarded in a comfort zone by a security perimeter) for the adult, "normal," civilized, rational human being.

This is what David Freedberg reproaches them for in his pioneering study dedicated to the power of images, which links in a

transcultural sense the legend of Pygmalion to the rites of consecration that—as in the case of the *nētra pinkama* (the ceremony of opening the eyes of the Buddha statue in the Theravadan tradition)—give vitality to the inanimate object through the incorporation of the organ of sight, which more than any other expresses vitality.[26] More generally, this foundational study of visual anthropology introduces us to the fascinating realm of actions and reactions that characterize the human being's dealings with images whenever a relationship is established that is not ascribable to disinterested aesthetic contemplation, as in the case, for example, of religious and ritual or erotic or even legal functions.

A notable example is offered by the pilgrimage dating back to the late fifteenth century to the "sacred mountains" scattered throughout Piedmont and Lombardy,[27] shrines nestling in the foothills of the Alps and housing in their chapels life-size statues in polychrome terracotta or wood that depict in a highly realistic style scenes from the life of Christ, the Virgin Mary, and the saints. (Construction of the most famous of these, at Varallo, dates from 1481.) But (as Aby Warburg and Julius von Schlosser had already observed)[28] of all the materials available to sculptors, it was wax in particular that guaranteed the most effective rendering of living flesh in terms of verisimilitude of representation, offering the best chance of blurring the threshold separating representation and presence.[29]

The millennia-old dream of the vivification of the statue[30] gained momentum in philosophical reflection in particular from the seventeenth century onward, thanks to the impetus triggered by Descartes, who in the *Traité de l'homme* (published posthumously in 1664) likened the human body to a sculpture or *machine de terre*: "I suppose the body to be nothing but a statue or machine made of earth."[31]

This Cartesian identification inaugurated a series of meditations that would grow in number throughout the eighteenth century, combining aesthetics as a theory of sensibility with aesthetics as a theory of the arts in a veritable "Pygmaliomania."[32] This century would also try to give a name to the statue, which had remained innominate

until then. After a few faltering attempts (Agalméris, Elise), Galatea finally established herself as appellation thanks to the successful melodrama *Pygmalion, scène lyrique* (libretto by Jean-Jacques Rousseau, musical interludes by Horace Coignet).[33]

What awakened the attention of eighteenth-century intellectuals to the figure of the sculptor was the entry for "Pygmalion" in Pierre Bayle's *Dictionnaire historique et critique* in the third edition of 1730, which (unlike Ovid) identifies him with the king of Cyprus, asserting his dignity as ruler, but emphasizing his morally contradictory nature. While Pygmalion consecrates himself to celibacy out of revulsion against the inherently depraved nature of his island's women, he ends up loving "criminellement une Statue de Venus," bedding her to satisfy his "brutalité."[34]

And it was André-François Boureau-Deslandes, a reader of Bayle, who with his *Pigmalion, ou la statue animée* (1741)[35] described the animation of the statue not as an abrupt event, but as a slow passage, day after day, from the inanimate to the animate, which passes through imperceptible movements and minute nuances, encouraged by the pleasure aroused by the sculptor's kisses, until thought and feeling manifest themselves illuminating the darkness of mere matter.

The second half of the century would be punctuated by explicit or implicit references to the Pygmalion myth, starting with the *A Treatise on the Sensations*, published in 1754 by Étienne Bonnot de Condillac in which the author calls on us to feel a true bodily empathy with the statue as it gradually acquires one sense after another, from smell to touch via hearing, taste, and sight (considered individually and in combination):

> It is very important to put himself [i.e. the reader] exactly in the place of the statue we are going to observe. He should begin to live when it does, have only a single sense when it has only one, acquire only those ideas that it acquires, contract only the habits that it contracts: in short, he must be only what it is. The statue will judge things as we do only when it has all the senses and all the experiences we do: and we will judge in the same way it judges only when we suppose ourselves deprived of everything that it lacks.[36]

David Mackenzie's film *Perfect Sense* (2011), about an epidemic that causes the progressive loss of senses starting with the sense of smell, seems like a rewrite *à rebours* of Condillac's fantasy.

The famous marble group *Pygmalion at the Feet of His Statue, Which Is Coming to Life* (also known by the title *Pygmalion and Galatea*), presented by Étienne-Maurice Falconet at the 1763 Salon, challenges the Pygmalion motif in the very subject matter of sculpture. While painting can play with the colors of the flesh to emphasize the statue's transition from inert to living, sculpture must do everything with its own medium, as it were. Denis Diderot praises its "truth" and ability to bring out the emergence of life and thought: "She is at her first thought. Her heart begins to thrill, but it will not be long before it is pounding. What hands! What soft flesh! No, it is not marble. Lay your finger on it, and the matter that has lost its hardness will yield to your pressure." Yet the philosopher is not completely satisfied with this and pushes the art of ekphrasis to the point of proposing to the reader's imagination an inversion in counterpart: let us imagine, he suggests, the composition arranged "from right to left and not from left to right." In this way, "my figures would be grouped even better than his. They would be touching."[37]

In *D'Alembert's Dream* (1769), Diderot proposes to Jean le Rond D'Alembert a radical experiment to be performed on Falconet's *Pygmalion*: "I will take that statue you see there, put it in a mortar, and after a few good blows with my pestle...." Once reduced to a fine powder and mixed with earth, it will become humus for planting vegetables, which in turn will turn into living, human flesh (not Galatea's, but that of the philosopher himself): "I'll plant seeds in the humus — peas, beans, cabbages and other garden vegetables. The plants will get their food from the earth and I will get mine from the plants."[38] An extreme version, this, of total assimilation, incorporation, embodiment.

A less radical (yet no less significant) species of bodily empathy is referred to in Johann Gottfried Herder's *Sculpture* (1778), whose subtitle, *Some Observations on Form and Figure from Pygmalion's Creative*

Dream, acknowledges the debt owed to Ovid's tale. How, he asks, could the mythical sculptor ever have so effectively depicted the female body if he had not embraced it in his arms? Not only is it the maker of the sculpture who must embrace ("Pity the sculptor of an Apollo or a Hercules who has never embraced the body of an Apollo, who has never touched, even in a dream, the breast or the back of a Hercules"), but the viewer himself, if he really wants to know a statue, must make himself a tactile subject: "His eye becomes his hand.... With his soul he seeks to grasp the image that arose from the arm and the soul of the artist." In turn, "A sculpture before which I kneel can embrace me, it can become my friend and companion: it is *present*, it is *there* [*sie ist gegenwärtig, sie ist da*]."[39] Thus, it is not a detached contemplation of a work of art enclosed in its separateness of *representation*, but a mutual embrace under the banner of *presence*.

A crucial moment in this transition from representation to presence is the negation of the framing device, which in the case of sculpture is the pedestal. As much in literature (for instance, in Deslandes, when at night the statue ventures off the plinth to wander unseen in the salon) as in iconography (think of Louis-Jean-François Lagrenée's painting *Pygmalion and Galatea*, made in 1781 and preserved at the Detroit Institute of Arts), "*the step* going beyond *the plinth*"[40] marks a fatal framing that, by crossing the threshold separating the iconic world from the real world, promotes the process of progressive environmentalization of the image to be discussed more fully in the next chapter.

Inanimation of the Animate

There is a fundamental counterpoint to the strategies of animating the inanimate in the equal and opposite process of "inanimating" the animate, some exemplary cases of which were recalled in the previous section. Occupying center stage here are *tableaux vivants*, of which there are records at least from the Hellenistic period onward: flesh-and-blood people who are "frozen" with the intention of reproducing paintings or sculptures of sacred or profane themes,

"living individuals, immobilised so as to resemble works of art and thereby imprinting themselves, as exemplary entities, upon the minds of spectators."[41]

The effect could be not only exemplary, but also dramatic and disruptive. In 1453, during a festival dedicated to Florence's patron saint, John the Baptist, a German mounted the wagon carrying a *tableau vivant* representing the Roman emperor Augustus to topple both a statue depicting him and the actor embodying him: "It was the figures' sheer presence, alternating as it did between artifice and animation, that would have induced him to commit two forms of iconoclasm: an attack upon a work of sculpture and an attack upon a living image."[42] From this point of view, the *tableau vivant* shares with the theater the constitutive threat to the representational function that is determined by the presence of real living bodies on stage, performing for an equally flesh-and-blood audience.

In his celebrated study *The Autumn of the Middle Ages*, Johan Huizinga reported paradigmatic instances of these iconic enactments, referred to in the late medieval period as *personnages*; for example, the so-called Feast of the Pheasant (Voeu du Faisan), the banquet offered by Philip III, Duke of Burgundy, on February 17, 1454, in Lille, in order to rally support for a crusade against the Ottoman Empire of Muhammad II, which had conquered Constantinople the previous year. While Huizinga stigmatizes these cultural phenomena as "barbaric princely ostentation" and "unusually insipid performances,"[43] he also recognizes the collective experience of celebration, supported in the most lavish cases by complex mechanical apparatuses and the sophisticated skills of painters and sculptors, as achieving a kind of fusion between art and life.

In this respect, Huizinga aligns himself with the conception of festivity outlined by Jacob Burckhardt as a "point of transition from real life into the world of art"[44] and later taken up by Aby Warburg in his reflections on the "festive essence" (*Festwesen*). Analyzing the intermezzos staged in 1589 in Florence on the occasion of the wedding between Grand Duke Ferdinand I de' Medici and Christina of

Lorraine, Warburg observed that such forms of performance occupied an intermediate status not only in that as interludes they interrupted banquets or ceremonies, but also because they were by their very nature "between real life and dramatic art," offering "a unique opportunity for members of the public to see the revered figures of antiquity standing before them in flesh and blood."[45]

Far from being limited to the medieval and renaissance periods, this genre continued to develop in later centuries, reaching all the way to our contemporary times. In an annotation in his *Italian Journey*, Goethe tells us how Sir William Hamilton, the English ambassador to Naples, used to dress his young mistress, Miss Emma, in the old-fashioned manner and invite her to assume poses that reproduced works of art in order to find in her "all the antiquities, all the profiles of Sicilian coins, even the Apollo Belvedere. This much is certain: as a performance it's like nothing you ever saw before in your life"[46] — unique, but actually quite widespread at the turn of the eighteenth and nineteenth centuries.[47]

In fewer than a hundred years, the practice became a domestic amusement. Published in 1860, James H. Head's book *Home Pastimes, or Tableaux Vivants*[48] stands as a veritable practical manual. Starting from the premise that art should beautify every dwelling and enliven every spirit, its author offers precise instructions (costumes, set design, postures), on how to set up living pictures representing imaginary situations as well as literary and artistic scenes. Thus we find mythological themes (such as Venus rising from the waters), religious themes (such as the return of the prodigal son), historical themes (such as Napoleon and his guard at Waterloo), or genre themes (the repose of a peasant family). The "Notes and Explanations" section lays out technical tips on how to reproduce the rumble of thunder or artillery, bleeding wounds.... Copper nitrate crystals dissolved in wine and then set on fire will produce an emerald-green flame very suitable for scenes of spells and demonic manifestations. Gauze curtains interposed between the actors and the audience will not only make it possible to conceal scene changes, but will also

impart to the tableau a peculiar "misty appearance," a blurred hue that we can imagine to be particularly effective for the weakening of the threshold separating image from reality of which such representations constitute a notable example.

Contemporary practices in the visual arts, photography, and film have explored the potential of the *tableau vivant* extensively, often hybridizing media.[49] From Méliès (*La statue animée*, 1903) to Pier Paolo Pasolini (*La ricotta*, 1963), from Peter Greenaway (*The Mysteries of Compton House Garden*, 1982) to Jean-Luc Godard (*Passion*, 1982), cinema, the medium par excellence of the moving image, has shown itself to be particularly fascinated by the static image, regressing, as it were, to the stillness of painting and sculpture.[50]

Regarding the legends (mentioned above) of statues escaping if they are not tied in place, Agamben argues eloquently that "a certain kind of *litigatio*, a paralyzing power whose spell we need to break, is continuously at work in every image; it is as if a silent invocation calling for the liberation of the image into gesture arose from the entire history of art."[51] However, this desire seems to represent only one side of the coin, the other (the one mentioned in the *tableaux vivants* tradition) consisting in the equal and opposite desire to immobilize movement. From the ancient metamorphoses by petrification[52] to the contemporary mineralizations of the living explored far and wide by the cinema,[53] we can grasp endless variations of a powerful theme: the irresistible attraction to the inorganic to which the organic wants to return by yearning to regress to the stage from which it proceeds. (This is the "longing to revert" or "dim memory" of the mineral realm for Worringer, death as the "aim of all life is death" for Freud.)[54]

The examples are of course innumerable. The series of *One Minute Sculptures*, initiated by Erwin Wurm in 1988, proposes through different media (photographs, videos, and performances) still lifes lasting sixty seconds, which the participants (anonymous subjects, but also artists, curators, the author himself) embody by interacting with everyday objects according to the precise instructions given to them.

More recently, examples of this practice have been offered by the

Artcock collective of photographers and video artists, founded in Rome in 2006, which stages reenactments of works by Caravaggio and Titian, and by Vanessa Beecroft's choreographic performances — for example *VB62* (2008), *VB70*, and *VB MARMI* (2011) — which explore the uncanny affinity between the motionless bodies of nude models and the motionless coldness of marble.

A peculiar counterpoint that by contrast reveals to us the nature of the *tableau vivant* is suggested by the video-sound installation *The Greeting* (1995), in which Bill Viola dynamizes in slow motion the sacred scene of the Visitation of the Virgin Mary to Saint Elizabeth, depicted in Pontormo's painting (ca. 1528) preserved in the rectory of Saints Michael and Francis in Carmignano.[55] Thanks to a kind of alienating anachronism, we perceive the static image of the Renaissance artist as if it were the *tableau vivant*/video still of his contemporary admirer.

Finally, the most extreme solution imaginable for the inanimation of the animate is the hyperrealistic representation of the corpse as practiced by Maurizio Cattelan. Regarding his life-sized and disturbingly realistic wax or resin mannequins, Massimiliano Gioni fittingly points out in 2003 that these puppets look "empty and absent, like corpses."[56] The following year, Cattelan took this seriously and "hanged" three children, leaving them dangling as if from a gallows from the oak tree in Milan's Piazza XXIV Maggio. The public outcry provoked by this installation was not limited to reactions of shock and the blocking of traffic, but went as far as taking action. On the evening of May 6, a bricklayer from the Ticinese neighborhood, Franco De Benedetto, armed himself with a ladder and saw, climbed the tree, and removed them before crashing to the ground himself and ending up in the hospital, earning for himself on top of that a criminal prosecution and a two-month jail sentence for aggravated damage (a sentence later suspended because he had no previous criminal record). "It made people sick, so real did it look,"[57] he declared to the press, thus testifying firsthand that those puppets looked like living children *turned into* dead ones, turned into images of themselves (fig. 3.2).

Figure 3.2. Maurizio Cattelan, *Untitled*, mixed media installation, three life-size mannequins, Piazza XXIV Maggio, Milan (May 5–June 6, 2004), Nicola Trussardi Foundation (photo: Attilio Maranzano; courtesy Archivio Maurizio Cattelan).

In a remarkable passage, Maurice Blanchot observes that the remains of a body are now a thing (a mere body [*Körper*], no longer a living body [*Leib*], to use the terminological distinction the German language grants us). Yet the individual who has just died resembles to the utmost degree the living person he was: "Yes, it is he, the dear living person, but all the same it is more than he. He is more beautiful, more imposing; he is already *monumental* and so absolutely himself that it is as if he were *doubled* by himself, joined to his solemn impersonality by resemblance and by the image."[58] Cattelan's hanging children thus close in macabre fashion the circle opened by Ovid's Pygmalion, a sculpture that seems to come to life only to go to its death.

Andréides

In its countless variations, the Pygmalion theme radiates throughout nineteenth-century culture, intersecting with the automaton motif.[59] Think, to mention but a few famous literary instances, of E. T. A. Hoffmann's "The Sandman" (1815), Mary Shelley's *Frankenstein* (1816–1817), and especially of Villiers de l'Isle-Adam's *Tomorrow's Eve* (1885–1886), a novel considered among the incunabula of science fiction literature that tells the story of Lord Celian Ewald, an English nobleman in love with Alicia Clary, a woman as beautiful as a classical statue ("She has indeed the splendor of a Venus Victorious, but humanized," "from the brow to the feet, a sort of Venus Anadyomene," and even in photographs, she appears "in her native purity of marble"), but stolid and intellectually dull, as well as afflicted with a "moral clumsiness." "If she were deprived of all thought, I could understand her. The marble Venus, in fact, has nothing to do with thinking. The goddess is veiled in stone and silence."[60] However, she does have a soul, but one glutted with mediocre common sense.

To remedy this discrepancy between material form and spirit, Thomas Edison comes to his rescue, replacing Alicia with Hadaly, an equally comely, but spiritually superior artificial "andréide." The "sorcerer from Menlo Park," a prolific inventor and soon to be

pioneer of the cinematograph (he would shortly thereafter patent the kinetoscope in 1888), makes a simulacrum so perfect that the lover will be able to mistake it for his beloved, because he imprints Alicia's own features on it through a projective device, transferring them from a photograph. In her inhuman perfection, Hadaly thus "rehabilitates" both the sculpture and the photograph: she completes the animation of the statue, which Alicia only incompletely embodied, and makes the photographic image three-dimensional and mobile, metamorphosing it from representation to immediate presence. "This *copy*, let's say, of Nature—if I may use this empirical word," Edison prophesies, "will bury the original": by comparison, the most renowned makers of automata (Albert the Great, Vaucanson, Mälzel...) will look like "makers of scarecrows."[61] The story does not conclude with a happy ending. During the ocean crossing to return home with Alicia and her replica, Hadaly, Lord Ewald will by great good fortune save himself from the shipwreck of the ocean liner *The Wonderful*, but both the woman and the *andréide* will be lost to him, swallowed by the waves. In a telegram from Liverpool addressed to Edison, he makes clear that only for the latter will he wear mourning clothes.

However, we have to wait until 1935 to witness a fulminating encounter between the past and the future—what Benjamin, as we have seen, calls a *téléscopage* of temporal dimensions between the Ovidian legend of the sculptor in love with the statue and the prefiguration of virtual reality. In June of that year, the short story "Pygmalion's Glasses," by visionary American science fiction writer Stanley G. Weinbaum, was published in *Wonder Stories* magazine. The protagonist, Dan Burke, groggy after drinking too much at a New York party that he finds boring, goes out for air in Central Park and runs into a gnomelike old man who berates him and pontificates about reality ("all is dream, all is illusion"), inflicting on him a tirade about Bishop Berkeley and his theories on sensation. Dan's skepticism eventually gives way to curiosity. The old man (actually Professor Albert Ludwig) intrigues him by telling him about a device

of his own invention, haughtily snubbed by the film industry, that can make dreams real and "make a—a movie—*very* real indeed." Unfortunately, only one person can enjoy it at a time, but the benefits outweigh the limitations:

> But listen—a movie that gives one sight and sound. Suppose now I add taste, smell, even touch, if your interest is taken by the story. Suppose I make it so that you are in the story, you speak to the shadows, and the shadows reply, and instead of being on a screen, the story is all about you, and you are in it. Would that be to make real a dream?[62]

The dream is that of the "total" and synesthetic cinema that Sergei Eisenstein, René Barjavel, and André Bazin would theorize a few years later (as will be discussed in Chapter 6) and at the same time of immersivity (you are not in front of a screen, but you are part of the environment) presence (it affects you personally) and interactivity (you speak to the images and are responded to).

Accessing this miracle requires wearing special glasses—a combination of gas mask, aviator's goggles, and diving snorkel—over which Ludwig will pour a "liquid positive" (in the sense of photographic positive) onto the mask. And here we move from Berkeley to Leibniz: "Every drop has all of it." Through a process of electrolysis, the epiphany will occur. Sitting in the professor's dingy hotel room, Dan will find himself in an incredible prehistoric forest enlivened by the warbles and trills of birds. Initially, he will look for grasps on reality to resist the illusion: gripping onto the arms of the chair to remind himself that he is in the hotel, dragging his feet on the carpet to gainsay the verdant moss offered to his view. But the appearance of a girl—Galatea—wrapped in a translucent robe will swallow him up definitively in the simulated environment: "He had completely forgotten about the paradoxes of illusion, because what he was experiencing, for him, was reality." In Paracosma—thus the name of that otherworldly land—guided by the graceful maiden, Dan traverses meadows and streams, walks and swims, is amazed to discover that melodies come not from birds, but from flowers. Truly, reading

Weinbaum's inspired pages, one comes to repeat with Stoichita that "at the threshold of the Pygmalion effect ... is virtual reality."[63]

At the end of his wanderings through that Edenlike garden, Dan finally comes into the presence of old Leucon, the Gray Weaver. And here the trouble begins. The sage reveals to him the laws that govern life on Paracosma, and in particular the rules of romance. Galatea, with whom Dan is now hopelessly in love, has already been betrothed to another. After all, she, being *substance*, could never marry him, a *shadow*, a *ghost*. Yet like her mother (also named Galatea), the maiden is willing to break from custom and face a fate of unhappiness in order to match the love of Dan (promptly renamed by her as Philometros, literally "measure of love"). But Leucon steps in, drives the girl away, and shatters the dream. Desperate, Dan-Philometros calls out to her in vain, only to find himself standing before a window hovering in midair: it is none other than the window of Ludwig's squalid hotel room. His glasses fall to the floor, a lens shatters, the mysterious liquid leaks out, the spell breaks: "In love with a vision! ... He saw finally the implication of the name Galatea. Galatea — Pygmalion's statue, given life by Venus in the ancient Grecian myth. But *his* Galatea, warm and lovely and vital, must remain forever without the gift of life, since he was neither Pygmalion nor God."[64]

A glance at the clock shows Dan that the adventure lasting days in Paracosma in fact corresponds to five hours in the real world. Back in his hometown of Chicago, Dan by chance encounters Professor Ludwig in the Loop. The magic is revealed, as was "trick photography, but stereoscopic," to which the lover himself had willingly submitted by actively participating, "You co-operated, then. It takes self-hypnosis." The forest was a blow-up of a patch of moss, and the first-person view a photographic recording captured by the inventor himself, "I went around with the photographic apparatus strapped on my head, to keep the viewpoint always that of the observer." Finally, Galatea turns out to be Ludwig's own niece, a college senior who is fond of acting, "Why? Want to meet her?"[65] *Happy ending.*

As long as the reality effect of the illusion lasts, not only does

Paracosma appear perfectly real to Dan, but this effect produces an ontological reversal of the actual reality from which he comes. It is his world that is considered phantasmatic, compared with the simulated one. In this regard, it should be emphasized that both Villiers de l'Isle-Adam's andréide and Weinbaum's Galatea are simulations of the real based on the reworking of *photographs*. The photographic medium—both the *icon* deemed to most resemble the real and its *index* dependent on reality as an effect on its cause (to use Peirce's terminology)—is the most effective springboard for securing the effect of reality on the artifice of simulation.

In his "digression on photography," Günther Anders observes that through this medium, "the real becomes the reproduction of its own images.... Reality is produced by reproduction."[66] While the millenarian tradition that we might call Platonistic had conceived of the image as ontologically and gnoseologically dependent on the actual model of which it was a representation, with the advent of the photographic image, a fateful reversal of relationships takes place. We ask photography (and then video) to certify the actual having happened of an event, the having existed of a person or an event. Nothing really exists unless it is captured by an image. The real becomes a function of its representation. Jean Baudrillard pushes this argument to its extreme consequences: "In the shroud of the virtual, the corpse of the real is forever unfindable." Simulation would remove ground from under the feet of traditional metaphysical oppositions: reality/representation, real/illusory, reality/image. The virtual would be "merely the mania for making an image no longer an image."[67] Lacking any structure of reference, of referral, of "image-of" something that in turn is not an image, the simulated world is a perfect doppelgänger: "What we have in virtuality is no longer a hinterworld: the substitution of the world is total; this is the identical doubling of the world, its perfect mirroring."[68]

Yet the outcome of the love stories, while radically different—ending in tragedy for Ewald and Hadaly and in comedy for Galatea and Philometer—suggests to us that the experience of virtual simu-

lation (just like any experience we can conduct today with a VR headset) is a constitutively *finite* experience. It is a segment of lived experience temporally framed by a beginning and an end, within which we experience a blurring of the boundaries between reality and its representation and a beclouding of our ability to perceive them, a segment at the conclusion of which we are led to reflect on what unites and what distinguishes one and the other dimension. That is, to reflect on the *threshold* that unites and at the same time separates them.

Androids

In the famous 1919 essay "The Uncanny," the *unheimlich* feeling that undermines our securities and does not allow us to rest in the comfort of our inner home (*Heim*), Freud considered the animation of the inanimate among the possible causes that trigger such a state of mind, concluding, however, that this process is far from fulfilling the necessary and sufficient condition for one to speak of an uncanny effect. Many fairy tales, for example those of Andersen, are inhabited by objects that come to life: "I cannot cite," Freud objects, "one genuine fairy tale in which anything uncanny occurs.... Even when Pygmalion's beautiful statue comes to life, this is hardly felt to be uncanny."[69]

For one to be able to speak of the uncanny it is necessary for the situation to be accompanied by the removal of something that was familiar to us and by a feeling of danger, which is exactly what is defused by the fictional nature of fantastic tales: "Many things that would be bound to seem uncanny if they happened in real life are not so in the realm of fiction" unless the author renounces the use of fantastic and supernatural creatures and places himself on the terrain of ordinary life: "By doing so he adopts all the conditions that apply to the emergence of a sense of the uncanny in normal experience; whatever has an uncanny effect in real life has the same in literature."[70]

Freud's analysis takes its starting point, as is well known, from a study by psychiatrist Ernst Jentsch published in 1906. Freud, while

acknowledging its merit for having first posed the problem, quickly dismisses it by criticizing its insufficiency. For Freud, his German colleague had limited himself to the equation "disturbing = unusual," tracing the psychological effect back to human beings' instinctive fear of change ("misoneism") and the disorientation produced by the presentation to consciousness of novel phenomena that the individual does not know how to deal with.

Actually, Jentsch does something more. He draws our attention to the fact that the sensation of the uncanny persists as long as the situation holds us in a state of uncertainty, of suspension between the domains of the inanimate and the animate, without being able to ascribe what we perceive to one or the other realm with certainty. What produces the *Unheimliches*, then, is "doubt as to whether an apparently living being is animate and, conversely, doubt as to whether a lifeless object may not in fact be animate.... As long as the doubt as to the nature of the perceived movement lasts, and with it the obscurity of its cause, a feeling of terror persists in the person concerned."[71] In the terms of the argument I am pursuing, this suspension described by Jentsch corresponds to the *threshold* between reality and its representation on which we are forced to linger without being able to say properly that we are at home (*un-Heim*) in either dimension.

It is in this regard very significant that the examples Jentsch reports refer precisely to exhibition spaces of threshold images — wax-figure cabinets, panopticons and panoramas — that, as we will see in the next chapter, constitute the forerunners of virtual immersive environments, which aim precisely to weaken our ability to distinguish between the real and the iconic and consequently lead us to question what separates and what unites the two realms.

Jentsch adds a further noteworthy observation, pointing out how "true art, in wise moderation, avoids the absolute and complete imitation of nature and living beings, well knowing that such an imitation can easily produce uneasiness."[72] In later twentieth-century thinking, this discomfort (*Missbehagen*) took on a specific name:

uncanny valley. The definition is owed to the Japanese robotic engineer Masahito Mori,[73] who in 1970 investigated the effects produced by the efforts to make robots increasingly humanlike. According to the results of his research, an artificial being will appear more familiar to us the more humanlike its outward appearance is. If, however, its features become too similar to a human being, there will be a sudden collapse in familiarity values (displayed by a "valley" in the graph representing them). These values will start to rise again only when the android is so similar to humans that it cannot be distinguished from them.[74]

In the field of intelligent robotics, special mention in this regard goes to the Geminoid project, coordinated by Hiroshi Ishiguro, professor of artificial intelligence at Osaka University.[75] Geminoid-F (2010) is a young woman who can modulate facial expressions and adapt voice pitch to different emotional expressions. She even appears as an actress in *Sayonara*, a play directed by Oriza Hirata, impersonating a caregiver who assists a woman with cancer (actress Bryerly Long) after a casual encounter with her on the street. The fields of counseling and caregiving are counted among the professional practices that most need empathic skills. The progressive integration of androids in such activities evidently requires an expansion of the very notion of empathy in the direction of human/nonhuman interaction.[76]

However, Ishiguro did not limit himself to designing humanoid caregivers. He also thought of equipping himself with a double, Geminoid HI-1, a true robotic alter ego that replicates the features of its inventor and represents (as, moreover, the Latin *geminus* evoked by the name suggests) a twin clone of himself. While HI-1 is teleoperated, Erica is an "autonomous conversational robot" that can communicate with humans through voice, bodily gestures, facial expressions, eye contact, and touch.[77]

The objectives pursued by Ishiguro today have numerous precursors in the cinematic imagination. Among the now countless films that could be mentioned, *Blade Runner*, made by Ridley Scott in 1982

(director's cut, 1992; final cut, 2007)[78] and inspired by Philip K. Dick's novel *Do Androids Dream of Electric Sheep?* (1968),[79] deserves special mention precisely because it focused on the possibility of discerning between human and android on the basis of a test of the subject's empathic abilities, the Voight-Kampff test. Dick had set his novel in San Francisco in January 1992; Scott transposes the story to 2019 Los Angeles, that is, the day before yesterday. What's more, while Dick's novel treated androids rather cynically as stupid household appliances to be unceremoniously retired in the event of a defect or failure, Scott's film transfigures the fearsome Nexus-6s into titanic heroes animated by the desire — human, all too human — to escape death.

Among the many sequences salient to our discussion, what takes place at the Bradbury Apartments in the home/museum of J. F. Sebastian (the genetic designer afflicted with Methuselah syndrome, played by William Sanderson) should be noted for its specific Pygmalionic quotient. Sebastian is not only professionally involved in the design of the nervous system for the androids of Eldon Tyrell's company, but also builds artificial friends for himself, automaton playthings that are part inorganic and part organic. Android hunter Rick Deckard (Harrison Ford), assigned to "retire" them from circulation, breaks into the apartment on the trail of android Pris (Daryl Hannah), a "pleasure model" designed to satisfy carnal desires, a highly sophisticated version of a sex doll.[80] But Pris has camouflaged herself among the many life-size dolls crowding Sebastian's *Wunderkammer*, immobilizing herself like a deactivated automaton and covering herself with a bridal veil (fig. 3.3).

The unveiling performed by a hesitant and wary Deckard will lead to sudden recognition: combining acrobatic gymnastics and martial arts, Nexus-6 will try to get the better of the hunter, only to end up agonizing on the floor riddled with bullets. But if Pris is a replicant that perfectly simulates the body of a human being (and indeed enhances its physical abilities), what is Pris when she perfectly mimics a mannequin?

Figure 3.3. Daryl Hannah and Harrison Ford in a film still from *Blade Runner* (1982), directed by Ridley Scott (photo: Ronald Grant Archive Collection/ Alamy Stock Photo).

The sequence in question is not the only one in which Scott's film engages in thematizing threshold phenomena. In fact, *Blade Runner* ends up completely subverting its own premise, which is centered on the possibility of distinguishing androids from humans on the basis of the ability to empathize. Much more than the humans, it is rather the androids who are shown to be capable of empathy. The gang's most dangerous and intelligent leader, Roy Batty (Rutger Hauer), decides to save Deckard (who intended to "retire" him, too) as he slips off the roof of the Bradbury Building because he loves life itself: "I don't know," recites Deckard's voice-over (deleted in editions after the 1982 premiere), "why he saved my life. Maybe in those last moments he loved life more than he ever had before. Not just his life, anybody's life, my life. All he'd wanted were the same answers the rest of us want: where do I come from? Where am I going? How long have I got?"

Deckard himself falls in love, reciprocated, with the charming replicant Rachael (Sean Young) who was not even aware that she was one. However, beginning with the director's cut (1992), the suspicion grows that Deckard is himself, just as unwittingly, a replicant. That would evidently come back to reshuffle the cards in an intraspecies sense. So Batty saves Deckard because he somehow knows that Deckard, too, is a "skin job," a fake human; then Deckard and Rachael fall in love because they are both cyborgs.... After all, the motto of the Tyrell Corporation, which builds them, is "More human than human."

But is it really necessary to masquerade as a human for androids to love each other? In shooting the video clip for Björk's single "All Is Full Of Love" (1999),[81] Chris Cunningham seems to have wanted to get rid of this pretense. The video opens in a highly technological environment, somewhere between an assembly bench and an aseptic automated operating room. A prostrate, unfinished anthropomorphic robot is being cared for by servo-assisted mechanical arms—veritable robotic Pygmalions—whose injectors and soldering irons, pouring lubricating fluids and causing sparks, seem to

breathe life into its artificial body, animating its joints, cables, and circuits. The operation having finished, the android sits down to find itself in the presence of a second, nearly identical and already completed android who smiles and invites it with a gesture of the right arm to join it in intercourse. "All Is Full of Love," moreover, fully corresponds to the poetics of the Icelandic singer, who has declared in an interview that she considers *everything* as natural, including technology: a wooden hut or the telephone, when just invented, are *techno*, but over the years they become *nature*. It is just a matter of time.[82]

I write "android," but should I rather say "andréide"? The two robots, on closer inspection, are gendered. The two porcelain-white metal bodies are female (we can tell by the breasts they both have). Gynomorphic robots, then, but with their pneumatic actuators and machinic and wired anatomy well in view. Now they are kneeling, in profile, kissing and caressing each other, still assisted on either side by the mechanical arms that ensure the constant lubrication of the components engaged in the loving embrace (fig. 3.4).

Cunningham's much-celebrated video (the two robots were exhibited at MoMA in 2015) has been hailed by some feminist theorists as a paean of lesbian love. However, upon closer examination of the two robots' faces, in particular (the more realistically humanized part), we realize that it is Björk's own face coming to life on both andréides. So has the artist doubled herself into a *mirror self*, an almost identical clone of herself, and is it instead an externalized autoerotic fantasy? "As Björk embraces Björk, the digital celebrates its nuptials with the organic."[83] The contemporary techno-organic combination of sex and machine, already highlighted by Marshall McLuhan in the middle of the last century,[84] reaches its acme here.

As has been rightly observed, this video invites us to question the notion of the *similar*:[85] the two cyborgs making love to each other are neither completely identical nor completely dissimilar, one and the same Björk, yet different. The very difference between organic and technological, between the human body and its simulation, that

Figure 3.4. Björk, *All Is Full of Love*, film still from the music video (1999), directed by Chris Cunningham (photo: One Little Independent Records).

their intercourse stages and embodies is a threshold of uncertainty on which we are invited to linger.

To a similar lingering on the threshold we are led by the four seasons of the award-winning television series *Westworld*, created by Jonathan Nolan and Lisa Joy and produced by HBO, whose opening theme music seems almost a quote from Cunningham's video. Inspired by the 1973 film of the same name (written and directed by Michael Crichton and starring Yul Brynner and James Brolin), the series transports us to a theme park in which anything is allowed. The human guests go there for a vacation of unbridled moral transgression in order to vent their most vile and criminal fantasies on the hosts, androids in every way resembling human beings, indistinguishable to the eye, who repeatedly suffer abominable violence, massacres, rapes without being able to rebel or exact revenge. They are in fact programmed to obey the First Law of Robotics formulated by Isaac Asimov in the 1940s, according to which a robot can never harm a human.[86] The narrative lines that structure life in the park and that the androids are programmed to replicate indefinitely are not retained in their memory. The traumas the cyborgs suffer at the hands of humans are ever new, their wounds ever again healed and their bodies ever again readjusted in the laboratories of Delos Inc. Dr. Robert Ford (Anthony Hopkins), founder of the visionary project and novice Pygmalion, pontificates on the perfection of the simulation technology he has invented from the armchair of his study, surrounded by a gallery of physiognomic busts (the models for the replicants) (fig. 3.5).

The whole thing seems destined for a never-ending rerun of the same stories until a bug in the software update unexpectedly allows memories of the violence suffered to resurface — at first sporadically and confusingly, then in an increasingly consistent way — to the consciousness of some of the replicants. The ranch girl Dolores Abernathy (Evan Rachel Wood) begins to remember and to become aware of the repetitions and slowly but surely comes to recognize her own android nature. This realization is transformed into political

Figure 3.5. Anthony Hopkins in a film still from the television series *Westworld* (first episode of the first season), HBO TV Series (2016) (photo: Album/Alamy Stock Photo. © 2015/IPA Images).

and military action: *pace* Asimov's First Law, Dolores spearheads an android revolution and rallies a veritable army, which she will lead out of the park into the real world with the intention of giving humans a taste of their own medicine. Better still, turning their own technology against them, outside the park, to evade capture, Dolores will learn how to incarnate herself in different bodies, assuming heterogeneous images and identities that multiply the replication effect dizzyingly.[87]

The themes that had already emerged in *Blade Runner* (the android unaware of its own artificial nature, the robot more human than the human not only in terms of anatomy, but also in terms of emotional capacity)[88] are intertwined with the *topos* of the revolt of the machines. The servant (servo-assisted) rebels against the master. The image is unframed (the park, after all, is in every way a framing device, a huge pedestal) to escape into the real world. Here the clash between hosts and humans will develop to the point where the survival of humanity itself will be threatened.

From Pygmalion and Galatea to Ford and Dolores, the cases I have mentioned are of course but a very small sampling of a very complex cultural tradition. But they are sufficient to identify a dialectical movement between the image becoming a living body (animation of the inanimate) and the living body becoming an image (inanimation of the animate), a dialectical movement that is highly significant for the argument I am endeavoring to develop here since it falls squarely within the general context of the processes of environmentalizing the image and weakening the threshold that separates the realm of the iconic from and unites it with the real world.

Figure 4.1. Joachim von Sandrart, *Parrhasius velo, volucris ceu fallitur uva*, engraving from *Academia Nobilissimae Artis Pictoriae*, Nürnberg-Frankfurt, 1683, New York, The New York Public Library (photo: Art & Architecture Collection, NYPL).

CHAPTER FOUR

The Environmental Image

Zeuxis in HD

It is still to the figure of Narcissus that we must again return in order to undertake further exploration of the "immersive" journey down through the centuries that will lead to contemporary virtual environments.

While the previous chapter opened with the ekphrasis of the rhetorician Callistratus commenting on a marble Narcissus looking at himself in the spring, here we turn to another ekphrasis contained in the famous collection of *Eikones* by Philostratus Major, also a rhetorician, who lived between the second and third centuries AD. The author offers his work to us as a set of descriptions, presented for the benefit of an audience of young readers, of sixty-four paintings housed in a Neapolitan picture gallery. The twenty-third description is devoted to a painting depicting Narcissus: "A youth just returned from the hunt stands over a pool, drawing from within himself a kind of yearning and falling in love with his own beauty; and ... he sheds a radiance into the water." It would thus seem that it is the type of the "conscious" Narcissus, aware of being the object of his own enchantment and of being himself portrayed in the reflected image, that Philostratus here wishes to evoke.

Like Callistratus, whom we have heard elaborate on a situation of image within image, the *mise en abîme* of the image marble being

portrayed in the image water, Philostratus opts for a *mise en abîme* between image painting and image water: "The pool paints Narcissus, and the painting represents both the pool and the whole story of Narcissus." But the self-awareness of the conscious Narcissus as represented in the image is placed significantly in tension with the beclouding of image consciousness that strikes Philostratus himself as an observer of the scene depicted: "The painting has such regard for realism that it even shows drops of dew dripping from the flowers and a bee settling on the flowers—whether a real bee has been deceived by the painted flowers or whether we are to be deceived into thinking that a painted bee is real, I do not know. But let that pass."[1]

We should by no means let go of this uncertainty of Philostratus. On the contrary, we must take it up and relaunch it, for it effectively introduces us to a crucial dimension for understanding the particular class of iconic objects that are images that deny themselves—the world, as seductive as it is controversial, of trompe l'oeil. Trompe l'oeil consists precisely in the production of an image that is installed in real space not by separating itself from it through framing devices, but by proposing an environmental continuity with it, that is, by presenting itself as a habitable place in which the subject can perform actions.

Certainly the best-known place that paradigmatically exhibited this condition must be sought in a famous page of Pliny the Elder's *Naturalis historia* that tells us of the dispute between two great painters who lived between the fifth and fourth centuries BC, Zeuxis and Parrhasius:

> [Parrhasius], it is said, entered into a pictorial contest with Zeuxis, who represented some grapes, painted so naturally that the birds flew towards the spot where the picture was exhibited. Parrhasius, on the other hand, exhibited a curtain, drawn with such singular truthfulness, that Zeuxis, elated with the judgment which had been passed upon his work by the birds, haughtily demanded that the curtain should be drawn aside to let the picture be seen. Upon finding his mistake, with a great degree of ingenuous candour he

admitted that he had been surpassed, for that whereas he himself had only deceived the birds, Parrhasius had deceived him, an artist.[2]

Both the victor and the vanquished in this competition (which testifies to the emergence of an illusionistic style in Greek art of the time) find themselves engaged in painting an image that denies its own iconic status in order to present itself immediately as if it were reality: the grape, the curtain. The engraving reproduced in Joachim von Sandrart's *Academia Nobilissimae Artis Pictoriae* (1683) (fig. 4.1) shows us, significantly, two *actions*. On the right, the birds, who, unaware of the iconic nature of the grapes painted by Zeuxis, descend from the sky to peck at them; on the left, Zeuxis himself, who, similarly unable to reach this awareness, stretches out his hand to lift the covering painted by Parrhasius. By denying themselves as images, such an-iconic objects weaken in their users, whether animal or human, the consciousness of the threshold that divides reality from its representation and elicit practical operations (the pecking, the lifting). That is to say, they offer possibilities for action, what James J. Gibson would call true *affordances*.

Centuries later, an advertisement for the Samsung 6-series TV set, in order to emphasize the high definition of its LED screen, recreates the scene of the bird fooled by inviting red berries (fig. 4.2).

We do not know if Samsung's art director had read Pliny and intentionally made reference to that famous anecdote, but the *longue durée* effect of that ancient story — a prototype of the artist's mimetic mastery[3] — cannot be overlooked even within contemporary digital image reproduction technologies.

Moreover, Zeuxis, again according to Pliny, had a certain fixation with those grapes: "There is a story, too, that at a later period, Zeuxis having painted a child carrying grapes, the birds came to peck at them; upon which, with a similar degree of candour, he expressed himself vexed with his work, and exclaimed — 'I have surely painted the grapes better than the child, for if I had fully succeeded in the last, the birds would have been in fear of it.'"[4]

Figure 4.2. Advertising image for the Samsung Series 6 LED television.

The topos of the animal confusing reality and representation by being unable to access the experience of image consciousness famously abounds in numerous variants in the artistic literature of antiquity.[5] It is Pliny again who mentions the case of Apelles, who, suspecting that corrupt judges were not making the correct appraisals in a competition for which he had submitted his own painting depicting a horse, appealed to the judgment of the animals themselves: "He had some horses brought, and the picture of each artist successively shown to them. Accordingly, it was only at the sight of the horse painted by Apelles that they began to neigh."[6]

The history of the effects of this issue endures for centuries and reaches us in the present day with Arthur Danto's pigeons learning to discern photographic representations of trees (chosen as the most closely mimetic images) from photographs of nontrees not because they can distinguish images from reality, but on the contrary, because they grasp "that which is invariant between photographs and visual reality."[7]

Here, however, we must abandon this line of research, stimulating as it is, and focus not on animals, but on humans: that is, not on the birds trying to peck at the grapes painted by Zeuxis, but on Zeuxis himself trying to lift the curtain covering the painting of his rival Parrhasius. For this strand, too, the tradition of artistic literature has handed down colorful anecdotes. Among the most famous is undoubtedly the scene recounted by Giorgio Vasari in *The Life of Giotto*: "It is said that when Giotto was still a young man with Cimabue, he once painted upon the nose of a figure that Cimabue had completed a fly which looked so natural that when his master returned to continue his work, he tried more than once to drive the fly away with his hand, convinced that it was real, before he realized his mistake."[8]

The use of trompe l'oeil depictions of insects was very common in the Renaissance period.[9] For Flemish painting, mention should be made of the *Portrait of a Carthusian* by Petrus Christus (painted around 1446 and preserved at the Metropolitan Museum of Art in New York), in which a life-size fly appears on the lower edge of the

frame. For Italian painting, in Carlo Crivelli's *St. Catherine of Alexandria* (produced in the early 1490s and preserved at the National Gallery in London) a fly appears on the left jamb of the niche in which the saint is placed with the attribute of her martyrdom, the breaking wheel that will tear her body apart (fig. 4.3).

Two aspects are particularly noteworthy here in this tempera-on-wood panel measuring 38 by 19 centimeters. On the one hand, the difference in scale between the fly, painted life size (complete with a shadow cast on the background to enhance the three-dimensional effect) and the saint, represented in reduced proportions, an apparent incongruity in dimensions that results in enhancing the illusionistic effect, emphasizing the iconic and representational character of the saint (it is "only" a painting) as opposed to the "real" and "natural" character of the insect. On the other hand, the solicitation of the image's framing devices, where not only the jamb on which the "real" fly has landed (which, by appearing real, also gives a status of reality to the surface on which it rests and that it occludes), but also the lower edge of the plinth from which the saint's right foot protrudes; undoubtedly "painted," yet almost yielding to the temptation to step out of its condition as an image, to invade the real space in which the viewer finds himself.

The immobility of the viewer's eye is, of course, a necessary condition for trompe l'oeil to be successful. As the viewpoint moves, our kinesthetic sense (i.e., the dynamic correlation between the appearance of the percept and the mobility of the percipient) requires that the relationships between the painted objects and the relationship between the bodies and their shadows should also change, which is not the case. While this can be remedied for shadows by preferring flat or shallow compositions, for mobility, as Ernst H. Gombrich admits, "We contribute some of the imagined movement from the store of our own expectations."[10]

The attraction exerted on painters by trompe l'oeil has nurtured a very rich tradition and multifarious variations of illusionistic strategies over the centuries.[11] In the taxonomy proposed by Michael

Figure 4.3. Carlo Crivelli, *Saint Catherine of Alexandria*, egg tempera on wood, 38 x 19 cm, ca. 1491–1494 (© The National Gallery, London).

Kubovy,[12] Crivelli's fly, as well as the tags painted by Antonello da Messina or Francisco de Zurbarán that appear glued to the canvas from the outside, exemplify "extrinsic" trompe l'oeil. This strategy amplifies its ability to negate itself as an image—a phenomenon I would describe as "an-iconic"—by conflicting sharply with the viewer's recognition that the underlying surface is undeniably a depiction. By contrast, the class of "intrinsic" trompe l'oeil includes paintings that as a whole are not perceived as such. This is the case with the simulation of textures or reliefs (e.g., in the techniques of *camaïeu* or *grisaille*), of actual environments, or of display boards, such as the letter racks painted by William Harnett and John Peto.

Kubovy characterizes the experience of trompe l'oeil as an "epistemological close call." The interesting aspect of this type of imagery is revealed "after the painting has ceased to *tromper* our *yeux*; it is when we have ceased to be the unwitting targets of a practical joke, and we have decided to reflect upon the experience we have just gone through, that the painting acquires its meaning."[13] Recalling the polarity between the naive Narcissus and the conscious Narcissus explored in Chapter 1, we might say this is the moment when we move from the former to the latter.

There are those who tend to trace the anecdotes that ever since the dispute between Zeuxis and Parrhasius onward have spread about the phenomenal ability of certain artists to produce images interchangeable with reality to a rhetorical formula peculiar to the genre of encomium. They would downplay the success rate achieved by the illusory power produced by trompe l'oeil, but recognize that the theme around which the efforts devoted to this class of images revolve consists precisely in the threshold that separates and connects image and reality. The trompe l'oeil addresses the viewers impudently by operating an invasion of his perceptual space, while at the same time avoiding saying "I"[14] by substituting for the pictorial representation a kind of self-presentation of things themselves.

As a rule, trompe l'oeil works would not be painted primarily for the purpose of inducing a true perceptual illusion, but rather to

elicit from us an astonished wonder that forces us to reconsider the distinction between reality and its depiction. Such works "engage us in a game that deals with the illusory character of depiction: precisely because the trompe l'oeil image conceals the elements that reveal its character as an image, the viewer is encouraged to reveal the distinction that separates the image from reality,"[15] that is, to become fully aware of what makes an image an *image* and to reflect on what aspects of the nature of an icon, if undermined or appropriately worked on, can cause ambiguity and uncertainty in that awareness.

For this reason, Baudrillard was able, when discussing trompe l'oeil, to speak of "anti-peinture" and "anti-représentation." It is never a matter of confusing image and reality, rather, "What is important is the production of a simulacrum in full consciousness of the game and of the artifice by miming the third dimension, throwing doubt on the reality of that third dimension in miming and outdoing the effect of the real, throwing radical doubt on the principle of reality."[16]

In the terms of a theory of mediality that conceives of the representational medium as polarized between transparency and opacity, between transitivity and intransitivity, the trompe l'oeil sits on the "edge," on the "limit," on the "crest of representation," "in a place that is not yet beyond it, but is no longer even in it,"[17] on the threshold at which indirect representation is about to tip over into direct presence.

A common thread connects the Renaissance illusionistic efforts, which we have seen epitomized in Crivelli's fly, backward to the bee described by Philostratus[18] and forward to more recent fancies, such as that of "escaping from criticism," represented in 1874 by the Catalan painter Pere Borrell del Caso in the form of a boy who, clinging to the vertical uprights of the picture frame, leans out, levering himself upward with his right foot to leave the painting and enter real space. His stunned gaze conveys to us all the astonishment, a mixture of excitement and fright, that follows such an escapade (fig. 4.4).

Nearly a hundred years later, the unbuttoned shirt gives way to full nudity and apprehension to a determined desire to "step out

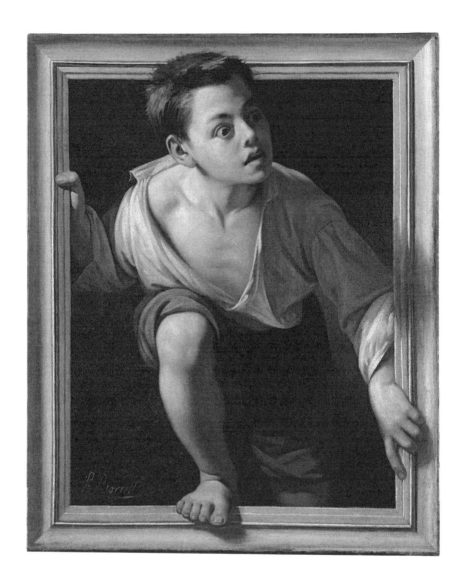

Figure 4.4. Pere Borrell del Caso, *Escaping Criticism*, oil on canvas, 1874, Madrid, Collecíon Banco de España (photo: © Fine Art Images/Bridgeman Images/ Mondadori Porfolio).

of the frame." In 1965, the French artist ORLAN had herself photographed in several performances (some with a mask) in the act of overcoming the barrier that holds the image within the iconic space: out goes a hand, an arm, the right leg, both legs.... In a moment, the performer's whole body will have crossed the threshold, definitively abandoning the dimension of the image to take possession of the space outside and find her place in the real (fig. 4.5).

Unframings

In the span of time between Borrell del Caso and ORLAN a lot has happened. But mainly this: many visual artists have worked tirelessly at a systematic deconstruction of the framing device to the point that one might go so far as to say that it was the rejection of the frame in the practice of art that triggered, by a backlash effect, the theoretical reflection on the frame itself, what we might call a veritable "frameology" of the twentieth century. Indeed, the historical evolution of theories of the frame of the picture[19] leads us to see that this device assumed the status of a subject of theoretical study at the beginning of the twentieth century precisely at the moment when the avant-garde was preparing to radically question it with the aim of contesting it, deforming it, and finally rejecting it altogether.

It was certainly not only at the dawn of the last century that the essential role played by the frame in the experience of the pictorial image was identified. The famous and oft-quoted passage from Poussin's letter to his patron Chantelou in 1639 demonstrates this unequivocally. The painter recommends that his painting *The Israelites Gathering Manna in the Desert* be furnished with a frame so that the viewer's gaze is invited to focus on the image and not to lose itself in contemplation of its surroundings (other objects, and among them, other paintings).[20] In the next century, paragraph 14 of the *Critique of Judgment* in which Kant touches on the issue of the frame as *parergon* and ornament of the work,[21] confirms that the issue had already been brought into theoretical focus.

Figure 4.5. ORLAN, CORPS-SCULPTURES, *Tentative de sortir du cadre à visage découvert*, 1966, black-and-white photograph, courtesy STUDIO ORLAN et Galerie Ceysson & Bénétière (photo: © ORLAN, by SIAE 2024).

But it is with Georg Simmel's essay published in 1902 and explicitly devoted to the frame that this device makes its full entry into the category of objects worthy of aesthetic consideration. By turning his attention to the frame as a figure of the threshold, Simmel confirms his inclination to explore a structurally dialectical function (which interests him not only from an aesthetic point of view, but more generally from a social and cultural one) — separation as it is inextricably linked to connection. In this regard, the frame seems to render concrete the specifically human capacity to separate and connect, to bind and unbind, as the two sides of the same gesture.

The frame performs the fundamental task of ensuring the work's isolation from all that is foreign to it. It defends the image against external interference, and it separates it from the world while concentrating and reunifying the elements within it. That is, it connects the image to its own interior. Thanks to this strict separation and synthetic capacity, the framed image can shut itself away in its being-for-itself, and paradoxically, it is precisely by virtue of this strict being-for-itself that art can become an effective being-for-us, penetrating all the more deeply into our lives. According to Simmel, the frame is truly a frame when it is willing to render its services humbly and discreetly, never forgetting that it is precisely nothing more than the frame of a picture, that is, a functional element subordinate to the isolation of the artistic image from the real space that surrounds and menaces it.

The moment the frame claims to assume an autonomous aesthetic value, acquiring through its forms and colors an individuality that deserves to be considered in its own right, it abdicates its ancillary function, entering into competition with the work of art contained within it. That the painting may go out into the world or that, conversely, the world may enter the painting; it is this double movement — a "fortunately rare misdirection" — that the frame must at all means prevent if it is to safeguard (as Simmel demands) an idea of art as a world of values in itself, perfectly indifferent to ordinary life and its practical implications: "The frame, through its configuration,

must never offer a gap or a bridge through which, as it were, the world could get in or from which the picture could get out."[22]

Misdirection could perhaps be said to be still rare at that time (Vincent van Gogh had been so bold when tracing his *japonaiseries* on frames in the 1880s), but it would soon become common currency in the practices of deconstruction of the frame in which the avant-garde would engage. (One might think, to mention but a few striking cases, of the painted frames of Umberto Boccioni, Giacomo Balla, Gino Severini, Robert Delaunay, Wassily Kandinsky....) It is what the Groupe μ, cataloging the various types of rhetorical frame effect that exploit figurative deviations from the literal degree zero of the simple rectangular frame composed of four unpretentious strips of wood, designated as a figure of suppression by "trespassing [*débordement*]."[23] That theorists were by no means resigned to accepting these transgressions as permissible syntactic and semantic practices, however, is attested by an author such as Rudolf Arnheim, in other ways very sensitive to the energetic and dynamic strategies of framing devices. Even in 1982, he did not forego espousing a normative approach to boxing the ears of those who dare to trespass: "The artist risks an uncontrollable extension of his composition, which will make it ambiguous, self-contradictory, unreadable."[24]

But the history of artistic practices had long since shed these qualms. The stress test on the framing device that had already begun in the last decades of the nineteenth century had prepared the ground for the "environmentalization" of the image that Germano Celant effectively brought back at the 1976 Venice Biennial under the title of *Ambiente/arte* (Environment/art). Here he mapped a time span from futurism to body art, thanks in part to the historical reconstruction of such environments as Vladimir Tatlin's *Corner Counter-Relief* (1914–1915), Ivan Puni's installation at the Berlin gallery Der Sturm (1921), the room designed by Kandinsky for the Berlin exhibition *Juryfreie Kunstschau* (1922), the *Prounenraum* presented by El Lissitzky at the Grosse Berliner Kunstausstellung (1923), and *Madame B..., à Dresde* by Piet Mondrian (1926). Referring to such environmental interventions,

which were radically critical of a conception of the work as painting or sculpture that is transportable and disengaged from its context, Celant observes that the work is not "contoured," "cropped" with respect to the surrounding space containing it; rather, "a continuum is created between the image, superficial and volumetric, and the given context, in which the osmosis changes due to different environmental conditions."[25]

However, the construction of a world environment is traversed, as Celant again notes, by an immanent dialectic. The "cavern," "cavity" or "total envelope" can enclose itself within and seal the artist as if in a "second skin" (as in the case of Kurt Schwitters's *Merzbau*) or open to the outside and the social and occupy public environments (as in the case of the interventions of Balla, Mondrian, and Fortunato Depero). It is the same dialectic that, mutatis mutandis, we find today in the comparison between virtual reality and augmented reality (AR). While VR on the one hand immerses the subject in a digital environment, making him feel intensely present to that space and to the artificial objects he encounters there, on the other hand it seals him in a primarily audiovisual solipsistic bubble, segregating him from the external world and from his own body. (If I wear a headset, I cannot see my real hands; at most, I perceive and move the digitized hands that appear to me inside the virtual world thanks to the VR gloves, which make interaction possible.) In contrast, AR devices immerse the digital object in the real environment, which continues to be perceptible along with the user's own body itself. It is integrated, enriched, and indeed "augmented" by artificial entities that can be produced, shared, and manipulated in cooperation with other participants, thus ensuring a public and intersubjective dimension to the process. We would be wrong if we emphasized excessively the polarization between a solipsistic VR and an intersubjective AR. As we will see in the last section of this chapter, the role played by avatars will be crucial in this regard in blurring this opposition. However, it remains the case that at least at the current state of development of immersive digital technologies, VR inclines toward a complete removal of the

external world and its total replacement by a simulated world, while AR aims at an overlay of the digital with the real.[26]

That the juxtaposition of avant-garde works/environments with contemporary, digital immersive environments is not extravagant seems, after all, to be suggested by Celant himself when he writes that "space becomes a 'field' or place of dynamic fullness and emptiness, in which futurist artists seek to *immerse themselves* in order to make it a pulsating and vital material."[27] This is a process Umberto Boccioni calls for in his usual robust manner as early as 1910, along with comrades Carlo Carrà, Luigi Russolo, Balla, and Severini: "The construction of pictures has hitherto been foolishly traditional. Painters have shown us the objects and the people placed before us. We shall henceforward put the spectator in the center of the picture."[28] The shift from the "in front" to the "inside" marks that effort to overcome the separateness of the iconic space and to establish a continuity between it and the practical space in which the viewers find themselves, being in turn metamorphosed into inhabitants of the environment. Subsequently, the "Technical Manifesto of Futurist Sculpture," also by Boccioni, which came out in 1912, made explicit the sculpted or modeled volume what had already been pronounced for the painted surface: we will have to operate "in such a way that the sculptural block itself will contain the architectural elements of the *sculptural environment* in which the object exists. In this way we shall be producing a sculpture of the environment." While traditional sculpture takes shape by delineating and enclosing itself against a space that contains it, futurist sculpture must do exactly the opposite: "Let's turn everything upside down and proclaim the absolute and complete abolition of finite lines and the contained statue. Let's split open our figures and place the environment inside them."[29]

Accompanying these unframing practices addressed to the frame of the painting and the pedestal or niche of the statue was an effort to integrate the collaboration of the entire human sensorium into the aesthetic experience of art, no longer optically contemplative, but participatory and physical. Among the various projects, "The Painting

of Sounds, Noises, Smells," a manifesto proclaimed by Carrà in 1913, brings into play hearing and smell with the aim of creating a *"total painting*, which requires the active cooperation of all the senses . . . you must paint, as drunkards sing and vomit, sounds, noises and smells!"[30] For his part, Filippo Tommaso Marinetti in his 1921 "Il tattilismo" (Tactilism) envisions an "educational scale of touch" through the use of "tactile tables" that map fundamental tactile values. Here is an example:

> I created the first abstract suggestive tactile table, the name of which is *Sudan-Paris*. In its *Sudan* part this table has spongy material, sandpaper, wool, pig's bristle, and wire bristle. (*Crude, greasy, rough, sharp, burning tactile values, that evoke African visions in the mind of the toucher.*) In the *sea* part, the table has different grades of emery paper. (*Slippery, metallic, cool, elastic, marine tactile values.*) In the *Paris* part, the table has silk, watered silk, velvet, and large and small feathers. (*Soft, very delicate, warm and cool at once, artificial, civilized.*)[31]

From tables such as this one Marinetti imagines a development that expands in the direction of similarly tactile "rooms," "streets," and "theaters," fitting into a tradition of synesthetic and multimodal environments that, as we will see in the next chapters, will later extend into the contemporary world, traversing the experiments of "total cinema" and 3-D to arrive at VR immersive environments.

One only has to scroll through the index of the mapping carried out by Celant to realize the very broad dimension of this phenomenon of environmentalization in twentieth-century visual arts practices. Futurist prodromes are followed by Suprematism and Constructivism, neoplasticism and rationalism, metaphysics, Dada and surrealism, action painting and informal art, New Dada, environment, Pop, Nouveau Réalisme, Fluxus, kinetic art, minimal art, California environmental art, Arte Povera, body art. . . . Those who have pursued the adventures of the environmentalization of art even beyond the time limit of the 1976 Biennale mapping[32] have traced this process to a constellation of only partly overlapping experiences, such as assemblage, environment proper, happening, installation,

participation, interaction.... Among the many artists who could be mentioned, special recognition should be given to Allan Kaprow and Ilya Kabakov for their theoretical contributions concerning the concepts of "environment" and "*totale Installation*," respectively.³³

The participatory aspect of these environments (albeit differentially modulated on each occasion), calling for the physical presence of the viewer as a necessary prerequisite for the work to be completed, has often encouraged enthusiastic interpretations that applaud the overcoming of the producer/recipient, artist/audience dichotomy and the emancipation of the viewer from the role of passive contemplator. In contrast, Boris Groys has emphasized the broader political implications of installation practices, highlighting their dark side, so to speak, consisting in the fact that the artist exercises the role of "legislator" and "sovereign" of his installation space; here the visitor finds himself as if "in exile," on "foreign ground," and cannot but submit to the coercive will and authoritarian control of the artist.³⁴ In the last chapter, we will again find this dialectic between freedom and nonfreedom precisely in relation to virtual immersive environments.

From Pyramid to Sphere

On the trail that leads from the futurist avant-garde to contemporary installation practices, the process of progressive unframing seems at first glance to be part of that overall revolt against the rules of perspective, the "antiperspective malignity"³⁵ that has characterized much of the twentieth century. Certainly, if we look to the canonical place in which the norm for the correct rendering of perspective is established, Alberti's *On Painting*, we find that the cutout that frames that famous window ("I trace as large a quadrangle as I wish, with right angles, on the surface to be painted; in this place, it [the rectangular quadrangle] certainly functions for me as an open window through which the *historia* is observed"), must be understood as the plane of intersection of the "visual pyramid" whose vertex is in the eye of the observer and the base in the object to be represented: "A painting therefore will be the intersection of the visual pyramid

according to a given distance after having set the center and established the lights, [an intersection] reproduced with art by means of lines and colors on the given surface."[36]

Yet the same perspective device[37] can itself be put at the service of an immersive movement that carries the viewer inside the image. As Erwin Panofsky famously observes, perspective in fact proves to be a "two-edged sword." While on the one hand it establishes a distance between the viewer and the rigorous geometric representation of reality, on the other hand, it ends up reabsorbing him within this same representation: "The history of perspective may be understood with equal justice as a triumph of the distancing and objectifying sense of the real, and, as a triumph of the distance-denying human struggle for control."[38]

The second aspect of this dialectical tension is what is of particular interest to us here. We hear from Vasari's words the effect produced for him by the sight of a perspective-constructed space such as the one masterfully painted by Masaccio in the fresco *The Holy Trinity* in Santa Maria Novella in Florence: "What is most beautiful, besides the figures, is the barrel vault drawn in perspective and divided in squares full of rosettes which are so well diminished and foreshortened that the wall appears to have holes in it."[39] The surface that seems to open inward acts as a decoy, a lure. It invites the viewers to penetrate the space of representation virtually, calls them to cross the threshold separating the real and iconic dimensions, actively to explore the world of the image.

How intimately the perspective construction is pervaded by a desire to penetrate the image is shown vividly by a famous woodcut by Albrecht Dürer made in 1525.[40] A draftsman and a reclining model are separated by a grid device[41] that allows the transposition of the representation in correct perspective onto the surface of the sheet. The artist's penetrating gaze, an active pole of scopophilic exploration of a half-naked and passively abandoned female body, emphasizes his voyeurism, almost transforming the scene into an examination in the gynecologist's office (fig. 4.6).

Figure 4.6. Albrecht Dürer, *Draughtsman Making a Perspective Drawing of a Reclining Woman*, woodcut, 1525, New York, Metropolitan Museum of Art, gift of Henry Walters, 1917.

It is a paradigmatic example of what visual culture studies would call *male gaze* that Marcel Duchamp made explicit, taking it up and relaunching it in his environmental installation *Etant donnés 1° la Chute d'eau 2° le gaz d'éclairage* (1966), directly inspired by Dürer's engraving.[42] The nude female body is presented in his work not in profile, but from the front, and the eye of the draftsman depicted by Dürer in the third person is transformed into the subjective eye of the viewer-voyeur peering at the scene through the peephole.

Perspective construction according to Alberti's visual pyramid does not exhaust the solutions explored by Renaissance visual culture in the construction of immersive spatiality. A strategy in some ways antipodal to the artifices of linear perspective was adopted by Giulio Romano in configuring the architectural and pictorial ensemble of Palazzo Te in Mantua, which was the lovers' retreat of Marquis Federico II Gonzaga and his mistress, Isabella Boschetti. He conceived it as an illusionistic machine that invites reflection on the visual act of the viewer as a participatory response to the iconic

stimulus.⁴³ This strategy, deployed in increasing progression in the sequence of the rooms that follow one another along the perimeter of the palace, culminates in the Sala dei Giganti (Chamber of the Giants). This room, created between 1532 and 1535, houses an illustration of the Fall of the Giants, an episode that Ovid recounts in book 1 of the *Metamorphoses* (fig. 4.7):

> Giants, it's said, to win the gods' domain
> Mountain on mountain reared and reached the stars.
> Then the Almighty Father hurled his bolt
> And shattered great Olympus and struck down High Pelion piled on Ossa.⁴⁴

Giulio's subtext is pure political iconography: Zeus stands for Emperor Charles V (with whom Federico sided) and the Giants for the Italian lords who still resisted his dominance over the peninsula.

It is again Vasari who introduces us to the experience of this room. Referring back to his visit to the palace conducted in 1541, he describes the Chamber of the Giants as a masterpiece of the "inventive and resourceful" Giulio, a "round room" in which the walls would correspond to the paintings in order to deceive and terrify the visitors.⁴⁵ Not only do the walls (which Vasari perceives as rounded as a result of the illusionistic effect of the fresco, when in fact it is the corners between the walls and between these and the vault that are rounded, and only the vault is circular) contribute to this effect of tremendous "ruin," but also the floor is designed by Giulio Romano in such a way as to accentuate the overall environmental effect of the scene.

In the second edition of the *Lives* (published after a further visit to Mantua in 1566), Vasari expands further on the illusionistic effects in general and of the floor in particular: "This room, which is no longer than fifteen arm's-lengths, seems like a place in the countryside; in addition, since the pavement is made of small, round stones set in with a knife, and the lower parts of the walls are painted with the same stones, no sharp angle appears there, and the entire room comes to look as if it were one vast plane."⁴⁶

In this impression of artificial architectural space seeming to

Figure 4.7. Giulio Romano, *Fall of the Giants*, detail, 1532–1535, courtesy of the Municipality of Mantova—Musei Civici and the Fondazione Pallazo Te (photo: © Musei Civici di Mantova, Palazzo Te).

break through to the infinity of nature, Giulio took up the challenge with a prestigious predecessor in the same city, Andrea Mantegna, who had completed in 1474 his famous illusionistic oculus open to the sky in the Camera degli Sposi (Bridal Chamber) of the Castle of San Giorgio. Giulio's walls and vault help produce a perceptual bubble to which the floor, whose real stones merge seamlessly with the painted stones to create a total image, also contributes: "What is marvellous about the work is that the entire painting has neither beginning nor end, and that it is all tied together and runs on continuously without boundary or decoration"[47] — an experience of unframing that today we would qualify as seamless,[48] a true "catastrophe of form," as Gombrich calls it.[49]

Today, the effect is unfortunately undone, because the original floor was replaced during the second half of the eighteenth century by a floor designed by Paolo Pozzo. Likewise, we can only imagine the kinematic effect produced on the giant figures by the flickering flames of the fireplace, which was installed between the two windows. But at the time, the visitor would have been able to perceive a true 360-degree immersive environment. Forster and Tuttle significantly describe the Chamber of the Giants as a "totally enveloping visual panorama" that combines the visual impression of spherical envelopment with peculiar acoustic effects that today we would qualify as *surround*: a true "kinesthetic ensemble."[50] Those who today experiment with virtual immersive environments that integrate the audiovisual with additional sensory channels, whether olfactory or tactile (as in the case of Alejandro G. Iñárritu's *Carne y Arena*, which I will discuss in the final chapter), find themselves in a direct line of continuity with Giulio's experiment.

Thus, it is certainly not necessary to wait until contemporary times to witness the advent of immersive, enveloping space. The transition from Masaccio's pyramid to Giulio Romano's sphere signals a precocious sensitivity to the 360-degree mode of viewing that would become common currency from the late eighteenth century, thanks to the invention of the panorama.

Ramamania

The panorama device (from *pan*, "all," and *orama*, "view, spectacle") was officially patented on June 19, 1787, by Scottish painter Robert Barker under the French term "Nature à coup d'oeil," a 360-degree view of the artist's native city of Edinburgh. It was the first in a long series of panoramas (as the device was renamed a few years after its first unveiling) made by Barker himself and by imitators and competitors throughout Europe.[51] Feeding on the illusionistic tradition of baroque ceilings (for example, Pietro da Cortona's frescoes for the Palazzo Barberini [1632–1639] or Andrea Pozzo's for the 1685 ceiling of Sant'Ignazio di Loyola in Campo Marzio), this circular device, which often reached considerable size, allowed a kind of "teleportation" of observers into the midst of natural and urban landscapes or salient historical episodes. In contemporary VR literature and in the accounts that users report of immersive experiences, the expression "being there" is widely employed to characterize the user's sense of presence within a virtual environment.

The panorama allowed a sort of teleportation that today we would call *embodied*. Triggered by a total vision that also involved the viewer's rotating bodily movement in order to appreciate the image in all its circular breadth, this transfer, which we could certainly qualify as virtual, produced a somatic illusionistic effect: "The most powerful illusion in the Panorama was the physical, whole-body immersion through sight: it was a stepping out of oneself into another dimension."[52] If we read what was written by one of the pioneers of VR, MIT scientist Marvin Minsky, in his seminal 1980 article "Telepresence" (ushering in a rich season of so-called "presence studies"), we can understand how the panorama must be rightfully included among the forerunners of this kind of somatic experience. A video camera installed on the roof of a building in Philadelphia is remotely controlled by a headset adjusted so that the rotational movement of the user's head corresponds to a double rotation of the lens. "Wearing this helmet," Minsky recounts, "you have the feeling of being on top of the building and looking around.... You turn your head 30

degrees, the mounted eye turns 60 degrees; you feel as if you had a rubber neck, as if you could turn your 'head' completely around!"[53]

Barker's first choice of name was therefore not apt. Here was no "coup d'oeil" that would allow the viewer to take in the scene in its entirety with a single glance, but rather a physical progression of the act of viewing, which would be maintained even as the device was set into motion and the panorama was transformed into a moving panorama.[54]

In *Old Man Goriot*, Honoré de Balzac leaves us an amusing portrayal of the "conceit of ending words in *rama*,"[55] a veritable "RAMAmania" that had taken hold of common parlance in nineteenth-century France. Giving in to the dizzying effects of the list, in section Q of *Passagenarbeit* devoted to the panorama Walter Benjamin tried to enumerate its kindred contraptions, almost all with the suffix *rama* (more or less of the same age as the *passages*), catching the foreshadowing of cinema there: "There were panoramas, dioramas, cosmoramas, diaphanoramas, navaloramas, pleoramas (*pleō*, "I sail," "I go by water"), fantoscope(s), *fantasma-parastases*, phantasmagorical and fantasmaparastatic *expériences*, picturesque journeys in a room, georamas; optical picturesques, cinéoramas, phanoramas, stereoramas, cycloramas, *panorama dramatique*."[56]

I will not dwell at length on these devices, for which we possess a now very rich literature, even with explicit reference to the genealogical line connecting them to contemporary virtual immersive environments.[57] Rather, prompted by Benjamin, I would like to recall a nineteenth-century device of image environmentalization that, despite its name, works in the opposite sense to the panorama: the Kaiserpanorama. While in fact in the panorama the observer is inside the device and can move on a platform to admire the iconic landscape in 360 degrees, the Kaiserpanorama takes the form of a cylinder around which spectators are seated, each in front of a stereoscope, to contemplate a series of stereograms (urban or rural views on backlit glass plates) that followed each other in succession, thanks to a rotating mechanism, "unframing" each other. As Benjamin himself tells

us, "The picture would sway within its little frame and then immediately trundle off to the left"⁵⁸ (fig. 4.8).

The device, presented in Breslau in 1880 by August Fuhrmann and subsequently patented by him in London eight years later, offered a kind of peep show⁵⁹ characterized by strong three-dimensional effects, thanks precisely to the stereoscopic effect obtained by the dual photographic representation in parallel of the same scene from different camera points, resulting in an enhanced apprehension of relief and depth. From the inventions of the early pioneers of stereoscopy, Charles Wheatstone (1832), David Brewster (1849), Oliver Wendell Holmes (1861)⁶⁰ followed a line of development that, by setting stereograms into motion in the Kaiserpanorama would lead to 3-D cinema, which I will address in Chapter 6.⁶¹

"Every day," Benjamin observes, "the need to possess the object in close-up in the form of a picture, or rather a copy, becomes more imperative."⁶² The stereoscope, by offering an almost touchable relief, allows for the possibility of a progressive approach to the image to the point of immersion. By narrowing the visual field to coincide with the iconic field, this device "shattered the *scenic* relationship between viewer and object,"⁶³ encompassing the former in the latter. It is no coincidence that just as with VR headsets today, one of the most significant uses of the stereoscope was the viewing of erotic and pornographic images (fig. 4.9).⁶⁴

By virtue of that dialectic of immersion and emersion (of "in/out," as I will discuss in the next chapter) marking the processes of acclimatization that occur between the iconic world and the world of the viewer, *immersive* devices such as the panorama and the stereoscope, which invite viewers to *enter* the images, are counterbalanced by *emersive* devices, which produce a true epiphany of the image in the environment in which the viewer finds himself. Such is the case with phantasmagoria. Invented in 1792 by Paul Philidor (a pseudonym masking a still-uncertain identity) and then pirated five years later by Étienne-Gaspard Robertson (physicist, artist, and aeronaut), this image-producing technology consisted, as the name itself indicates

Figure 4.8. Vienna Kaiserpanorama around 1900 (photo: © BTEU/Gerfototek/Alamy/IPA Images).

Figure 4.9. Félix Jacques Moulin, *Female Nude Kissing Her Reflection in a Mirror*, stereograph, 1854, Los Angeles, J. Paul Getty Museum.

Figure 4.10. Étienne-Gaspard Robertson, *Mémoires récréatifs, scientifiques et anecdotiques du physicien-aéronaute*, frontispiece of the first volume, 1831, Harry Houdini Collection (photo: Library of Congress, Rare Book and Special Collections Division).

(from the Greek *phantasma* and *agoreuein*, "to manifest"), in the use of moving magic lanterns that projected inside a darkened room ghostly images of varying sizes onto media of various types (from glass to semitransparent fabric, from veil to smoke) in order to create spectral effects—a true resurrection of the dead (fig. 4.10).

Viewer testimonies confirm the emersive effect and at the same time the feeling of teleportation: "The phantoms appear in the distance, they grow larger and come closer before your eyes and disappear with the speed of light.... We believe ourselves to be transported into another world and into other centuries."[65]

Caught between the scientific aim of unmasking pseudoreligious credulity on the paranormal and the need for a progressive spectacularization that would appeal to public demand, the successful projective machine of the *phantasmagoreute* Robertson had various imitators and epigones, and numerous admirers. (Lewis Carroll himself entitled one of his 1869 poems "Phantasmagoria.")[66] But above all, he represented a crucial "optical-environmental agglomeration" that would set the stage for the advent of the hologram, 3-D cinema, and VR environments.[67]

The latter two devices I will discuss in the following chapters. Of the "hologram," it should first be said that what we are interested in for our discussion is not so much the object produced by holography (a technology dating back to the middle of the last century that uses the interference of two beams of laser light to obtain a three-dimensional image), but rather the so-called "Pepper's Ghost" (named after the chemist John Henry Pepper, who patented it in 1879 based on an invention by Henry Dircks).[68] The basic elements of this optical trick are already laid out by Giambattista Della Porta in the second edition of his *Natural Magick*, published in 1589. In a chapter devoted to catoptric effects, the Neapolitan philosopher illustrates how to "see in a chamber things that are not" through the use of a mirrored window placed in a dark room.[69]

But it was from its widespread use on the Victorian stage that this illusory artifice took hold. In the midst of the flesh-and-blood actors

Figure 4.11. World's first hologram demonstration, held in front of the Congress of Deputies in Madrid against the Citizen Security Law, also known as the "Gag Law," 2015 (photo credit: © Marcos del Mazo/LightRocket/Getty Images).

appeared the ghostly figure of an actor hidden behind the scenes, whose figure was reflected on glass panels on the stage, but that were invisible to the audience.[70] The prodigious machines of the sinister inventor Orfanik—capable of projecting ghostly, flaming images accompanied by blood-curdling siren sounds, that we read about in Jules Verne's 1892 Gothic novel *The Castle in Transylvania*[71]—likewise seem to be variations of Pepper's Ghost.

Pepper's Ghost has experienced a significant revival in more recent years. Indeed, it has been employed to bring (iconic) musical stars such as Tupac Shakur and Michael Jackson back to life,[72] to allow a gigantic President Erdoğan to tower over a rally in Izmir in 2014, or to allow the appearance of Indian Prime Minister Narendra Modi (also in 2014) and Jean-Luc Mélenchon (French presidential candidate in 2017) in several different locations simultaneously. The march of the holograms (fig. 4.11), organized in Madrid in 2015 by the No Somos Delito association to protest the enactment of a national security law christened "Ley Mordaza" (Gag Law) by its opponents, made clear the urgency of reflecting on the new political subjectivities introduced by this emersive technology.[73]

Ghostly apparitions can also be evoked by technologies such as holofans (holographic 3-D LED fans) and anamorphic screens producing powerful 3-D images. Augmented or "mixed" reality devices such as the Microsoft Hololens 2[74] represent the latest frontier of the Pepper's Ghost effect, promising to alter radically the possibilities of interaction between the real and digital environment through their ability to produce, visualize, and manipulate (pseudo)holograms with powerful 3-D effects and so offering broad application opportunities in recreational, educational, and professional fields.

The various processes of image environmentalization, which in the cases analyzed in this chapter we have seen polarized in the dialectic of immersiveness and emersiveness, are located at the intersection of *icono-logy* and *eco-logy*, where the iconic (*eikon*) and the environmental (*oikos*) meet to form an *eco-iconological* plexus.

Figure 5.1. Giovanni Anselmo, *Entering the Work*, photograph with self-timer reproduced on canvas (1971), Trento, Museo di arte moderna e contemporanea di Trento e Rovereto (photo: MART, Archivio Fotografico e Mediateca, © Giovanni Anselmo, courtesy Archivio Anselmo ETS).

CHAPTER FIVE

The Subject in Question

A Game of Gazes

In the previous chapter, the constellation of devices that I gathered under the term "ramamania" showed us some paradigmatic technical solutions, immersive and emersive, for the construction of a representational spatiality and a corresponding spectatorship that favor the process of image environmentalization. In the following pages, I will offer some reflections concerning the articulation of a subjectivity that is placed at the service of that environmentalization.

In the first place, that articulation announces itself in the form of the modulation of the gaze. However, it is not a question here of the gaze that the viewer directs at the image, but rather of the gaze that the image returns to us: to paraphrase a felicitous formulation by Georges Didi-Huberman, it is not "ce que nous voyons," but "ce qui nous regarde."[1] The gaze addressed to us by the image itself interpellates us directly, "piercing" the threshold of separation between the real and iconic worlds and drawing us into a shared space-time.

Indeed, in an essay devoted to the picture frame, Louis Marin[2] draws attention to the way in which in *On Painting* (1435), Alberti sanctioned the use of the figure of the *admonitor* or *advocator*, the character who from within the image addresses the viewer directly and by means of gestures and expressions directs the focus of the viewer's gaze and emotional response to the figurative content of the painting:

It seems opportune then that in the *historia* there is someone who informs the spectators of the things that unfold; or invites with the hand to show; or threatens with severe face and turbid eyes not to approach there, as if he wishes that a similar story remains secret; or indicates a danger or another [attribute] over there to observe; or invites you with his own gestures to laugh together or cry in company. It is necessary, in the end, that also all [the occurrences] that those painted [characters] made with the spectators and with themselves, concur to realize and explain the *historia*.³

Among modern theorists, a prominent place in the conceptualization of the gaze emanating from images belongs to Vienna School art historian Alois Riegl. Analyzing the genre of the Dutch group portrait, and in particular depictions of autopsies such as Thomas de Keyser's *The Anatomy Lesson of Dr. Sebastiaen Egbertsz de Vrij* (1619) or Rembrandt's more famous *The Anatomy Lesson of Dr. Nicolaes Tulp* (1632), Riegl proposes a distinction between the "inner unity" (*innere Einheit*) that is established between the characters who look at each other as it were inside the painting and the "outer unity" (*äußere Einheit*) that embraces the iconic and extraiconic spheres through the gaze that one of the characters in the group directs at the viewer outside the painting. In the case of Rembrandt's painting, the function of Alberti's *admonitor* is provided by the onlooking surgeon who towers behind the other characters, looking directly at us and inviting us with his right index finger to focus on the autopsy table: "So, while the other seven figures seem to cohere internally in their mutual interaction, that is, in subordinating their attentiveness to the professor, the eighth establishes the external coherence with the viewer. He directs the viewer's attention to the lecture with a subordinating point of the finger."⁴

In *Las Meninas* (1656), Diego Velázquez composed a similar interplay of gazes between characters, who seem now to turn to each other or to look at elements inside the iconic space, now to look in the direction of the viewer (or rather to an invisible character inside the iconic space itself of whom the painter would offer us what in a film

we would call the "point-of-view shot"). In his famous and controversial reading of the painting, Michel Foucault emphasizes the inclusive and at the same time authoritarian power of the gaze that comes to us from the self-portrait of Velázquez intent on painting at the easel: "As soon as they place the spectator in the field of their gaze, the painter's eyes seize hold of him, force him to enter the picture, assign him a place at once privileged and inescapable."[5]

The gaze that is directed toward us by the image, looking directly at us, represents an "I" that calls us "you." Meyer Schapiro points out, precisely in the terms of the personal pronouns involved, the difference between frontal and profile posture in pictorial depiction:

> The profile face is detached from the viewer and belongs with the body in action (or in an intransitive state) in a space shared with other profiles on the surface of the image. It is, broadly speaking, like the grammatical form of the third person, the impersonal "he" or "she" with its concordantly inflected verb; while the face turned outwards is credited with intentness, a latent or potential glance directed to the observer, and corresponds to the role of "I" in speech, with its complementary "you." It seems to exist both for us and for itself in a space virtually continuous with our own.[6]

To this "I" who calls us "you" we can in turn reply by reciprocating "you." This is what Warburg makes explicit in his youthful fragments on expression when, addressing the image directly as a living and animated, yet ultimately harmless entity, he addresses it thus: "You live and do me no harm."[7]

A notable alternative that escapes the profile/frontality antithesis, or rather a perfectly complementary case of frontality itself, is the so-called *Rückenfigur*, the figure seen from behind made famous by Caspar David Friedrich's Romantic landscapes, which contain figures with their back to us, as in the case of *Woman before the Setting Sun* or *Wanderer above the Sea of Fog* (both 1818), or *Woman at a Window* (1822).[8] This is a compositional choice that has exerted considerable influence on various artists, such as Edvard Munch and Gerhard Richter. The origins of this topos are very ancient. While the

presence of such figures in Paleolithic painting is controversial (given the level of stylization of the bodies),[9] it is, by contrast, unequivocally attested in ancient mosaics, frescoes, and vase paintings.[10]

By performing a "hinge function,"[11] the *Rückenfigur* turns out to be a true dialectical entity, the effects of which are paradoxical and oxymoronic. On the one hand, by turning its back to the viewer, it seems to want to ensure the closure of the iconic space, separating it from the real space in which the viewer finds himself; on the other hand, it makes the threshold between the fictional space inside the image and the real space outside it permeable and transitable, offering the possibility of a "reflection" of the gaze of the outside observer in the gaze of the painted figure[12] so as to invite the viewer to merge empathetically with the character depicted and to look at the landscape from that character's own point of view.

Taking full advantage of the technical possibilities offered by photography, in 1971, Giovanni Anselmo pointed his lens in the direction of a meadow and adjusted the self-timer so that he could run in front of the camera and be captured, literally, entering the work (exactly as the title of the photograph says). In this way, by being immortalized from behind by the camera, Anselmo achieved a perfect combination of self-portrait and *Rückenfigur*, looking as it were from the outside *into* the image (fig. 5.1).

In postphotographic image production, too, the iconographic tradition of the *Rückenfigur* has exerted considerable influence, inspiring shoulder shots in cinema[13] and a considerable number of third-person avatars in video games.[14]

Farewell to the Fourth Wall

Since the mid-1980s, visual culture studies have dealt with the I/you theme in various ways, thanks to the research of Wolfgang Kemp, David Freedberg, James Elkins, W. J. T. Mitchell, Hans Belting, and Horst Bredekamp,[15] to mention but a few names. The exchange of gazes between devotee and idol represents one of the cornerstone themes of the anthropology of the visual proposed by Alfred Gell.[16]

The finger of Uncle Sam, accompanying the imperious appeal "I Want You for U.S. Army" in the military recruitment poster created by James Montgomery Flagg in 1917, endlessly reinterpreted in the subsequent history of propaganda posters and in advertising images,[17] represents for our imagination the canonical and iconic fusion of word and image in the structure of interpellation.

Michael Fried calls such a structure "theatricality," contrasting it with "absorption." The former term refers to images that address the viewer directly, involving him or her in a shared space, while the latter term designates those images that, as it were, mind their own business, as if the viewer were not present.[18] In its explicit reference to the theater, the notion of theatricality opens the argument in the direction of noniconic media. It is Fried himself who traces the roots of the issue back to the eighteenth century and in particular to the reflections of Diderot, who in his *Discours sur la poésie dramatique* enjoins, "Whether you compose or act, think no more of the beholder than if he did not exist. Imagine, at the edge of the stage, a high wall that separates you from the orchestra. Act as if the curtain never rose."[19]

The "high wall" that Diderot demanded as a product of the imagination from both those who write for the theater and those who perform in it would become in the regulations governing French theaters a material barrier, albeit semitransparent, that prevented direct vision of the scene and attenuated the verisimilitude of the performance (and certainly, prudently, also the possibility of ill-intentioned spectators throwing objects at the actors). It was against such a barrier that, to the cry of "Vive la liberté!" (it was July 14, 1789, and word had just spread of the storming of the Bastille), Plancher Valcour, director of the Paris theater of the Délassements-Comiques, clenched his fist and tore through the gauze curtain imposed on all theaters by the Comédie Française in order to separate actors from their audience.[20]

It is Eisenstein[21] who relates this anecdote to other episodes of "unframing." The closest in time is represented by the curtain that

was not lifted, but rather directly torn open, so as to reveal a black square by Kazimir Malevich in the staging of the Russian futurist opera *Victory Over the Sun*, first performed on December 2, 1913, at the Luna Park Theater in St. Petersburg (text by Aleksej Kručënych, music by Mihail Matjušin, set and costumes by Malevich himself).[22] The most distant in time concerns none other than the resurrection of Christ as narrated in the Gospel of Matthew (27:51–53): "And behold, the curtain of the temple was torn in two, from top to bottom; and the earth shook, and the rocks were split; the tombs also were opened, and many bodies of the saints who had fallen asleep were raised, and coming out of the tombs after his resurrection they went into the holy city and appeared to many."[23]

The very etymology of "temple" (*templum* in Latin, *temenos* in Greek), which refers to the root *tem-* indicating a cut, suggests a clear separation of sacred space from profane space.[24] Retranslated from the realm of the mythic-religious to the aesthetic-artistic, the "contempl-action"[25] of a framed painting or performance corresponds, mutatis mutandis, to the spectator's correlation to a separate and other spatiality, that of the pictorial or theatrical performance.

The question of the abolition of the fictional barrier figured from the mid-1930s among the cornerstones of the theory of a non-Aristotelian dramaturgy advocated by Bertolt Brecht. Despite the fact that Diderot and Brecht are often associated as theorists who advocate "cold" and nonimmersive performance on the part of the actor, on this issue, the two could not be further apart.[26] Contrary to Diderot's wish for a fourth wall that would enclose actors in an impenetrable hermetic bubble, Brecht aimed for a permeable and porous space that would allow communication between the two domains and thus promote the possibility of an estrangement effect (*Verfremdungseffekt*) seeking to avert identification. In his effort to delineate a "non-Aristotelian" theater, the German playwright looked to the East: the procedure of breaking down Diderot's fourth wall was for him a ploy, at least exquisitely "Chinese," if not exclusively so. (Think of the *parabasis* of the chorus in ancient Attic comedy, for example in

Cratinus and Aristophanes.)[27] In his essay titled "The Fourth Wall of China" (first published in English in 1936 in the journal *Life and Letters To-day* and published in German only in 1949 under the title "Verfremdungseffekte in der chinesischen Schauspielkunst"), we read:

> The Chinese artist never acts as if there were a fourth wall besides the three surrounding him. He expresses his awareness of being watched. This immediately removes one of the European stage's characteristic illusions The audience can no longer have the illusion of being the unseen spectator at an event which is really taking place. A whole elaborate European stage technique, which helps to conceal the fact that the scenes are so arranged that the audience can view them in the easiest way, is thereby made unnecessary.[28]

But the intention that sustained Brecht in his attempt to import the Chinese stratagem into his own dramaturgy turns out to be diametrically opposed to what animated Eisenstein. While by breaking down of the fourth wall the former aimed to promote in the audience the critical awareness of attending a performance by establishing "a grandiose distance from the events,"[29] the latter pursued, on the contrary, proximity, emotional involvement, and identification. As Rancière has aptly observed, "unlike Brecht, Eisenstein never wanted to instruct or to teach his audience how to see and create a distance. Brecht set out to purge theatrical representation of identification, fascination, absorption. Eisenstein, instead, wanted to capture all of them and multiply their power."[30]

From this point of view, the experiences that go under the name of "immersive theater" today and that are reflected in numerous levels of audience involvement (from overcoming frontality to integrating the spectator into the physical space of the performance, from multisensory involvement to actual direct interaction with actors)[31] represent varied embodiments of a broadly Eisensteinian line.

Contrary to the interpretation of Barthes, who in his essay "Diderot, Brecht, and Eisenstein" insists on the shared position of the three on the need to think of "the scene, the picture, the shot" as a "cut-out rectangle,"[32] it must therefore be emphasized that for

both the Soviet director and the German playwright, Diderot's rectangle (of framing and scene) must be put in place in order to be transgressed. But their purposes are antithetical. As we will see, it will be the direction taken by Eisenstein that will mark the path from the breaking down of the theatrical fourth wall through cinema and video games to contemporary virtual immersive environments. Let us consider more closely the steps in that process.

Interpellation and the Point-of-View Shot

Diderot's admonition to imagine a fourth wall of the stage is placed by Eisenstein as an epigraph to his essay "Diderot Talked about Cinema," in which the mediums of theater and cinema are compared with regard to their possibilities and limitations. Cinema is the "natural child" of the theater, and particularly of Diderot's theater, insofar as the latter was "the prediction of a theater that can be realized only through its natural descendant, the cinema."[33]

As the director himself recalls, his encounter with the fourth wall occurred in 1920 in Moscow, at Konstantin Stanislavsky's Art Theater, a theater that nurtured the dream "that on stage one lived and behaved as in a room."[34] But then Eisenstein, sitting in the front row at a performance of Henning Berger's *The Deluge*, perceives his own boots in the same field of vision in which the actor Michael Aleksandrovič Chekhov appears to him: "And here it is that the encounter of my white felt boots with Michael Chekhov destroys for me, once and for all, the myth of the fourth wall."[35] The continuity that is established between real and fictional space helps to dissolve the illusion of the fourth wall, which, moreover, is already compromised by the very demands of theatrical acting, requiring an affected exaggeration of gestures and diction so that the whole audience can see and hear clearly. The rule to be followed is that of not walking, but strutting; not speaking, but proclaiming; an unnatural exaggeration that already in itself betrays the fact that this is aimed precisely at an audience and its primarily perceptual needs, that is to say, it is a rule imposed for the purpose of performance.

On the contrary, thanks to the cinecamera's flexibility and its ability to adapt to the actor's needs by filming him or her from countless different points of view, macroscopically emphasizing a detail of his or her face or microscopically shrinking his or her body, cinema allows for the kind of naturalness and authenticity that is precluded by performance in the theater. Diderot had to enjoin imagining a fourth wall precisely because the stage, open from the proscenium to the stalls, forced the actors into a predetermined unidirectional orientation toward the audience. In cinema, by contrast, the actor does not worry about the direction from which the camera lens points and can concentrate instead on the performance while interacting with his or her fellow actors. The filming technique itself will have to conform to this requirement: "There must be a shift from one-sided recording of the event to recording in the round: to the event laid bare on all sides."[36] This is the foreshadowing of the 360-degree shooting that will characterize virtual reality works, which I will discuss in the last chapter.

Hence, for Eisenstein, it is all the more important that the training of film actors takes place in ways and following paradigms that differ from those of the theatrical actor. In Russian cinema, the resistance of the theatrical pedagogical tradition in maintaining itself as a model for that of film entails an exacerbating "false theatricality" that plagues film acting. In contrast, in American cinematography, film acting has long since freed itself from such fetters, and the result is the effect of rendering transparent the medium: "It is almost unthinkable, here, to watch the film for what it is: without taking your eyes off the screen you watch the lives of the female characters, under the conditions presupposed, strikingly recreated by astonishing actresses."[37]

In American cinema, Eisenstein identifies specific strategies adopted in order to promote "direct contact" effectively and "restore the lost unity" between actor and spectator.[38] On the one hand, what in the theater would be called the *a parte* and that is presented in the film as a direct interpellation by the character of the audience[39] and, on the other hand, the point-of-view shot.[40] These are two opposite

and complementary strategies of modulating the gaze with the intention of weakening the threshold separating the intradiegetic universe in which the narrative takes place and the extradiegetic world in which the viewer finds himself. In the case of direct interpellation (heir to that gaze that the image addresses to us, which we mentioned above), the intraiconic element seems to want to escape from the screen to embrace representation and reality in a single environment; in the case of the point-of-view shot, it is the viewer who "enters" the world of the image, his or her own gaze coming to coincide with the character's gaze.

It is an in/out dialectic of which Eisenstein calls to mind several examples. For directly addressing the audience, among others, *The Knockout* (Charlie Chaplin, 1914) is mentioned at the point where Fatty Arbuckle, challenged to a boxing match, undresses to put on his shorts and looks shamefacedly into the camera asking the cameraman to raise the lower edge of the image to hide his underwear from the view of the audience and so maintain his dignity. For the point-of-view shot, the most striking case is *Lady in the Lake* (Robert Montgomery, 1947), which was shot entirely in this manner, making character and lens coincide throughout the film, with nonetheless disturbing effects on the viewer.[41]

Formal comparison of two famous final scenes in which a gun is directly aimed at the camera — those of *The Great Train Robbery* (Edwin S. Porter, 1903) and *Spellbound* (Alfred Hitchcock, 1945) — allows Eisenstein to emphasize the shift from direct interpellation to point-of-view shot. While in the former case, the bandit shoots "point-blank into the lens — at the camera — at the audience," in the latter, Dr. Murchison (Leo G. Carroll) turns the gun on himself to commit suicide, and in doing so, "he is not simply shooting at the audience. He is making the audience ... shoot itself!"[42]

As Schapiro had already done for static images, a "grammatical declension" in terms of personal pronouns has also been proposed for moving images. While the impersonal "objective" shot (think of the long or very long-field panoramas of classical Hollywood cinema) has

been called "'nobody's' shot"[43] or a "third-person shot," the point-of-view shot evidently represents the point of view of the first person.[44]

If, following Eisenstein's own approach, we adopt the perspective of comparative mediology, we could conceive of the point-of-view shot as the result of the viewer's gradual rapprochement with the figure seen from behind until this results in the former's complete embodiment into the latter, an embodiment that allows for a full identification of three gazes: of the camera, the character, and the viewer.

The over-the-shoulder shot, a shot from the character's shoulder (in which part of the character's head is included in the right or left side of the shot itself, occupying more or less one-third of the field) represents an intermediate stage between the "objective" and "subjective" shots. The head of the character operates as a kind of partial avatar of the viewer, who is invited to assume its point of view.

The embodiment effect produced by the subjective camera (the "camera eye" that becomes the "camera I,"[45] is further intensified by what has been called the "first-person shot,"[46] a type of filming made possible by technological innovations such as the Steadicam, handheld or headset-mounted cameras, digital sensors, and increasingly fluid and realistic video games (particularly the first-person shooter genre and driving and pilot simulators).

If in the history of video games we consider the evolution of the correlation between the player's gaze, the construction of space, and storytelling, we can describe it in terms of a progressive subjectivization of the point of view[47] and a transition of the game's spatiality from mere background to a habitable environment. The introduction of the first-person perspective dates from the early 1990s, thanks to video games such as *Catacomb 3-D* (id Software, 1991) and *Wolfenstein 3D* (id Software, 1992).[48] The creation of a space that must be constructed, developed, and inhabited by the user dates from the late 1980s, a prominent example being *SimCity*, by Will Wright (1989). The landscape as a mere backdrop to the action has evolved from a viable (*Super Mario Bros*, 1985) and explorable space (*Myst*, 1993) to a manipulable and buildable environment (*Minecraft*, 2009).[49] Recent

cinema has drawn heavily on this formal repertoire. Two outstanding examples are offered by Gaspar Noé's *Enter the Void* (2009) and *Hardcore Henry* (2015), directed by and starring Ilya Naishuller and shot entirely with GoPro cameras.

In the recording of the event proper to the first-person shot, what is important is not so much the capturing of the event itself, but the fact of conveying the presence on the scene of the user who is filming, giving an impression of his or her neurophysiological reactions. Thus, what has been felicitously named a "somatic image" shot with a "body-camera"[50] is produced. It is an invitation to empathize somatically that is addressed to the viewer by this type of filming, which is based on an idea of shared experience. It is the device itself that undergoes a kind of "avatarization," becoming the substitute for the user (better, the *experiencer*) and thus generating a kind of mobile self-portrait, a dynamic *proxy*. This is the term used by Nick Paumgarten to describe his reaction to the sight of a GoPro video shot by his ten-year-old son during a downhill ski run: "I didn't need a camera to show me what he looked like to the world, but was delighted to find one that could show me what the world looked like to him. It captured him better than any camera pointed at him could. This was a proxy, of sorts."[51]

Avatāra

The term "avatar" has recurred on a number of occasions in the preceding paragraphs. In the immersive dynamics that characterize the contemporary scenario of digital environments, avatars are graphic representations that act as digital proxies through which users of the internet, a cybercommunity, or a computer interface (as in the case of video games) negotiate their presence and interact with artificial objects or other avatars in the digital world. These are thus elements that ensure a crucial function in the process of image environmentalization that we are describing.

Operating as a surrogate or representative of personal identity, the avatar is related to a broader constellation of concepts embracing similar figures that we have already mentioned in previous chapters,

such as the alter ego,[52] the double or doppelgänger, and the hologram. The functional spectrum of the avatar ranges from the disclosure of the self (a kind of truthful self-portrait) to the dissimulation of the mask: by virtue of such a wide range of possibilities, the avatar serves as an identity operator that enables a virtually infinite number of transactions. It enables that peculiar experience that has been called "self-empathy,"[53] that is, the possibility of empathizing with the other in me, of taking a perspective on the world as if from a point of view external to my own, yet somehow always my own.

Far from being a one-way access from the real to the digital, avatars constitute a two-way mediation, which also allows interventions from the virtual to the real world. Recent neurocognitive experiments have shown that avatars impact real life, for example, by modifying gender or racial prejudices through the production of the so-called "full body ownership illusion." Adopting an avatar of a different gender (e.g., in the case of domestic violence)[54] or putting oneself in an avatar with a different skin color[55] in the virtual environment is an experience that can reverberate in the real world, helping to correct social stereotypes through the adoption of an alternative "perspective taking" and the stimulation of empathic processes. Lower-level body representations condition higher-level attitudes and beliefs. In the significant words of a group of researchers working intensively on such issues, "changing bodies changes minds."[56] In addition, the use of avatars has proven to be particularly significant in the clinical treatment of pathological syndromes such as in the detection of symptoms of body image disturbance related to anorexia and other eating disorders,[57] or post-traumatic stress disorder.[58] The to-ing and fro-ing that crosses the threshold between the iconic and the real world in both directions thus finds in these areas significant applicative possibilities in the context of the environmentalization of the image that we are considering.

In the sphere of new media arts, the use of avatars impacts significantly both production and reception in a scenario that has been modeled in the virtual world of *Second Life* (SL).[59] Cao Fei is a Chinese

multimedia artist who documented in a video entitled *i.Mirror* (2007) the life in SL of his own avatar, China Tracy. Also active in SL, Canadian artist Jon Rafman experiences through his own avatar flâneur the virtual subcultures proliferating in this parallel cyberworld.[60] Combining computer-generated art and videogame stylemes, American artist Ian Cheng introduces canine avatars of his own dog Mars into his works. This is the case, for example, with *Bad Corgi* (commissioned in 2015 by the Serpentine's Digital Commission, later becoming a smartphone app), or even with Shiba Inu–breed avatars, as in *Emissary Forks at Perfection* (2015–2016).[61]

The virtual world can provide both anonymity and visibility. LaTurbo Avedon[62] is an avatar who has been operating since 2008 on social networking platforms, as much as an artist as a curator. Their name corresponds to a face that is presented in several self-portraits, but that at the same time protects the visual identity of the human subject(s) controlling them.

On the reception side, the viewer can also come to be represented by his or her own avatar, which replaces him or her during a virtual visit to an exhibition. Once again, *Second Life* has been a pioneering experience that has enabled the diffusion of a significant number of virtual exhibition spaces.[63] But what happens to our aesthetic experience when we go beyond individual online browsing and find ourselves sharing our emotions in copresence and interaction with other avatars? Does such a virtual setting impact our lived experience in specifically qualitative ways? Questions of this kind inspired a recent interdisciplinary experiment entitled "Art Distance Sharing,"[64] designed to assess the neural, cognitive, and perceptual processes that are triggered when a number of users, physically distant from each other but copresent together in virtual space, share through their avatars the experience of works of art, a significant example of what has long since been called "the social life of avatars"[65] (fig. 5.2).

The list of avatarial artistic practices could be lengthened with many more instances. It is thus worth reflecting on the historical and cultural background of this phenomenon from a genealogical

Figure 5.2. An avatar scene from the virtual world *Second Life* (photo credit: © Friedrich Stark/Alamy/IPA Images).

perspective. The dissemination of the term is due to its widespread use in the sphere of video games (starting with *Avatar*, developed in 1979 by the University of Illinois' Control Data Corporation System PLATO System), chat rooms, social networks, and more generally digital communication. The use of the term has spread exponentially in recent years, partly due to the box-office success of the film *Avatar*, directed by James Cameron, released in 2009 and shot using sophisticated stereoscopic techniques.[66]

But the history of the term is much older. Its first occurrences in Western languages can be traced to the eighteenth century, and it stands out as the title of a short novel published by Théophile Gautier in 1856.[67] However, it is to the East and to the religious sphere that we need to look in order to better understand the status of this mediating (and therefore threshold) figure. In fact, the notion of "avatar" has its roots in the ancient Hindu tradition. The Sanskrit term *avatāra* refers to the descent to earth and the perceptible appearance of a deity, particularly Vishnu, who intervenes in earthly affairs to restore cosmic order. The forms assumed by the deity may vary according to circumstances. Among those embodied by Vishnu we find, for example, the fish, the tortoise, the boar, the lion-man, the dwarf, and the Buddha. Each *avatāra* is thus to be considered only a partial manifestation of the corresponding deity it makes visible. Once the *avatāra* has performed the task entrusted to it, it merges back into its original deity.[68] From the perspective of the comparative history of religions, the Hindu idea expressed in the *avatāra* has been associated with other, similar representations of divine appearance, as is the case with the Christian "incarnation."[69]

An analogous structure, then, links the avatar in the religious sphere to the avatar in the cyberspace sense. In fact, it promotes a process of environmentalization between two heterogeneous spheres: in the first case between the sacred and the profane, in the second case between the digital and the real.

Like the drive toward immersivity, which can be traced back as far as the ahistorical dimension of myth, the avatarial state in the broadest

sense of the term (that is, as the surrogate presence of the producer or user of the image) can also be identified as a strategy that has been at work since ancient times. Consider in this regard the representation of hands in Upper Paleolithic wall paintings. Techniques can vary. Hands were painted (with mostly red, white, or black pigments) and then applied to the surface of the rock (this is the so-called "positive handprint"), or the hand was placed on the stone and its outline was highlighted by spraying the pigment through a tube or simply spitting it out of the mouth, or even by running a brush around the perimeter (the so-called "negative hand stencil"). The oldest stencil so far found (dating back to about 37,900 BCE) was discovered on the Indonesian island of Sulawesi.[70] Although we do not know much about the reasons that ultimately motivated such artifacts, it does not seem inappropriate to recognize them as partial avatars of the prehistoric self, iconic representatives of the human body in its archaic identity, that allowed for both self-recognition and self-duplication. As a kind of archaic prototype of Lacan's mirror stage (with which they share the lateral inversion, so that the right hand serving as a model turns out to be the left once depicted in image, and vice versa) "handprints" and "hand stencils" can be seen as figures that transform the opaque surface into a mirrored surface on which the self can reflect itself and, as thousands of years later Giovanni Anselmo declares, "be in the work." The swaying lights of torches will certainly have added a fitting dynamism to the whole, thus achieving a protocinematographic effect.

In any case, if the Platonic cave has been likened by Baudry to a prototype of the cinematograph,[71] the Upper Paleolithic caves (Chauvet, Lascaux, Altamira in Europe, the Cueva de las Manos in Argentina, to mention only the most famous) could well be considered as archaeo-immersive environments for the way in which they completely envelop the observer with their painted surfaces.[72] It is surely no coincidence that a specific type of virtual immersive environment has indeed been named CAVE (Cave Automatic Virtual Environment).[73] From the prehistoric cave to the digital CAVE there stretches a span of time, some segments of which we explore in this book.

Figure 6.1. Film still from *Sherlock Jr.*, 1924, directed by Buster Keaton (photo: TCD/Prod. DB/Alamy).

CHAPTER SIX

In/Out

The China Syndrome

The journey through immersive optical devices in the nineteenth century has led us to the advent of cinema and the various strategies for modulating the gaze that moving-image technology can offer in order to promote an osmosis between reality and representation. In this chapter, I would like to put forward an analysis of exemplary cases in the history of cinema that have focused on the dual "in/out" movement of entering (*immersion*), and exiting (*emersion*) the image.

Bizarre as it may seem at first glance, to prepare the ground for these analyses, I will recall to mind in a preliminary excursus a series of Chinese and Japanese legends, all revolving around the theme of the threshold that separates and connects reality and its representation (both pictorial and literary.) As we will see, it will be precisely these legends that will provide a key to interpret film theorists such as Benjamin, Béla Balázs, and Kracauer, who will reflect on movement into and out of the screen.

Among the most well-known stories is undoubtedly that concerning a celebrated painter of the T'ang dynasty, Wu Tao Tzu (680–760 CE). This mysterious tale, readapted by Sven Lindqvist in his 1967 book,[1] was well known in Europe at least as early as 1886, when the English surgeon and collector William Anderson reported on it in his pioneering catalog of Chinese and Japanese paintings. Commissioned

by Emperor Xuan Zong to create a landscape painting on a palace wall, Wu Tao Tzu invited the ruler to admire the painting up close. At the clap of his hands, a door painted on the side of a mountain opened wide: "He passed within, turning round to beckon his patron to follow, but in a moment the gateway closed, and before the amazed monarch could advance a step, the whole scene faded away, leaving the wall white as before the contact of the painter's brush. And Wu Tao-tsz' was never seen again."[2] Anderson's version, which did not refer to any source, was taken up and disseminated by the eminent Cambridge sinologist Herbert Allen Giles, who had to confess, however, "I myself have failed to find the Chinese text."[3]

For his part, Giles had translated in 1880 the *Liaozhai zhiyi* by Pu Songling (1640–1715)[4] under the title *Strange Stories from a Chinese Studio*, a collection of Chinese fairy tales (completed in 1679 but not published until 1766), which includes "The Painted Wall." Here, a certain Mr. Chu is invited by an old Buddhist monk to admire some wonderful wall paintings. He pauses, enraptured, before the image of a smiling maiden intent on picking flowers. Suddenly he finds himself in the world of the painting and is joined by the girl. The monk then knocks on the painted wall, calling him back, "and immediately Mr. Chu descended from the wall, standing transfixed like a block of wood, with starting eyeballs and trembling legs." Meanwhile, the maiden in the painting has changed her hairstyle into that typical of married women.[5] In a note to his translation, Giles does not fail to point out the similarities with Carroll's *Alice Through the Looking-Glass*.[6]

The motif of entering and leaving the painting was destined to become transcultural. As has been suggested, the story of Pu Songling may have inspired the Japanese writer Kōsai Ishikawa, and in particular his writing of the legend of the painter Kwashin Koji, included in the collection *Yasō Kidan* (1889–1894),[7] which was made available to Western readers in the early twentieth century thanks to the works of Lafcadio Hearn. The painter approached the screen painted with the Eight Beautiful Views of Lake Ōmi, beckoning

toward a minute boat depicted in the distance. The boat suddenly turned toward the viewers, coming closer and closer as the water overflowed from the painting into the room. Kwashin Koji jumped on, and the boatman rowed back, moving away toward the horizon as the water flowed back into the image. The boat became a tiny dot, "And then it disappeared altogether; and Kwashin Koji disappeared with it. He was never again seen in Japan."[8]

An obvious echo of this legend is discernible in Marguerite Yourcenar's oriental novella *How Wang-Fô Was Saved*. Wang-Fô is an old painter who wanders the streets of the Han kingdom together with his disciple Ling. Fallen into disgrace at the court of the emperor (who wants revenge for being deceived by the beauty of his images, unmatched perfection that the real world can never equal), Wang-Fô saves himself from execution by painting billowing ocean waves onto one of his landscapes from the unfinished imperial collection, which end up overflowing into the room in which he is being held prisoner. A rowboat then emerges and leads the painter and his assistant to safety, drifting away until it disappears into the freshly painted jade-blue sea. Now almost completely immersed in water, the emperor and his soldiers "will soon be dry again and will not even remember that their sleeves were ever wet.... These people are not the kind to lose themselves inside a painting."[9]

The dissemination of these Eastern topoi had a major impact on European culture in the late nineteenth century and the early decades of the twentieth. Between Giles's early English translations and Yourcenar's reworking came a series of publications in Central Europe. A German translation of Pu Songling collection had appeared in 1911 under the title *Chinesische Geister — und Liebesgeschichten* with a preface by Martin Buber.[10] Balázs had published the collection of Chinese fairy tales *Hét mese* in 1918 in Hungarian, later translated into German in 1921 under the title *Sieben Märchen*.[11] Here, in the story "Wan Hu-Chen's Book," we find the protagonist who, to recover from his unrequited love for the governor's beautiful daughter, writes a tale about a girl named Li-Fan with whom he ends up falling madly in love. From

the book she asks him to join him in the valley of the white apple blossoms, "Oh, but how could I make it there, Li-Fan?" — "Write yourself into the book just as you wrote me."[12]

This legend describes, it is true, the disappearance of the author into the literary rather than into the iconic world. But in the Chinese calligraphic tradition, it is still the brush that is the medium that makes possible the two registers of word and image: two sides of the dimension of representation that are not considered to be poles apart, as is the case in our tradition.

Relying on Balázs, it was Ernst Bloch in his *Durch die Wüste* (1923) who explicitly links the legend of the writer Wan Hu-Chen disappearing into his own book to that of the painter Wu Tao Tzu from which we have taken our starting point, defining them in Hegelian fashion as *Selbstaufhebungen im Werk*,[13] that is, as instances of overcoming-keeping the self in the work. In the version reworked seven years later in *Traces*, in the chapter significantly devoted to a threshold figure such as the "The Motif of the Door," the emperor is replaced by a group of friends, whom we imagine to be just as bewildered as the sovereign:

> The story of the old painter belongs here, who showed his friends his final painting: in it was a park, a narrow path winding gently past trees and ponds up to the little red door of a palace. But as the friends turned back toward the artist — that strange red — he was no longer next to them, but within the painting, strolling down the little path toward the fabulous door, standing quietly before it; turned, smiled, opened it, and vanished.[14]

Through the Screen
In all likelihood, it is to his friend Bloch that Benjamin owes his knowledge of the story of the Chinese painter who disappears into his own painting. And it is to Benjamin that we owe the connection between that legend and the cinematic image. An avid reader of Chinese legends, Benjamin made an early reference to the legend of Wu Tao Tzu in "Die Mummerehlen," a short text published under the

pseudonym Detlef Holz in 1933 and later included as a section of his "Berlin Childhood Around 1900." Benjamin's version seems to derive directly from Bloch's (alongside the painter are his friends, but not the emperor) and is brought into play to establish an analogy between the painter's disappearance and his own childhood experiences with painting: "In the same way, I too, when occupied with my paintpots and brushes, would be suddenly displaced into the picture. I would resemble the porcelain which I had entered in a cloud of colors."[15]

In his famous essay "The Work of Art in the Age of Its Technological Reproducibility," on which Benjamin began work around September 1935, we read by contrast the anecdote:

> Distraction and concentration form an antithesis, which may be formulated as follows. A person who concentrates before a work of art is absorbed by it [*versenkt sich*]; he enters into the work, just as, according to legend, a Chinese painter entered his completed painting while beholding it. By contrast, the distracted masses absorb the work of art into themselves [*versenkt in sich*]. Their waves lap around it; they encompass it with their tide.[16]

Within a short period of time (we are still in the early 1930s), even in the preservation of the metaphor of water and immersion, the meaning that Benjamin ends up attributing to this legend thus undergoes a significant reversal in the transition from "Berlin Childhood" to this essay on the work of art. In the first case, the disappearance of the painter in his own painting was taken as a positive example of an immersive sinking into the image, of a bodily (and thus *tactile*) identification with things and their colors that topples the traditional gnoseological and ontological opposition of subject and object (a theme among the most recurrent in that writing focused on childhood experiences). In the second case, the anecdote is taken as an exemplary case of contemplative (and thus *optical*) sinking into the work typical of the traditionally bourgeois way of enjoying visual art, consisting of gathering one's thoughts and concentrating in front of a painting in order to lose oneself in it. As such, this mode of contemplation is contrasted with the attitude of the distracted masses, who,

on the contrary, plunge the work into their own bosom in tactile manner, reabsorbing it into themselves and thus profoundly transforming the style of reception.[17] While in the former case, immersion is a process that proceeds from the viewer toward the painting, in the latter, it is instead a movement from the image toward the "waves" and "tides" of the multitude.

By relating the legend of the Chinese painter to the medium of film, Benjamin is notably ahead of those film theorists who, like Balázs and his friend Kracauer,[18] would expressly resort to the legend of Wu Tao Tzu to illustrate the nature of the cinematic experience. Not only does he precede them, however; he stands on the theoretically opposite side, insofar as he conceives of film as a type of image in which that identification and sinking *cannot* indeed take place, since the screen is not the canvas or the painted wall.

Let us read the way Balázs and Kracauer treat the anecdote and the interpretation they put forward. In *Film: Return to Physical Reality* (1960), Kracauer observes that the film viewer is absorbed by the scene projected on the screen, "penetrates it, so he drifts toward and into the objects — much like the legendary Chinese painter who, longing for the peace of the landscape he had created, moved into it, walked toward the faraway mountains suggested by his brush strokes, and disappeared in them never to be seen again."[19]

Balázs expounds this theme at greater length in his *Theory of the Film: Character and Growth of a New Art* (1949), proposing a comparison on the one hand between painting and cinema and on the other hand between Chinese, European, and American mentalities. In ancient Chinese culture, works of art were not considered to be the expression of *another*, unapproachable and separate world. This is effectively shown precisely by the legend of the old painter who, after painting a splendid landscape, enters it to disappear into a mountain without ever returning. On the contrary, in European culture, such a fable would never have found favorable terrain because the space of the work of art comprised within the delimitation of the painting is felt to be impenetrable (and here Balázs seems to

echo implicitly the frame theorist Georg Simmel, whose student he had been in Berlin).[20] Things would be different, however, for American culture:

> But such strange stories as those Chinese tales could easily have been born in the brain of a Hollywood American. For the new forms of film art born in Hollywood show that in that part of the world, as in old China, the spectator does not regard the inner world of a picture as distant and inaccessible. Hollywood invented an art which disregards the principle of self-contained composition and not only does away with the distance between the spectator and the work of art but deliberately creates the illusion in the spectator that he is in the middle of the action reproduced in the fictional space of the film.[21]

But really, as Balázs claims, could such a "Chinese" ploy never have touched the imagination of a European? Does the European really, as we have heard him say, perceive the space limited by the picture as "inaccessible"? Even leaving aside the experiments of the avant-garde (which Balázs, too, writing these words in 1949, knew well), we have seen that the rich and complex tradition of trompe l'oeil proves exactly the opposite. It is certainly true, however, that cinema (not only American) has developed this motif with particular intensity and effectiveness. *Pace* Benjamin.

We recall first and foremost Buster Keaton and his formidable *Sherlock Jr.*, released in 1924. In the film, Keaton plays a projectionist in love with an attractive young woman and is put in a bad light when an unscrupulous rival has him falsely accused of stealing a watch belonging to her father. Falling asleep during a showing, the projectionist dreams that he is a detective, climbs onto the stage, enters the film he is projecting by passing through the screen (an illusion created by setting up a theatrical scene identical to the movie set), and starts interacting with characters from his real life (fig. 6.1).[22] On awakening after a series of daredevil adventures, the projectionist discovers that the object of his love has meanwhile identified the real perpetrator of the theft, that he is exonerated, and that he can finally prevail over his rival and win the girl.

Sherlock Jr. offers a sharp reflection on the specific nature of cinematic montage as opposed to theatrical stage construction. The protagonist, once he enters the screen, lives in a space-time continuum, but the space-time of the environment in which he comes to find himself changes abruptly from time to time precisely by virtue of montage, creating nostop comic effects and gags. This film interests us here as an early example of crossing the screen and obliterating the threshold between the space of representation and the space of reality: a "Chinese" move, according to Balázs, successively taken up and deployed in various ways by later cinema.

The list of examples to mention of this "in/out" dialectic would be endless.[23] We might recall Bert's moving in and out of chalk drawings in the musical *Mary Poppins*, directed by Robert Stevenson (1964), and the tribute paid to Keaton by Woody Allen in *The Purple Rose of Cairo* (1985).

But already two years earlier, David Cronenberg—a master of inhabiting the threshold that separates and connects image and reality, perception, and hallucination—had thematized this to-ing and fro-ing through the television screen in *Videodrome*. Not only does Max Renn (James Woods) pass through the television screen by his head in response to the seduction of the inviting female lips that sigh sensuously, inciting him to a technosomatic copulation, but from the screen itself a handgun protrudes menacingly toward the protagonist, yet another embodiment of the hybridization between the organic and the technological that is the hallmark of the Canadian director's work (fig. 6.2).

The mysterious Professor Brian O'Blivion, who delivers his prophetic oracles in video recordings without ever appearing in person, explains to him that "TV is reality and reality is less than TV. Your reality is already half video hallucination." "O'Blivion suffers from a brain tumor. However, it is not the tumor that causes the hallucinations, but conversely, the visions of extreme images of violence and pornography that produce the tumor. The "door" that shuts the image within its boundaries is now unhinged, "We are all unhinged."[24]

Figure 6.2. Film still from *Videodrome*, 1984, directed by David Cronenberg (courtesy of Universal Studios Licensing, LLC).

A famous example of this threshold-breaking in the field of animation is presented by the video clip made in 1985 by Steve Barron using the technique of rotoscoping for the song "Take on Me" by the Norwegian synth-pop group a-ha. A young woman (Therese "Bunty" Bailey) sitting at a table in a diner (it was London's Kim's Café) flips through a comic book telling a story of bikers competing in a motorcycle sidecar race. The hero, who wins the race (Morten Harket), busy toasting his victory, suddenly seems to wink at her from the page. After an initial moment of astonishment, she decides to accept the extraordinary invitation, grabs the hand that reaches out from the two-dimensional drawing, and agrees to plunge into the paper world, leaving the bill to be paid and an irate waitress tossing the newspaper into the trash can (fig. 6.3).

The following scenes present us with an alternation of comic book (in black and white) and reality (in color), in a back-and-forth that plays with the theme of door and window. The arrival of the opposing racers, armed with wrenches to get their revenge on the hero, triggers a stampede. Only the girl, taking advantage of a window opened by her beloved in the comic book, will manage to return to the real world. But she will not give up. Retrieving the crumpled comic book from the basket, she will return home and eagerly follow the unfolding of the confrontation. The hero looks dejected, unconscious on the ground. But no, he picks himself up from the floor: the last page shows him beating his fists against the edges of the comic strip (yet another framing device). The girl hears pounding on the doorjamb. It is the boy, who has finally joined her in the real world. Happy ending.

TV commercials have also exploited this motif. Think of The Quest campaign created in 2018 by McCann for Nespresso. Starring in a costume drama, the knight George Clooney, after slaying a fearsome dragon that had threatened the survival of the kingdom, exits the screen and ventures into the Big Apple, complete with broadsword and armor, in search not of the Holy Grail, but of the best coffee. Once he has found it, he reenters the screen and returns to the

Figure 6.3. a-ha, "Take On Me," film still from music video, 1986, directed by Steve Barron (photo: © Rhino Entertainment Company, a Warner Music Group Company).

queen, who, however, is not satisfied with just one cup and sends him back to get a proper supply of the delicious beverage.[25]

The cases mentioned are only a few among many examples that could be cited of the thematization of the screen as a passageway that allows a two-way transit between the world of reality and the world of representation. A motif whose reflexive, "metamedia" nature should not be overlooked, it is a representational medium that thematizes within itself the crossing of the threshold separating representation and reality.

Watch Out for the Train!

Among many instances, Akira Kurosawa's film *Dreams* (1990) deserves special attention because it allows us to take a further step on our journey. The episode "Crows" tells us about an aspiring young artist (Akira Terao) who, visiting a museum, absorbed in the admiration of a series of paintings by van Gogh, finds himself at a certain point literally immersed in them and begins to wander through the painted landscapes in search of his idol. Significantly, of all the paintings contemplated by the visitor, it is a version of *The Langlois Bridge* (the one with washerwomen, boats, and horse cart, painted in Arles in 1888) that marks the transition from the real space of the museum to the intraiconic world (fig. 6.4). In the section "Unframings," we heard Simmel forbidding the frame to become a bridge; such a metamorphosis would in fact permit that transit from the world to the painting and vice versa, which for the Berlin philosopher would constitute the greatest imaginable misdirection. It was precisely to the bridge (and to the door, as figures of the threshold) that Simmel had dedicated one of his most pointed essays. What was denied to the frame as a device whose prerogative was to safeguard the separation between art and life, between image and reality, was, on the other hand, recognized as the highest expression of mankind's own ability to connect what is separated. In the bridge, the human will to conceive the separate as connected is objectified and externalized: "Whereas in the correlation of separateness and

Figure 6.4. Film still from *Dreams*, 1990, directed by Akira Kurosawa (© 1989 Warner Bros./Album/Alamy).

unity, the bridge always allows the accent to fall on the latter, and at the same time overcomes the separation of its anchor points that make them visible and measurable."[26] What is thus illegitimate in the world of art — bridging to the real — appears on the contrary crucial and foundational to human experience in the face of the real itself.

The Langlois Bridge painted by van Gogh is thus transformed in Kurosawa's film into a real bridge (the set design, however, retains the painting's own coloring, so that the cinematic image comes across as a hybrid of the real/filmed and the pictorial).

The would-be painter, equipped with the tools of his trade, canvases, easel, and paint box, turns to the now flesh-and-blood washerwomen to ask where he can find van Gogh. One woman points him in the right direction, warning him, however, that the artist has just been released from the lunatic asylum. The meeting takes place in a wheat field with haystacks. The artist (Martin Scorsese), with a bandage over his severed ear, reprimands the youth abruptly, asking why he is not painting that landscape bathed in light. "When that natural beauty is there I just lose myself in it," he confesses. But the process of painting is arduous: "I work, like a slave, I drive myself like a locomotive." (This is a cryptic quote from a letter from van Gogh to his brother Theo.)[27]

The sharp editing break just at this point shows us a black-and-white close-up of the wheels and piston rods of a steam locomotive, moving diagonally from right to left in the frame. The following scenes alternate close-ups of van Gogh and images of the pistons and smokestack of the train. It will be the steam whistle that interrupts not only the sequence's accompanying music (Chopin's Prelude op. 28, no. 15, known as *The Drop of Water*), but also the young admirer's immersion in van Gogh's work. From a wheat field over which dozens of cawing black crows flap their wings, he will find himself at the museum in front of the painting *Wheatfield with Crows* (painted in 1890 and housed at the Van Gogh Museum in Amsterdam).[28] Unlike with Wu Tao Tzu, whom we saw disappear into his painting and

never return to the emperor or his friends, here, the threshold of the painting is crossed in both directions.

What motivates the alternation between the close-up of the artist and the locomotive is certainly the visualization of the identification between him and the locomotive expressed by the painter. But it is hard not to think of one of the founding myths of early cinema (a phase also called to mind by Kurosawa's black-and-white train), which also tells us of the "bridging" nature of the medium: legend would have it that at the first screening, on January 6, 1896, of the Lumière Brothers' film *L'arrivée d'un train en gare de La Ciotat*, the panic-stricken audience fled the auditorium in disarray in fear of being run over by the locomotive, which moved diagonally from a considerable depth of field and approached ominously toward the foreground (fig. 6.5).

Benjamin observes that "it has always been one of the primary tasks of art to create a demand whose hour of full satisfaction has not yet come,"[29] aiming at effects that only later technical and media development will be able to realize fully. In this sense, we could say that the Lumières succeed in realizing the effect that Monet had sought some twenty years earlier by repeatedly painting trains and locomotives. Of these, *Le train dans la neige, la locomotive* (1875, preserved at the Musée Marmottan Monet) seems to offer the filmmaker brothers a model of framing.

Often mistakenly regarded as the first film ever screened in front of an audience, this 35-mm short film lasting about fifty seconds shares with its previous title by the same authors (*La Sortie de l'Usine Lumière à Lyon*, screened on December 28, 1895, at the Salon Indien du Grand Café on the Boulevard des Capucines in Paris) the movement from the back of the image toward the front, approaching the viewer's eye. The exit of the workers from the factory and the entrance of the train into the station are opposites from a narrative point of view but perceptually homologous.

While there is no way to find direct evidence of this event, either among spectator accounts or in police reports,[30] it should not

Figure 6.5. Film still from *L'arrivée d'un train en gare de La Ciotat*, 1895, directed by Auguste and Louis Lumière (photo: RGR Collection/Alamy).

therefore be relegated to the mere repertoire of groundless legendary anecdotes. This would overlook its considerable power of shedding light on the subsequent (love) story between railroads, on the one hand, and cinema and postcinema, on the other.[31] The Lumière short celebrated the perfect marriage between the moving image and the modern means of transportation, which embodied the driving force itself and which in the nineteenth century had profoundly altered perception of space-time.[32] Countless offspring ensued, starting with the so-called "phantom rides" of early cinema, a veritable genre so named because the camera strapped on the front of the locomotive provided a nonhuman subjective view of the tracks and the landscape that seemed to be traversed by an unstoppable, impersonal power.[33] Dziga Vertov provides us with an example of the "in/out" dialectic of this railway motif in *Kino-Eye* (1924) and *Man with a Movie Camera* (1929). The former presents us with the approach of a train to the foreground, the latter with the progression of the locomotive into the deep field, seen from a nonhuman perspective, that of the tracks, which invites the viewers to embody themselves in the direction of the movement taken by the camera-train ensemble. In his adaptation of Émile Zola's novel *La bête humaine* (*The Evil Angel*, 1938), Jean Renoir elevates the locomotive "Lison" to the level of protagonist on par with the main character.

But the peculiarity of the myth that shrouded the first screening of the Lumière brothers' *L'arrivée d'un train en gare de La Ciotat* lies in the fact that it revolves around both the train and the spectators' physical response, presenting itself as a glimpse into the spectatorship of the origins of the cinematograph. Early cinema immediately exploited the motif: think of "rube films"[34] such as *The Countryman's First Sight of the Animated Pictures* (Robert W. Paul, 1901) or *Uncle Josh at the Moving Picture Show* (Edwin S. Porter, 1902), two shorts that, as veritable metafilms, have as their theme the naive country bumpkin at his first film screening. Initially amused and even loudmouthed in front of (and even behind) the screen, in both cases, upon the arrival of the train, the simpleton does not hesitate to bolt off for fear of

being run over. These are scenes that intentionally are parodies, certainly, as was Neri Parenti's 1986 *Superfantozzi*, yet they shed light on the illusionistic and hallucinatory capacity of early cinema.

The *longue durée* of the effects of the train legend, passing through the experiments of the avant-garde,[35] reaches the present day. In 2011, Scorsese decided to offer us a reenactment of the panic scene in his first 3-D film, *Hugo* where the young protagonist (Asa Butterfield), along with his friend Isabelle (Chloë Grace Moretz), goes to the Bibliothèque Sainte-Geneviève hunting for books on cinema. There he comes across the volume of René Tabard (Michael Stuhlbarg), *Inventer le rêve*, which reveals the fateful episode to him. The still from the Lumière short reproduced in the book leaps from the page onto the cinema screen, shocking the terrified audience.

Four years later, we move from 3-D to VR: the virtual reality film *Evolution of Verse*, made by Chris Milk (2015), begins with a long train convoy pulled by a whistling locomotive with smoke bellowing from its stack. It quickly arrives from a long shot, crossing the waters of a placid mountain lake to impact straight "in the face" of the viewer, ideally breaking through the threshold separating profilmic space from off-screen space. "With a tip of the hat to the Lumière Brothers," admits the presentation text of the production company Within.[36] But as the impact dissolves the train into a flock of thousands of flapping black birds, we might also suspect a hidden reference to Kurosawa's "Crows."

From Lumière to Milk, what has been effectively termed the "*La Ciotat* effect" unfolds,[37] the effect produced by "reality media," that is to say, those media based on the moving image: cinema, television, 360-degree video, the new immersive digital technologies in AR and VR, each according to its own possibilities and limitations. Instead of relying on the trigger of the imagination and internal visualization (as a poem or a novel would do), these directly address our perception of the world, challenging our sensory relationship in general and visuomotor relationship with reality in particular.

It is not so much a matter of producing a perfect illusion of reality

that would be achieved through an accomplished transparentization of the medium forced upon an audience passively willing to be hypnotized by the apparatus nor of comparing the first viewers of early cinema to gullible children who in later generations would develop more mature forms of image consciousness (as Christian Metz thought).[38] If so, should today's viewer panic and flee in front of the Lumière film transposed and enhanced in Ultra HD? This is what was done by YouTuber Denis Shiryaev, who by resorting to machine learning repurposed *L'arrivée d'un train*, taking it from the original 16/18 to 60 frames per second, converting it to 16:9 format, and raising the quality of 35-mm analog film to 4K digital resolution.

Rather, while maintaining awareness of a mediation, it is a matter of arousing amazement at the way in which that mediation itself manages to simulate the real, realizing at the same time the uncanny [*unheimlich*] sensation of reality and unreality.[39] Dallying, then, on the threshold.

The Bow of the Potemkin

The idea that a train could literally come off the screen and run over the audience in the theater must therefore be recontextualized in the ambit of negotiation between perception of the real and perception of its simulation. But what if it were a battleship? For the first screening of the film *The Battleship Potemkin* on December 21, 1925, at the Bolshoi Theater in Moscow, Sergei Eisenstein had imagined an extreme solution for the final scene (fig. 6.6). He recalls it retrospectively thus in his *Nonindifferent Nature*: "According to the director's idea, the last shot of the film — the oncoming nose of the battleship — had to cut . . . the surface of the screen: The screen had to be cut in two and reveal behind it an actual memorable solemn meeting of real people — the participants of the events of 1905."[40]

Of this never-realized project, which has been appropriately called a "missed act," we are left with two eloquent caricatures, in addition to the recollection quoted above.[41] But the idea of it is enough to prove how seriously the Soviet director took the question of the

Figure 6.6. Film still from *The Battleship Potemkin*, 1925, directed by Sergei Eisenstein (photo: © Bridgeman Images/Mondadori Porfolio).

threshold between image and reality and its possible transgression.

Among the most powerful tools for realizing such a possibility, Eisenstein includes stereoscopic cinema, to which he dedicates the essay "Stereokino," written between 1946 and 1948. Although brief, this paper represents one of the first attempts to think broadly about the implications of a technique for producing images with a powerful three-dimensional effect. In the opening, the Soviet director immediately declares his enthusiasm for stereoscopy:

> These days you run into a whole lot of people asking: "Do you believe in stereocinema?" To my mind this question sounds about as absurd as if they were to say: do you believe that it will be night-time at midnight, that one day the snow in the streets of Moscow will melt away, that there will be green trees in the summer and apples in the fall? That today will give way-to tomorrow! To doubt that tomorrow belongs to stereocinema is just as naive as it is to doubt the very coming of tomorrow![42]

Indeed, as the Soviet director states, stereoscopy is not only the future of cinema, as we can easily confirm today with the spread of 3-D, but also its past, if we consider that experiments with stereo-pair cameras are basically contemporaneous with the birth of cinema itself. Louis Lumière himself showed considerable interest in stereoscopic filming beginning in the early twentieth century and in the mid-1930s shot a 3 D remake of *L'arrivée d'un train*.[43]

What particularly excites Eisenstein's imagination and fuels his hopes is the ability of stereoscopic cinema to produce the illusion of real life, starting from the illusion of three-dimensionality. This effect of reality, which is already ensured by the zero degree of stereoscopy, that is, by a kind of high relief that appears as if suspended above the surface of the screen, is further intensified by a double movement (receding into the inner space of the screen, or jutting out from it toward the audience): "And what we have become accustomed to seeing as an image on the screen suddenly 'swallows' us up into unprecedented depths, beyond the plane of the screen, or 'thrusts out' at us with unprecedented force."[44]

Viewers are absorbed into the interior space of the screen or struck by elements that seem to fly out of the screen itself: "Birds fly out of the auditorium into the depth of the screen, or settle down along a wire that stretches — literally and palpably — from what was once the 'plane of the screen' all the way to . . . the projection booth."[45] (Zeuxis's birds are not explicitly recalled, but we know that Eisenstein was a reader of Pliny.)[46] This is a dialectic of comings and goings that problematizes the threshold placed as a separation between image and reality, turning it into a passageway that can be traveled in both directions. Stereoscopic cinema offers us "the ability to 'pull' the spectator — with unprecedented intensity — into what was once the plane of the screen, and to 'precipitate' upon him — with equally devastating force — all that had previously remained splayed out upon its reflective surface."[47]

The type of film that Eisenstein has in mind here is the kind made by Soviet cinema in those years, and in particular Aleksandr Andriyevsky's *Robinson Crusoe*, released in 1947. The sequence of Robinson's raft trying to make its way through the tangle of lianas is considered a particularly effective moment of stereoscopy. Moreover, Andriyevsky's film was also groundbreaking from a strictly technical point of view. In fact, it was the first case of a stereoscopic film that, by employing special lenticular screens, did not require two-color (anaglyphic) glasses for its three-dimensional effects to be appreciated.

As is always the case in Eisenstein's reflections, the treatment of the technical aspect is crucial, but never an end in itself, rather always connected to its aesthetic implications in the more general sense of *esthesis*, the possibility of sensory experience. These implications manifest themselves first and foremost in the prosthetic nature of technical instruments, among which stereoscopy itself must be counted. However, the progressive enhancement, throughout history, of the natural abilities of the human body through the integration of technical prostheses — an enhancement of which stereoscopic cinematography represents one of the most advanced stages — is grafted onto a deeper layer, which seems to present itself as a true

anthropological constant operative since the dawn of time. Indeed, stereoscopy corresponds to an intimate need of both the artist and the viewer. It is even a phenomenon that satisfies an innate need of human nature:

> Can it be said that the three-dimensional principle in the stereoscopic film fully and consecutively answers some inner urge, that it satisfies some inborn requirement of human nature? Can it be said further that, in striving to realize this urge, humanity for centuries has been heading for the stereoscopic film as a complete and direct expression of this striving, a striving which, at different stages of social development and evolution of artistic means of expression, invariably and persistently tended to realize some inner urge though in different ways and incompletely? I think it can.[48]

This centuries-old tension expresses a tendency that, well before the invention of the medium of cinema, has been evident in almost every era of theater history and that extends to the search for three-dimensional effects in cinema as seen in its most recent phase of evolution, that is, the tendency to emphasize the "relations between" and "interdependence of the spectacle and the spectator," to reunify the schism that has opened between the two divided halves of actor and audience by leading them back to their "original 'common nature'"[49] following the double movement (attracting the spectator within the fictional space, or conversely allowing the actors to penetrate the real space of the audience) that we have already had occasion to explore in the previous chapter regarding the fall of the "fourth wall."

Untangling alchemical and Kabbalistic references, Dao and mysticism, cultural anthropology and literature, Dionysian rites and Wagnerisms,[50] sexology and psychoanalysis, Eisenstein seems to think of the stereokino as an instrument capable of fulfilling the erotic task of reuniting actor and spectator. Moreover, this erotic implication is promptly confirmed by the way Eisenstein himself characterizes the project of the laceration of the screen by the bow of the battleship, "spreading through *the film as a whole* . . . beyond the limits of

the film itself."[51] The expression "beyond the limits of the film itself" is one of the explications of the concepts—central cornerstones in Eisenstein's aesthetic—of pathos and ecstasy (*isstuplenie*): "Pathos is what forces the viewer to jump out of his seat. It is what forces him to flee from his place. It is what forces him to clap, to cry out. It is what forces his eyes to gleam with ecstasy before tears of ecstasy appear in them. In word, it is everything that forces the viewer to 'be beside himself.'"[52]

"Being beside oneself" is thus essentially a movement leading from one condition to another, a change of state (analogous to the natural processes of going from liquid to gaseous or solid state), a transition from one situation to its opposite—from stasis to mobility, from silence to sound, from sitting to jumping up, from dry to wet, and so on—brought about by the pathos effect of the image. (Although not familiar with Warburg's research on *Pathosformel*—a term he introduced in 1905[53]—Eisenstein surprisingly employs the same expression: "pathos formula [*pàfosa formula*].")[54]

This metamorphosis is perfectly summarized by the concept of ecstasy: "We might say that the effect of the *pathos* of a work consists in the bringing the viewer to the point of ecstasy... *ex stasis* (out of a state) means literally the same thing as 'being beside oneself' or 'going out of a normal state' does."[55] Special cases of the ecstatic experience are religious ecstasy, hysteria, and orgasm. But the project of tearing through the screen by means of the bow of the *Potemkin* on closer inspection raises the reflection to a *metamedia* level. It is no longer just a matter of a particular shot or a specific montage being able to provoke a pathemic and ecstatic effect in the viewer, but—as we read in the passage in question—of a real "spreading through *the film as a whole*." That is, it would be the film *Battleship Potemkin* as a whole that would ecstatize itself, stepping outside the boundaries of the image into the real. In doing so, the ecstatization of this film would have entailed the ecstatization of the cinema medium itself, its crossing the threshold that held it in the sphere of the image to break into the real world.

While remaining (or perhaps precisely because it remained) at the merely imaginative stage, Eisenstein's project is particularly revealing in its pushing to the extreme the consequences of the unstoppable propensity toward the stereo image, film as a "new, dynamic stereosculpture." Preparing consciousnesses "for new themes, consistent with and enhanced by technological advances, which will require a new aesthetic,"[56] and this is the task that for Eisenstein confronts the artist of the future. The question that remains unanswered, however, is whether this new aesthetic will be able to shoulder responsibility for an image that, in order to pursue the drive toward stereoscopy fully, ends up abdicating its own nature as an image, "deframing itself" and "unframing itself" totally in order to make itself, simply, reality.

Total Cinema

Eisenstein's ecstatic unrealized project suggests to us that the process of "unframing," which we explored in Chapter 4 with regard to the visual arts (and which consists, as we have seen, in a systematic deconstruction of the boundaries of the picture — the frame — in order to promote an environmentalization of the image), must therefore also be examined for the framing of film. The picture frame and film framing are the two main historical objectifications of the framing device, which seem to share not only obvious structural properties — executing the dual function of separating the image from what image is not and succinctly unifying the elements within the image itself — but also a common fate. One fully understands their nature and status the moment they are about to fail. Paraphrasing McLuhan's famous metaphor of the rearview mirror,[57] one might well say that it is the obsolescence of frame and framing that reveals their essence.

However, if we compare the cinematic frame with the pictorial frame,[58] things seem at first glance to have turned out very differently. In fact, thinking of it from its demise, from its becoming in Hegelian fashion "a thing of the past" in its dissolving into the

360-degree shots practiced in contemporary postcinema and virtual immersive environments (which seem to promise the elimination of the off-screen for the benefit of a total grip on the real), it would be very hard to argue that it is from such a dissolution that—ever melancholically or mournfully—we would begin to reflect on the theoretical status of the cinematic frame, the first omnidirectional cameras date from the 1990s,[59] thus far later than intense theorizing about filmic *framing*.

Yet looking closer, there are perhaps reasons to believe that it is possible to apply the same line of argument in the case of cinema, too. If we accept—as I think we should—the hypothesis that 3-D[60] (fig. 6.7) is a technical apparatus that is a precursor of 360-degree virtual immersive environments (by virtue of the strategy of "environmentalizing" the image and the strong presence effect that they share), and if we accept—as I think we should—Thomas Elsaesser's proposal to attempt "an alternative genealogy of cinema," looking at the history of cinema not as a slow and fitful evolution from 2-D to 3-D, but as a history in which "3-D actually preceded 2-D," then "the return of 3-D would reveal that 3-D has never gone away. On the contrary, in different mutations it has been the *basso continuo* accompanying the cinema throughout the twentieth century."[61]

Cinema was born as a dream of total representation, that is to say, as a dream of its own elimination as a representational medium, as an "image-of" consubstantial with framing.[62] From this perspective, all reflection on framing should be considered as a reflection on "a thing of the past" *from the very beginning*.

It is certainly no coincidence that it was a great framing theorist such as Eisenstein who became interested in 3-D. The Soviet director was not alone in this. In the same years that he was writing about the stereokino, the notion of "total cinema" was being theorized in France. In his collection of articles entitled *Cinéma Total*, published in 1944, René Barjavel asserts that every advance of the seventh art "allows it to come closer and closer to the real, to the point of perfect illusion."[63] It is worth repeating a few passages from this book,

Figure 6.7. Sharks jump out of the screen as a man watches a 3-D film, 2011 (photo: © PBWPIX/Alamy/IPA Images).

which it would not be an exaggeration to call prophetic because of its explicit reference to the advent of the *image virtuelle*. The article "Cinema in Relief," commenting on the Lumières' striving toward stereoscopic three-dimensionality and especially on potential later developments, looks forward to seeing the overcoming of the flat medium of film and a movement toward a medium capable of offering a full volumetric effect: "It will be necessary to transform the images of real objects directly into waves, then these waves into virtual images [*images virtuelles*]. These images will be materialized without the screen or in the frame of a voluminous and transparent screen, perhaps even immaterial, consisting, also, of a beam of waves."[64]

Virtuality passes through an effort to transparentize the medium, and the screen itself, along with the frame, must be negated. The article "Cinema and the Waves" (which foreshadows a time when we will be equipped with receiving devices with meters capable of recording our consumption of wavelengths and their respective film rights) describes the new viewer of virtual images thus:

> At home, the total cinema, captive for an instant to the receiver device and its screen, will escape to stroll through the apartment. The bourgeois gentleman, well satiated with his meal, sunk in his armchair, will project the virtual image at his feet, on the carpet, or near the table, or somewhere in space, between the parquet floor and the ceiling. One too many turns of the knob, a whim of the device, and the image, crossing the walls, will go strolling through the neighborhood.[65]

It does not seem far-fetched to juxtapose this characterization of the bourgeois gentleman grappling with virtual images "between the parquet floor and the ceiling" with the client of the Ikea Place app (available for smartphones since 2017), which allows the user to position 3-D augmented reality digital images of furniture from the Swedish company's catalog in the space of his or her home so as to see how they might look once ensconced there. From here to the professional user of augmented reality devices such as the Microsoft HoloLens 2,[66] the step is short.

As Barjavel continues, he expands the line of reflection around the transformations of the ways in which images are distributed and consumed (that Paul Valéry already had inaugurated in 1928) in a short text entitled "The Conquest of Ubiquity":

> It will be possible to send anywhere or to re-create anywhere a system of sensations, or more precisely a system of stimuli, provoked by some object or event in any given place. Works of art will acquire a kind of ubiquity.... Just as water, gas, and electricity are brought into our houses from far off to satisfy our needs in response to a minimal effort, so we shall be supplied with visual or auditory images, which will appear and disappear at the simple movement of the hand, hardly more than a sign.[67]

For his part, writing in the same period as Eisenstein and Barjavel, André Bazin, albeit in different tones and for different purposes, in his article "The Myth of Total Cinema," spoke of the "reconstruction of a perfect illusion of the outside world in sound, color, and relief" as the original founding myth of cinema itself, of its dream of "integral realism." In this sense, any advance in film technique that proceeds toward the progressive fulfillment of that inaugural desire only reactualizes that mythical *incipit*: "Every new development added to the cinema must, paradoxically, take it nearer and nearer to its origins. In short, cinema has not yet been invented!"[68]

Morel Reloaded

In the following years, Bazin would in fact devote special attention to 3-D technologies and large formats such as the three-screen, three-projector synchronized Polyvision pioneered by Abel Gance for his *Napoléon* (1927), the Cinerama (also a three-projector system that made its public debut in 1952) and the Cinemascope (an anamorphic lens system introduced in 1953).[69]

Giving credence to the legend of the spectators' flight in front of the Lumières' train, Bazin interprets it as a historically determined correlation between a certain degree of technological advance in the illusionistic representation of movement and depth and the level of

habitual perception on the part of the spectator community. By the 1950s, tolerance of that kind of shot was well established, and no one would panic at such scenes anymore. But the advent of the extralarge screens of Cinerama and Cinemascope may revive that effect on a new scale.[70] An observation that comes back to the correspondence that we have on more than one occasion emphasized from the perspective of an archaeology of media: immersive representational technologies cannot be compared in the abstract, disregarding the historical context that binds a certain type of spectatorship to the techniques available in a given era.

In the mid-1950s, an attentive and knowledgeable observer such as Bazin seems to have no doubts about the developments that the future holds. Because of the discomfort caused by the need to wear anaglyphic glasses, the two interruptions required to recharge the two projectors that must work simultaneously, and the resistance of distributors, Bazin records "the complete failure of stereoscopic relief."[71] This failure also plagues directors such as Hitchcock: "Technologically, the balance sheet of the entire '3D' operation is largely negative,"[72] since the quality of the projection and of the image itself often turns out to be inferior to what could be achieved in earlier films made with more traditional equipment.

What is of particular interest to us is that at that time, Bazin tends to favor the potential of the megascreen over the effects of 3-D, even foreshadowing a time when film production will be forced to choose one of the two options to the exclusion of the other:

> There will likely be a choice made between binocular stereovision and the widescreen; it would be truly shocking if these two processes could maintain themselves simultaneously.... Insofar as prognostics can express an idea in an area where the favor of the public comes into play, for my part I would gladly put more trust in widescreen than in 3D, precisely because it seems to me that its aesthetic resources are superior.[73]

In the light of the technological developments of the second half of the twentieth century and the first decades of the twenty-first

century, we may well say that not only did Bazin's prediction not come true, but that on the contrary, it was precisely that convergence between two devices that took place: the panoramic screen and stereoscopic vision, which would eventually meet in virtual reality headsets. Here, as we will see more fully in the last chapter, the screen is certainly not the large format investigated by Bazin, but the phenomenological effect of 360-degree vision ensures an unprecedented panoramic effect, together with a novel impression of depth.

While, mutatis mutandis, Eisenstein, Barjavel, and Bazin reason in terms of an increasingly realistic illusionistic representation, their horizon of reflection is at the same time preceded in time and overtaken in radicality by the Argentine writer Adolfo Bioy Casares, who as early as 1940, in his novel *La invención de Morel*, had gone so far as to imagine a machine capable not only of recording reality in all its multisensory aspects, but also of reproducing it indefinitely. And of reproducing it without necessarily implying a human being as its recipient.... Indeed, in the stated intentions of its inventor, this apparatus, placed on a desert island, should on the contrary have operated in a perfect absence of human spectatorship, as an assemblage of natural and mechanical forces: "The regularity of the lunar tides and the frequency of the meteorological tides assure an almost constant supply of motive power. The reefs are a vast system to wall out trespassers.... The light is clear but not dazzling — and makes it possible to preserve the images with little or no waste."[74] Bioy Casares thus eliminates the framing of the image and its phenomenological experience in a single move: if the image, ceasing to be cropped in the real, comes to coincide with it exactly, there is no longer the need for any spectatorial structure nor for any act of image consciousness.

Only the chance shipwreck of a fugitive who has escaped from jail allows a human eye from outside the media bubble painstakingly constructed by Morel to land on the island. This eye, at first hesitant for fear of being discovered and handed back to the prison authorities, surreptitiously scrutinizes the lives of a group of friends, men and women whom Morel has gathered on the island for a vacation

of cliff walks, swimming in the pool, elegant parties, card games, and scintillating conversation. Growing gradually more confident, the runaway becomes infatuated with and then falls madly in love with a woman in the group, Faustine. He sets up flower beds for her and leaves clues to his presence along her customary walks, but the woman does not seem to notice him and his gifts. Nor do the other members of the group, totally oblivious to his presence. Slowly but surely, the fugitive realizes that his gaze is not reciprocated in a mutual interchange, that is, he gradually acquires an image consciousness.

In a still from the film of the same name that Emidio Greco made from the novel in 1974,[75] we see a moment in that process. The fugitive (Giulio Brogi) is present, yet unseen as he watches, along with another bystander, a card game between Faustine (Anna Karina) and three guests (fig. 6.8). From our perceptual point of view, only the incongruence between the castaway's dirty, tattered clothes and the card players' elegant 1920s-style outfits signals a separateness in what would otherwise appear as a seamless homogeneous environment.

During a visit to the mansion, the castaway catches Morel in the act of reading a programmatic and at the same time explanatory statement to his own guests: photography, the cinema, television, on the one hand, radio telephones, the phonograph, and the telephone, on the other, so the inventor explains, to cancel absence in space and time only as far as concerns sight and hearing. Instead, his project aims at recording and reproducing the full range of sensory channels, such as tastes, tactile waves, olfactory waves (think of the Odorama and AromaRama experiments dating back to the 1950s). And, finally, of consciousness itself: "When all the senses are synchronized, the soul emerges. That was to be expected. When Madeleine existed for the senses of sight, hearing, taste, smell, and touch, Madeleine herself was actually there."[76]

The series of events the castaway is thus witnessing consists of not just an audiovisual, but an integral playback of a vacation recorded years earlier and reproduced in loop. The subjects participating in

Figure 6.8. Film still from *Morel's Invention*, 1974, directed by Emidio Greco (© 2012 Estate of Emidio Greco; photo: VIGGO Srl/Foto Alga Cinematografica/Mount Street Film/Kobal/Shutterstock).

the vacation are long dead; indeed, it was that peculiar recording that killed them, immortalizing them for eternity. The only hope for the castaway to join Faustine is to record himself in turn (and thus die) in order to enter the image. But who will manage the montage of the two different recordings so as to enable such a reunion? "To the person who reads this diary and then invents a machine that can assemble disjoined presences, I make this request: Find Faustine and me, let me enter the heaven of her consciousness. It will be an act of piety."[77]

The most radical version of this first-person somatic empathizing has been envisioned by films that take as their theme a *brain-computer interface* capable of recording sensations and emotions experienced by one individual and replicating them in playback so that a different person can see and feel another's experience integrally, as if he or she were experiencing it firsthand. For example, this is the case with the recorder developed by scientists Lillian Reynolds (Louise Fletcher) and Michael Brace (Christopher Walken) in *Brainstorm* (directed by Douglas Trumbull after an original idea of Bruce Joel Rubin, 1983), which allows one to reproduce another's experience "like you were there. Taste, smell, everything." During a heart attack that will prove fatal to her, Lillian records her own psychophysiological reactions and the transition from life to death. Michael will be able to relive this extreme experience only by deactivating the parameters of heart and respiratory function. Otherwise, he will die of the same attack.[78]

In *Strange Days* (1995), the science fiction thriller written by James Cameron and Jay Cocks and directed by Kathryn Bigelow, the story revolves around the SQUID, an illegal head-mounted device capable of recording on a MiniDisc-like support memories and physical sensations directly from the cerebral cortex of the subject wearing it during the actual experience (fig. 6.9). The device subsequently allows playback, a possibility that fuels a black market, as lucrative as it is vile, in scenes of violence, rape, sex and murder.[79]

More recently, the Netflix series *Black Mirror* has taken up and

Figure 6.9. Film still from *Strange Days*, 1995, directed by Kathryn Bigelow (photo: © Photo 12 / Alamy / IPA Images).

revived the motif, updating it to the level of bionanotechnology. In the third episode of the first series "The Entire History of You" (2011, written by Jesse Armstrong and directed by Brian Welsh), a tiny implant (called a grain) inserted behind the ear allows one to record experiences and replay memories by projecting them on a screen or by viewing them directly through one's own eyes.[80]

Figure 7.1. BeAnotherLab, *The Machine to Be Another*, 2013, FabLab, Barcelona (courtesy BeAnotherLab).

CHAPTER SEVEN

Empathy Machine?

VR as an Empathic Catalyst
Giving a name to "Expanded Cinema" back in the 1970s, Gene Youngblood characterized it as "synesthetic" and capable of triggering "kinetic empathy."[1] Contemporary immersive virtual environments — partly due to the integration of immersive audio[2] and haptic,[3] olfactory, and gustatory[4] stimuli — seem to fit squarely with this characterization, carrying our multimodal and multisensory engagement with images to the highest degree technologically feasible today.

Considered from the point of view of its mode of operation — consisting in the interplay between a technical apparatus and the correlating ideological discourses — virtual reality clearly presents itself as a catalyst for empathy in the sense of the ability to put oneself in the other's shoes, to decenter oneself by assuming the other's perspective, to promote a prosocial disposition. Noteworthy in this regard is The Machine to Be Another (TMBA), a VR application project initiated by BeAnotherLab in Barcelona in 2012 and constantly nourished by an open community of scientists, artists, performers, and participants. The aim is to reduce the impact of various types of social biases (gender, ethnic, generational, hierarchical...) through the method of *embodiment virtual reality* (EVR) combined with the experience of *body transfer illusion*. The system allows users to perceive themselves

inside a body other than their own and to interact with other individuals not only audiovisually, but also through haptic feedback. In one of the experiments designed by the group, two users of different sexes sit with their backs to each other (fig. 7.1); they wear virtual reality headsets connected to a camera that transmits to each the other's subjective field of view. Agreeing on gestures to be performed simultaneously, they explore the other's body, first clothed and then naked — an attempt at "gender and body swap": "Our intention was to promote mutual respect and understanding through an embodied exchange of perspectives, to critically reflect on consensus and to address gender inequalities."[5]

From a rich array of research that has developed in recent years in the field of cognitive neuroscience and experimental psychology, we know that this possibility of empathic perspective-taking is also verified in the case where the body that we are invited to identify with is that of a digital other, an avatar, for example, stepping into the shoes of a black avatar if we are white promises to reduce our implicit racial bias.[6]

It is a promise that transcends the boundaries of science labs to the sphere of art and media and explains the recent conversion of no few artists and filmmakers to VR. When asked why she made her "VR turn" on the occasion of making the documentary *The Protector: Walk in the Ranger's Shoes* (released in 2017 and dedicated to the rangers of Garamba National Park in the Democratic Republic of Congo whose task is to defend elephants from poachers), Kathryn Bigelow responded without hesitation, "I think that the simple answer is empathy."[7] For the humanitarian implications of his works Ai Weiwei has often referred to empathy, in Chinese, "*tongqing* 同情. It means you share feeling or emotion with another person."[8] His work in VR *Omni* (2017) — a combination of two videos, *Displaced Working Elephants in Myanmar* and *Rohingya Refugees in Bangladesh* — "gives viewers an intimate view of the uprooted, both animals and humans, as they experience various forms of displacement,"[9] allowing viewers to put themselves in the shoes of both animals and refugees, presented as sharing the same fate.

This trend is most evident in contemporary practices of so-called *immersive journalism*.¹⁰ In motivating his shift from directing video clips to making documentaries in VR in collaboration with the United Nations, Milk resorted to the ultimate formula of virtual reality as "the ultimate empathy machine," capable of transporting the viewer inside the "frame" of the story and inducing "more visceral emotional reactions": "I don't want you in the frame, I don't want you in the window, I want you *through* the window, I want you on the other side, in the world, inhabiting the world."¹¹ The medium that enables this transition is VR, conceived as an "experiential medium" that can make you "feel your way inside of it." It is a machine, but it also "feels like real life, it feels like truth": in *Clouds over Sidra* (2015), the truth of the life of Sidra, a twelve-year-old Syrian girl in a refugee camp in Jordan; in *Waves of Grace* (2015), the truth of Decontee Davis, a twenty-three-year-old Liberian woman who survived the Ebola epidemic; in *My Mother's Wing* (2016), the truth of the mother who lost her two children in Gaza.¹²

Using recording technology that combines 3-D footage and binaural microphones, Milk achieves what might be called an "environmentalization" of the image, that is, an iconic 360-degree landscape in which the viewer is fully immersed in the feeling of "being there." You do not look at Sidra through a screen or a window; you sit there with her, "you empathize with her in a deeper way." Milk seems implicitly to be arguing that virtual immersive environments allow us to move beyond that centuries-old tradition of Alberti's window mentioned in Chapter 4, which considers our image experience identical to the practice of standing at a window, contemplating the portion of the world that is seen through the frame, along with the actions of the *historia* that take place there. In contrast, in a 360-degree iconic environment, there seem to be no windows: the possibility of directing the gaze in any direction without the flow of images ever coming to a halt would allow the emancipation of the viewer from the "director's cut." The frame comes to coincide with the visual field of the percipient, who can actively select which portion of the landscape to focus on.

Milk is decidedly optimistic about the anthropological, biopolitical, and humanitarian potential of this kind of immersive approach: "We can change minds with this machine"—presenting, for example, his films in VR at the World Economic Forum in Davos (January 2015) and thus affecting people whose decisions can in turn affect the lives of millions of others. It is within this framework that his collaboration with the United Nations should be placed.[13] In Milk's view, this would be only the beginning of a process of discovering the "true power of virtual reality," the power to transform the individual's perceptions of other people and ultimately to change the world.

Alejandro G. Iñárritu espoused a very similar argument about his shift to VR when making the installation *Carne y Arena: Virtually Present, Physically Invisible*, which premiered in 2017 at the Cannes Film Festival[14] and was then fully staged at the Fondazione Prada in Milan (which coproduced it) from June 7, 2017 to January 15, 2018, an immersive environment that transports you to the desert amid a group of South American migrants who are caught by the US Border Patrol trying to cross the border illegally.

To see it, or rather to experience it, you make a reservation on the website, enter at the appointed time into a preparatory antechamber, a cold room bringing to mind *las hieleras*, the "iceboxes," as the first reception cells of migrants taken prisoner by border guards are called. On the floor, shoes and slippers (what's left of them) lost by the desperate. You have to take off your socks and shoes, leave them in a locker, stand barefoot on the freezing floor. At last the signal interrupts your uneasy waiting. You open a heavy metal door, enter, and find yourself in a dark room, your feet on sand (coarse-grained and rough, not the fine-grained kind that would caress you. It is a contemporary version of Giulio Romano's cobblestone floor in the Chamber of the Giants in Palazzo Te in Mantua, discussed in Chapter 4). Two assistants greet you to equip you with what you need, an Oculus Rift, a pair of headsets, and a backpack. You are ready to enter a nightmare.

I said "to see it, or rather to experience it." "To see" is already an inappropriate term when talking of a film. You watch it and you

listen to it, it is audiovisual. But here, the sand underfoot and the wind add the tactile dimension. And at certain moments, you also imagine the smells of the desert, the shrubs, the wild animals. The sweat of fatigue and fear. The heavy breath of fugitives and policemen who have not slept. Smells in *Carne y Arena* are not to be perceived yet but they will come. In a month, in a year (in fact, they are already available in some devices).[15]

Carne y Arena has a subtitle, *Virtually Present, Physically Invisible*. In its double meaning, this subtitle clarifies respectively the virtues and limitations of Iñárritu's installation.

Virtually Present: you are transported to the middle of the desert, among men, women, and children attempting the journey of hope. You move with them. You not only have them in front of you, but also beside you, and you feel them behind you if you turn around. You explore a wild space fraught with pitfalls in the uncertain nocturnal light. Above you, ominous, a helicopter, with its intrusive beam, its spotlight pinning you down. The frenzied yelling of the border guards, the shotguns pointing at you. The field of view, fully saturated as in normal vision, seals you hermetically into the media environment. There are no edges, no frames whatsoever against which to distinguish an in-image and an out-image. The feeling of presence, of "being there," is very intense.

Physically Invisible: you are present, but no one sees you. Not the migrants with whom you walk. Not the policemen, who seem to be shouting at you, shining flashlights at you, threatening you with their rifles. And you are invisible even to yourself. If you look at your feet, which you also feel in the sand, you do not see them. If you extend a hand in front of your eyes, nothing appears in your field of vision. You then get the urge to make yourself noticed, to make it clear that you are there (after all, you are fully "present"). And since no one sees you, you reach out to those bodies with your own body, to touch them, to make contact with them. A need for pressing presence, for social recognition, which nevertheless shatters against the limits of the device, and virtual bodies "explode" upon encounter, transforming into a beating heart.

In an interview with Jenna Pirog for the Phillips Collection in 2018 on the occasion of the Washington showing, Iñárritu explicitly states that compassion is the feeling his VR installation is designed to evoke.[16] Rejecting any form of activism or political engagement and declaring himself concerned solely and exclusively with humanity, the director explains that the installation's script, based on interviews with more than one hundred and twenty migrants, is geared toward allowing the viewer to share their experience sensorially and emotionally. This *sharing*, however, is not intended in the way we habitually (and superficially) conceive it in our hyperconnected world of digital devices and social networks. Iñárritu calls for a personal sharing experience that comes to be established between the user (sealed in the virtual reality headset that isolates her from her *Umwelt*) and the migrants, and not a sharing between the user and other users. The viewers of *Carne y Arena* are in fact made to leave their cell phones at the entrance and are thus prevented from sharing their experience in real time during the six and a half minutes of the installation.

A migrant himself, Iñárritu said on various occasions that he felt compelled to make this film in VR as a reaction to a general "deficit of compassion" — a statement that significantly echoes Barack Obama's famous "empathy deficit" speech delivered in 2006 before students at Northwestern University.[17] In the abovementioned interview, Iñárritu invites Donald Trump and all politicians who make decisions about immigrants to at least understand and experience what they go through. Thus, *Carne y Arena* is intended to operate as a compassion machine, putting people in the shoes of others. And it is a compassion machine precisely because it is able "to break the dictatorship of the frame."[18]

The End of the Other
The cases mentioned above should, of course, be carefully examined in their specific characteristics. To mention only one aspect, while the VR videos of Bigelow, Ai Weiwei, and Milk are also freely

accessible via 2-D screen on the sites I mentioned in the footnotes, Iñárritu's installation involves a complex protocol that begins with booking the visit on the website and unfolds in a passage through different spaces, of which the specifically VR moment is only one segment. Also different is the approach to the user's so-called "degrees of freedom." In the case of the first group, one can rotate one's gaze 360 degrees, but translational motion is not included, whereas *Carne y Arena* permits this, allowing the user to move closer to or farther away from the migrants and the guards.

Here, however, I must overlook these (by no means marginal) differences in order to focus instead on an element common to these works of humanitarian engagement, namely, the fact that the ideological orientation of the empathic catalyst contrasts significantly with the supposed emancipation from the dictatorship of the frame afforded by 360-degree recording. On the one hand, this type of recording offers the perceptual possibility for the viewer to choose his or her own viewing angle in a first-person perspective. This seems to function in an emancipatory way, freeing the viewer as much from the framing of the window that would cut off the visual field as from the imposition of the camera's gaze (and the authorial gaze embedded in it).[19] From an ontological perspective, there is a peculiar hybridization of *object* and *event*: where every individual experience (or of the same individual at different times) of an object in VR "eventializes" it, makes of it an event, actualizing its potential in different ways.[20]

On the other hand, the gaze of the user thus emancipated finds itself ensnared in a powerful predetermined emotional and ideological framework and is invited to reproduce mimetically the sympathetic gaze of the machine. This contradiction turns out to be governed by a relationship of direct proportionality: the more freely you feel that you can decide your personal perspective, the stronger the ideological conditioning surreptitiously operates. You end up following, obediently, what you think you determine independently.

This condition appears to depend closely on the very nature of the medium employed, a medium that tends to undermine at its

foundations the traditional experiential structure of image reception. In a virtual immersive environment, the viewer's ability to distinguish between the medium and the image appearing in it and at the same time to be able to grasp both aspects — the "twofoldness" described by Richard Wollheim as constitutive of image experience[21] — is diluted in favor of a progressive confusion between image experience and experience tout court.[22]

This is not, of course, to celebrate the end of the medium, as Lev Manovich shows himself to mean when he states, "With VR, the screen disappears altogether."[23] Just as the frame does not disappear, the screen does not disappear. Rather, our ability to thematize it is systematically and progressively weakened and stripped of power. Translated into phenomenological terms, *Perzeption* as the kind of perception proper to image consciousness (perception that does not posit its object as actually existing) gives way to *Wahrnehmung* (literally, to "taking for real") as the kind of perception aimed at grasping things in the flesh.[24] This medium tends to deny its own existence on the basis of what has been called the logic of "transparent immediacy,"[25] an apparent immediacy of the immersive medium achieved — paradoxically — by means of highly sophisticated technological mediation.

In such an effect of transparency, by virtue of which users become progressively less and less aware of the mediated and constructed nature of the perceived scene, their awareness of the point of view (perceptual as much as ideological) expressed by the filmmaker and embedded in the gaze of the camera also tends to blur until it dissolves. While we are convinced that we are autonomously controlling the framing, we are being framed by and in the discourse of the author.

But that is not all. This weakening of our awareness of the mediated and opaque character of the immersive apparatus in VR is accompanied by a further risk implied in the rhetoric of virtual empathy, that is, the risk associated with believing that one can have direct access to the other in his otherness without recognizing it in its irreducibility (a necessary condition for an authentically empathic

experience, which does not involve any fusion or confusion between me and the other).²⁶

In the absence of feedback and reciprocal interaction in dialogue, empathic "perspective taking,"²⁷ in the sense of a decentering of the self in order to assume the other's point of view ends up becoming reinforced in the absent presence (or, which is basically the same, in the present absence) of the other represented virtually. In the immersive environment I feel "there" with the other, but the gaze he returns to me is blind, while the gaze I fix on him is the one-sided gaze of the voyeur in a "dark tourism" setting. There is no mutual recognition.

Once again, this aspect is intimately related to the nature of the immersive apparatus. Shooting with 360-degree cameras seems not only to promise (without of course ever being able to guarantee it) a free and "total" exploration of the space captured by the recording, as if there were no longer an out-of-field (in any of the six possible senses of this term described in his time by Noël Burch).²⁸ But also promising (without, of course, ever being able to guarantee it) a progressive gain in knowledge and introspection of the people, or rather the characters, who inhabit that space.

In other words, the 360-degrees becomes a "figure in the round," both in the sense of the topological totality of filmic space (which is presented as coinciding with real space) and in the sense of the completeness of interpersonal experience, an unframing that is as much perceptual as it is relational. However, that totality and completeness are "frozen." The Sidra and Decontee of Milk, as well as the gestures of Iñarritu's migrants, who are thus the "interlocutors" supposedly taking part in our conversation, and the spaces in which they are placed, have been *recorded* by the filmmakers and their technicians. What Barthes called the "that-has-been" of photography (its "noeme," the "aorist" that expresses its specific time)²⁹ must also be considered constitutive characteristics of 360-degree recording.

With all due respect to "being there" as an effect produced by the immersive environment and the possibility of exploring

space in different directions and from potentially infinite angles each time I access the film in VR, I will never be able either to transcend or to change the center of recording of the 360-degree camera or gain a different form of access to the subjective, emotional, and existential life of the people I encounter in that world. This would be possible only in the context of an effectively intersubjective, that is, precisely, empathic relationship, which would allow me to become progressively more aware of the other in his or her thoughts, feelings, motivations, intentions as his or her "interiority" manifests itself to me and mine to the other—progressively, yes, but never totally, and always potentially exposed to the risk of misunderstanding and misinterpretation—in our mutual social interaction.

The otherness of the other is thus obliterated in two respects, that is, as the otherness of the filmmaker embedded in the camera gaze and as the otherness of the person represented in the VR installation. The 360-degree "autopsy" (in the etymological sense of *autos optos*: "I saw it with my own eyes") embodied in the first-person perspective and the powerful sensation of "being there" granted by the technological apparatus approximate "autopsy" in the sense of a postmortem examination. On the one hand, the author's intentions embodied in the filmmaker's gaze tend to disappear phantasmagorically as a result of the transparentization of the medium, leaving behind the stiffened corpse of "reality" in its mere factuality. On the other hand, the other embodied in the collocutor is apparently mobile and animated, but such mobility, frozen in the recording, resembles that of a puppet that cannot respond to my further exchanges.

How literally this postmortem condition should be taken is demonstrated by the VR documentary *Meeting You*, produced by the South Korean Munhwa Broadcasting Corporation in 2020. In a simulated virtual reality environment, a mother, Jang Ji-sung, equipped with a headset and haptic gloves, meets her little daughter Nayeon, who passed away in 2016 from an incurable disease when she was only seven years old.[30]

Immersive VR environments that set themselves humanitarian purposes (such as those considered in the preceding pages) turn out to be polarized between these two extremes. On the one hand, they are structured in such a way as to encourage the assumption of a first-person perspective combined with a strong sense of presence, as if the user has repositioned herself in the virtual body of the collocutor so as to look at the world from her point of view. On the other hand, due to the "frozen" condition of the collocutor, such environments suggest a mimetic mirroring of the emotional and experiential patterns embalmed, so to speak, in the virtual storytelling, which is driven from the outset by the gaze of the machine (and the director embodied in it).

Finally, a decisive point should not be overlooked: in identifying VR as an empathic catalyst, an approach such as that advocated by Bigelow, Ai Weiwei, Milk, and Iñárritu evidently adopts a very narrow meaning of "empathy," a concept with a very complex and problematic semantic spectrum that in these cases is made to coincide exclusively with a prosocial inclination toward compassion for people suffering and in need of help and ultimately identified with a generically humanitarian sympathy for the weak, the poor, the outcast.[31] Whereas, to make but one counterexample, it could be observed that even the sadist needs to be capable of empathy in order to know where to hurt his victim most effectively.[32]

The Caveat of the Bat

The limitations I have pointed out in the use of VR for the fostering of interhuman empathy find an interesting counterpoint in the use of the same technology for interspecific empathy experiences, that is, between human beings and other animal species.

A particularly significant case in point is the ability to identify with a bird. The fascination exerted by the ability to fly (one of the oldest human desires, as attested by the myth of Icarus and his multiple reincarnations)[33] has encouraged over the centuries an identification of human beings with flying animal creatures. Humans

have desperately tried to put themselves in the shoes (or rather the wings) of birds.

Not surprisingly, echoes of such attempts have reverberated over the centuries in the history of visual arts, and more generally in the history of images, in relation to the so-called "bird's eye view," a view of an object or landscape taken from an elevated position, just as if the observer were a bird. This is a type of perspective that is frequently employed in the creation of maps, charts, and plans for both natural and urban spaces. Particularly significant examples are the *Bird's Eye View of a Coast*, made around 1515 by Leonardo da Vinci, and Jan Micker's *Bird's Eye View of Amsterdam*, dating from around 1652. This type of view is complementary to the opposite perspective of the *di sotto in su* (as Italian art history terminology defines it), which in English is called "worm's eye view" and in German *Froschperspektive* (the view of the scene from a frog's point of view).

It is difficult to establish the precise origin of the representational genre of the aerial view. According to some hypotheses, it could even be traced back to very archaic modes of topographic rendering such as that attested, for example, by the petroglyphs located north of Prescott, Arizona, and attributed to the Hohokam people.[34] What is certain is that a progressively increasing drive in the use of aerial views is clearly recognizable in the early modern age,[35] beginning with the military use of balloons in the Napoleonic and Franco-Prussian Wars and ending with the use of aircraft,[36] satellites, and drones[37] in recent times. Not surprisingly, many aircraft models have been named after bird species, with a significant recurrence of hawks and falcons, such as the Nieuport Nighthawk fighter jet (1919), the Dassault Falcon business jet (1963), the Sikorsky UH-60 Black Hawk utility helicopter (1974), the Northrop Grumman RQ-4 Global Hawk surveillance drone (1998), the SpaceX Falcon 9 space rocket (2010), the TwoDots Falcon drone (2016), and the HawkEye microsatellites (2018). Of course, we should not omit from this list the Millennium Falcon, the famous spaceship from the *Star Wars* saga.

Although it is easy to recognize in the variety of these modes of aerial view a family resemblance traceable precisely to the class "views from above," it is important to emphasize the fact that in the era preceding machine-assisted human flight, the term "bird's-eye view" designates an *imaginary* point of view, which is distinct from the mere elevated viewpoint (e.g., from a tower or mountaintop) that allows actual, direct observation from above. In the bird's-eye perspective, humans have attempted to transpose themselves imaginatively into a point of view secured to a nonhuman body endowed with nonhuman motor skills, that is, they have operated an extraspecific *perspective taking*.

The link between the purely imagined bird's-eye view and actual aerial photography or filming (carried out by manned or unmanned aircraft) could be identified in experiments such as those practiced by Julius Neubronner, who patented his aerial photography with carrier pigeons (*Brieftaubenphotographie*) in 1907. Neubronner designed a camera that could be secured to the body of a pigeon and was able to take photographs automatically during the animal's flight.[38] This animal-machine combination was employed in both World War I and World War II for aerial reconnaissance. The CIA would continue such surveillance experiments with pigeon photographers until the 1970s, and "details of pigeon missions are still classified."[39] The integration of animal flight and the machine eye adopted by Neubronner can be seen as a precursor to recent visual practices, such as Dubai's world record eagle flight, set in 2015 as the highest record for bird flight from a man-made structure. Darshan, a male imperial eagle equipped with a camera strapped to its back, made a majestic 830-meter descent from the top of the Burj Khalifa skyscraper to the arm of its trainer, falconer Jacques-Olivier Travers.

From the perspective of the phenomenology of perception, however, the human's imaginative adoption of the bird's eye perspective raises several problems. In a famous article published in 1974, Thomas Nagel asks, "What is it like to be a bat?" Is it ever possible for a human being to understand the experiential world of these fascinating

creatures? His answer was unequivocally negative. Nagel focuses on the notion of the "subjective character of the experience" as the hallmark of consciousness itself, its *pour-soi*. This *"pour-soi"* — the *for-oneself* of experience in the phenomenological sense — is precisely the pivot around which Nagel's argument revolves.

The intuitive example of the bat furnishes Nagel with a revealing case study. The foreign (to us) character of such a creature is clearly illustrated by a comparative description of the function of localization (by which we discriminate size, distance, shape, motion, and texture of objects in space) as performed by bats and humans. While the latter locate objects primarily through the sense of sight, the former (particularly the suborder of microbats) rely on sonar and emit high-frequency sound pulses and identify objects by measuring the return of the sound waves they reflect. The type of localization that is peculiar to them is echolocation: "But bat sonar, though clearly a form of perception, is not similar in its operation to any sense that we possess, and there is no reason to suppose that it is subjectively like anything we can experience or imagine. This appears to create difficulties for the notion of what it is like to be a bat."[40]

The qualification of subjective in the expression "subjective character of the experience" thus does not refer to the individual aspect of experience (experienced by this particular bat or this particular human being), but rather to the species-specific access to experience itself, that is, to experience as experienced by bats or human beings insofar as they are different species of living beings.

Can we find a way to solve this difficulty, considering that as humans, we do not possess a sense comparable to that of bat sonar? The scientific explanation of the nervous, sensory, and motor systems of bats obviously does not offer us the bat "experience." An alternative route might be to resort to imagination where we might try to imagine what it would be like to have interdigital membranes that allow us to fly and a mouth suitable for catching insects, what it would be like to hang by our feet from the ceiling, even what the perception of the environment would be like by means of sound

reflection. However, Nagel objects, "In so far as I can imagine this (which is not very far), it tells me only what it would be like for *me* to behave as a bat behaves. But that is not the question. I want to know what it is like for a *bat* to be a bat."[41] However, the species-specific constitution of my human experience prevents me from even imagining what it would be like to be a bat.

No species can ever put itself in the shoes of other species. No perspective taking, no empathy, can ever be possible here. If we insist on taking a subjective (zoo)phenomenological perspective (in the sense specified above, that is, in the *specific* sense), the transcendence of interspecies barriers is precluded.

Although bats, as is well known, are not birds but mammals, for our purposes here, Nagel's main argument can be extended to any animal capable of autonomous flight. Since humans do not enjoy such an ability, they will never be in a position truly to understand from a phenomenological point of view what it means to be a flying animal. The very expression "bird's eye view," therefore, from which we have taken our starting point, would constitute a fundamental fallacy: humans will never be able to understand what it means to see the world as birds see it.

Soap Bubbles

The *subjective* question in zoophenomenology was certainly not initiated by Nagel. In the early twentieth century, Jakob von Uexküll launched a research program centered on the idea of a "subjective biology [*subjektive Biologie*]"[42] in the dual sense of a science elaborated by subjects who engage in the study of other subjects. In his monadological conception (with a Leibnizian flavor), each species appears to be locked within its own perceptual possibilities as if in a soap bubble: "We may therefore picture all the animals around us, be they beetles, butterflies, flies, mosquitoes or dragonflies that people a meadow, enclosed within soap bubbles, which confine their visual space and contain all that is visible to them."[43]

The field of investigation of this subjective biology — which has

succeeded in attracting the attention of numerous philosophers, from Scheler to Peter Sloterdijk via Martin Heidegger, Cassirer, Gilles Deleuze, and Agamben—is the "inner world [*Innenwelt*]" of animals.[44] Building on Kant and the fundamental acquisition of the transcendental role of subjectivity in the constitution of experience while at the same time expanding his transcendental aesthetics essentially centered on the *Mensch*, on the human being in general, Uexküll initiates a process of multiplication of the a priori forms of space and time, the range of which eventually corresponds to the number of animal species.

Dependent on the constraints imposed by its structural plan (*Bauplan*), each organism is equipped with specific receptors that select the innumerable stimuli from the environment, taking in only the part that is significant to the organism. That part is then analyzed according to the nature of the receptors (the same light stimulus may produce chromatic effects in some animals, mere chiaroscuro or thermal effects in others) and finally transformed into nerve excitation.[45] Although different animal species cohabit in the same world, each of them will experience it as its own world environment (*Umwelt*, literally "surrounding world") in a specific way inaccessible to all others, as conditioned by its specific organization.

But the act of reception is only one side of the coin, the side that corresponds to the *Merkwelt* (the perceptual world, offered to the *Merken*, the noticing or heeding of something, of *Merkmale* as "perceptual marks" in the phenomenal field, an operation that is performed by the receptor organs). The other side consists of the *Wirkwelt* (the operational world, modified by the *Wirken*, by the action of the living being on its environment exerted through the effector organs).

The relationship between subject and *Umwelt* thus comes to take the form of a reciprocal action, which Uexküll refers to as a "functional cycle [*Funktionskreis*]."[46] It is a correlation in which the subject both gives and receives. After experiencing an effect caused by a certain perceptual mark, the animal exerts a countereffect on its environment. Subject-environment interaction amounts to a nonstop

interpretation of salient and relevant marks, both received and sent. The semiotic theory of sensation (already set forth by Hermann Lotze and Hermann von Helmholtz) is expanded in the direction of an ecological zoosemiotics.[47] In each animal, it is its specific *Bauplan* that ensures the possibility of perfect "adequacy" between receptor organs and perceptual marks, on the one hand, and between effector organs and operational marks on the other. The wasp encounters in its environment wasp things, the dog dog things. The dog does not sit in a chair, since the chair offers the human an opportunity to sit, not a canine (a specific *affordance*, to use James J. Gibson's terminology).[48]

Throughout his work as a zoologist, Uexküll fought against anthropocentric prejudices that prevent an adequate understanding of the animal world, starting with biological terminology. As a young scholar, in collaboration with colleagues Theodor Beer and Albrecht Bethe, he proposes introducing an "objective biological nomenclature"[49] that would replace, for example, sight and smell with the more neutral expressions of photoreception and stiboreception. His reflections on such issues would later lead him to the opposite solution in order to answer the same problem, that one cannot dream of arriving at objective neutrality. On the contrary, one must opt for a "subject-referenced" nomenclature, considered on a case-by-case basis and shaped according to the specific constitution of the animal, in recognition of the plurality of subjectivities and corresponding organizations.[50]

With this, Uexküll provided a solid biological basis for the non-anthropocentric transcendental perspectivism that had been vigorously proclaimed by Friedrich Nietzsche in the early 1870s: man "even has to make an effort to admit to himself that insects or birds perceive a quite different world from that of human beings, and that the question as to which of these two perceptions of the world is the more correct is quite meaningless, since this would require them to be measured by the criterion of the *correct perception*, i.e. by a *non-existent* criterion."[51]

Yet the anthropocentrism that Uexküll decisively chases out the

door seems to sneak back in through the window. If every animal, including humans, is a prisoner in its own soap bubble and there is no way for other animals to access it and for that animal to access bubbles foreign to its own, how could the fatal interaction between predator and prey ever occur? It is Nature itself that harmoniously embraces the perceptual and operational marks of different animal worlds, a Nature with a capital "N," which thus becomes a kind of meta-animal or immanent and omniscient deity that perceives all and knows all while individual species are bound to the limits imposed on them by the corresponding *Bauplan*. "How does Nature see itself?" wonders Uexküll, to answer thus, "It sees itself with infinite different eyes, of which each is placed at the center of a different world. Each world is perfectly enclosed by its horizon, and in each of them what is actually seen is also all that can be seen."[52]

However, it is difficult to escape the impression that at times Uexküll tends to make this synoptic and panoptic viewpoint equivalent to the zoologist's own viewpoint and ultimately with his own. That is, he seems to admit that the human being as the supreme animal somehow has access to the environment of a fly or a mollusk, whose specific "worldviews" are obtained through a progressive impoverishment of the photographic image — which is considered (very problematically) equivalent to human vision — through the use of screens and an effect that today we would call "pixelization."[53]

Thus, a peculiar tension is established between a strictly monadological and antianthropocentric approach (by virtue of which each animal species, including humans, experiences its own space-time and movement in a way that remains inaccessible to other species) and an anthropocentric temptation which allows human beings, thanks in part to technological prostheses such as the camera, to puncture their own soap bubble so as to go peek into the bubbles of other organisms, putting themselves in their experiential shoes.

Despite this oscillation, or perhaps because of it, Uexküll's merit remains uncontested: that of having placed at the heart of biological research the interactive relationship between organism and

environment to which Jean-Baptiste Lamarck had already drawn attention in the early nineteenth century and that would later find full development in contemporary biology through the theory of the ecological "niche."⁵⁴

Beyond the Threshold

The challenge formulated by Uexküll in its inherent paradoxicality — theorizing on the one hand a monadology of soap bubbles and on the other hand admitting the possibility of human beings peeking into the bubbles of other species — seems to have been picked up and given new life by technological media: first by cinema⁵⁵ and later by immersive virtual reality environments, in particular by the development of animal flight simulators. Let us consider three examples.

Aquila Bird Flight Simulator (developed by Graeme Scott) is a VR app launched in 2017. Originally designed for the Oculus Rift and later made available for OpenVR, *Aquila* offers the user the ability to switch between third-person and first-person perspectives. In third-person, the body of the flying eagle can be seen in its entirety, as if being perceived by another bird at its side. In first-person, the user assumes the viewpoint of the eagle itself. In this case, the ends of the wings can be perceived in the field of view. The presentation text of this simulation software reads thus, "Have you dreamed of what it would be... to soar like an eagle? *Aquila Bird Flight Simulator* lets you experience soaring bird flight using the Oculus Rift headset."⁵⁶

Eagle Flight is a VR simulation video game developed by Ubisoft and released for Microsoft Windows and PlayStation 4 in late 2016. Unlike *Aquila Bird Flight Simulator*, the only perspective granted here is the first-person perspective, but one can switch between single-player and multiplayer modes. The direction of flight is determined by the tilt of the user's head. So we read in the introduction to this simulator:

> Humans can't fly on their own in real life, but we can at least experience the sensation thanks to *Eagle Flight*. The first VR game to come out of Ubisoft's

Fun House studio, *Eagle Flight* lets you soar as an eagle above the streets of an abandoned Paris. Vegetation has overtaken its most popular monuments. Its human population has been replaced with all manner of creatures. But as it turns out, there's still plenty for an eagle to do.[57]

Immersive VR devices often induce in users so-called "cybersickness" (a syndrome including nausea, dizziness and lightheadedness, loss of balance, and blurred vision)[58] that is caused by the conflicting information provided to the brain by three different systems, the vestibular, the visual, and the proprioceptive. The subject is affected by a discrepancy between two conditions. The vestibular and proprioceptive systems confirm that the body is sitting and static, but the visual system registers that the body is not only moving, but is even flying over a rural or urban landscape. In order to reduce the unpleasant effects of this contradiction, Ubisoft adopted two strategies, the introduction of "blinkers" that reduce the field of view in the phase of intense movements and the insertion of the eagle's beak in the lower part of the field of view.[59] Acting as a partial avatar of the user's own body, the beak operates as a surrogate for the tip of the human nose, which is always included in our field of view, even though it is not routinely taken into consideration explicitly in standard perceptual life (and is indeed excluded from the field of view while I wear a headset during an immersive VR experience).

A further step in the field of bird flight simulation has been taken by Birdly, designed in 2013 by Max Rheiner, Fabian Troxler, and Thomas Tobler in the laboratories of Zürcher Hochschule der Kunst(ZHdK) and later developed by Somniacs. The official presentation describes it, no less, as a chance finally to fulfill "the Ultimate Dream of Flying": "For millennia, humans have longed to fly like a bird, to take to the sky, arms outstretched, with power and innate grace. While human biomechanics will never allow for unfettered flight, today's virtual reality (VR), coupled with robotics and simulation technology, can deliver an experience like never before ... fulfilling our ultimate dream of flying."[60]

Unlike other flight simulators, Birdly requires no joystick or mouse, but is directly controlled by a series of operations of the user's own body that include instinctive arm and hand movements in order to control speed, altitude, and direction of navigation. Inputs provided by the user's body, lying horizontally on a cross-shaped stand with arms spread like wings, are translated by a virtual flight processor and then returned in terms of physical feedback to the body itself. A fan placed in front of the user's face produces the sensation of wind, and surround sound broadcast from headphones built into the headset helps complete the reality effect of the flight experience as a whole (fig. 7.2). One can choose the "New York Experience" and fly through the skyscrapers of Manhattan, even meeting up with King Kong at the top of the Empire State Building, or opt for the prehistoric route and plunge like a pterosaur into "Jurassic Flight."

Birdly and other bird flight simulators appear to aim at achieving what Primo Levi imagined back in 1966 in his short story "Retirement Fund" exploring the various applications of the Torec (Total Recorder), a total recorder of experience (like the one employed in *Strange Days*) capable of making the wearer relive not only experiences of other human beings, but also that of a bird of prey snatching a hare.[61]

These attempts at virtual simulation should be considered in the broader context of an anti-anthropocentric aspiration, which seems to characterize in recent years not only the VR world, but more generally contemporary visual culture in different media domains. This aspiration has recently been designated as a *nonhuman* turn: "The nonhuman turn more generally, is engaged in decentering the human in favor of a turn toward and concern for the nonhuman, understood variously in terms of animals, affectivity, bodies, organic and geophysical systems, materiality, or technologies."[62]

In this context, of particular interest for our discussion is the specific attention paid to "nonhuman vision," to be understood not only as machinic/machine and prosthetic vision (offered, for example, by CCTV cameras, telescopes, microscopes, endoscopic instruments,

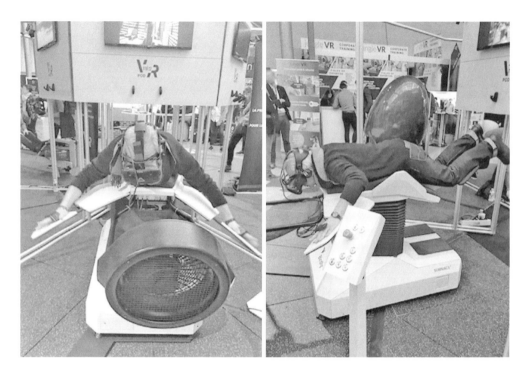

Figure 7.2. User experiencing the Birdly® flight simulator (Somniacs) during the presentation of the device at the Virtuality Summit, Paris, 2018 (photo: Giacomo Mercuriali).

satellites, drones...), but in a broader sense as a vision that conceives "the human as part of a complex assemblage of perception in which various organic and machinic agents come together — and apart — for functional, political, or aesthetic reasons."[63]

In this scenario, animal perception plays a prominent role. As the Other closest to the human being, the animal offers multiple possibilities for exploration that are investigated from the perspectives of both fiction and nonfiction. In the nonfiction genre, a noteworthy case is presented to us by the ethnographic documentary *Leviathan* (2012), directed by Lucien Castaing-Taylor and Verena Paravel. The filmmakers installed GoPro cameras on different bodies — of fishermen, of fish, of the ship — in the context of a trip by a fishing boat in the North Atlantic, thus restoring to us a polyprospectivity of human and nonhuman subjectivities.[64] YouTube hosts many compilations of GoPro videos recorded from the animal's point of view.

As far as the fiction genre is concerned, a very rich tradition to draw on is represented by those horror films in which animal viewpoints are employed to render theriomorphic perception:[65] *Empire of the Ants* (1977), a sci-fi horror film directed by Bert I. Gordon and loosely based on the short story of the same name by H. G. Wells, is particularly significant because it attempts to reproduce through a multiplication of the same percept the iterative vision characteristic of the compound eye of insects, consisting of a large number of small lenses. A similar approach inspired more recently the EYEsect project, developed in 2013 by Berlin-based artist collective The Constitute. Two independent video cameras installed on an Oculus Rift headset provide different visual information to the left and right eye, displacing the conventional stereoscopic field characteristic of human vision (fig. 7.3). "It allows users to take the perspective of a horse, chameleon or a totally out of body point of view," states Christian Zöllner, one of the members of the collective.[66]

A similar effort is made by those science fiction films that attempt to replicate the perception proper to alien life forms while at the same time making it paradoxically perceptible to human sense

Figure 7.3. The Constitute, EYEsect project, 2013, Berlin (photo: © The Constitute).

organs. Of all of them, the *Predator* saga is particularly interesting, starting in 1987 with the film, directed by John McTiernan, continued with *Predator 2* (1990), *Predators* (2010), *The Predator* (2018), and crossed with the *Alien* saga in the films *Alien vs. Predator* (2004) and *Alien vs. Predator: Requiem* (2007). The deadly extraterrestrial hunter Yautja is equipped with a helmet (the "biomask") that allows him not only to see a spectrum ranging from ultraviolet to infrared thermal vision (modeled on the visual system of snakes), but also to sense electromagnetic fields in order to detect xenomorphs (the aliens, in fact).

Such attempts intensify, on the one hand, the effort to go beyond anthropocentric constraints by an effort of imagination. On the other hand, they evidently fail to escape the caveat pronounced at the time by Nagel: to the extent that they are rendered visually on a screen, the vision of the compound eye or that of the two independent eyes or even of thermal vision will still have to be visions processable by the human eye-brain system. The human species-specific organization operates as a physiological and phenomenological a priori together that cannot be bypassed.

At the same time, we would be mistaken if we understood this a priori as something tetragonal and unitary. Within what Nagel calls a "type"[67] and what Uexküll would call "species," there can be significant variations: as far as the human species is concerned. For example, people who are blind perform localization tasks by processing tactile or acoustic stimuli, and the understanding of such practices by normally sighted individuals raises difficulties similar to those related to human understanding of bat sonar.

VR is also being measured on this aspect today. As a counterpoint to those now numerous applications of virtual reality for diagnostic and therapeutic purposes in the field of so-called "e-Health" (thus aimed at patients),[68] there is a remarkable development of immersive VR environments dedicated to able-bodied individuals, who are invited to step into the shoes of the sick or disabled person.

Presented in 2016 at the Sundance Film Festival, *Notes On Blindness* tells the story of John Hull, a writer and theologian who progressively

lost his sight in the early 1980s and began keeping an audio diary over the course of three years to try to make sense of that traumatic experience through storytelling. This work in VR represents a virtual remediation of two earlier works, and it was in fact preceded by a short film documentary, shot two years earlier by directors Peter Middleton and James Spinney,[69] which followed the publication of Hull's diary as a book with the title *Touching the Rock* in 1990.[70] This is a first-person phenomenology of blindness complementary to that attempted in the third person by José Saramago in his *Ensaio sobre a cegueira*[71] a few years later. Through the use of enveloping binaural audio that delivers John's voice to us and fluctuating bluish 3-D real-time animations that interrupt the 360-degree darkness, *Notes On Blindness* invites us to put ourselves in the shoes of the blind person, offering to our eyes the subjective perceptual grasp of his world environment and to our ears the account of his experiences and emotional reactions.

Similar explorations of human, but "other" experiential worlds[72] have been attempted, again in VR environments, for various forms of deprivation, such as Alzheimer's disease. *A Walk Through Dementia*,[73] developed by Alzheimer's Research UK, is a smartphone app, usable both onscreen as a 360-degree video and in VR format via Google Carboard, that aims to confront the user with three everyday situations typical of the sufferer of this disease in the supermarket, on the street, and at home. The app "puts you in the shoes of someone with dementia," therefore challenging people not affected by the disease (primarily family members and caregivers) to take on the point of view of the sufferer's own world, understanding subjectively their obstacles and fears in order "to give an insight into the varied symptoms people with dementia can experience in everyday life."

As often happens in such cases, the boundary that separates fiction and nonfiction is quite blurred. This is demonstrated by *Cosmos within Us*, by Tupac Martir, presented at the VR section of the Venice Biennale in 2019.[74] It is a reflection that, starting from the experience of Aiken, a sixty-year-old man afflicted with the disease and the

resulting loss of memory (and thus of personal identity), expands to embrace the more general issue of loss tout court as a universally human experience.

In these and similar attempts, there recurs the tension we have seen established between the Nagel position and the Uexküll position. On the basis of the first, we can never hope to access phenomenologically and firsthand the experience of a person who is blind or one living with Alzheimer's. We will never really know "what is it like." On the basis of the second, we will never cease to attempt to accede to it, albeit asymptotically, by devising technoimaginative and technoaesthetic combinations that allow us to get some idea of it, however imperfect.

The paradox we have seen embodied in Uexküll's stance — theorizing the impenetrability of soap bubbles and doing no less than trying to penetrate the thresholds that separate them — demands, in the end, the recognition of a characteristic feature of humanity, that is, the need to go beyond the limits imposed by our physiological constitution through the joint action of perception, imagination, and technology.

Epilogue

In one of his most brilliant essays, "Bridge and Door," Georg Simmel forcefully made the point that binding and unbinding, the one a reciprocal presupposition of the other, are constitutive acts of the human being, "the bordering creature who has no border."[1] The philosopher of *separation*, Simmel, averts the blurring of image and reality through a strict framing device. He is also, inevitably, the philosopher of connection who knows how these two operations bond in an intimate, dialectical embrace. *Threshold* is the name of this embrace. The boundary line between inside and outside, the interval between the iconic and the real, it is both bridge and door between these two worlds.

At the very moment when the image establishes itself as an island, as a space-time other than the spatiotemporal structure of ordinary reality, severing the ties that fetter it to the innumerable cause-effect relations and the chains of means-ends that weave the real and our transactions there, the desire is irresistibly triggered to throw a bridge across the moat, to conquer that island, to reconnect those ties and open a passageway that would allow transit in both directions.

No epoch seems to have been immune to such a desire: each visual culture, employing the technologies available in its time and its own iconic strategies, has interrogated that threshold in its own way, engaging both producers and users of the image to reflect on which elements distinguish the iconic experience from ordinary perceptual

experience and which unite them. The mere hypothesis that it is possible to trace the incunabula of this engagement as far back as Upper Paleolithic cave paintings raises the dizzying question of whether any evolutionary utility and adaptive function is to be ascribed to this lingering on the threshold between image and reality, a question that is destined to remain unanswered for now.

This book has not ventured to provide a solution. Instead, it has tried to tell, over the arc of time that stretches from the myth of Narcissus to contemporary virtual reality technologies, the story of this millennial desire in some of its most noteworthy manifestations, recognizing it in the mirror of the ideas and devices (very often paradoxical) that express this desire and attempt to satisfy it. The heterogeneity of the media that have been crossed—from ancient illusionistic painting to contemporary immersive digital technologies, via sculpture, photography, theater, precinema projection devices, and cinema itself—shows that this desire is *transmedial* and that every medium is open to the attempt to satisfy it. Transmediality does not mean, however, that it is permissible to lump all mediums together. Each medium must be explored in its potentialities and limitations, as well as in its rhetoric and ideology, insofar as it corresponds to that desire and the strategies put in place to achieve it.

More than once, even a nonvisual medium such as literature has been drawn upon. Myths, fables, narratives into which through the centuries that desire has plunged as a document of its time while stimulating the technological imagination of later generations to transform imagination effectively into image. These are, quite literally, science fiction and technofiction, that is, wishful fantasies that fuel the design of scientific-technical devices of *image making*.

As the last chapter has made clear, the effort to cross the threshold of the image in the end comes to correspond to the effort, at once vain and yet irrepressibly human, to surpass the human itself. Johann Wolfgang von Goethe definitively lays to rest such presumption: "Man," he says in one of his maxims, "never understands how anthropomorphic he is."[2] In this "never" is enshrined the willful obstinacy of which this book has reconstructed some moments.

Acknowledgments

The idea for this book arose from an encounter with a legend: not that of Narcissus, from which I start in Chapter 1, but that of the Chinese painter who disappears into his own painting, which I discuss in Chapter 6. I came across it many years ago, reading it in Walter Benjamin, and since then, that story about a threshold and its transgression has never ceased to tickle me (let us say, to obsess me): I believed I would find it again by looking backwards, transfigured in the mists of myth, and forwards, remodeled in sophisticated digital technologies.

I have been able to take advantage of the generosity of colleagues and friends, whom I have variously questioned over the past few years about that *idée fixe* and its progressive ramifications: Cristina Baldacci, Giuliana Bruno, Chiara Cappelletto, Mauro Carbone, Giovanni Careri, Barbara Carnevali, Francesco Casetti, Michele Cometa, Pietro Conte, Georges Didi-Huberman, Giuseppe Di Liberti, Ruggero Eugeni, Daniela Ferrari, Kurt W. Forster, David Freedberg, Mildred Galland, Dario Gamboni, Barbara Grespi, Maurizio Guerri, Sara Guindani, Pietro Montani, Silvia Romani, Antonio Somaini, Victor Stoichita, Enrico Terrone, Caroline van Eck, and Matthew Vollgraff.

To the theme of the threshold between image and reality I was able to devote a first reflection of a systematic nature thanks to a Eurias Marie Skłodowska-Curie senior fellowship I benefited from

at the Institut d'Études Avancées in Paris in the academic year 2017–2018, developing the project *Hyper-Image: Simulation, Immersion, and the Challenge of Hyper-Realistic Environments*. I subsequently pursued further implications of that idea thanks to a research period spent in 2019, also in Paris, at the Fondation Maison des Sciences de l'Homme, as "Directeur d'études associé" working on the project *Avatarization: Social Ontology of Digital Proxies*.

That *idée fixe* matured into an ERC-Advanced research project: *AN-ICON: An-Iconology. History, Theory, and Practices of Environmental Images* (2019–2025), hosted by the Department of Philosophy "Piero Martinetti" of the University of Milan La Statale. The themes I address in this book were discussed far and wide with the research team I have the privilege of coordinating: Ilaria Ampollini, Giulia Avanza, Fabrizia Bandi, Federica Cavaletti, Rosa Cinelli, Alessandro Costella, Anna Caterina Dalmasso, Alfio Ferrara, Margherita Fontana, Rossana Galimi, Giancarlo Grossi, Irene Magrì, Roberto P. Malaspina, Giacomo Mercuriali, Elisabetta Modena, Sofia Pirandello, Maria Serafini, Ilaria Terrenghi. Special thanks go to Margherita and Sofia for their invaluable work with the bibliographic research and translation of the notes.

I am grateful to John Eaglesham for his patient attention in translating the text and Bud Bynack for his effective copyediting that improved the expression of my thoughts in many places.

Finally, my profound gratitude goes to Jonathan Crary for welcoming this work into the Zone Books catalog, to Kyra Simone for editing the iconographic apparatus, and to Meighan Gale for her assiduous care in following all stages of the gestation of this volume.

Notes

CHAPTER ONE: THE TWO NARCISSUSES

1. Pausanias, *Description of Greece*, vol. 1, *Guide to Greece* 9.31.6, trans. James G. Frazer (Cambridge: Cambridge University Press 2013), p. 483.

2. Leon Battista Alberti, *On Painting* 2.26, trans. Rocco Sinisgalli (1435; Cambridge: Cambridge University Press, 2011), p. 46. Commenting on this passage in *Nouvelle Revue de Psychanalyse* in 1976, Hubert Damisch played on the word *tableau* (painting), breaking it down into *tabl-eau* (table-water): "D'un Narcisse l'autre," in Jean-Bertrand Pontalis, ed., *Narcisses* (Paris: Gallimard, 2000), p. 168. On the famous Albertian passage, with extensive bibliography, see Elena Filippi, "Narciso nel Quattrocento: Percezione, conoscenza, arte," *Rivista di estetica* 73.1 (2020), pp. 96–117.

3. Ovid, *Metamorphoses*, trans. A. D. Melville (Oxford: Oxford University Press, 1998), book 3, vv. 503–505, p. 66. On the relationship between vision, reflection, and desire, see David Summers, *Vision, Reflection, and Desire in Western Painting* (Chapel Hill: University of North Carolina Press, 2007). See in particular chapter 4, "Narcissus and the Mirror without Stain," pp. 112–54.

4. *The Narratives of Konon* 24, ed. Malcolm Kenneth Brown (Munich: Saur, 2002), p. 172.

5. Plotinus, *Enneads* 1.6.8, trans. Arthur Hilary Armstrong, 7 vols. (Cambridge, MA: Harvard University Press, 1989), vol. 1, p. 257.

6. Severus Sophista Alexandrinus, *Progymnasmata quae exstant omnia*, ed. Eugenio Amato (Berlin: De Gruyter, 2009), p. 5. Translation by the author.

7. Pierre Hadot, "Le mythe de Narcisse et son interprétation par Plotin," *Nouvelle Revue de Psychanalyse* 13 (Spring 1976), in Pontalis, ed., *Narcisses*, pp. 127–60.

8. See Marsilio Ficino, *Commentary on Plato's Symposium on Love* (1469), ed. and trans. Sears Jayne, 2nd ed. (Woodstock: Spring Publications, 2000), chapter 16, pp. 140–41. For this Neoplatonic reading, see Friedrich Creuzer, *Symbolik und Mythologie der alten Völkern, besonders der Griechen*, 4 vols. (Leipzig: Leske, 1821), vol. 3, pp. 553–58.

9. Ovid, *Metamorphoses*, book 3, vv. 446–56, p. 64.

10. Dante Alighieri, *The Divine Comedy: Paradiso: Italian Text and Translation*, ed. Charles S. Singleton, 3 vols. (Princeton: Princeton University Press, 1975), vol. 3, part 1, pp. 27–29.

11. Françoise Frontisi-Ducroux and Jean-Pierre Vernant, *Dans l'oeil du miroir* (Paris: Odile Jacob, 1997), p. 216. Chapters 10 and 11 are devoted to the figure of Narcissus.

12. Ovid, *Metamorphoses*, book 3, vv. 463–64, pp. 64–65.

13. Ibid., v. 434, p. 64.

14. Ibid., vv. 347–48, p. 61. Also insisting on the centrality of the failure to recognize the image as such is Thomas Macho, "Narziß und der Spiegel: Selbstrepräsentation in der Geschichte der Optik," in Almut-Barbara Renger, ed., *Narcissus: Ein Mythos von der Antike bis zum Cyberspace* (Stuttgart: Metzler, 2002), pp. 13–25, in particular, pp. 20–23.

15. Pausanias, *Description of Greece* 9.31.6, p. 483.

16. On the concomitance of self-knowledge and knowledge of the medium, see Christiane Kruse, "Selbsterkenntnis als Medienerkenntnis: Narziß an der Quelle bei Alberti und Caravaggio," *Marburger Jahrbuch für Kunstwissenschaft* 26 (1999), pp. 99–116.

17. Julia Kristeva, *Tales of Love*, trans. Leon S. Roudiez (New York: Columbia University Press, 1987), p. 104. Chapter 3 is entirely devoted to the figure of Narcissus.

18. Ovid, *Metamorphoses*, book 3, vv. 474–78, p. 65.

19. Paul Zanker, "*Iste ego sum*: Der naive und der bewußte Narziss," *Bonner Jahrbücher* 166 (1966), pp. 152–70. More generally on the mirror image as a motif in ancient art, see Lilian Balensiefen, *Die Bedeutung des Spiegelbildes als ikonographisches Motiv in der antiken Kunst* (Tübingen: Wasmuth, 1990).

20. Ovid, *Metamorphoses*, book 3, vv. 480–81, p. 65.

21. James Hall, *The Self-Portrait: A Cultural History* (London: Thames & Hudson, 2014), p. 47.

22. This is the thesis of Alberto Boatto, *Narciso infranto: L'autoritratto moderno da Goya a Warhol* (Rome/Bari: Laterza, 1997), p. 4.

23. Christa Lichtenstern, *Metamorphose: Vom Mythos zum Prozeßdenken; Ovid-Rezeption, surrealistische Ästhetik, Verwandlungsthematik der Nachkriegskunst* (Weinheim: VCH Acta

Humaniora, 1992), p. 24. On the iconography of Narcissus, see chapter 1.1, "Narziß im Wechsel der Perspektiven: Vom Klassizismus bis zum Surrealismus," pp. 24–84.

24. Steven Zalman Levine, *Monet, Narcissus, and Self-Reflection: The Modernist Myth of the Self* (Chicago: University of Chicago Press, 1994).

25. Ades Dawn, ed., *Freud, Dalí and the Metamorphosis of Narcissus* (London: Freud Museum, 2018). Published in conjunction with an exhibition of the same title, organized by and presented at the Freud Museum of London, October 3, 2018–February 17, 2019.

26. Lea Vergine, *Body Art and Performance: The Body as Language* (London: Thames & Hudson, 2000), p. 12.

27. See Graham Bader, "Donald's Numbness," *Oxford Art Journal* 29.1 (2006), pp. 93–113, especially "Lichtenstein's Narcissus."

28. On the "narcissistic" background of this work, see "A Conversation Between Hans Belting and Bill Viola," in John Walsh, ed., *Bill Viola: The Passions* (Los Angeles: J. Paul Getty Museum, 2003), p. 206, and Henri de Riedmatten, *Narcissus in Troubled Waters: Francis Bacon, Bill Viola, Jeff Wall* (Rome: L'Erma di Bretschneider, 2014), chapter 5, "Bill Viola: a Disturbed Mirror," especially pp. 166–73. See also Sophie-Isabelle Dufour, *L'image vidéo: D'Ovide à Bill Viola* (Paris: Archibooks + Sautereau, 2008).

29. Pausanias, *Description of Greece* 9.31.6, p. 483. See Françoise Frontisi-Ducroux and Jean-Pierre Vernant, "Narcisse et ses doubles," in *Dans l'oeil du miroir*, pp. 200–21.

30. Emanuele Lelli, ed., *I proverbi greci: Le raccolte di Zenobio e Diogeniano* (Soveria Mannelli: Rubbettino, 2006), p. 89. Translation by the author.

31. Albert Wesselsky, "Narziß oder das Spiegelbild," *Archiv Orientální* 7 (1933), pp. 37–63 and 328–50.

32. Eugene Watson Burlingame, ed., *Buddhist Legends*, 3 vols. (Cambridge, MA: Harvard University Press, 1921), vol. 3, p. 332.

33. Lucius Junius Moderatus Columella, *On Agriculture*, trans. E. S. Forster and Edward H. Heffner, 3 vols. (Cambridge: Harvard University Press, 1954), vol. 2, p. 213.

34. James George Frazer, *The Golden Bough: A Study in Magic and Religion* (1922), abridged ed. (London: Palgrave Macmillan, 1990), p. 189. See also Frazer, "The Legend of Narcissus," *The Journal of the Anthropological Institute of Great Britain and Ireland* 16 (1887), p. 344.

35. Géza Rohéim, *Spiegelzauber* (Leipzig: Internationaler psychoanalytischer Verlag, 1919), in particular, chapter 5, "Spiegelschauverbote," pp. 163–87.

36. For modern developments of the theme in prepsychoanalytic culture, see Louise Vinge, *The Narcissus Theme in Western European Literature Up to the Early 19th Century*, trans.

R. Dewsnap (Lund: Gleerups, 1967), and Niclas Johansson, *The Narcissus Theme from "Fin de Siècle" to Psychoanalysis: Crisis of the Modern Self* (Frankfurt am Main: Peter Lang, 2017).

37. A useful historical survey of the narcissistic personality disorder is offered by Brin F. S. Grenyer, "Historical Overview of Pathological Narcissism," in John S. Ogrodniczuk, ed., *Understanding and Treating Pathological Narcissism* (Washington, DC: American Psychological Association, 2013), pp. 15–26.

38. Alfred Binet, "Le fétichisme dans l'amour," *Revue Philosophique de la France et de l'Étranger* 24 (1887), p. 264, n. 1.

39. Havelock Ellis, "Auto-erotism: A Psychological Study," *Alienist and Neurologist* 19.2 (1898), p. 280. Confronting psychoanalytic and anthropological perspectives, Ellis would later return to the topic in the essay "The Conception of Narcissism," *Psychoanalytic Review* 14 (1927), pp. 129–53.

40. Paul Näcke, "Die sexuellen Perversitäten in der Irrenanstalt," *Psychiatrische en Neurologische Bladen* 3 (1899), pp. 122–49.

41. Isidor Sadger, "Psychiatrisch-Neurologisches in psychoanaliytischer Beleuchtung," *Zentralblatt für das Gesamtgebiet der Medizin und ihrer Hilfswissenschaften* 4.7–8 (1908), pp. 45–47 and 53–57 (on identification in particular, p. 54; on *Doppelgängerei* in particular, pp. 55–56).

42. Sigmund Freud, "On Narcissism: An Introduction" (1914), in *The Standard Edition of the Complete Psychological Works of Sigmund Freud*, ed. James Strachey, 24 vols. (London: The Hogarth Press and The Institute of Psycho-Analysis, 1953–1974), vol. 14, p. 76.

43. Sigmund Freud, "Leonardo Da Vinci and a Memory of His Childhood" (1910), in *The Standard Edition of the Complete Psychological Works of Sigmund Freud*, vol. 11, p. 100. On the "narcissistic libido," see also Freud, "Three Essays on the Theory of Sexuality" (1905), in vol. 7, p. 218, and "Psycho-analytic Notes on an Autobiographical Account of a Case of Paranoia (Dementia Paranoides)" (1911), vol. 12, pp. 60–62.

44. Otto Rank, "Ein Beitrag zum Narzissismus," *Jahrbuch für Psychoanalytische und Psychopathologische Forschungen* 3 (1911), p. 404. Translation by the author.

45. Pierre Hadot, "Le mythe de Narcisse et son interprétation par Plotin," especially "Narcisse et narcose," pp. 129–31.

46. Pliny the Elder, *Natural History* 21.128, trans. John Bostock and H. T. Riley, 6 vols. (London: Henry G. Bohn, 1855), vol. 4, p. 367.

47. Clement of Alexandria, *Christ, the Educator*, trans. Simon P. Wood (Washington, DC: Catholic University of America Press, 1954), p. 154.

48. Marshall McLuhan, *Understanding Media: The Extensions of Man* (1964; Cambridge, MA: MIT Press, 1994), pp. 41–42. See Thomas Wegmann, "Erkennen als Verkennen: Der mythische Narziß in der medialen Endlosschleife," in Renger, ed., *Narcissus*, pp. 167–79.

49. McLuhan, *Understanding Media*, p. 149.

50. Ibid., p. 43.

51. Ibid., p. 45. On these issues see Francesco Parisi, *La trappola di Narciso: L'impatto mediale dell'immagine fotografica* (Florence: Le lettere, 2011).

52. Marshall McLuhan, interview given to *Playboy* in 1969, in Eric McLuhan and Frank Zingrone, eds., *Essential McLuhan* (London: Routledge, 1997), p. 238.

53. Christopher Lasch, *The Culture of Narcissism: American Life in an Age of Diminishing Expectations* (1979; New York: W. W. Norton, 1991), p. 47.

54. Christopher Lasch, *The Minimal Self: Psychic Survival in Troubled Times* (New York: W. W. Norton, 1984), p. 19.

55. Ibid., p. 184. The same argument will later be reiterated by Lasch in the "Afterword: The Culture of Narcissism Revisited" (1990), in *The Culture of Narcissism*, p. 241.

56. Régis Debray, *Vie et mort de l'image: Une histoire du regard en Occident* (Paris: Gallimard, 1992), p. 416. Translation by the author.

57. Among the many publications, see: Mary Anne Moser and Douglas MacLeod, eds., *Immersed in Technology: Art and Virtual Environments* (Cambridge, MA: MIT Press, 1996); Marie-Laure Ryan, *Narrative as Virtual Reality: Immersion and Interactivity in Literature and Electronic Media* (Baltimore: Johns Hopkins University Press, 2001); Alison Griffiths, *Shivers Down Your Spine: Cinema, Museums, and the Immersive View* (New York: Columbia University Press, 2008); Gordon Calleja, *In-Game: From Immersion to Incorporation* (Cambridge, MA: MIT Press, 2011); Matthew Lombard et al., eds., *Immersed in Media: Telepresence Theory, Measurement and Technology* (Cham: Springer, 2015); Fabienne Liptay and Burcu Dogramaci, eds., *Immersion in the Visual Arts and Media* (Leiden: Brill, 2016); Ariel Rogers, "'Taking the Plunge': The New Immersive Screens," in Craig Buckley, Rüdiger Campe, and Francesco Casetti, eds., *Screen Genealogies: From Optical Device to Environmental Medium* (Amsterdam: Amsterdam University Press, 2019), pp. 135–58.

58. See Jan Holmberg, "Ideals of Immersion in Early Cinema," *Cinémas* 141 (2003), pp. 129–47.

59. See Adriano D'Aloia, "Film in Depth: Water and Immersivity in the Contemporary Film Experience," *Film and Media Studies* 5 (2012), pp. 87–106.

60. *Spaced Out*, Sundance Archive, https://history.sundance.org/films/11048/spaced_out; see also Sundance Institute, "Meet the Artist: Pierre 'Pyaré' Friquet — 2020 Sundance Film Festival," YouTube, https://www.youtube.com/watch?v=GJRSEcrpfdM.

61. *Aquaphobia*, Jakob Steensen's website, http://www.jakobsteensen.com/aquaphobia. See also Cristina Baldacci, "Re-enacting Ecosystems: Jakob Kudsk Steensen's Environmental Storytelling in Virtual and Augmented Reality," *piano b. arti e culture visive*, 6.1 (2021), pp. 67–86.

62. MephistoFiles, http://mefistofiles.com.

63. *Apnea*, Vanessa Vozzo's website, VANESSAV, https://www.vanessav.net/projects/apnea. See also Tatiana Mazali and Vanessa Vozzo, "Immersiveness and Interactivity in Documentary Storytelling. The *Apnea* Case Study," *DigitCult* 4.3 (2019), pp. 27–38.

64. See Walter Benjamin, *The Arcades Project*, trans. Howard Eiland and Kevin McLaughlin (Cambridge, MA: Belknap Press of Harvard University Press, 1999), N7a,3, p. 471 and N3,1, pp. 462–63.

65. Oliver Grau insists on this point, arguing that immersion "is characterized by diminishing critical distance to what is shown and increasing emotional involvement in what is happening." See Oliver Grau, *Virtual Art: From Illusion to Immersion* (Cambridge, MA: MIT Press, 2003), p. 13. More recently, for a critique of immersiveness as the watchword of the contemporary art scene, see Paolo D'Angelo, *La tirannia delle emozioni* (Bologna: il Mulino, 2020).

66. The first theoretician of the concept of *hikikomori* stressed the importance of being able to recognize in the love of others a form of mirroring love for oneself. This is precisely what does not happen in the case of the narcissistically oriented *hikikomori*: "Young people who are in a withdrawn state, however, do not have that sort of mirror. All that they have is an empty mirror that never reflects anything but their own face." In Saitō Tamaki, *Hikikomori: Adolescence without End* (1998), trans. Jeffrey Angles (Minneapolis: University of Minnesota Press, 2013), p. 108.

CHAPTER TWO: ALICE'S MIRROR

1. Plato, *The Republic* 10.596d–e, trans. G. M. A. Grube, rev. C. D. C. Reeve, in *Complete Works*, ed. John M. Cooper (Indianapolis: Hackett, 1997), p. 1201.

2. See Ernst Cassirer, "Eidos and Eidolon: The Problem of Beauty and Art in the Dialogues of Plato" (1924), in *The Warburg Years (1919–1933): Essays on Language, Art, Myth, and Technology*, trans. Steve G. Lofts with Antonio Calcagno (New Haven: Yale University Press, 2013), pp. 239–42, and Erwin Panofsky, *Idea: A Concept in Art Theory* (1924), trans.

Joseph J. S. Peake (Columbia: University of South Carolina Press, 1968), pp. 3–6.

3. See Slavko Kacunko, *Spiegel. Medium. Kunst: Zur Geschichte des Spiegels in Zeitalter des Bildes* (Munich: Fink, 2010).

4. Michel Foucault, "Of Other Spaces," in Michiel Dehaene and Lieven De Cauter, eds., *Heterotopia and the City: Public Space in a Postcivil Society* (London: Routledge, 2008), p. 17.

5. Jurgis Baltrušaitis, *Le miroir: Essai sur une légende scientifique — Révélations, science-fiction et fallacies* (Paris: Elmayan-Le seuil, 1978).

6. Leon Battista Alberti, *On Painting* (1435), trans. Rocco Sinisgalli (Cambridge: Cambridge University Press, 2011), book 2, paragraph 46, p. 70.

7. Leonardo da Vinci, *Leonardo on Painting: An Anthology of Writings by Leonardo da Vinci with a Selection of Documents Relating to His Career*, ed. Martin Kemp, trans Martin Kemp and Margaret Walker (New Haven: Yale University Press, 1989), p. 203, my emphasis.

8. Sigmund Freud, *The Uncanny* (1919), trans. David McLintock (London: Penguin Books, 2003), p. 162 n. 1.

9. Plato, *Timaeus* 46b, trans. Donald J. Zeyl, in *Complete Works*, ed. John M. Cooper (Indianapolis: Hackett, 1997), p. 1249. See also *Theaetetus* 193c–d, trans. M. J. Levett, in *Complete Works*, p. 214.

10. Umberto Eco, "Mirrors," in *Semiotics and the Philosophy of Language* (New York: Macmillan, 1984), p. 205.

11. Ibid.

12. Lewis Carroll, *Through the Looking-Glass and What Alice Found There* (1871), in *The Annotated Alice*, ed. Martin Gardner (New York: W. W. Norton, 2015), pp. 166–67. On the genesis of the mirror theme and Carroll's fascination with inversions more generally, see the remarks of Martin Gardner, ibid. pp. 166–70.

13. In their recent work on mirrors, Maria Danae Koukouti and Lambros Malafouris have related the alternative ontology of Carroll's mirror world to the alternative ontologies investigated by cultural anthropologists such as Eduardo Viveiros de Castro and Philippe Descola. See Maria Danae Koukouti and Lambros Malafouris, eds., *An Anthropological Guide to the Art and Philosophy of Mirror Gazing* (London: Bloomsbury, 2021). See in particular chapter 4, "Looking Through the Looking-Glass," pp. 49–61.

14. Jacques Lacan, "Hommage à Lewis Carroll" (1966), in "De Jacques Lacan à Lewis Carroll," ed. Jacques-Alain Miller, special issue, *Ornicar?* 50 (2003), pp. 9–12.

15. Jacques Lacan, "The Mirror Stage as Formative of the I Function" (1949), in *Écrits:*

The First Complete Edition in English, trans. Bruce Fink (New York: W. W. Norton, 2006), p. 76. See also Jacques Lacan, *Family Complexes in the Formation of The Individual* (1938), trans. Cormac Gallagher, http://www.lacaninireland.com/web/wp-content/uploads/2010/06/FAMILY-COMPLEXES-IN-THE-FORMATION-OF-THE-INDIVIDUAL2.pdf.

16. With explicit reference to the legend of Narcissus, Maurice Merleau-Ponty discusses the infantile experience of the mirror in the 1950–1951 course at the Sorbonne titled "The Child's Relations with Others," limiting himself, however, to pointing out that by mirroring himself, the child realizes that he is visible both to himself and to others, that is, that he can be "spectacle." See Maurice Merleau-Ponty, "The Child's Relations with Others," trans. William Cobb, in *The Primacy of Perception*, ed. James M. Edie (Evanston: Northwestern University Press, 1964), pp. 96–155, in particular chapter 3, pp. 125–55, and on Lacan, especially pp. 135–37.

17. Lacan, "The Mirror Stage as Formative of the I Function," p. 77.

18. Isidor Sadger, "Psychiatrisch-Neurologisches in psychoanalytischer Beleuchtung," *Zentralblatt für das Gesamtgebiet der Medizin und ihrer Hilfswissenschaften* 4.7–8 (1908), pp. 55–56.

19. Otto Rank, *The Double*, trans. Harry Tucker (1914; Chapel Hill: University of North Carolina Press, 1971), p. 86. Chapter 5 is devoted to the relationship between narcissism and the figure of the doppelgänger.

20. See the extensive study by Massimo Fusillo, *L'altro e lo stesso: Teoria e storia del doppio* (Modena: Mucchi, 2012). See also Victor Ieronim Stoichita, ed., *Das Double* (Wiesbaden: Harrassowitz, 2006), and Deborah Ascher Barnstone, ed., *The Doppelgänger* (Bern: Peter Lang, 2016). On the double in ancient culture, see Maurizio Bettini, ed., *La maschera, il doppio e il ritratto: Strategie dell'identità* (Rome: Laterza, 1991). On the mirror in particular, see Giulio Guidorizzi, "Lo specchio e la mente: Un sistema d'intersezioni," in ibid., pp. 31–46.

21. Adelbert von Chamisso, *The Wonderful History of Peter Schlemihl* (London: The Rodale Press, 1954).

22. Ernst Theodor Amadeus Hoffmann, "A New Year's Eve Adventure" (1815), in *The Best Tales of Hoffmann*, ed. Everett Franklin Bleiler (New York: Dover, 1967), p. 122.

23. Ibid., p. 128.

24. Rank, *The Double*, pp. 7 and 4.

25. See Graeme Gilloch, "'Mirror, Mirror': *The Student of Prague* in Baudrillard, Kracauer and Kittler," in David B. Clarke, et al., eds., *Jean Baudrillard: Fatal Theories* (London: Routledge, 2009), pp. 105–18.

26. Siegfried Kracauer, *From Caligari to Hitler: A Psychological History of the German Film*,

ed. Leonardo Quaresima (1947; Princeton: Princeton University Press, 2019), p. 30.

27. Friedrich A. Kittler, *Gramophone, Film, Typewriter*, trans. Geoffrey Winthrop-Young and Michael Wutz (Stanford: Stanford University Press, 1999), p. 155. On this theme, see also Kittler, "Romantik—Psychoanalyse—Film: Eine Doppelgängergeschichte," in Jochen Hörisch and Georg Christoph Tholen, eds., *Eingebildete Texte: Affairen zwischen Psychoanalyse und Literaturwissenschaft* (Munich: Fink, 1985), pp. 118–35.

28. Jean Baudrillard, *The Consumer Society: Myths and Structures* (London: SAGE Publications, 1998), pp. 192–95.

29. Jean Baudrillard, *Simulacra and Simulation*, trans. Sheila Faria Glaser (Ann Arbor: University of Michigan, 1994), pp. 147–48 n.1.

30. Jean Baudrillard, *The Perfect Crime*, trans. Chris Turner, 2nd ed. (London: Verso, 2008), p. 34.

31. Ibid., p. 150.

32. Jorge Luis Borges, "Fauna of Mirrors," in *The Book of Imaginary Beings*, trans. Norman Thomas di Giovanni in collaboration with the author (New York: Penguin Books, 2006), p. 68.

33. Carroll, *Through the Looking Glass*, p. 167.

34. On Méliès's films based on fairy tales and fantastic stories, see Jack Zipes, *The Enchanted Screen: The Unknown History of Fairy-Tale Films* (New York: Routledge, 2011), in particular chapter 3, "Georges Méliès: Pioneer of the Fairy-Tale Film and the Art of the Ridiculous," pp. 31–48.

35. Jacques Rigaut, *Lord Patchoque and Other Texts*, trans. Terry Hale (London: Atlas Press, 1993).

36. See Jean-Luc Bitton, *Jacques Rigaut: Le suicidé magnifique* (Paris: Gallimard, 2019).

37. On the "zone," see James S. Williams, *Jean Cocteau* (Manchester: Manchester University Press, 2006), in particular chapter 4, "In the Zone: *Orphée*," pp. 110–135. On the threshold between reality and image in Cocteau, see Caroline Surmann, "Le réel de l'imaginaire dans le cinéma de Jean Cocteau," in "Jean Cocteau," ed. Serge Linarès, special issue of *Cahiers de L'Herne* 113 (2016), pp. 449–56.

38. See Richard Martin, *The Architecture of David Lynch* (London: Bloomsbury, 2014), pp. 158–60, and Franck Boulegue, *Twin Peaks: Unwrapping the Plastic* (Chicago: Intellect Books, 2017), pp. 23–24.

39. Jean Cocteau, *Cocteau on the Film: Conversations with Jean Cocteau Recorded by André Fraigneau* (1951), trans. Vera Traill (New York: Dover, 1972), p. 113.

40. Carroll, *Through the Looking-Glass*, p. 318. On the dream dimension, see Hélène Cixous, "Introduction to Lewis Carroll's Through the Looking-Glass and The Hunting of the Snark," trans. Marie Maclean, *New Literary History* 13.2 (Winter 1982), pp. 231–51.

41. Aristotle, "On Divination in Sleep" 464b10, in *The Complete Works of Aristotle*, ed. Jonathan Barnes, 2 vols. (Princeton: Princeton University Press, 1985), vol. 1, p. 739. See also Aristotle, "On Dreams" 461a14–25, in *Complete Works*, vol. 1, pp. 730–31.

42. Jorge Luis Borges, "The Dream of the Butterfly," in Jorge Luis Borges, Silvina Ocampo, and Adolfo Bioy Casares, eds. *The Book of Fantasy* (New York: Carroll & Graf, 1990), p. 95.

43. On "mirror shots" see Edward Branigan, *Point of View in the Cinema: A Theory of Narration and Subjectivity in Classical Film* (Berlin: Mouton, 1984), pp. 127–29.

44. See Thomas Elsaesser and Malte Hagener, *Film Theory: An Introduction Through the Senses*, 2nd ed. (New York: Routledge, 2015). Chapter 3 is devoted to the various types of the mirror as a metaphor for cinema.

45. Hugo Münsterberg, *Hugo Münsterberg on Film: The Photoplay: A Psychological Study and Other Writings*, ed. Allan Langdale (London: Routledge, 2002), p. 70.

46. Béla Balázs, *Béla Balázs: Early Film Theory*, trans. Rodney Livingstone (New York: Berghahn Books, 2010), p. 88. On the mirror, see also Balázs, *Theory of the Film: Character and Growth of a New Art*, trans. Edith Bone (London: Dobson, 1952), pp. 66 and 110.

47. Jean-Louis Baudry, "Ideological Effects of the Basic Cinematographic Apparatus," trans. Alan Williams, *Film Quarterly* 28.2 (Winter 1974–1975), pp. 44–47.

48. Christian Metz, *The Imaginary Signifier: Psychoanalysis and the Cinema*, trans. Celia Britton, Annwyl Williams, Ben Brewster, and Alfred Guzzetti (Bloomington: Indiana University Press, 1982). See in particular "Identification, Mirror," pp. 42–57.

49. Eco, "Mirrors," p. 224.

50. Vittorio Gallese and Michele Guerra, *The Empathic Screen: Cinema and Neuroscience* (Oxford: Oxford University Press, 2019).

51. Rosalind Krauss, "Video: The Aesthetics of Narcissism," *October* 1 (Spring 1976), p. 50.

52. Vito Acconci, "Air Time," in Lea Vergine, *Body Art and Performance: The Body as Language* (London: Thames & Hudson, 2000), p. 29.

53. Krauss, "Video," pp. 53–54.

54. John Muse, "Nancy Holt and Richard Serra, Boomerang," https://www.youtube.com/watch?v=8z32JTnRrHc.

55. Krauss, "Video," p. 59.

NOTES

56. On the use of mirrors in contemporary art, see Agnes Husslein-Arco, Edelbert Köb, and Thomas Mießgang, eds., *The Other Side: Mirror and Reflections in Contemporary Art* (Vienna: Belvedere, 2014), published in conjunction with an exhibition of the same title organized by and presented at the Belvedere Museum in Vienna, June 18, 2014–October 12, 2014.

57. On Woodman see Rosalind Krauss, *Bachelors*, 2nd ed. (Cambridge, MA: MIT Press, 2000), chapter 6, "Francesca Woodman: Problem Sets," pp. 161–78; Chris Townsend, *Francesca Woodman: Scattered in Space and Time* (London: Phaidon, 2006); Marco Pierini, "Attraverso lo specchio: La coscienza del proprio corpo in Francesca Woodman," *Ricerche di storia dell'arte* 119 (2016), pp. 13–22; Isabella Pedicini, *Francesca Woodman: The Roman Years between Flesh and Films* (Rome: Contrasto, 2012).

58. Billy Klüver, "Pepsi-Cola Pavilion, Osaka 1970," *Arch+* 149–150 (2000), pp. 126–33; Cyrille-Paul Bertrand, "The Pepsi-Cola Pavilion, Osaka World's Fair, 1970," in Ulrich Gehmann, ed., *Virtuelle und ideale Welten* (Karlsruhe: KIT Scientific, 2012), pp. 185–97.

59. Gene Youngblood, *Expanded Cinema: Fiftieth Anniversary Edition* (1970; New York: Fordham University Press, 2020), p. 417.

60. See Cristina Albu, *Mirror Affect: Seeing Self, Observing Others in Contemporary Art* (Minneapolis: University of Minnesota Press, 2016).

61. Claire Bishop, *Installation Art: A Critical History* (London: Tate, 2005), pp. 92–94. See also "Mirror Displacements," ibid., pp. 87–90.

62. *20:50*, by Richard Wilson, Matt's Gallery, https://www.mattsgallery.org/exhibitions/20-50.

63. Christoph Benjamin Schulz, Eleanor Clayton, Gavin Delahunty, eds., *Alice in Wonderland Through the Visual Arts* (London: Tate, 2011).

64. Kate Bailey and Simon Sladen, eds., *Alice: Curiouser and Curiouser* (London: V & A Publishing, 2020), published in conjunction with an exhibition of the same title organized by and presented at the Victoria and Albert Museum, May 22–December 31, 2021.

65. Victoria and Albert Museum, "Curious Alice: The VR experience," https://www.vam.ac.uk/articles/curious-alice-the-vr-experience.

66. Ivan E. Sutherland, "The Ultimate Display," in Wayne A. Kalenich, ed., *Proceedings of the IFIP Congress 65*, 2 vols. (Washington, DC: Spartan Books, 1965), vol. 1, pp. 506–508. See Frieder Nake, "The Display as a Looking-Glass: Zu Ivan E. Sutherlands früher Vision der grafischen Datenverarbeitung," in Hans Dieter Hellige, ed., *Geschichten der Informatik: Visionen, Paradigmen, Leitmotive* (Berlin: Springer, 2004), pp. 339–65.

67. Ivan E. Sutherland, "A Head-Mounted Three-Dimensional Display," in *AFIPS Conference Proceedings*, vol. 33 (Washington, DC: Thompson Books, 1968), pp. 757–64.

68. "Who Coined the Term "Virtual Reality?," "Virtual Reality Society, https://www.vrs.org.uk/virtual-reality/who-coined-the-term.html.

69. Jaron Lanier, *Dawn of the New Everything: A Journey through Virtual Reality* (London: Bodley Head, 2017), pp. 234–35.

70. Janine Cirincione and Brian D'Amato, eds., *Through the Looking Glass: Artists' First Encounters with Virtual Reality* (Jupiter: Softworlds, 1992), published in conjunction with an exhibition of the same title curated by Janine Cirincione and presented at Jack Tilton Gallery in New York, June 4–July 17, 1992.

71. "Works of this sort, based on the high-tech and big-budget attraction of computers, have undeniable glamour. But are they art?" wonders Charles Hagen in the columns of the *New York Times*, July 5, 1992, in a review of the exhibition entitled precisely "Virtual Reality: Is It Art Yet?"

72. Donna Haraway, "The Materiality of Information," in Cirincione and D'Amato, *Through the Looking Glass*, p. 19.

73. See Terence McSweeney and Stuart Joy, "Change Your Past, Your Present, Your Future? Interactive Narratives and Trauma in 'Bandersnatch'," in Terence McSweeney and Stuart Joy, eds., *Through the Black Mirror: Deconstructing the Side Effects of the Digital Age* (Cham: Palgrave Macmillan-Springer, 2019), pp. 271–84, and Chris Lay and David Kyle Johnson, "'Bandersnatch': A Choose-Your-Own Philosophical Adventure," in David Kyle Johnson, ed., *Black Mirror and Philosophy: Dark Reflections* (Hoboken: Wiley Blackwell, 2020), pp. 199–238.

74. Carroll, *Through the Looking Glass*, p. 174.

75. Lewis Carroll, *The Hunting of the Snark* (1876; Oxford: Oxford University Press, 1940), p. 47.

76. Carroll, *Through the Looking Glass*, p. 232.

77. Joe Utichi, "Charlie Brooker and Annabel Jones Celebrate 'Black Mirror' Noms and Talk Future of 'Bandersnatch': A Virtual Reality Port?," *Deadline*, July 16, 2019, https://deadline.com/2019/07/charlie-brooker-annabel-jones-black-mirror-bandersnatch-vr-emmys-1202647177.

78. La Biennale di Venezia, "Down The Rabbit Hole," https://www.labiennale.org/it/cinema/2020/venice-vr-expanded/down-rabbit-hole.

79. See Giancarlo Grossi, *La notte dei simulacri: Sogno, cinema, realtà virtuale* (Monza:

Johan & Levi, 2021), and Pietro Montani, *Technological Destinies of the Imagination*, trans. Barbara Fisher (Milan: Mimesis International, 2022), pp. 151-55.

CHAPTER THREE: PYGMALION IN WESTWORLD

1. Ovid, *Metamorphoses* trans. A. D. Melville (Oxford: Oxford University Press, 1998), book 3, vv. 398-99, p. 63.

2. Callistratus, "Descriptions 5: On the Statute of Narcissus," in Philostratus the Elder, "Imagines"; Philostratus the Younger, "Imagines"; Callistratus, "Descriptions," trans. Arthur Fairbanks (Cambridge, MA: Harvard University Press, 1931), p. 393.

3. Ovid, *Metamorphoses*, book 10, vv. 253-93, pp. 233-34. See Gianpiero Rosati, *Narcissus and Pygmalion: Illusion and Spectacle in Ovid's Metamorphoses* (Oxford: Oxford University Press, 2021).

4. Giorgio Agamben, *Stanzas: Word and Phantasm in Western Culture*, trans. Ronald L. Martinez (Minneapolis: University of Minnesota Press, 1993), pp. 67 and 82. On the Narcissus-Pygmalion polarization, see chapters 3.11 and 3.15, pp. 63-72 and 111-23.

5. Guillaume de Lorris and Jean De Meun, *The Romance of the Rose*, trans. Charles Dahlberg (Princeton: Princeton University Press, 1971), section 2, vv. 20866-75, p. 341.

6. Victor I. Stoichita, *The Pygmalion Effect: From Ovid to Hitchcock*, trans. Alison Anderson (Chicago: University of Chicago Press, 2008), pp. 2-3. See also Jean-Claude Lebensztejn, *Pygmalion* (Dijon: Les presses du réel, 2010).

7. "Thus that Cyprian Pygmalion became enamoured of an image of ivory: the image was Aphrodite, and it was nude. The Cyprian is made a conquest of by the mere shape, and embraces the image. This is related by Philostephanus." Clement of Alexandria, "Exhortation to the Heathen," in *The Writings of Clement of Alexandria*, trans. William Wilson, 2 vols. (Edinburgh: Alexander Roberts and James Donaldson, 1867), vol. 1, p. 61. See also Arnobius, *The Case Against the Pagans*, 2 vols., trans. George E. McCracken (New York: Newman Press, 1949).

8. Lucian of Samosata, "Essays in Portraiture," in *Lucian*, 8 vols., trans. Austin M. Harmon (Cambridge, MA: Harvard University Press, 1969) vol. 4, p. 263.

9. Quoted in Maurizio Bettini, *The Portrait of the Lover*, trans. Laura Gibbs (Berkeley: University of California Press, 1999), p. 64. In particular, chapter 6. "Incredible Loves," pp. 59-74.

10. See the translation into English from the Persian version: *The Tooti Nameh, or Tales of the Parrot*, trans. Francis Gladwin (London: Calcutta Printed, 1801), pp. 49-53.

11. Paull Franklin Baum, "The Young Man Betrothed to a Statue," *PMLA* 34.4 (1919), pp. 523-79.

12. Joseph von Eichendorff, *Das Marmorbild: Novelle* (1819; Frankfurt am Main: S. Fischer, 2011), and Prosper Mérimée, "The Venus of Ille" (1837), in Théophile Gautier and Prosper Mérimée, *Tales before Supper*, trans. Myndart Verelst (New York: Brentano's, 1887), pp. 175–224.

13. See George L. Hersey, *Falling in Love with Statues: Artificial Humans from Pygmalion to the Present* (Chicago: University of Chicago Press, 2009).

14. Wilhelm Jensen, "Gradiva: Pompeian Fancy," (1903), in Sigmund Freud, *Delusion and Dream: An Interpretation in the Light of Psychoanalysis of Gradiva, a Novel by Wilhelm Jensen*, trans. Helen M. Downey (New York: Moffat, Yard, 1922), p. 14.

15. Sigmund Freud, "Delusions and Dreams in Jensen's *Gradiva*" (1906), in ibid., pp. 3–86.

16. Gabriele Huber, "Warburgs Ninfa, Freuds Gradiva und ihre Metamorphose bei Masson," in Silvia Baumgart, ed., *Denkräume zwischen Kunst und Wissenschaft* (Berlin: Reimer, 1993), pp. 443–60, and Roland Barthes, *A Lover's Discourse: Fragments*, trans. Richard Howard (New York: Hill and Wang, 1978), pp. 124–26.

17. See Alexander Scobie and A. J. W. Taylor, "Perversions Ancient and Modern: I. Agalmatophilia, the Statue Syndrome," *Journal of the History of the Behavioral Sciences* 11.1 (1975), pp. 49–54; Laura Bossi, *De l'agalmatophilie ou l'amour des statues* (Paris: L'Échoppe, 2012); the articles collected in *Ágalma: Journal of Cultural Studies and Aesthetics* 27 (2014).

18. Paul Moreau, "On the Aberration of the Genesic Sense," *Alienist and Neurologist* 5 (1884), pp. 367–85.

19. Richard von Krafft-Ebing, *Psycopathia Sexualis*, trans. Franklin S. Klaf (1886; New York: Stein and Day, 1965), p. 351.

20. Ernst Kris and Otto Kurz, *Legend, Myth, and Magic in the Image of the Artist: A Historical Experiment*, trans. Alastair Laing and Lottie M. Newman (1934; New Haven: Yale University Press, 1979), in particular chapter 3, pp. 71–84.

21. Plato, *Meno* 97d, trans. G. M. A. Grube, in *Complete Works*, ed. John M. Cooper, p. 895. On this see Françoise Frontisi-Ducroux, *Dédale: Mythologie de l'artisan en Grèce ancienne* (Paris: Maspero, 1975), in particular chapter 2, "Statues vivantes," pp. 95–117.

22. Aristotle, *Politics* 1.1253b, trans. Ernest Barker (London: Oxford University Press, 1977), p. 10.

23. Homer, *The Iliad* 18.417–20, trans. Martin Hammond (London: Penguin, 1987), p. 305. For the Hephaestus-Daedalus nexus, see Bernhard Schweitzer, "Daidalos und die Daidaliden in der Überlieferung," in *Xenokrates von Athen: Beiträge zur Geschichte der antiken Kunstforschung und Kunstanschauung* (Halle: Max Niemeyer, 1932), pp. 20–31.

24. Callistratus, "Descriptions: On the Statue of Bacchante 2.2–3," pp. 381 and 383.

25. Kris and Kurz, *Legend, Myth, and Magic*, p. 76.

26. David Freedberg, *The Power of Images: Studies in the History and Theory of Response* (Chicago: University of Chicago Press, 1989), pp. 84–87.

27. See the recent mapping offered by Guido Gentile, *Sacri monti* (Turin: Einaudi, 2019). See also Freedberg, *The Power of Images*, in particular, chapter 9, "Verisimilitude and Resemblance: From Sacred Mountain to Waxworks," pp. 192–245.

28. Aby Warburg, "The Art of Portraiture and the Florentine Bourgeoisie" (1902), in *The Renewal of Pagan Antiquity*, 2 vols., trans. David Britt (Los Angeles: Getty Research Institute, 1999), vol. 1, pp. 185–222, and Julius von Schlosser, "History of Portraiture in Wax" (1911), in Roberta Panzanelli, ed., *Ephemeral Bodies: Wax Sculpture and the Human Figure* (Los Angeles: Getty Research Institute, 2008), pp. 170–314.

29. See in this regard the fine phenomenological observations of Pietro Conte, *In carne e cera: Estetica e fenomenologia dell'iperrealismo* (Macerata: Quodlibet, 2014), and "The Fleshiness of Wax," in Marjolijn Bol and E. C. Spary, eds., *The Matter of Mimesis: Studies of Mimesis and Materials in Nature, Art and Science* (Leiden: Brill, 2023), pp. 270–89.

30. For a wide-ranging mapping see Kenneth Gross, *The Dream of the Moving Statue* (Ithaca: Cornell University Press, 1992).

31. René Descartes, "Treatise on Man" (1662, posthumously), in *The Philosophical Writings of Descartes*, 2 vols., trans. John Cottingham, Robert Stoothoff, and Dugald Murdoch (Cambridge, MA: Cambridge University Press, 1985), vol. 1, p. 99.

32. See Joseph Lloyd Carr, "Pygmalion and the Philosophes: The Animated Statue in Eighteenth-Century France," *Journal of the Warburg and Courtauld Institutes* 23 (1960), pp. 239–55; the anthology by Henri Coulet, ed., *Pygmalions des lumières* (Paris: Desjonquères, 1998); and the study by Aurélia Gaillard, *Le corps des statues: Le vivant et son simulacre à l'âge classique (de Descartes à Diderot)* (Paris: H. Champion, 2003).

33. Jean-Jacques Rousseau, *Pygmalion: A Poem* (1762; London: J. Kearby, 1779). See Meyer Reinhold, "The Naming of Pygmalion's Animated Statue," *Classical Journal* 66.1 (1970), pp. 316–19.

34. Pierre Bayle, *Dictionnaire historique et critique*, 4 vols., 3rd ed. (Amsterdam: P. Brunel, 1730), vol. 3, p. 722. 35. André-François Boureau-Deslandes, *Pigmalion, ou La statue animée* (1741; Paris: Hachette Livre BNF, 2016). For a framework in the eighteenth-century reception of the Pygmalion myth, see the introduction of the Italian translation by Eugenio Pesci, *Pigmalione, o la statua animata* (Milan: Angeli, 2008), pp. 7–102.

36. Étienne Bonnot de Condillac, "A Treatise on the Sensations" (1754), in *Philosophical Writings of Étienne Bonnot, Abbé de Condillac*, trans. Franklin Philip and Harlan Lane (Hillsdale: Lawrence Erlbaum Associates, 1982), p. 155.

37. Denis Diderot, "Salon 1763," in *Salons*, 4 vols. (London: Oxford University Press, 1957), vol.1., pp. 245, 246, 247.

38. Denis Diderot, "D'Alembert's Dream" (1769), in *Rameau's Nephew, and Other Works*, trans. Jacques Barzun and Ralph H. Bowen (Indianapolis: Hackett, 2001), pp. 94 and 95.

39. Johann Gottfried Herder, *Sculpture: Some Observations on Shape and Form from Pygmalion's Creative Dream*, ed. Jason Gaiger (1778; Chicago: University of Chicago Press, 2002), pp. 75, 42, 41, 45.

40. Stoichita, *The Pygmalion Effect*, p. 114. On Pygmalion iconography, see Andreas Blühm, *Pygmalion: Die Ikonographie eines Künstlermythos zwischen 1500 und 1900* (Frankfurt am Main: Lang, 1988).

41. Horst Bredekamp, *Image Acts: A Systematic Approach to Visual Agency*, 2nd ed., trans. Elizabeth Clegg (Berlin: Walter de Gruyter, 2018), p. 82. On the genre, see the essays collected in Julie Ramos, ed., *Le tableau vivant ou l'image performée* (Paris: Mare & Martin/ INHA, 2014), and Flaminio Gualdoni, *Corpo delle immagini, immagini del corpo: Tableaux vivants da San Francesco a Bill Viola* (Monza: Johan & Levi, 2017).

42. Bredekamp, *Image Acts*, p. 80. For an examination of the sources reporting this episode see Philine Helas, *Lebende Bilder in der italienischen Festkultur des 15. Jahrhunderts* (Munich: Akademie, 1999), pp. 86–87 and 198.

43. Johan Huizinga, *The Autumn of the Middle Ages*, trans. Rodney J. Payton and Ulrich Mammitzsch (1919; Chicago: University of Chicago Press, 1996), p. 302. On these themes, see in particular chapter 12, "Art in Life," pp. 294–328.

44. Jacob Burckhardt, *The Civilization of the Renaissance in Italy*, trans. Samuel G. C. Middlemore (1860; London: Penguin, 1990), p. 256. See in particular part 5. "Society and Festivals," pp. 230–70.

45. Warburg, "The Theatrical Costumes for the Intermedi of 1589 Bernardo Buontalenti's Designs and the Ledger of Emilio de' Cavalieri" (1895), in *The Renewal of Pagan Antiquity*, vol. 1, p. 369.

46. Johann Wolfgang Goethe, *Italian Journey*, trans. Wystan H. Auden and Elizabeth Mayer (London: Penguin, 1962), p. 208 (note taken in Caserta, March 16, 1787).

47. On the phenomenon in this period, see Kirsten Gram Holmström, *Monodrama, Attitudes, Tableaux Vivants: Studies on Some Trends of Theatrical Fashion 1770–1815* (Stockholm:

Almquist & Wiksell, 1967), and Birgit Jooss, *Lebende Bilder: Körperliche Nachahmungen von Kunstwerken in der Goethezeit* (Berlin: Dietrich Reimer, 1999).

48. James Howard Head, *Home Pastimes: Or Tableaux Vivants* (Boston: J. E. Tilton, 1860). For a similar manual in German, see Edmund Wallner, *Eintausend Sujets zu lebenden Bildern* (Erfurt: F. Bartholomäus, 1876).

49. See Sabine Folie and Michael Glasmeier, eds., *Tableaux vivants: Lebende Bilder und Attitüden in Fotografie, Film und Video* (Vienna: Kunsthalle, 2002).

50. On *tableaux vivant* and poses in cinema, see Vito Adriaensens and Steven Jacobs, "The Sculptor's Dream: Tableaux Vivants and Living Statues in the Films of Méliès and Saturn," *Early Popular Visual Culture* 13.1 (2015), pp. 41–65; the essays by Valentine Robert, "Le tableau vivant ou l'origine de l'"art' cinématographique," and by Jérémie Koering, "Sur le seuil: Tableau vivant et cinéma," in Ramos, ed., *Le tableau vivant ou l'image performée*, pp. 263–82 and 305–20, respectively; Barbara Grespi, "Pantomimes in Stone: Performance of the Pose and Animal Camouflage," in Alessandra Violi et al., eds., *Bodies of Stone in the Media, Visual Culture and the Arts* (Amsterdam: Amsterdam University Press, 2020), pp. 63–88.

51. Giorgio Agamben, "Notes on Gesture," in *Means without End: Notes on Politics*, trans. Cesare Casarino and Vincenzo Binetti (Minneapolis: University of Minnesota Press, 2000), p. 56.

52. See Silvia Romani, "Translated Bodies: A 'Cartographic Approach,'" in Violi et al., eds., *Bodies of Stone in the Media*, pp. 45–61.

53. See Michele Bertolini, "Animated Statues and Petrified Bodies: A Journey Inside Fantasy Cinema," and Vinzenz Hediger, "The Ephemeral Cathedral: Bodies of Stone and Configurations of Film," in ibid., pp. 89–104 and 105–26, respectively.

54. See Wilhelm Worringer, *Abstraction and Empathy: A Contribution to the Psychology of Style*, trans. Michael Bullock (1907; Chicago: Ivan R. Dee, 1997), pp. 35–36; Sigmund Freud, "Beyond the Pleasure Principle" (1920), in *The Standard Edition of the Complete Psychological Works of Sigmund Freud*, ed. James Strachey, 24 vols. (London: The Hogarth Press and The Institute of Psycho-Analysis, 1953–1974), vol. 18, p. 38.

55. See Salvatore Settis, *Incursioni: Arte contemporanea e tradizione* (Milan: Feltrinelli, 2020), in particular chapter 8, "Bill Viola: I conti con l'arte," pp. 233–74.

56. Massimiliano Gioni, "Maurizio Cattelan—Rebel with a Pose," in Francesco Bonami, *Maurizio Cattelan* (London: Phaidon, 2003), p. 180.

57. Quoted in Sara Bracchetti and Daniele Lorenzetti, "L'uomo che salvò i bambini impiccati," *La Repubblica*, Dec. 28, 2004, https://ricerca.repubblica.it/repubblica

/archivio/repubblica/2004/12/28/uomo-che-salvo-bambini-impiccati.html. On this installation see Pietro Conte, "(An)Aesthetics of Affect," in Ernst van Alphen and Tomáš Jirsa, eds., *How To Do Things With Affects: Affective Triggers in Aesthetic Forms and Cultural Practices* (Leiden: Brill, 2019), pp. 40–58.

58. Maurice Blanchot, *The Space of Literature*, trans. Ann Smock (Lincoln: University of Nebraska Press, 1982), pp. 257–58.

59. J. Hillis Miller, *Versions of Pygmalion* (Cambridge, MA: Harvard University Press, 1990); Michelle E. Bloom, "Pygmalionesque Delusions and Illusions of Movement: Animation from Hoffmann to Truffaut," *Comparative Literature* 52.4 (2000), pp. 291–320; Essaka Joshua, *Pygmalion and Galatea: The History of a Narrative in English Literature* (Aldershot: Ashgate, 2001); Amelia Yeates, "Recent Work on Pygmalion in Nineteenth-Century Literature," *Literature Compass* 7.7 (2010), pp. 586–96.

60. Auguste Villiers de l'Isle-Adam, *Tomorrow's Eve*, trans. Robert Martin Adams (1885–1886; Urbana: University of Illinois Press, 2001), pp. 29, 36, 35, 41.

61. Ibid., pp. 60 and 61. See Annette Michelson, "On the Eve of the Future: The Reasonable Facsimile and the Philosophical Toy," *October* 29 (1984), pp. 3–20. On the automaton more generally, see Gian Paolo Ceserani, *Gli automi: Storia e mito* (Rome: Laterza, 1983); Mario Giuseppe Losano, *Storie di automi: Dalla Grecia classica alla Belle Époque* (Turin: Einaudi, 1990); Victoria Nelson, *The Secret Life of Puppets* (Cambridge, MA: Harvard University Press, 2001); Bredekamp, *Image Acts*, pp. 95–107.

62. Stanley G. Weinbaum, "Pygmalion's Spectacles," *Wonder Stories*, June 1935, pp. 29 and 30.

63. Stoichita, *The Pygmalion Effect*, p. 204.

64. Weinbaum, "Pygmalion's Spectacles," p. 39.

65. Ibid., p. 105.

66. Günther Anders, *Die Antiquiertheit des Menschen*, volume 1, *Über die Seele im Zeitalter der zweiten industriellen Revolution* (Munich: Beck, 1961), pp. 179–80.

67. Jean Baudrillard, *The Perfect Crime*, trans. Chris Turner, 2nd ed. (London: Verso, 2008), pp. 49 and 32.

68. Jean Baudrillard, *The Intelligence of Evil or The Lucidity Pact*, trans. Chris Turner (Oxford: Berg, 2005), p. 27. See Giovanni Gurisatti, *Scacco alla realtà: Dialettica ed estetica della derealizzazione mediatica* (Macerata: Quodlibet, 2012), in particular chapter 5, "Baudrillard: La simulazione," pp. 204–48.

69. Sigmund Freud, *The Uncanny*, trans. David McLintock (1919; London: Penguin Books, 2003), p. 153.

70. Ibid., pp. 156–57.

71. Ernst Anton Jentsch, "On the Psychology of the Uncanny" (1906), trans. Roy Sellars, *Angelaki: Journal of the Theoretical Humanities* 2.1 (1997), p. 11.

72. Ibid., p. 12.

73. Masahiro Mori, "The Uncanny Valley" (1970), *IEEE Robotics & Automation Magazine* 19.2 (2012), pp. 98–100.

74. See Catrin Misselhorn, "Empathy with Inanimate Objects and the Uncanny Valley," *Minds and Machines* 19.3 (2009), pp. 345–59, and Pietro Conte, "Unheimlich: Dalle figure di cera alla Uncanny Valley," *Psicoart* 2.2 (2011–2012), pp. 1–21.

75. Hiroshi Ishiguro and Fabio Dalla Libera, eds., *Geminoid Studies: Science and Technologies for Humanlike Teleoperated Androids* (Singapore: Springer, 2018).

76. See Emma Rooksby, *Email and Ethics: Style and Ethical Relations in Computer-Mediated Communications* (New York: Routledge, 2007), chapter 2, "Empathy in Computer-Mediated Communications," pp. 39–70, and Paul Dumouchel and Luisa Damiano, *Living with Robots*, trans. Malcolm DeBevoise (Cambridge, MA: Harvard University Press, 2017).

77. See the various projects developed by Ishiguro at https://eng.irl.sys.es.osaka-u.ac.jp/robot.

78. On the film, see Judith B. Kerman, ed., *Retrofitting Blade Runner* (Bowling Green: Bowling Green State University Popular Press, 1991).

79. Philip K. Dick, *Do Androids Dream of Electric Sheep?* (New York: Random House, 1996).

80. On sex dolls, see David Levy, *Love and Sex with Robots: The Evolution of Human-Robot Relationships* (New York: Harper Collins, 2007), and Nicola Liberati, "Phenomenology and Sex Robots: A Phenomenological Analysis of Sex Robots, Threesomes, and Love Relationships," *International Journal of Technoethics* 12.2 (2021), pp. 18–32.

81. Cunningham's video clip can be accessed at Glassworks VFX, "Bjork 'All is Full of Love'," Vimeo, https://vimeo.com/242618438.

82. Björk, interview given to Evelyn McDonnell, in *Army of She: Icelandic, Iconoclastic, Irrepressible Björk* (New York: Random House, 2001), p. 77.

83. Steven Shaviro, *Connected, or What It Means to Live in the Network Society* (Minneapolis: University of Minnesota Press, 2003), p. 103.

84. Marshall McLuhan, *The Mechanical Bride: Folklore of Industrial Man* (New York: Vanguard Press, 1951).

85. Ulrike Bergermann, "Robotik und digitale Schmiermittel: Björks doppelte Maschinenliebe in All Is Full of Love," *Frauen und Film* 65 (2006), pp. 117–31.

86. Isaac Asimov, *I, Robot* (New York: Gnome Press, 1950).

87. James B. South and Kimberly S. Engels, eds., *Westworld and Philosophy: If You Go Looking for the Truth, Get the Whole Thing* (Hoboken: Wiley Blackwell, 2018).

88. See Benjamin Schrader, "Cyborgian Self-Awareness: Trauma and Memory in *Blade Runner* and *Westworld*," *Theory & Event* 22.4 (2019), pp. 820–41.

CHAPTER FOUR: THE ENVIRONMENTAL IMAGE

1. Philostratus The Elder, *Imagines* 1.23, trans. Arthur Fairbanks (London: William Heinemann, 1931), pp. 89 and 91.

2. Pliny the Elder, *Natural History* 35.36, trans. John Bostock and H. T. Riley, 6 vols. (London: Henry G. Bohn, 1855), vol. 6, p. 251. On the myth of Zeuxis and the history of its effects see Elizabeth C. Mansfield, *Too Beautiful to Picture: Zeuxis, Myth, and Mimesis* (Minneapolis: University of Minneapolis Press, 2007).

3. See Hans Körne, ed., *Die Trauben des Zeuxis: Formen künstlerischer Wirklichkeitsaneignung* (Hildesheim: Olms, 1990).

4. Pliny the Elder, *Natural History* 35.66, vol. 6, p. 252.

5. See Ernst Kris and Otto Kurz, *Legend, Myth, and Magic in the Image of the Artist: A Historical Experiment*, trans. Alastair Laing and Lottie M. Newman (1934; New Haven: Yale University Press, 1979), in particular, pp. 60–69. See also Stephen Bann, *The True Vine: On Visual Representation and the Western Tradition* (Cambridge: Cambridge University Press, 1989).

6. Pliny the Elder, *Natural History* 35.95, vol. 6, p. 262.

7. Arthur C. Danto, "The Pigeon within Us All: A Reply to Three Critics," *Journal of Aesthetics and Art Criticism* 59.1 (2001), p. 41.

8. Giorgio Vasari, "The Life of Giotto, Florentine Painter, Sculptor, and Architect," in *Lives of the Artists*, trans. Peter Bondanella (1568; Oxford: Oxford University Press, 2010), p. 35.

9. Kandice Rawlings, "Painted Paradoxes: The *Trompe-l'Oeil* Fly in the Renaissance," *Athanor* 26 (2008), pp. 7–13. For the development of this entomological theme in seventeenth-century Dutch painting, see Bernhard Siegert, "Figures of Self-Reference: A Media Genealogy of the Trompe-l'oeil in Dutch Still Life," in, *Cultural Techniques: Grids, Filters, Doors, and Other Articulations of the Real*, trans. Geoffrey Winthrop-Young (New York: Fordham University Press, 2015), pp. 164–91.

10. E. H. Gombrich, *Art and Illusion: A Study in The Psychology of Pictorial Representation* (Princeton: Princeton University Press, 2000), p. 276.

11. Marie-Louise d'Otrange Mastai, *Illusion in Art, Trompe L'Oeil: A History of Pictorial Illusionism* (New York: Abaris Book, 1975); Patrick Mauriès, ed., *Le trompe-l'oeil: De l'antiquité au XXe siècle* (Paris: Gallimard, 1996); Sybille Ebert-Schifferer, ed., *Deceptions and Illusions: Five Centuries of Trompe-l'Oeil Painting* (Washington, DC: National Gallery of Art, 2002), published in conjunction with an exhibition of the same title held at National Gallery of Art, Washington, October 13, 2002–March 2, 2003.

12. Michael Kubovy, *The Psychology of Perspective and Renaissance Art* (Cambridge: Cambridge University Press, 1986), chapter 6, "Illusion, Delusion, Collusion, & Paradox," pp. 49–60.

13. Ibid. p. 56.

14. See Omar Calabrese, *L'arte del trompe-l'oeil* (Milan: Jaca Book, 2011), p. 13.

15. This is the argument of Paolo Spinicci, "Trompe l'oeil and the Nature of Pictures," in Clotilde Calabi, ed., *Perceptual Illusions: Philosophical and Psychological Essays* (Basingstoke: Palgrave MacMillan, 2012), p. 150.

16. Jean Baudrillard, "The Trompe-l'Oeil" (1977), in Norman Bryson, ed., *Calligram: Essays in New Art History from France* (Cambridge: Cambridge University Press, 1989), p. 58.

17. Louis Marin, "Imitation et trompe-l'oeil dans la théorie classique de la peinture au XVIIe siècle," in *L'imitation: Aliénation ou source de liberté?* (Paris: Rencontres de l'École du Louvre, La Documentation française, 1985), p. 190.

18. It was Erwin Panofsky who directly related Giotto's and Carlo Crivelli's flies to Philostratus' ekphrasis. See *Early Netherlandish Painting: Its Origin and Character* (Cambridge, MA: Harvard University Press, 1953), p. 489 n.5.

19. See Daniela Ferrari and Andrea Pinotti, eds., *La cornice: Storie, teorie, testi* (Milan: Johan & Levi, 2018), with texts by Georg Simmel, José Ortega y Gasset, Ernst Bloch, Meyer Schapiro, Jacques Derrida, Rudolf Arnheim, Louis Marin, Groupe μ, and Victor Stoichita.

20. Nicolas Poussin, letter to P. Fréart de Chantelou, April 28, 1639, in *Correspondance de Nicolas Poussin*, ed. Charles Jouanny (Paris: F. De Nobele, 1968), p. 20.

21. Immanuel Kant, *Critique of Judgment*, trans. James Creed Meredith (1790; Oxford: Oxford University Press, 2007), p. 57.

22. Georg Simmel, "The Picture Frame: An Aesthetic Study" (1902), trans. Mark Ritter, in *Essays on Art and Aesthetics*, ed. Austin Harrington (Chicago: University of Chicago Press, 2020), p. 149.

23. Groupe μ, "Sémiotique et rhétorique du cadre," *La Part de l'Oeil* 5 (1989), p. 120.

24. Rudolf Arnheim, *The Power of the Center: A Study of Composition in the Visual Arts* (Berkeley: University of California Press, 1982), p. 67.

25. Germano Celant, *Ambiente/Arte: Dal Futurismo alla Body Art; Biennale Arte 1976* (1976; Venice: La Biennale di Venezia, 2020), anastatic copy, p. 5.

26. For an initial orientation, see Paul Milgram and Fumio Kishino, "A Taxonomy of Mixed Reality Visual Displays," *IEICE Transactions on Information Systems* 77.12 (1994), pp. 1321–29; Valentino Catricalà and Ruggero Eugeni, "Technologically Modified Self-Centred Worlds," in Federico Biggio, Victoria Dos Santos, and Gianmarco T. Giuliana, eds., *Meaning-Making in Extended Reality* (Rome: Aracne 2020), pp. 63–90; Jay David Bolter, Maria Engberg, and Blair MacIntire, *Reality Media: Augmented and Virtual Reality* (Cambridge, MA: MIT Press, 2021).

27. Celant, *Ambiente/Arte*, p. 8. In a retrospective interview given in 2018, Celant explicitly referred to terms such as "immersive installation" and "enveloping process." "Inside Ambiente/Arte: Introduction/Interview with Germano Celant," in *Ambiente/arte*, pp. vii and xii.

28. Umberto Boccioni, "Futurist Painting: Technical Manifesto" (April 11, 1910), in *Futurist Manifestos*, ed. Umbro Apollonio, trans. Robert Brain and R. W. Flint (Boston: MFA Publications, 2001), p. 28.

29. Umberto Boccioni, "Technical Manifesto of Futurist Sculpture" (April 11, 1912), in *Futurist Manifestos*, pp. 62–63.

30. Carlo Carrà, "The Painting of Sounds, Noises and Smells" (August 11, 1913), in *Futurist Manifestos*, p. 115.

31. Filippo Tommaso Marinetti, "Tactilism" (1921), in *Futurist Manifestos*, pp. 110–11.

32. See the surveys by Julie H. Reiss, *From Margin to Center: The Spaces of Installation Art* (Cambridge, MA: MIT Press, 1999), and Claire Bishop, *Installation Art: A Critical History* (London: Tate, 2005). However, both of these studies overlook the founding role of futurism in establishing the "installation" orientation of contemporary art.

33. See the texts collected in Allan Kaprow, *Assemblage, Environments and Happenings* (New York: Harry N. Abrams, 1966); Ilya Kabakov, *On the Total Installation* (Bielefeld: Kerber, 2008). See also the collections Allan Kaprow, *Essays on the Blurring of Art and Life* (Berkeley: University of California Press, 1993), and Ilya Kabakov, *On Art* (Chicago: University of Chicago Press, 2018).

34. Boris Groys, "Politics of Installation," *e-flux journal* 2 (2009), https://www.e-flux.com/journal/02/68504/politics-of-installation.

35. Paolo Spinicci, *Il palazzo di Atlante: Contributi per una fenomenologia della rappresentazione prospettica* (Milan: Guerini, 1997), p. 11, Translation by the author.

36. Leon Battista Alberti, *On Painting* 2.26, trans. Rocco Sinisgalli (1435; Cambridge: Cambridge University Press, 2011), pp. 39 and 34. On the evolution of the Albertian window, see Anne Friedberg, *The Virtual Window: From Alberti to Microsoft* (Cambridge, MA: MIT Press, 2009).

37. Of the many studies devoted to such a device, I will mention only Hubert Damisch, *The Origin of Perspective*, trans. John Goodman (Cambridge, MA: MIT Press, 1994), and Emmanuel Alloa, *Partages de la perspective* (Paris: Fayard, 2020).

38. Erwin Panofsky, *Perspective as Symbolic Form*, trans. Christopher S. Wood (New York: Zone Books, 1991), p. 67.

39. Giorgio Vasari, "The Life of Masaccio from San Giovanni di Valdarno, Painter," in *Lives of the Artists*, p. 104.

40. The engraving was included at the end of the Dürerian treatise *Underweysung der Messung mit dem Zyrckel und Richtscheyt* (first published in 1525) only in the posthumous second edition, published in 1538 in Nuremberg for Hieronymus Andreae Formschneider.

41. On the grid, see Jack H. Williamson, "The Grid: History, Use, and Meaning," *Design Issues* 3.2 (1986), pp. 15–30; Bernhard Siegert, "Waterlines: Striated and Smooth Spaces as Techniques of Ship Design," in *Cultural Techniques*, pp. 153–54.

42. See Jean Clair, "Duchamp and the Classical Perspectivists," *Artforum* 16.7 (1978), pp. 40–50.

43. On Palazzo Te as theory in practice and Giulio's de facto response to contemporary debates on the visual arts, see Sally Hickson, "More Than Meets the Eye: Giulio Romano, Federico II Gonzaga, and the Triumph of Trompe-l'Oeil at the Palazzo del Te in Mantua," in Leslie Anne Boldt-Irons, Corrado Federici, and Ernesto Virgulti, eds., *Disguise, Deception, Trompe-l'Oeil: Interdisciplinary Perspectives* (New York: Peter Lang, 2009), pp. 41–59.

44. Ovid, *Metamorphoses*, trans. A. D. Melville (Oxford: Oxford University Press, 1998), book 1, vv. 152–55, p. 5.

45. Giorgio Vasari, "Giulio Romano: Pittore et Architetto," in *Le vite de' più eccellenti pittori scultori e architettori*, 6 vols. (Florence: Sansoni, 1971), vol. 3, pp. 71–72.

46. Giorgio Vasari, "The Life of Giulio Romano, Painter," in *Lives of the Artists*, p. 373.

47. Ibid.

48. See Paula Carabell, "Breaking the Frame: Transgression and Transformation in Giulio Romano's Sala dei Giganti," *Artibus et Historiae* 18.38 (1997), pp. 87–100.

49. E. H. Gombrich, "Zum Werke Giulio Romanos: Der Palazzo del Te," *Jahrbuch der Kunsthistorischen Sammlungen in Wien* 8 (1934), p. 101. The feeling of suffocating oppression is significantly compared with the anguished experience of the protagonist of Edgar Allan Poe's short story "The Pit and the Pendulum." See *The Pit and The Pendulum and Other Stories* (London: Penguin Books, 1995), pp. 1–19.

50. Kurt W. Forster and Richard J. Tuttle, "The Palazzo del Te," *Journal of the Society of Architectural Historians* 30.4 (1971), p. 285.

51. See Stephan Oettermann, *The Panorama: History of a Mass Medium*, trans. Deborah Lucas Schneider (New York: Zone Books, 1997); Katie Trumpener and Tim Barringer, eds., *On the Viewing Platform: The Panorama Between Canvas and Screen* (New Haven: Yale University Press, 2020).

52. Silvia Bordini, *Storia del panorama: La visione totale nella pittura del XIX secolo* (Rome: Officina, 1984), p. 142.

53. Marvin Minsky, "Telepresence," *Omni* (June 1980), p. 50. See Matthew Lombard and Theresa Ditton, "At the Heart of It All: The Concept of Presence," *Journal of Computer-Mediated Communication* 3.2 (1997), unpaginated, https://doi.org/10.1111/j.1083-6101.1997.tb00072.x; Matthew Lombard et al., *Immersed in Media: Telepresence Theory, Measurement and Technology* (Cham: Springer, 2015).

54. See Erkki Huhtamo, *Illusions in Motion: Media Archaeology of the Moving Panorama and Related Spectacles* (Cambridge, MA: MIT Press, 2013).

55. Honoré de Balzac, *Old Man Goriot* (1834), trans. Olivia McCannon (London: Penguin Books, 2011), p. 46: "'still *aliverama?*'... ' The weather's mighty *coltorama*!'... 'Here comes a glorious *soupeaurama*.'"

56. Walter Benjamin, "Panorama," in *The Arcades Project*, trans. Howard Eiland and Kevin McLaughlin (Cambridge, MA: Belknap Press of Harvard University Press, 1999), Q.11, p. 527.

57. Dolf Sternberger, *Panorama of the Nineteenth Century*, trans. Joachim Neugroschel (1938; New York: Urizen Books, 1977); Gian Piero Brunetta, *Il viaggio dell'icononauta: Dalla camera oscura di Leonardo alla luce dei Lumière* (Venice: Marsilio, 1997); Vanessa R. Schwartz, *Spectacular Realities: Early Mass Culture in Fin-de-Siècle Paris* (Berkeley: University of California Press, 1998); Barbara Maria Stafford, Frances Terpak, and Isotta Poggi, eds., *Devices of Wonder: From the World in a Box to Images on a Screen* (Los Angeles: Getty Research Institute, 2001); Oliver Grau, *Virtual Art: From Illusion to Immersion* (Cambridge, MA: MIT Press, 2003), chapters 2 and 3, "Historic Spaces of Illusion," and "The

Panorama of the Battle of Sedan: Obedience through Presence," pp. 24–89 and 90–139, respectively.

58. Walter Benjamin, "Berlin Childhood Around 1900" (1933), trans. Howard Eiland, in *Selected Writings, Volume 3: 1935–1938*, eds. Howard Eiland and Michael W. Jennings (Cambridge, MA: Harvard University Press, 2002) p. 347. See Karin Gaa and Bernd Krüger, eds., *Das Kaiserpanorama: Berlin um 1900* (Berlin: Berliner Festspiele, 1984).

59. Jonathan Crary, *Suspensions of Perception: Attention, Spectacle, and Modern Culture* (Cambridge, MA: MIT Press, 1999); Veronica Peselmann, "Enacting Public Perception in the Late 19th Century: The Kaiserpanorama," *Figurationen* 17.2 (2016), pp. 70–88.

60. David Brewster, *The Stereoscope: Its History, Theory, and Construction* (London: J. Murray, 1856); Oliver Wendell Holmes, "The Stereoscope and the Stereograph," *Atlantic* (June 1859), pp. 738–48. See Paul Wing, *Stereoscopes: The First One Hundred Years* (Nashua: Transition, 1996); Laura Burd Schiavo, "From Phantom Image to Perfect Vision: Physiological Optics, Commercial Photography, and the Popularization of the Stereoscope," in Lisa Gitelman and Geoffrey B. Pingree, eds., *New Media, 1740–1915* (Cambridge, MA: MIT Press, 2003), pp. 113–37.

61. Ray Zone, *Stereoscopic Cinema and the Origins Of 3-D Film, 1838–1952* (Lexington: University Press of Kentucky, 2007); Miguel Almiron, Esther Jacopin, and Giusy Pisano, eds., *Stéréoscopie et illusion: Archéologie et pratiques contemporaines; Photographie, cinéma, arts numériques* (Villeneuve d'Ascq: Presses universitaires du Septentrion, 2018).

62. Walter Benjamin, "A Short History of Photography" (1931), in *One-Way Street and Other Writings*, trans. Edmund Jephcott and Kingsley Shorter (New York: Verso, 1997), p. 250.

63. Jonathan Crary, *Techniques of the Observer: On Vision and Modernity in the Nineteenth Century* (Cambridge, MA: MIT Press, 1990), p. 127. Emphasis in the original.

64. Leighton Evans, "'The Embodied Empathy Revolution...': Pornography and the Contemporary State of Consumer Virtual Reality," *Porn Studies* 8.1 (2021), pp. 121–27.

65. Quoted in Laurent Mannoni, *The Great Art of Light and Shadow: Archaeology of the Cinema*, trans. Richard Crangle (Exeter: University of Exeter Press, 2000), pp. 161–62. For the history of phantasmagoria, see pp. 141–75.

66. Lewis Carroll, "Phantasmagoria," in *Jabberwocky and Other Nonsense* (Mineola: Dover, 2001), pp. 25–35.

67. On this point see Barbara Grespi and Alessandra Violi, eds., *Apparizioni: Scritti sulla fantasmagoria* (Canterano: Aracne, 2019); on the device, see also Max Milner, *La*

fantasmagorie: Essai sur l'optique fantastique (Paris: Presses universitaires de France, 1982); Noam M. Elcott, "The Phantasmagoric *Dispositif*: An Assembly of Bodies and Images in Real Time and Space," *Grey Room* 62 (2016), pp. 42–71; Jérôme Prieur, *Lanterne magique: Avant le cinema* (Paris: Fario, 2021); Francesco Casetti, *Screening Fears: On Protective Media* (New York: Zone Books, 2023), in particular chapter 2, pp. 45–69.

68. Sean F. Johnston, *Holographic Visions: A History of New Science* (Oxford: Oxford University Press, 2006), and Johnston, *Holograms: A Cultural History* (Oxford: Oxford University Press, 2016), pp. 222–24. See the memoir by John Henry Pepper, *The True History of the Ghost: And All about Metempsychosis* (1890), reissued as Pepper, *The True History of Pepper's Ghost* (London: The Projection Box, 1996). On Pepper, see Jeremy Brooker, "The Polytechnic Ghost: Pepper's Ghost, Metempsychosis and the Magic Lantern at the Royal Polytechnic Institution," *Early Popular Visual Culture* 5.2 (2007), pp. 189–206.

69. Giovan Battista Della Porta, *Natural Magick in Twenty Books* (London: John Wright, 1669), book 17 ("Wherein are propounded Burning-glasses, and the wonderful sights to be seen by them"), chapter 12, p. 370.

70. See Tom Gunning, "To Scan a Ghost: The Ontology of Mediated Vision," *Grey Room* 26 (2007), pp. 94–127.

71. Jules Verne, *The Castle in Transylvania*, trans. Charlotte Mandell (1892; New York: Melville House, 2010), especially chapter 15.

72. Jimi Famurewa, "Inside the Bitter War to Bring Tupac and Michael Jackson Back to Life," *Wired*, May 8, 2018, https://www.wired.co.uk/article/tupac-michael-jackson-billie-holiday-dead-celebrity-holograms.

73. See Pietro Montani, *Tre forme di creatività: Tecnica, arte, politica* (Naples: Cronopio, 2017), p. 137.

74. "Microsoft HoloLens 2," https://www.microsoft.com/en-us/hololens. See Ruggero Eugeni, *The Wiener Galaxy: Algorithmic Images, Post-Media Dispositifs, and The New Political Economy of Light*, trans. Michael Bergstein (Amsterdam: Amsterdam University Press, forthcoming), chapters 1 and 2.

CHAPTER FIVE: THE SUBJECT IN QUESTION

1. *Ce que nous voyons, ce qui nous regarde* — literally "what we see, what looks back at us" — is the title of one of Georges Didi-Huberman's books (Paris: Editions de Minuit, 1992).

2. Louis Marin, "The Frame of Representation and Some of Its Figures," in *On Representation*, trans. Catherine Porter (Stanford: Stanford University Press, 2001), p. 358.

3. Leon Battista Alberti, *On Painting* 2.42, trans. Rocco Sinisgalli (1435; Cambridge: Cambridge University Press, 2011), p. 63.

4. Alois Riegl, *The Group Portraiture of Holland*, trans. Evelyn M. Kain and David Britt (1902; Los Angeles: Getty Research Institute, 1999), p. 256.

5. Michel Foucault, *The Order of Things: An Archaeology of the Human Sciences*, trans. Alan Sheridan (London: Routledge, 2005), pp. 5–6. On this and other discordant interpretations of the painting, see Alessandro Nova, ed., *Las Meninas: Velázquez, Foucault e l'enigma della rappresentazione* (Milan: il Saggiatore, 2003).

6. Meyer Schapiro, "Frontal and Profile as Symbolic Forms," in *Words and Pictures: On the Literal and the Symbolic in the Illustration of a Text* (The Hague: Mouton, 1973), pp. 38–39.

7. Aby Warburg, *Fragmente zur Ausdruckskunde*, in Ulrich Pfisterer and Hans Christian Hönes, eds., *Gesammelte Schriften*, 7 vols. (Berlin: Walter de Gruyter, 2015), vol. 4, annotation of 1888, p. 5, quoted in English in E. H. Gombrich, *Aby Warburg: An Intellectual Biography* (London: The Warburg Institute, 1970), p. 71.

8. Hartmut Böhme, "Rückenfiguren bei Caspar David Friedrich," in Gisela Greve, ed., *Caspar David Friedrich: Deutungen im Dialog* (Tübingen: Discord, 2006), pp. 49–94.

9. See Guntram Wilks, *Das Motiv der Rückenfigur und dessen Bedeutungswandlungen in der deutschen und skandinavischen Malerei zwischen 1800 und der Mitte der 1940er Jahre* (Marburg: Tectum, 2005), p. 18.

10. Margarete Koch, *Die Rückenfigur im Bild von der Antike bis zu Giotto* (Recklinghausen: Bongers, 1965).

11. Regine Prange, "Sinnoffenheit und Sinnverneinung als metapicturale Prinzipien: Zur Historizität bildlicher Selbstreferenz am Beispiel der Rückenfigur," in Verena Krieger and Rachel Mader, eds., *Ambiguität in der Kunst: Typen und Funktionen eines ästhetischen Paradigmas* (Cologne: Böhlau, 2010), p. 140.

12. Klaus Krüger, "Der Blick ins Innere des Bildes: Ästhetische Illusion bei Gerhard Richter," in Matthias Weiß et al., eds., *Zur Eigensinnlichkeit der Bilder* (Paderborn: Fink, 2017), p. 156.

13. Guido Kirsten, "Zur Rückenfigur im Spielfilm," *Montage AV* 20.2 (2011), pp. 103–24; Benjamin Thomas, ed., *Tourner le dos: Sur l'envers du personnage au cinema* (Saint Denis: Presses Universitaires de Vincennes, 2013).

14. Benjamin Beil, *Avatarbilder: Zur Bildlichkeit des zeitgenössischen Computerspiels* (Bielefeld: Transcript, 2012), pp. 131–70.

15. Wolfgang Kemp, ed., *Der Betrachter ist im Bild*, 2nd ed. (Berlin: Reimer, 1992); David

Freedberg, *The Power of Images: Studies in the History and Theory of Response* (Chicago: University of Chicago Press, 1989), p. 220–21; James Elkins, *The Object Stares Back: On the Nature of Seeing* (New York: Simon & Schuster, 1996); W. J. T. Mitchell, *What Do Pictures Want? The Lives and Loves of Images* (Chicago: University of Chicago Press, 2005); Hans Belting, "The Gaze in the Image: A Contribution to an Iconology of the Gazes," in Bernd Huppauf and Christoph Wulf, eds., *Dynamics and Performativity of Imagination: The Image between the Visible and the Invisible* (New York: Routledge, 2009), pp. 372–95; Horst Bredekamp, *Image Acts: A Systematic Approach to Visual Agency*, 2nd ed., trans. Elizabeth Clegg (Berlin: Walter de Gruyter, 2018), pp. 193–208.

16. Alfred Gell, *Art and Agency: An Anthropological Theory* (Oxford: Clarendon Press of Oxford University Press, 1998), pp. 116–20.

17. On the genealogy of the poster and the history of its effects, see Carlo Ginzburg, "Your Country Needs You: A Case Study in Political Iconography," *History Workshop Journal* 52.1 (2001), pp. 1–22; W. J. T. Mitchell, "What Do Pictures Really Want?," *October* 77 (1996), pp. 71–82.

18. Michael Fried, "Art and Objecthood" (1967), in *Art and Objecthood: Essays and Reviews* (Chicago: University of Chicago Press, 1998), pp. 148–72.

19. Denis Diderot, "Discours sur la poèsie dramatique" (1758), in *Oeuvres esthétiques* (Paris: Paul Vernière, 2018), pp. 179–287, quoted in English in Michael Fried, *Absorption and Theatricality: Painting and Beholder in the Age of Diderot* (Chicago: University of Chicago Press, 1980), p. 95.

20. See the testimony of actress Flore Corvée, in Henri d'Almeras, ed., *Mémoires de Mlle Flore, actrice des Variétés* (Paris: Société parisienne d'édition, 1903), p. 84. See Frederic William John, *Theatre and State in France, 1760–1905* (New York: Cambridge University Press, 1994), in particular chapter 4, "The Liberation of the Theatres," pp. 55–63.

21. Sergei Eisenstein, *Nonindifferent Nature: Film and the Structure of Things* (1945–1947), trans. Herbert Marshall (Cambridge: Cambridge University Press, 1987), p. 34.

22. See the materials collected in Rosamund Bartlett and Sarah Dadswell, eds., *Victory Over the Sun: The World's First Futurist Opera* (Exeter: University of Exeter Press, 2011).

23. *The New Oxford Annotated Bible: Revised Standard Version*, 2nd ed. (New York: Oxford University Press, 1973), p. 1211.

24. Heinrich Nissen, *Das Templum: Antiquarische Untersuchungen* (Berlin: Weidmann, 1869), in particular chapter 1, "Die Limitation," pp. 1–22. On this research rests the reflections on religious space of Ernst Cassirer, *The Philosophy of Symbolic Forms, Volume 2:*

Mythical Thought, trans. Ralph Manheim (1923; New Haven: Yale University Press, 1955), pp. 99–103.

25. On *templum* and "contemplate," see Daniel Arasse, *Histoires de peintures* (Paris: Denoël, 2004), p. 63–64, and Anna Caterina Dalmasso, "Cadre et *templum*: Une archéologie des limites de l'image," *La Part de l'Oeil* 33 (2020), pp. 257–75.

26. On similarities and differences between the Diderotian and Brechtian approaches, see Phoebe von Held, *Alienation and Theatricality: Diderot After Brecht* (London: Routledge, 2017).

27. On the function of *parabasis*, see Thomas K. Hubbard, *The Mask of Comedy: Aristophanes and the Intertextual Parabasis* (Ithaca: Cornell University Press, 1991).

28. Bertolt Brecht, "Alienation Effects in Chinese Acting," in *Brecht on Theatre: The Development of an Aesthetic*, trans. John Willett (New York: Hill & Wang, 1977), pp. 91–92.

29. Ibid., p. 92.

30. Jacques Rancière, *Eisenstein's Madness*, in *Film Fables*, trans. Emiliano Battista (Oxford: Berg, 2006), p. 31. Also along the same lines is Nico Baumbach, "Act Now!, or For an Untimely Eisenstein," in Naum Kleiman and Antonio Somaini, eds., *Sergei M. Eisenstein: Notes for a General History of Cinema* (Amsterdam: Amsterdam University Press, 2016), pp. 299–307, in particular, p. 305.

31. See the useful distinctions proposed by Catherine Bouko, "Le théâtre immersif est-il interactif? L'engagement du spectateur entre immersion et interactivité," *Tangence*, no. 108 (2015), pp. 29–50. See also James Frieze, ed., *Reframing Immersive Theatre* (London: Palgrave Macmillan, 2016). On the political-economic implications, see Adam Alston, *Beyond Immersive Theatre. Aesthetics, Politics and Productive Participation* (London: Palgrave Macmillan, 2016).

32. Roland Barthes, "Diderot, Brecht, Eisenstein," *Screen* 15.2 (1974), pp. 33–34.

33. Sergei Eisenstein, "Diderot a parlé de cinéma" (1943), in *Le mouvement de l'art*, French trans. François Albera and Naoum Kleiman (Paris: Cerf, 1986), pp. 77 and 78. See Jean-Claude Bonnet, "Diderot a inventé le cinéma," *Recherches sur Diderot et sur l'Encyclopédie* 18.1 (1995), pp. 27–33.

34. Eisenstein, "Diderot a parlé de cinéma," p. 83.

35. Ibid., p. 84.

36. Ibid., p. 90.

37. Ibid., p. 92.

38. Sergei Eisenstein, "On Stereocinema" (1947), trans. Sergey Levchin, in Janine Marchessault, Dan Adler, and Sanja Obradovic, eds., *3D Cinema and Beyond* (Bristol: Intellect, 2014), pp. 39 and 31.

39. On direct interpellation, see Tom Brown, *Breaking the Fourth Wall: Direct Address in the Cinema* (Edinburgh: Edinburgh University Press, 2012), and Federica Cavaletti, "A Transmedia Overturning: Direct Address from Theatre to Cinema," *Facta Ficta: Journal of Theory, Narrative & Media* 2.2 (2018), pp. 135–53.

40. On the point-of-view shot, see Edward R. Branigan, *Point of View in the Cinema: A Theory of Narration and Subjectivity in Classical Film* (New York: Mouton, 1984), pp. 103–121. and Elena Dagrada, *Between the Eye and the World: The Emergence of the Point-of-View Shot* (Brussels: Peter Lang, 2014).

41. See Julian Hanich, "Experiencing Extended Point-of-View Shots: A Film-Phenomenological Perspective on Extreme Character Subjectivity," in Maike Sarah Reinerth and Jan-Noël Thon, eds., *Subjectivity across Media: Interdisciplinary and Transmedial Perspectives* (New York: Routledge, 2017), pp. 127–44.

42. Eisenstein, "On Stereocinema," p. 51.

43. Nick Browne, "The Spectator-in-the-Text: The Rhetoric of 'Stagecoach,'" *Film Quarterly* 29.2 (1975–1976), p. 31.

44. See Bruce F. Kawin, "An Outline of Film Voices," in *Selected Film Essays and Interviews* (London: Anthem Press, 2013), pp. 153–66; Francesco Casetti, *Inside the Gaze: The Fiction Film and its Spectator*, trans. Nell Andrew with Charles O'Brien (Bloomington: Indiana University Press, 1999), pp. 45–66.

45. See Vivian Sobchack, *The Address of the Eye: A Phenomenology of Film Experience* (Princeton Princeton University Press, 1992), pp. 200–202.

46. Ruggero Eugeni, "First Person Shot: New Forms of Subjectivity between Cinema and Intermedia Networks," *Anàlisi* (2012), pp. 19–31.

47. Michael Hitchens, "A Survey of First-Person Shooters and Their Avatars," *International Journal of Computer Game Research* 11.3 (2011), pp. 96–120.

48. Steven Malliet and Gust De Meyer, "The History of the Video Game," in Joost Raessens and Jeffrey Goldstein, eds., *Handbook of Computer Game Studies* (Cambridge, MA: MIT Press, 2005), pp. 23–46.

49. For this taxonomy, see Agata Meneghelli, "Landscape and Action: Videogame Landscapes from Backgrounds to Whole World," in Enrico Prandi, ed., *Pubblico paesaggio: Documenti del Festival dell'Architettura 4 (2007–2008)* (Parma: Festival Architettura Edizioni, 2008), pp. 304–307.

50. Richard Bégin, "GoPro: Augmented Bodies, Somatic Images," in Dominique Chateau and José Moure, eds., *Screens* (Amsterdam: Amsterdam University Press, 2016), pp. 107–15.

51. Nick Paumgarten, "We Are a Camera: Experience and Memory in the Age of GoPro," *New Yorker*, September 22, 2014, https://www.newyorker.com/magazine/2014/09/22/camera.

52. Robbie Cooper, Julian Dibbel and Tracy Spaight, *Alter Ego: Avatars and their Creators* (London: Chris Boot, 2007).

53. Frédéric Tordo and Caroline Binkley, "L'auto-empathie médiatisée par l'avatar, une subjectivation de soi," in Étienne Armand Amato and Étienne Perény, eds., *Les avatars jouables des mondes numériques: Théories, terrains et témoignages de pratiques interactives* (Paris: Lavoisier, 2013), pp. 91–109.

54. Sofia Seinfeld et al., "Offenders Become the Victim in Virtual Reality: Impact of Changing Perspective in Domestic Violence," *Scientific Reports* 8.2692 (2018), pp. 1–11.

55. Tabitha C. Peck et al., "Putting Yourself in the Skin of a Black Avatar Reduces Implicit Racial Bias," *Consciousness and Cognition* 22.3 (2013), pp. 779–87; Béatrice S. Hasler, Bernhard Spanlang, and Mel Slater, "Virtual Race Transformation Reverses Racial In-Group Bias," *PLoS ONE* 12.4 (2017).

56. Lara Maister et al., "Changing Bodies Changes Minds: Owning Another Body Affects Social Cognition," *Trends in Cognitive Sciences* 19.1 (2015), pp. 6–12.

57. Simone Claire Mölbert et al., "Assessing Body Image in Anorexia Nervosa Using Biometric Self-Avatars in Virtual Reality: Attitudinal Components Rather Than Visual Body Size Estimation Are Distorted," *Psychological Medicine* 48.4 (2018), pp. 642–53; Silvia Serino, Nicoletta Polli and Giuseppe Riva, "From Avatars to Body Swapping: The Use of Virtual Reality for Assessing and Treating Body-Size Distortion in Individuals with Anorexia," *Journal of Clinical Psychology* 75 (2019), pp. 313–22.

58. Catherine E. Myers et al., "Beyond Symptom Self-Report: Use of a Computer 'Avatar' to Assess Post-Traumatic Stress Disorder (PTSD) Symptoms," *Stress* 19.6 (2016), pp. 593–98.

59. Denise Doyle, *New Opportunities for Artistic Practice in Virtual Worlds* (Hershey: Information Science Reference, 2015).

60. *Kool-Aid Man in Second Life (2008–2011)*, website of the project by Jon Rafman, http://koolaidmaninsecondlife.com.

61. For *Bad Corgi*, see The Serpentine's website, https://www.serpentinegalleries.org/whats-on/ian-cheng-bad-corgi. For *Emissary Forks at Perfection*, see the artist's website, http://iancheng.com/emissaries.

62. LaTurbo Avedon, https://turboavedon.com.

63. "Art Section," *Second Life* website, https://secondlife.com/destinations/art.

64. François Garnier, Loup Vuarnesson and Alain Berthoz, "An Immersive Paradigm to Study Emotional Perception in Co-Presence through Avatars," *International Journal of Virtual Reality* 17.2 (2017), pp. 46–64.

65. Ralph Schroeder, ed., *The Social Life of Avatars: Presence and Interaction in Shared Virtual Environments* (London: Springer, 2002).

66. Natalie Depraz, *Avatar "Je te vois": Une expérience philosophique* (Paris: Ellipses, 2012).

67. Pierre Jules Théophile Gautier, *Avatar, or, The Double Transformation* (1856; New York: Frank F. Lovell, 1888).

68. Paul Hacker, "Zur Entwicklung der Avatāralehre," *Wiener Zeitschrift für die Kunde Süd- und Ostasiens* 4 (1960), pp. 47–70; David Kinsley, s.v. "Avatāra," in Lindsay Jones, ed., *Encyclopedia of Religion*, 2nd ed. (Farmington Hills: Thomson Gale, 1987).

69. Edward Geoffrey Parrinder, *Avatar and Incarnation: The Divine in Human Form in the World's Religions* (Oxford: Oneworld, 1997); Noel Sheth, "Hindu Avatāra and Christian Incarnation: A Comparison," *Philosophy East and West* 52.1 (2002), pp. 98–125.

70. Maxime Aubert et al., "Pleistocene Cave Art from Sulawesi, Indonesia," *Nature* 514.7521 (2014), pp. 223–27.

71. Jean-Louis Baudry, "The Apparatus: Metapsychological Approaches to the Impression of Reality in Cinema," in Philip Rosen, ed., *Narrative, Apparatus, Ideology: A Film Theory Reader* (New York: Columbia University Press, 1986), pp. 299–302.

72. Joseph Nechvatal, "Immersive Excess in the Apse of Lascaux," *Technoetic Arts: A Journal of Speculative Research* 3.3 (2005), pp. 181–92; Bruno Di Marino, *Nel centro del quadro: Per una teoria dell'arte immersiva dal mito della caverna alla VR* (Milan: Aesthetica edizioni, 2021).

73. Siddhesh, Manjrekar et al., "CAVE: An Emerging Immersive Technology; a Review," *UKSim-AMSS: 16th International Conference on Computer Modelling and Simulation* (2014), pp. 130–36.

CHAPTER SIX: IN/OUT

1. Sven Lindqvist, *The Myth of Wu Tao-Tzu* (London: Granta, 2012). See Shieh Jhy-Wey, "Grenze wegen Öffnung geschlossen: Zur Legende vom chinesischen Maler, der in seinem Bild verschwindet," in Jürgen Wertheimer and Susanne Gösse, eds., *Zeichen lesen, Lese-Zeichen* (Tübingen: Stauffenburg, 1999), pp. 201–25.

2. William Anderson, *Descriptive and Historical Catalogue of a Collection of Japanese and Chinese Paintings in the British Museum* (London: Longmans, 1886), p. 485.

3. Herbert Allen Giles, *An Introduction to the History of Chinese Pictorial Art*, 2nd ed. (London: Quaritch, 1918), p. 52.

4. Romanized by Giles as P'u Sung-ling in the Wade-Giles system that Giles helped to create.

5. P'u Sung-ling, "The Painted Wall," in *Strange Stories from a Chinese Studio*, trans. Herbert A. Giles, 2 vols. (London: Thomas De La Rue, 1880), vol. 1, p. 12.

6. Giles, in *Strange Stories from a Chinese Studio*, p. 10 n.1.

7. Kôsai Ishikawa, *Yasô Kidan*, vol. 1 and vol. 2 (Tokyo: Azuma Kenzaburô, 1889, 1894).

8. Lafcadio Hearn, "The Story of Kwashin Koji," in *A Japanese Miscellany* (Boston: Little Brown, 1901), p. 51. See Sukehiro Hirakawa, "Animistic Belief and Its Use in Japanese Literature: The Final Disappearance of Kwashin Koji," in Kinya Tsuruta, ed., *Proceedings of the Conference on Nature and Selfhood in Japanese Literature* (Vancouver: University of British Columbia, 1993), pp. 79–85.

9. Marguerite Yourcenar, "How Wang-Fô Was Saved" (1936), in *Oriental Tales*, trans. Alberto Manguel (New York: Farrar, Straus and Giroux, 1985), p. 18. See Angelica Rieger, *"Comment Wang-Fô fut sauvé* de Marguerite Yourcenar, ou le tableau qui sauve," in Jean-Pierre Guillerm, ed., *Récits/tableaux* (Lille: Presses Universitaires de Lille, 1994), pp. 201–14.

10. Published by Rütten & Loening, Frankfurt am Main, 1911; the story of the painted wall ("Das Wandbild") is on pp. 1–5.

11. Béla Balázs, *Hét mese* (Gyoma: Kner, 1918), pp. 185–200 and in German, *Sieben Märchen* (Vienna: Rikola, 1921). Balázs edited a second collection of Chinese stories, *Der Mantel der Träume: Chinesische Novellen* (Munich: Bischoff, 1922). On the *Sieben Märchen*, see György Lukács, "Béla Balázs: *Hét mese*," in *Balázs Béla és akiknek nem kell: Összegyüjtört tanulmánok* (Gyoma: Kner Izidor kiadása, 1918), pp. 103–21.

12. Béla Balázs, "The Book of Wan Hu-Chen," in *The Cloak of Dreams: Chinese Fairy Tales*, trans. Jack Zipes (Princeton: Princeton University Press, 2010), p. 171.

13. Ernst Bloch, "Motive des inneren Verschwindens," in *Durch die Wüste* (Berlin: Cassirer, 1923), p. 146.

14. Ernst Bloch, *Traces* (1930), trans. Anthony A. Nassar (Stanford: Stanford University Press, 2006), p. 118. See Bernhard Greiner, *Hinübergehen in das Bild und Errichten der Grenze*, in Jürgen Wertheimer and Susanne Göße, eds., *Zeichen lesen, Lese-Zeichen* (Tübingen: Stauffenburg, 1999), pp. 175–99.

15. Walter Benjamin, "Berlin Childhood Around 1900" (1933), trans. Howard Eiland, in

Selected Writings, Volume 3: 1935–1938, ed. Howard Eiland and Michael W. Jennings (Cambridge, MA: Harvard University Press, 2002), p. 393. The reference to the legend disappears in "The Mummerehlen" version of the second draft (1938).

16. Walter Benjamin, "The Work of Art in the Age of Its Technological Reproducibility," 2nd version (1936), trans. Edmund Jephcott and Harry Zohn, in *The Work of Art in the Age of Its Technological Reproducibility, and Other Writings on Media*, eds. Michael W. Jennings, Brigid Doherty, and Thomas Y. Levin (Cambridge, MA: Belknap Press of Harvard University Press, 2008), pp. 39–40. The legend is mentioned in all but the first draft of the essay.

17. On the meaning of this interpretive reversal, see Andrea Pinotti, "The Painter through the Fourth Wall of China: Benjamin and the Threshold of the Image," *Benjamin-Studien* 3 (2014), pp. 133–49.

18. See Giovanni Gurisatti, "Due fisionomi al cinema: Benjamin, Balázs e l'anti-arte cinematografica," in Bruna Giacomini, Fabio Grigenti, and Laura Sanò, eds., *La passione del pensare: In dialogo con Umberto Curi* (Milan: Mimesis, 2011), pp. 527–46. On Benjamin and Kracauer, see Miriam Hansen, *Cinema and Experience: Siegfried Kracauer, Walter Benjamin, and Theodor W. Adorno* (Berkeley: University of California Press, 2012).

19. Siegfried Kracauer, *Theory of Film: The Redemption of Physical Reality* (Princeton: Princeton University Press, 1997), p. 165.

20. On the influence exerted by Simmel, see Gertrud Koch, "Béla Balázs: The Physiognomy of Things," *New German Critique* 40 (1987), pp. 167–77.

21. Béla Balázs, *Theory of the Film: Character and Growth of A New Art,* trans. Edith Bone (London: Dennis Dobson, 1952), p. 50.

22. On the role played by the dream dimension in Keaton's film see Mireille Berton, "L'illusion de réalité à l'épreuve de la scene: Théâtre, cinéma et rêve dans Sherlock Junior de Buster Keaton," *Pavillon: Une Revue de scénographie/scénologie* 1 (2007), pp. 6–17; Giancarlo Grossi, *La notte dei simulacri: Sogno, cinema, realtà virtuale* (Monza: Johan & Levi, 2021), pp. 78–79.

23. See on this theme Francesco Casetti, *Eye of the Century: Film, Experience, Modernity*, trans. Erin Larkin with Jennifer Pranolo (New York: Columbia University Press, 2008) pp. 144–49, and Mauro Carbone, *Philosophy-Screens: From Cinema to the Digital Revolution*, trans. Marta Nijhuis (Albany: State University of New York Press, 2019), pp. 81–91.

24. Bernhard Siegert, *Cultural Techniques: Grids, Filters, Doors, and Other Articulations of the Real*, trans. Geoffrey Winthrop-Young (New York: Fordham University Press, 2015), pp. 204 and 205. Siegert adds, "*Videodrome* teaches us how difficult/impossible it has become

to determine whether the perception of a thing corresponds to an inner or outer reality.... No one knows anymore whether a door opens to the imaginary or to the real." Ibid., p. 205.

25. "George Clooney and Natalie Dormer Star in Latest Nespresso Campaign, 'The Quest,'" https://www.nestle-nespresso.com/media/mediareleases/george-clooney-natalie-dormer-nespresso-campaign-quest.

26. Georg Simmel, "Bridge and Door" (1909), trans. Mark Ritter, *Theory, Culture & Society* 11 (1994), p. 7.

27. "I'm going like a painting-locomotive." Vincent van Gogh, letter to Theo, Arles, ca. Sept. 11, 1888, in *The Letters*, eds. Leo Jansen, Hans Luitjen and Nienke Bakker, 6 vols. (London: Thames & Hudson, 2009), vol. 4, p. 268.

28. For an analysis of this episode from the perspective of immersiveness, see Pietro Conte, *Unframing Aesthetics* (Milan: Mimesis International, 2020), pp. 95–98, and José Manuel Martins, "'Crows' vs. 'Avatar': or, 3D vs. Total-Dimension Immersion," *Film and Media Studies* 8 (2014), pp. 79–96.

29. Benjamin, "The Work of Art in the Age of Its Technological Reproducibility," p. 38.

30. Martin Loiperdinger and Bernd Elzer, "Lumière's *Arrival of the Train*: Cinema's Founding Myth," *Moving Image* 4.1 (2004), pp. 89–118. See also Stephen Bottomore, "The Panicking Audience? Early Cinema and the 'Train Effect,'" *Historical Journal of Film, Radio, and Television* 19.2 (1999), pp. 177–216.

31. A festival specifically dedicated to this relationship, "CineRAIL Festival International Trains & Cinema," was organized for more than two decades starting from 1992. See http://www.cinerail.fest.com

32. Wolfgang Schivelbusch, "Railroad Space and Railroad Time," *New German Critique* 14 (1978), pp. 31–40.

33. See Patrick Keiller, "Phantom Rides: The Railway and Early Film," in Matthew Beaumont and Michael J. Freeman, eds., *The Railway and Modernity: Time, Space, and the Machine Ensemble* (Oxford: Peter Lang, 2008), pp. 69–84.

34. On the genre, see Miriam Hansen, *Babel and Babylon: Spectatorship in American Silent Film* (Cambridge, MA: Harvard University Press, 1991), chapter 1, "A Cinema in Search of a Spectator: Film-Viewer Relations before Hollywood," pp. 23–59, and Wanda Strauven, "Early Cinema's Touch(able) Screens: From Uncle Josh to Ali Barbouyou," *Necsus* 1.2 (2012), pp. 155–76.

35. Christa Blümlinger, "Lumière, the Train and the Avant-Garde," in Wanda Strauven, ed., *The Cinema of Attractions Reloaded* (Amsterdam: Amsterdam University Press, 2006), pp. 245–64.

36. Within, "Evolution of Verse," YouTube, https://www.youtube.com/watch?v=5GcTaEiRzDo. See Anna Caterina Dalmasso, "I nuovi limiti della visione: Cornice e fuori campo tra soggettiva e realtà virtuale," *Fata Morgana* 13.39 (2019), pp. 33–53.

37. Maria Engberg and Jay David Bolter, "The Aesthetics of Reality Media," *Journal of Visual Culture* 19.1 (2020), pp. 81–95. See also Jay David Bolter, Maria Engberg, and Blair McIntyre, *Reality Media: Augmented and Virtual Reality* (Cambridge, MA: MIT Press, 2021).

38. Christian Metz, *The Imaginary Signifier: Psychoanalysis and the Cinema*, trans. Celia Britton, Annwyl Williams, Ben Brewster, and Alfred Guzzetti (Bloomington: Indiana University Press, 1982), p. 73.

39. Starting from the Lumières' train, Tom Gunning lays emphasis on astonishment in "An Aesthetic of Astonishment: Early Film and the (In)Credulous Spectator" (1989), in Linda Williams, ed., *Viewing Positions: Ways of Seeing Film* (New Brunswick: Rutgers University Press, 1995), pp. 114–33.

40. Sergei Eisenstein, *Nonindifferent Nature: Film and the Structure of Things*, trans. Herbert Marshall (Cambridge: Cambridge University Press, 1987) p. 34. See the evocation of the project also in Sergei Eisenstein, "On Stereocinema" (1947), trans. Sergey Levchin, in Janine Marchessault, Dan Adler, and Sanja Obradovic, eds., *3D Cinema and Beyond* (Bristol: Intellect, 2014), p. 42.

41. Reproduced in Sergei Eisenstein, *Le mouvement de l'art* (Paris: Éditions du Cerf, 1986), pp. 136–37. For the definition of the project as *acte manqué* see Massimo Olivero, "Le concept d'extase: Le cas de l'écran déchiré," in Philippe Dubois, Frédéric Monvoisin, and Elena Biserna, eds., *Extended Cinema: Le cinéma gagne du terrain* (Pasian di Prato: Campanotto, 2010), p. 150.

42. Eisenstein, "On Stereocinema," p. 20.

43. See the article by Louis Lumière, "Stereoscopy on the Screen," *Society of Motion Picture Engineers Journal* 27 (1936), later reproduced in Michael D. Smith et al., eds., *3-D Cinema and Television Technology: The First 100 Years* (White Plains: SMPTE, 2011), pp. 96–101. See also the catalog of the exhibition at the Musée Carnavalet, Françoise Reynaud, Catherine Tambrun, and Kim Timby, eds., *Paris in 3D: From Stereoscopy to Virtual Reality 1850–2000* (Paris: Paris-Musées, 2000), p. 123.

44. Eisenstein, "On Stereocinema," p. 23.

45. Ibid., p. 22.

46. See, for example, the reference to the *Naturalis Historia* contained in Eisenstein, *Nonindifferent Nature*, p. 103.

47. Eisenstein, "On Stereocinema," p. 26.

48. Ibid., p. 130.

49. Ibid., p. 134.

50. See Sergei Eisenstein, *Towards a Theory of Montage* (1937), trans. Michael Glenny (London: I. B. Tauris, 2010), p. 168.

51. Eisenstein, *Nonindifferent Nature*, p. 13.

52. Ibid., p. 27.

53. See Aby Warburg, "Dürer and Italian Antiquity" (1905), in *The Renewal of Pagan Antiquity: Contributions to the Cultural History of the European Renaissance*, trans. David Britt (Los Angeles: Getty Research Institute for the History of Art and Humanities, 1999), p. 555.

54. Eisenstein, *Nonindifferent Nature*, p. 168. For a comparison, see Sylvia Sasse, "Pathos und Antipathos: Pathosformeln bei Sergej Ejsenstejn und Aby Warburg," in Cornelia Zumbusch, ed., *Pathos: Zur Geschichte einer problematischen Kategorie* (Berlin: Akademie-Verlag, 2010), pp. 171–90, and Antonio Somaini, *Ejzenštein: Il cinema, le arti, il montaggio* (Turin: Einaudi, 2011), pp. 363–67.

55. Eisenstein, *Nonindifferent Nature*, p. 27.

56. Eisenstein, "On Stereocinema," p. 56.

57. Among the many places where Marshall McLuhan expounds his conception of "rearview mirror," see this formulation in the aforementioned interview with *Playboy* in 1969: "Because of the invisibility of any environment during the period of its innovation, man is only consciously aware of the environment that has preceded it; in other words, an environment becomes fully visible only when it has been superseded by a new environment; thus we are always one step behind in our view of the world." In Frank Zingrone and Eric McLuhan, eds., *Essential McLuhan* (London: Routledge, 1997), p. 227.

58. On filmic framing as "frame" see Thomas Elsaesser and Malte Hagener, *Film Theory: An Introduction Through the Senses*, 2nd ed. (New York: Routledge, 2015), chapter 1, "Cinema as Window and Frame," pp. 3–30. For a quick introduction to the concept, see Emmanuel Siety, *Le plan au commencement du cinéma* (Paris: Cahiers du Cinéma, 2001).

59. See Davide Scaramuzza, "Omnidirectional Camera," in Katsushi Ikeuchi, ed., *Computer Vision: A Reference Guide* (New York: Springer, 2014), pp. 552–60, and Peter Sturm, "Omnidirectional Vision," ibid., pp. 552–62.

60. On the history of 3-D cinema see: Lenny Lipton, *Foundations of the Stereoscopic Cinema: A Study in Depth* (New York: Van Nostrand Reinhold, 1982); Ray Zone, *Stereoscopic Cinema and the Origins of 3-D Film, 1838–1952* (Lexington: University Press of Kentucky,

2007); Miriam Ross, *3-D Cinema: Optical Illusions and Tactile Experiences* (Basingstoke: Palgrave Macmillan, 2015); David A. Cook, *A History of Three-Dimensional Cinema* (London: Anthem Press, 2021), on VR and 3-D, esp. chapter 8, pp. 137–50. See also the online archive at http://www.3dfilmarchive.com.

61. Thomas Elsaesser, "The 'Return' of 3-D: On Some of the Logics and Genealogies of the Twenty-First-Century," *Critical Inquiry* 39.2 (Winter 2013), pp. 235, 221, 241. See also Elsaesser, *Film History as Media Archaeology: Tracking Digital Cinema* (Amsterdam: Amsterdam University Press, 2016), esp. section 5, "Archaeologies of Interactivity," pp. 191–208.

62. Akira Mizuta Lippit, "Three Phantasies of Cinema — Reproduction, Mimesis, Annihilation," *Paragraph* 22.3 (1999), p. 213. See also Lippit, "Virtual Annihilation: Optics, VR, and the Discourse of Subjectivity," *Criticism* 36.4 (1994), pp. 595–610.

63. René Barjavel, *Cinéma total: Essai sur les formes futures du cinema* (Paris: Denoël, 1944), p. 60. See Alfio Leotta, "Total Cinema: René Barjavel and the Future Forms of Film," *Screen* 59.3 (2018), pp. 372–80.

64. Barjavel, *Cinéma total*, p. 59.

65. Ibid., pp. 67–68.

66. "Microsoft HoloLens 2," https://www.microsoft.com/en-us/hololens.

67. Paul Valéry, "The Conquest of Ubiquity" (1928), in *The Collected Works of Paul Valery*, ed. Jackson Mathews, vol. 13, *Aesthetics*, trans. Ralph Manheim (New York: Pantheon Books, 1964), pp. 225–26.

68. André Bazin, "The Myth of Total Cinema" (1946), in *What Is Cinema?*, trans. Hugh Gray, 2 vols. (Berkeley: University of California Press, 1956), vol. 1, pp. 20–21.

69. On large-format filmmaking, see Robert E. Carr and R. M. Hayes, *Wide Screen Movies: A History and Filmography of Wide Gauge Filmmaking* (Jefferson: McFarland, 1988).

70. André Bazin, "The House of Wax: Scare Me . . . in Depth!" (1953), in *André Bazin's New Media*, trans. Dudley Andrew (Oakland: University of California Press, 2014), pp. 251–53.

71. André Bazin, "The Real Crime on La Rue Morgue: They Assassinated a Dimension!" (1955), in ibid., p. 255.

72. André Bazin, "The 3D Revolution Did Not Take Place" (1956), ibid., p. 262.

73. André Bazin, "Will a War in Three Dimensions Take Place?" (1953), in ibid., p. 245–45

74. Adolfo Bioy Casares, "The Invention of Morel," in *The Invention of Morel: And Other Stories from "La trama celeste"* (1940), trans. Ruth L. C. Simms (Austin: University of Texas Press, 1985), p. 66. On this natural-machine assemblage, see Francesco Casetti and

NOTES

Andrea Pinotti, "Post-Cinema Ecology," in Dominique Chateau and José Moure, eds., *Post-Cinema: Cinema in the Post-Art Era* (Amsterdam: Amsterdam University Press, 2020), pp. 193–217.

75. In being inspired by Bioy Casares's novel, Emidio Greco had been preceded by Alain Resnais with the film *Last Year at Marienbad* (1961) and by Claude-Jean Bonnardot with the television film *The Invention of Morel* (1967). See also the transposition into comic format by Jean-Pierre Mourey, *L'invention de Morel* (Brussels: Casterman, 2007). The famous ABC network TV series *Lost* (2004–2010) is also indebted to the novel. In season 4, episode 4, we see the character James "Sawyer" Ford (Josh Holloway) reading precisely that book.

76. Bioy Casares, "The Invention of Morel," p. 63.

77. Ibid., p. 90. See Alf Seegert, "The Mistress of Sp[l]ices: Technovirtual Liaisons in Adolfo Bioy Casares's 'The Invention of Morel'," *Journal of the Fantastic in the Arts* 23.2 (2012), pp. 197–214.

78. See Joseph Maddrey, *Brainstorm* (Liverpool: Liverpool University Press, 2020).

79. See Steven Shaviro, "Straight from the Cerebral Cortex: Vision and Affect in *Strange Days*," in Deborah Jermyn and Sean Redmond, eds., *The Cinema of Kathryn Bigelow: Hollywood Transgressor* (London: Wallflower Press, 2003), pp. 159–77.

80. Henry Jenkins, "Enhanced Memory: 'The Entire History of You'," in Terrence McSweeney and Stuart Joy, eds., *Through the Black Mirror: Deconstructing the Side Effects of the Digital Age* (Basingstoke: Palgrave Macmillan, 2019), pp. 43–54.

CHAPTER SEVEN: EMPATHY MACHINE?

1. Gene Youngblood, *Expanded Cinema: Fiftieth Anniversary Edition* (1970; New York: Fordham University Press, 2020), p. 83. See Federico Biggio, "Augmented Consciousness: Artificial Gazes Fifty Years after Gene Youngblood's *Expanded Cinema*," *NECSUS European Journal of Media Studies* 9.1 (2020), pp. 173–92.

2. Ágoston Török et al., "It Sounds Real When You See It: Realistic Sound Source Simulation in Multimodal Virtual Environments," *Journal on Multimodal User Interfaces* 9 (2015), pp. 323–31.

3. Mark Paterson, *The Senses of Touch: Haptics, Affects and Technologies* (Oxford: Berg, 2007); David Parisi, *Archaeologies of Touch: Interfacing with Haptics from Electricity to Computing* (Minneapolis: University of Minnesota Press, 2018).

4. Matthieu Ischer et al., "How Incorporation of Scents Could Enhance Immersive Virtual Experiences," *Frontiers in Psychology* 5 (2014), p. 736; Marina Carulli, Monica

Bordegoni, and Umberto Cugini, "Integrating Scents Simulation in Virtual Reality Multisensory Environment for Industrial Products Evaluation," *Computer-Aided Design and Applications* 13.3 (2016), pp. 320–28.

5. "The Gender Swap," BeAnotherLab website, https://beanotherlabalreadyexists.wordpress.com/gender-swap-experiment.

6. Mel Slater et al., "First Person Experience of Body Transfer in Virtual Reality," *PLoS ONE* 5.5 (2010), e10564, and Tabitha C. Peck et al., "Putting Yourself in the Skin of a Black Avatar Reduces Implicit Racial Bias," *Consciousness and Cognition* 22.3 (2013), pp. 779–87.

7. Quoted in Adi Robertson, "VR Was Sold as an 'Empathy Machine'—But Some Artists Are Getting Sick Of It," *Verge*, May 3, 2017, https://www.theverge.com/2017/5/3/15524404/tribeca-film-festival-2017-vr-empathy-machine-backlash.

8. Ian Boyden, "Not Yet Complete: An Interview with Ai Weiwei: Part 5: The Conditions of Empathy," *China Heritage*, October 28, 2018, http://chinaheritage.net/journal/the-conditions-of-empathy-ai-weiwei-interview-part-5.

9. Quoted in the online presentation of Ai Weiwei's work *Omni*, https://acuteart.com/artist/ai-weiwei.

10. Nonny de la Peña et al., "Immersive Journalism: Immersive Virtual Reality for the First-Person Experience of News," *Presence* 19.4 (2010), pp. 291–301.

11. Chris Milk, "How Virtual Reality Can Create the Ultimate Empathy Machine," *TED Talk*, April 22, 2015, https://www.ted.com/talks/chris_milk_how_virtual_reality_can_create_the_ultimate_empathy_machine.

12. *Clouds over Sidra* (created by Chris Milk and Gabo Arora and directed by Gabo Arora and Barry Pousman), *Waves of Grace* (directed by Chris Milk with Gabo Arora), and *My Mother's Wing* (produced by Gabo Arora with Chris Milk) can be accessed on YouTube. For a critical analysis of Milk's work see Francesco Zucconi, *Displacing Caravaggio: Art, Media, and Humanitarian Visual Culture* (Cham: Palgrave Macmillan, 2018), in particular chapter 5, "On the Limits of the Virtual Humanitarian Experience," pp. 149–81.

13. See the presentation of this collaboration, *Virtual Reality Inspires Humanitarian Empathy at the United Nations*, accessible on YouTube.

14. On this work, see Joost Raessens, "Virtually Present, Physically Invisible: Alejandro G. Iñárritu's Mixed Reality Installation *Carne y Arena*," *Television & New Media* 20.6 (2019), pp. 634–48; Luca Acquarelli, "The Spectacle of Reenactment and the Critical Time of Testimony in Alejandro Gonzales Iñárritu's *Carne y Arena*," in Antonio Rafele, Frederick Luis Aldama, and William Anthony Nericcio, eds., *Cultural Studies in the Digital Age* (San

Diego: San Diego State University Press, 2021), pp. 159–80; Francesco Buscemi, "The Paradox of the Virtual: Iñárritu's *Carne y Arena* between Innovative Spect-actor and Traditional Fruition," *New Techno-Humanities* 2 (2022), pp. 108–12.

15. See the "Hyper-Gastronomy" synesthetic program at www.projectnourished.com.

16. The Phillips Collection, "Carne y Arena: Art and Technology," interview with Alejandro G. Iñárritu on YouTube, https://www.youtube.com/watch?v=-XcvJ6lUTwI.

17. "There's a lot of talk in this country about the federal deficit. But I think we should talk more about our empathy deficit—the ability to put ourselves in someone else's shoes.... We live in a culture that discourages empathy." Barack Obama, "Northwestern University Commencement Address, June 16, 2006," http://obamaspeeches.com/079-Northwestern-University-Commencement-Address-Obama-Speech.htm.

18. This statement by Iñárritu recurs in the texts accompanying the installation, e.g., https://www.eyefilm.nl/en/whats-on/carne-y-arena-virtually-present-physically-invisible/507887. For a phenomenological critique of the rhetoric of *Carne y Arena*'s framing, see Anna Caterina Dalmasso, "The Body as Virtual Frame: Performativity of the Image in Immersive Environments," *Cinéma & Cie* 19.32 (2019), pp. 101–19.

19. On the contrary, Mark Andrejevic and Zala Volcic claim recognition of the mediated and "linguistic" character of representation and its framing in "Virtual Empathy," *Communication, Culture and Critique* 13.3 (2020), pp. 295–310.

20. On this aspect see Pierre Lévy, *Becoming Virtual: Reality in the Digital Age*, trans. Robert Bononno (New York: Plenum Trade, 1998), p. 171; Roberto Diodato, *Aesthetics of the Virtual*, trans. Justin L. Harmon (Albany: State University of New York Press, 2012), pp. 10–12; Diodato, *Image, Art and Virtuality: Towards an Aesthetics of Relation*, trans. Tessa Marzotto Caotorta (Cham: Springer, 2021), pp. 61–63.

21. See Richard Wollheim, "Seeing-As, Seeing-In and Pictorial Representation," in *Art and Its Objects* (Cambridge: Cambridge University Press, 2015), pp. 137–51.

22. "Immersive virtual reality indeed emerges from an assimilation of the image object to the perception of a real thing," Lambert Wiesing, *Artificial Presence: Philosophical Studies in Image Theory* (Stanford: Stanford University Press, 2010), p. 89.

23. Lev Manovich, *The Language of New Media* (Cambridge, MA: MIT Press, 2001), p. 97.

24. For this terminological and conceptual distinction, see the texts collected in Edmund Husserl, *Phantasy, Image Consciousness, and Memory (1898–1925)*, trans. John B. Brough (Dordrecht: Springer, 2005).

25. Jay David Bolter and Richard Grusin, *Remediation: Understanding New Media*

(Cambridge, MA: MIT Press, 2000), p. 23. On the mythology of transparency, see Jay David Bolter and Diane Gromala, *Windows and Mirrors: Interaction Design, Digital Art, and the Myth of Transparency* (Cambridge, MA: MIT Press, 2003).

26. Among the classical theorists of empathy, Edith Stein, *On the Problem of Empathy*, trans. Waltraut Stein (1917; The Hague: Springer, 1964), insisted on this point. For a critique of virtual reality as incapable of accessing the dimension of otherness, see Grant Bollmer, "From Immersion to Empathy: The Legacy of Einfühlung in Virtual Reality and Digital Art," in Hava Aldouby, ed., *Shifting Identities: An Anthology of Presence, Empathy, and Agency in 21st-Century Media Arts* (Leuven: Leuven University Press, 2020), pp. 17–30.

27. On empathy as "perspective taking," see Daniel C. Batson, Shannon Early, and Giovanni Salvarani, "Perspective Taking: Imagining How Another Feels Versus Imaging How You Would Feel," *Personality and Social Psychology Bulletin* 23.7 (1997), pp. 751–58, and Ruby Perrine and Jean Decety, "How Would You Feel Versus How Do You Think She Would Feel? A Neuroimaging Study of Perspective-Taking with Social Emotions," *Journal of Cognitive Neuroscience* 16.6 (2004), pp. 988–99.

28. See the classic study by Noël Burch, *Theory of Film Practice*, trans. Helen R. Lane (Princeton: Princeton University Press, 1981), in particular chapter 2, "Nana, or the Two Kinds of Space," pp. 17–31.

29. Roland Barthes, *Camera Lucida: Reflections on Photography*, trans. Richard Howard (New York: Hill and Wang, 1990), pp. 77 and 96.

30. *Meeting You*, MBC Global Media website, http://content.mbc.co.kr/program/documentary/3479845_64342.html.

31. See, for example, an experimental study conducted on *Clouds over Sidra*, which begins from the premise that "empathy is a multicomponent positive characteristic consisting of both cognitive and affective components," in Nicola S. Schutte and Emma J. Stilinović, "Facilitating Empathy Through Virtual Reality," *Motivation and Emotion* 41 (2017), p. 709.

32. See in this regard Anna Donise, *Critica della ragione empatica: Fenomenologia dell'altruismo e della crudeltà* (Bologna: il Mulino, 2019).

33. Achim Aurnhammer and Dieter Martin, eds., *Mythos Ikarus: Texte von Ovid bis Wolf Biermann* (Leipzig: Reclam, 1998), and Piero Boitani, *Winged Words: Flight in Poetry and History*, trans. Noleen Hargan, Anita Weston, and Piero Boitani (Chicago: University of Chicago Press, 2007), in particular chapter 2, "Icarus," pp. 27–52.

NOTES

34. James A. Dockal and Michael S. Smith, "Evidence for a Prehistoric Petroglyph Map in Central Arizona," *Kiva* 4 (2005), pp. 413–21.

35. See Dieter R. Bauer and Wolfgang Behringer, eds., *Fliegen und Schweben: Annäherung an eine menschliche Sensation* (Munich: Dt. Taschenbuch-Verlag, 1997), and Daniela Stroffolino, *L'Europa "a volo d'uccello"* (Naples: Edizioni Scientifiche Italiane, 2012).

36. Wolfgang Sonne, "Weisungen der Vogelschau: Luftbild und Ästhetik der Gesamtstadt im frühen 20. Jahrhundert," in Hubert Locher and Rolf Sachsse, eds., *Architektur Fotografie* (Berlin: Deutscher Kunstverlag, 2016), pp. 84–96.

37. Andreas F. Beitin, "Imagination, Elevation, Battlefield Automation: From the Elevated View to Battle Drones," in Ulrike Gehring and Peter Weibel, eds., *Mapping Spaces: Networks of Knowledge in 17th Century Landscape Painting* (Munich: Hirmer, 2014), pp. 460–71.

38. Nicolò Degiorgis and Audrey Salomon, eds., *The Pigeon Photographer* (Bolzano: Rorhof, 2018), and Franziska Brons, "Bilder im Fluge: Julius Neubronners Brieftaubenfotografie," *Fotogeschichte: Beiträge zur Geschichte und Ästhetik der Fotografie* 100 (2006), pp. 17–36.

39. See the pigeon camera on the CIA museum website https://www.cia.gov/legacy/museum/artifact/pigeon-camera.

40. Thomas Nagel, "What Is It Like to Be a Bat?," *Philosophical Review* 83.4 (1974), pp. 440, 437, 438.

41. Ibid., p. 439.

42. Jakob Johann von Uexküll, "Die Umrisse einer kommenden Weltanschauung," in *Bausteine zu einer biologischen Weltanschauung* (Munich: Bruckmann, 1913), p. 143.

43. Jakob Johann von Uexküll, "A Stroll through the Worlds of Animals and Men: A Picture Book of Invisible Worlds" (1934), in Claire H. Schiller ed. and trans., *Instinctive Behavior: The Development of a Modern Concept* (New York: International Universities Press, 1957), p. 28.

44. Jakob Johann von Uexküll, *Umwelt und Innenwelt der Tiere* (Berlin: Springer, 1909), p. 6. Recall that Nagel similarly refers to the "inner life of the bat." "What Is It Like to Be a Bat?," p. 438.

45. Uexküll, *Umwelt und Innenwelt der Tiere*, p. 251.

46. Uexküll, "A Stroll through the Worlds of Animals and Men," p. 32.

47. Thomas A. Sebeok, "Biosemiotics: Its Roots, Proliferation, and Prospects," *Semiotics* 1.4 (2001), pp. 61–78.

48. See Georg Kriszat's illustrations relating to the room as perceived by the dog, the

human and the horsefly, in Uexküll, "A Stroll through the Worlds of Animals and Men," figs. 26 and 27. For the concept of *affordance*, see James Jerome Gibson, *The Ecological Approach to Visual Perception* (1979; New York: Taylor & Francis, 2015).

49. Jakob Johann von Uexküll, Theodor Beer, and Albrecht Theodor Julius Bethe, "Vorschläge zu einer objectivierenden Nomenklatur in der Physiologie des Nervensystems" (1899), in Jakob Johann von Uexküll, *Kompositionslehre der Natur* (Frankfurt am Main: Ullstein, 1980), pp. 92–100.

50. Jakob Johann von Uexküll and Friedrich Brock, "Vorschläge zu einer subjektbezogenen Nomenklatur in der Biologie" (1935), in ibid., pp. 129–42.

51. Friedrich Nietzsche, "On Truth and Lying in a Non-Moral Sense" (1873), in Raymond Guess and Ronald Speirs, eds., *The Birth of Tragedy and Other Writings*, trans. Ronald Speirs (Cambridge: Cambridge University Press), p. 148.

52. Jakob Johann von Uexküll, "Wie sehen wir die Natur und wie sieht sie sich selber?," *Naturwissenschaften* 10 (1922), p. 268.

53. See the images in Uexküll, "A Stroll through the Worlds of Animals and Men," pp. 24–25.

54. F. John Odling-Smee, Kevin N. Laland, and Marcus W. Feldman, *Niche Construction: The Neglected Process in Evolution* (Princeton: Princeton University Press, 2003).

55. See the substantial study by Inga Pollmann, "Invisible Worlds, Visible: Uexküll's Umwelt, Film, and Film Theory," *Critical Inquiry* 39.4 (2013), pp. 777–816.

56. *Aquila Bird Flight Simulator*, "Details," Metacritic website, http://www.metacritic.com/game/pc/aquila-bird-flight-simulator/details.

57. Giancarlo Varanini, "Eagle Flight—Everything You Need to Know," Ubisoft website, https://news.ubisoft.com/en-us/article/1dzrc9Ioi3FpspECqpcodD/eagle-flight---everything-you-need-to-know.

58. Alireza Mazloumi Gavgani et al., "A Comparative Study of Cybersickness during Exposure to Virtual Reality and 'Classic' Motion Sickness: Are They Different?," *Journal of Applied Physiology* 125.6 (2018), pp. 1670–80.

59. Ashley Whitlatch, "Tunnel Vision: How Ubisoft Created *Eagle Flight*, A VR Flying Game with No Nausea," *Upload VR*, Dec. 10, 2016, https://uploadvr.com/how-ubisoft-created-eagle-flight-sickness.

60. Birdly, http://birdlyvr.com.

61. Primo Levi, "Retirement Fund," in *The Sixth Day and Other Tales*, trans. Raymond Rosenthal (New York: Summit Books, 1990), pp. 107–25.

62. Richard Grusin, ed., *The Nonhuman Turn* (Minneapolis: University of Minnesota Press, 2015), p. vii.

63. Joanna Zylinska, *Nonhuman Photography* (Cambridge, MA: MIT Press, 2017), p. 14.

64. Michael A. Unger, "Castaing-Taylor and Paravel's GoPro Sensorium: *Leviathan* [2012], Experimental Documentary, and Subjective Sounds," *Journal of Film and Video* 69.3 (2017), pp. 3–18.

65. Lee Gambin, *Massacred by Mother Nature: Exploring the Natural Horror Film* (Baltimore: Midnight Marquee Press, 2012); Katarina Gregersdotter, Johan Höglund. and Nicklas Hållén, eds., *Animal Horror Cinema: Genre, History and Criticism* (Houndmills, Basingstoke: Palgrave Macmillan, 2015).

66. "EYEsect," *Guardian*, February 5, 2014, https://www.theguardian.com/technology/2014/feb/05/eyesect-constitute-berlin-world-eyes-chameleon.

67. "The subjective character of the experience of a person deaf and blind from birth is not accessible to me, for example, nor presumably is mine to him." Nagel, "What Is It Like to Be a Bat?," p. 440.

68. See, regarding cognitive impairment, Yao Liu et al., "A Review of the Application of Virtual Reality Technology in the Diagnosis and Treatment of Cognitive Impairment," *Frontiers in Aging Neuroscience* 11 (2019), p. 280.

69. The filmmakers recount the origin of the documentary project in the article "The Story Behind 'Notes on Blindness,'" which appeared in the *New York Times* on January 16, 2014, http://www.nytimes.com/interactive/2014/01/16/opinion/16OpDoc-NotesOnBlindness.html?_r=1.

70. John Martin Hull, *Touching the Rock: An Experience of Blindness* (New York: Pantheon Books, 1990).

71. José Saramago, *Blindness*, trans. Giovanni Pontiero (San Diego: Harcourt Brace, 1996).

72. See Giancarlo Grossi, *La notte dei simulacri: Sogno, cinema, realtà virtuale* (Monza: Johan & Levi, 2021), in particular "Stati alterati di immersività," pp. 128–36.

73. *A Walk Through Dementia*, Google Play Store website, https://play.google.com/store/apps/details?id=com.alzheimersresearchuk.walkthroughdementia&hl=en_GB.

74. *Cosmos within Us*, Venice Biennale website, http://www.labiennale.org/it/cinema/2019/venice-virtual-reality/cosmos-within-us.

EPILOGUE

1. Georg Simmel, "Bridge and Door" (1909), trans. Mark Ritter, *Theory Culture Society* 11.5 (1994), p. 10.

2. Johann Wolfgang von Goethe, *Maxims and Reflections*, trans. Elizabeth Stopp (London: Penguin, 1998), maxim 203, p. 35.

Index

Images are indicated by italic page number

ABSTRACT ART, 13.
Acco legend, 28.
Acconci, Vito, 59; *Air Time*, 60; *Centers*, 60.
Admonitor, 135, 136.
Aerial views, 200–201.
Affordances (Gibson), 8, 37, 105, 205.
Agalmatophilia, 75. *See also* Pygmalion.
Agamben, Giorgio, 70–72, 83, 204.
A-ha (synth-pop group), "Take on Me," 162, *163*.
Aitken, Doug, *Mirror*, 64.
Ai Weiwei, 190, 194, 199; *Omni*, 190.
Ajātasattu, 28.
Alberti, Leon Battista: on mirrors, 44; on Narcissus, 17, 22; *De pictura* (*On Painting*), 17, 120, 135–36; visual pyramid, 120–21, *122*; "window" of, 120, 191.
Alice (Lewis Carroll heroine), 46, 52–54, 65–68. *See also* Carroll, Lewis: *Through the Looking Glass*.
Alice Through the Looking Glass (James Bobin, 2016), 54.
Alien vs. Predator (2004), 213.
Alter ego, 93, 147. *See also* Avatars.
Anaglyphic glasses, 174, 182.
Anamorphic lenses and displays, 133, 181.
Anders, Günther, 90.
Andersen's fairy tales, 91.
Anderson, William, 153–54.
Andréides, 86–87, 90, 97. *See also* Androids.
Andriyevsky, Aleksandr, *Robinson Crusoe*, 174.

Androids, 72, 76, 93–97, 99–101. *See also Andréides*; Robots.
An-icons, 11–12, 13, 15, 105, 110.
Animals: bats, 201–203, 213; elephants, 190; flying, 199–200, 203, 207; in horror films, 211; response to images, 105–107; subjectivity of, 203–205; visual perception, 211–13. *See also* Birds.
Animation and comic books, 162.
Animation of the inanimate, 75–80, 92, 101; inanimation of the animate, 80–86, 101. *See also* Pygmalion.
Anselmo, Giovanni, 151; *Entering the Work*, *134*, 138.
Anthropocentrism, 38, 205–206, 209, 213.
Anthropomorphism, 96, 218.
Anti-anthropocentrism. *See* Anthropocentrism.
Antonello da Messina, 110.
Apelles, 107.
Aphrodite (Venus), 21, 70, 73, 78, 86, 233 n.7.
Apnea, 40.
Apnea (installation, Vanessa Vozzo, 2016), 40–42, *41*.
Apnea (VR video game), 40.
Aquila Bird Flight Simulator, 207.
Arbuckle, Fatty, 144.
Aristophanes, 141.
Aristotle, 58, 76.
Armstrong, Jesse, 187.
Arnheim, Rudolf, 116, 241 n.19.
Arnobius, 73.
AromaRama, 184.

INDEX

Arrivée d'un train en gare de La Ciotat, L' (Lumière Brothers, 1895), 167, *168*, 169, 170, 171, 256 n.39; 3-D remake, 173; in Ultra HD, 171.
Artcock collective, 84.
"Art Distance Sharing," 148.
Art movements, 119.
Asimov, Isaac, 99, 101.
Augmented reality, 9, 117–18, 180. *See also* Virtual reality.
Augustus, 81.
Autoeroticism, 23, 29–31, 97. *See also* Narcissism.
Automaton motif, 86–87, 93–96. *See also* Androids; Robots.
Autopsy, 198; depictions, 136.
Avant-garde, 113, 116–17, 118, 170.
Avatar (James Cameron, 2009), 150.
Avatar (video game), 150.
Avatars, 14, 47, 117, 146–47; canine, 148; eagle's beak in VR game, 208; and empathy, 146, 147, 190; Hindu tradition, 150; historical precedents, 138, 148–51; and image environmentalization, 146; LaTurbo Avedon, 148; in new media arts, 147–48; scene from *Second Life*, *149*; social life of, 148.

BAILEY, THERESE "BUNTY," 162.
Balázs, Béla, 153, 160, 253 n.11; *Theory of the Film*, 158–59; *Visible Man*, 59; "Wan Hu-Chen's Book," 155–56.
Balla, Giacomo, 116, 117, 118.
Baltrušaitis, Jurgis, 44.
Balzac, Honoré de, *Old Man Goriot*, 127.
Barjavel, René, *Cinéma Total*, 88, 178–81, 183.
Barker, Robert, panorama device, 126, 127.
Baroque ceilings, 126.
Barron, Steve, "Take On Me" video clip, 162, *163*.
Barthes, Roland, 75, 141, 197.
Bats, 201–203, 213.
Battleship Potemkin (Sergei Eisenstein, 1925), 171, *172*, *175*, *176*.
Baudrillard, Jean, 51, 90, 111.
Baudry, Jean-Louis, 59, 151.
Baum, Paull Franklin, 74.
Bava, Mario and Lamberto, 74.
Bayle, Pierre, *Dictionnaire historique et critique*, 78.

Bazin, André, 88, 181–83; "The Myth of Total Cinema," 181.
BeAnotherLab, *The Machine to Be Another*, *188*, 189–90.
Beauty, 13, 18, 21, 155, 166. *See also* Narcissus.
Bednar, Ryan, Down the Rabbit Hole, 67.
Beecroft, Vanessa, 84.
Beer, Theodor, 205.
"Being there," 8, 126, 191, 193, 197–98.
Belting, Hans, 138.
Benglis, Lynda, 59; *Now*, 61.
Benjamin, Walter, 13, 153, 167; "Berlin Childhood," 157, 254 n.15; and the Chinese legend of Wu Tao Tzu, 156–58, 159, 254 n.15; on the panorama, 127–28; telescoping of temporal dimensions, 42, 87; "The Work of Art in the Age of Its Technological Reproducibility," 157.
Berger, Henning, *The Deluge*, 142.
Berkeley, Bishop, 87.
Bête humaine, La (Jean Renoir, 1938), 169.
Bethe, Albrecht, 205.
Bigelow, Kathryn, 190, 194, 199; *The Protector*, 190; *Strange Days*, 186, *187*, 209.
Binet, Alfred, 29.
Biotechnology, 8, 187. *See also* Technological prostheses.
Bioy Casares, Adolfo, *La invención de Morel*, 183–86, 259 n.75.
Birdly, 208–209; user experiencing, *210*.
Birds, 199–201, 203; aircraft named for hawks and falcons, 200; Danto's pigeons, 107; flight, 201, 207–209, *210*; Kurosawa's "Crows," 164, 170; pigeon photography, 201.
Bird's eye view, 200–201, 203.
Bishop, Claire, 64–65.
Björk, "All Is Full Of Love" video clip, 96–99, *98*.
Black Mirror (series), 67–68, 186–87.
Blade Runner (Ridley Scott, 1982), 72, 93–96, 101; film still, *95*.
Blanchot, Maurice, 86.
Blindness, 213–14, 215, 265 n.67.
Bloch, Ernst: *Durch die Wüste*, 156; "The Motif of the Door" in *Traces*, 156, 157.
Boccioni, Umberto, 116, 118; "Technical Manifesto of Futurist Sculpture," 118.
Body art, 23, 116, 119.

Body camera, 146.
Body image disturbance, 147.
Body input, 93, 209.
Body transfer illusion, 189–90.
Boehm, Gottfried, 10.
Bonnardot, Claude-Jean, *The Invention of Morel* television film, 259 n.75.
Bonnot de Condillac, Étienne, *A Treatise on the Sensations*, 78.
Borges, Jorge Luis, 58; "Animals of Mirrors," 51–52.
Borrell del Caso, Pere, *Escaping Criticism*, 111, *112*.
Boschetti, Isabella, 122.
Boureau-Deslandes, André-François, *Pigmalion, ou la statue animée*, 78.
Brain-computer interfaces in cinema, 186–87.
Brainstorm (Douglas Trumbull, 1983), 186.
Brecht, Bertolt, 140; "The Fourth Wall of China," 141.
Bredekamp, Horst, 138.
Brewster, David, 128.
Bridge, 164–66, 217; cinema as, 167.
Brogi, Giulio, 184.
Brolin, James, 99.
Brooker, Charlie, *Black Mirror: Bandersnatch*, 67–68.
Brynner, Yul, 99.
Buber, Martin, 155.
Buddhism, 28, *nētra pinhama* ceremony, 77.
Burch, Noël, 197–98.
Burckhardt, Jacob, 81.
Burj Khalifa skyscraper (Dubai), 201.
Butterfield, Asa, 170.

CAGE, NICOLAS, 58.
Callipygian Venus, 21.
Callistratus, 76; *Ekphraseis*, 69–70, 103.
Camaïeu, 110.
Camerae pictae, 13.
Camera techniques, 126, 138, 143–45, 201. *See also* Stereoscopy; 360-degree shooting.
Cameron, James: *Avatar*, 150; *Strange Days*, 186, *187*.
Candy, Stuart, *NurturePod*, 6.
Cao Fei, *i.Mirror*, 147–48.
Cape Fear (Martin Scorsese, 1991), 38.

Caravaggio: *Narcissus at the Fountain* (attrib.), 22; reenactments of, 84.
Carrà, Carlo, 118; "Painting of Sounds, Noises, Smells" manifesto, 118–19.
Carroll, Leo G., 144.
Carroll, Lewis: *The Hunting of the Snark*, 67; "Jabberwocky," 67; "Phantasmagoria," 131; *Through the Looking-Glass*, 46, 52–54, *53*, 57, 65, 67–68, 154, 227 n.15. *See also* Alice.
Cassirer, Ernst, 43, 204.
Castaing-Taylor, Lucien, *Leviathan*, 211.
Catacomb 3-D (video game), 145.
Catoptrics. *See* Mirrors.
Cattelan, Maurizio, installations, 84–86, *85*.
Cave Automatic Virtual Environment (CAVE), 151.
Cave paintings, 151, 218.
Celant, Germano, 118, 119, 242 n.27; *Ambiente/arte*, 116–17.
Cellini Benvenuto, *Narcissus*, 22.
Cephisus, 18.
Chamber of the Giants (Sala dei Giganti, Mantua), 123–25, *124*, 192.
Chamisso, Adelbert von, "Peter Schlemihl," 48.
Chaplin, Charlie: *The Circus*, 58; *The Knockout*, 144.
Chekhov, Michael Aleksandrovič, 142.
Cheng, Ian: *Bad Corgi*, 148; *Emissary Forks at Perfection*, 148.
Chinese and Japanese legends, 153–56.
Chinese calligraphy, 156.
Chopin, Frédéric, *Drop of Water* prelude, 166.
Christina of Lorraine, 81–82.
Christus, Petrus, *Portrait of a Carthusian*, 107–108.
Chuang Tzu, 58.
CIA, 201.
Cimabue, 107.
Cinema: American, 143, 144, 159; automaton motif, 93–96; avant-garde, 170; as bridging, 167; camera techniques, 138, 143–45; contrasted with theater, 142–43, 160; direct interpellation, 143–44; doppelgänger theme in, 48–50; Eisenstein on, 142, 143–45, 173–77, 178; expanded cinema, 64, 189; filmic framing, 177–80; first screening, 167–70, *171*; horror films, 211; immersiveness in, 37–38;

269

inanimation theme, 79; influence of video games, 146; in/out movement in, 160, 164–67; interactive, 67, 159; and the legend of Wu Tao Tzu, 158–59; and mirrors, 54–57, 58–59; Narcissus theme, 48; phantom rides, 169; railroads in, 166–71; "rube films," 169–70; *Rückenfigur* in, 138; science fiction, 99–101, 186, 211–13; screen as threshold, 158–64, 170–71; stereoscopic techniques, 13, 150, 173–78, 182–83; synesthetic, 88, 189; *tableaux vivants* in, 83; and 360-degree shooting, 143, 178; total cinema, 119, 178–81; virtual reality, 40, 68, 170, 213–14; widescreen, 182. *See also* 3-D cinema; Immersive virtual environments: installations.
Cinerama and Cinemascope, 181, 182.
Circus, The (Charlie Chaplin, 1928), 58.
Cirincione, Janine, 66.
Citizen Security Law ("Gag Law," Spain), 132.
Clement of Alexandria, 33, 73, 233 n.7.
Clooney, George, 162.
Clouds over Sidra (Chris Milk, 2015), 191, 262 n.31.
Cocks, Jay, *Strange Days*, 186, *187*.
Cocteau, Jean, 54–57; *Le Sang d'un poète*, *56*, *57*; *Orphée*, 57.
Columella, Lucius Junius Moderatus, *De re rustica*, 28.
Comédie Française, 139.
Compassion machine, 194. *See also* Empathy.
Constitute, The, EYEsect project, 211, *212*.
Corpses, 84–86, 198.
Cosmos within Us (Tupac Martir, 2019), 214.
Countryman's First Sight of the Animated Pictures, The (Robert W. Paul, 1901), 169.
Cratinus, 141.
Crichton, Michael, 99.
Crivelli, Carlo, *Catherine of Alexandria*, 108–110, *109*, 111, 241 n.18.
Cronenberg, David, *Videodrome*, 160, *161*, 255 n.24.
Cunningham, Chris, 96–99; "All Is Full Of Love" video clip, *98*.
Cybersickness, 208.

DADA AND NEW DADA, 54, 119.
Daedalus, 76.
Dalí, Salvador, *Metamorphosis of Narcissus*, 23.
D'Amato, Brian, 66.

Damisch, Hubert, 221 n.2.
Dante Alighieri, *Paradise*, 19.
Danto, Arthur, 107.
Daumier, Honoré, 22–23.
Davis, Decontee, 191.
De Benedetto, Franco, 84.
Debray, Régis, 36.
Degrees of freedom, 65, 195.
Délassements-Comiques, 139.
Delaunay, Robert, 116.
Deleuze, Gilles, 204.
Della Porta, Giambattista, *Natural Magick*, 131.
Dementia, 214–15.
Depero, Fortunato, 117.
Der Sturm gallery, 116.
Descartes, René, *Traité de l'homme*, 77.
Descola, Philippe, 227 n.15.
Dhammapada, 28.
DiCaprio, Leonardo, 58.
Dick, Philip K., *Do Androids Dream of Electric Sheep?* 94.
Diderot, Denis: *D'Alembert's Dream*, 79; and the fourth wall, 139, 140, 141–42, 143.
Didi-Huberman, Georges, 135.
Dircks, Henry, 131.
Direct interpellation, 143–44.
Disney's Magical Mirror Starring Mickey Mouse, 54.
Di sotto in su (worm's eye view), 200.
Displaced Working Elephants in Myanmar (video), 190.
Documentaries, 40–42, 190–95, 198–99.
Doppelgängers, 47–50, 83, 90, 147, 228 n.19; doubling in Björk's "All Is Full Of Love" video clip, 97; robots as doubles, 93.
Down the Rabbit Hole (immersive diorama dir. Ryan Benar, 2020), 68.
Dreams, 31–32, 47, 50, 52, 54, 159; and mirrors, 51, 57–58; and VR, 68.
Dreams (Akira Kurosawa, 1990), 164–67, *165*.
Drones, 200, 211.
Duchamp, Marcel, *Etant donnés 1° la Chute d'eau 2° le gaz d'éclairage*, 122.
Dürer, Albrecht, *Draughtsman Making a Perspective Drawing of a Reclining Woman*, 121–22, *122*, 243 n.40.

EAGLE FLIGHT (VIDEO GAME), 207–208.

Echo (nymph), 60, 69.
Echolalia, 60.
Echolocation, 202.
Eco, Umberto, 45–46, 59.
Eco-iconological plexus, 133.
Ecological niche, 207.
Edison, Thomas, 86–87.
Effigy magic, 76.
E-Health, 213.
Eichendorff, Joseph von, "The Marble Statue," 74.
Eight Beautiful Views of Lake Ōmi, 154.
Eisenstein, Sergei, 88, 139, 183; *Battleship Potemkin*, 171, *172*, 175, 176; "Diderot Talked about Cinema," 142; and the fourth wall, 141–42, 143; *Nonindifferent Nature*, 171; on pathos and ecstasy, 176; "Stereokino," 173–75, 178; on modulating the gaze in American cinema, 143–45.
Ekphrasis, 79, 103, 241 n.18; of Callistratus, 69–70, 103.
Electronic music, 64.
Elephants, 190.
Eliasson, Olafur, *The Weather Project*, 64.
Elizabeth, Saint, 84–86.
Elkins, James, 138.
Ellis, Havelock, 29–30.
Elsaesser, Thomas, 178.
Embodiment, 37, 79, 126, 141, 145; embodiment virtual reality, 189–90.
Emersiveness, 133, 135; devices, 128–31; immersion and emersion dialectic, 128, 1333, 153.
Empathy, 94, 261 n.17, 262 n.31; avatars and, 146, 147, 190; in human/nonhuman interaction, 93; interspecies, 199–200, 203; self-empathy, 147; virtual reality as catalyst for, 189–91, 194, 195, 196–99, 262 n.26.
Empire of the Ants (Bert I. Gordon, 1977), 211.
"Entering the painting," 115–16, *134*, 137, 138, 144, 153–58, 186. *See also* Immersion; In/out movement.
Enter the Void (Gaspar Noé, 2009), 146.
Environmental art, 119–20.
Environmentalization of the image, 101, 119, 133, 135, 177; avatars and, 146, 147; Celant's *Ambiente/arte*, 116–18, 119; Kaiserpanorama, 127–28; *Milk's Clouds over Sidra*, 191. *See also* Unframing.

Enwaterment, 37.
Erdoğan, President, 133.
Eros, 20.
Erotic and pornographic images, 128.
Esthesis, 13; esthesiology, 34.
Estrangement effect, 44, 140.
Evolution of Verse (Chris Milk, 2015), 170.
Ewers, Heinz, 48.
Exhibitions, 65, 66, 116, 232 n.71; exhibition spaces, 40, 92, 148.
Expanded Cinema, 64, 189.
Experiments in Art and Technology, Pepsi Pavilion (Expo '70), 62, 63–64.
EYEsect project (The Constitute), 211, *212*.

FACEBOOK AS METAVERSE, 14.
Face/Off (John Woo, 1997), 58.
Fairy tales, 28, 91, 154, 155.
Falconet, Étienne-Maurice, *Pygmalion at the Feet of His Statue*, 79.
Feast of the Pheasant, 81.
Festivals, 81–82.
Fetishism, 29.
Ficino, Marsilio, 19.
Field of vision, 7, 142, 193.
First-person shot, 145–46.
Flagg, James Montgomery, "I Want You for the U.S. Army" poster, 139.
Fletcher, Louise, 186.
Flight, 201–203. *See also* Flight simulators.
Flight simulators, 207–209, *210*.
Ford, Harrison, 94, 95.
Forster, Kurt W., 125.
Foucault, Michel: on the mirror, 43–44; reading of Velázquez's *Las Meninas*, 137.
Fourth wall, 139–41, 175.
Frame: deconstruction of, 113, 116, 118, 177; "dictatorship" of, 194–95; filmic framing, 177–78; Kant on, 113; picture, 7, 113, 135, 177; in sculpture, 80; Simmel on, 115–16, 164; stepping out of, 111–13, *114*; theoretical study of, 113–16; and trompe l'oeil depictions, 108; in video art, 38, *39*; in VR, 8, 180, 194–96. *See also* Entering the painting; Environmentalization of the image; Unframing.
Frazer, James George, *The Golden Bough*, 28–29.
Freedberg, David, 76–77, 138.

Freud, Sigmund: "aim of all life is death," 83; "Leonardo Da Vinci and a Memory of His Childhood," 31; on narcissism, 23, 30–31; on Pygmalion, 75, 91; on the uncanny, 44–45, 91–92.
Freud, Dalí and the Metamorphosis of Narcissus (exhibition, 2018–2019), 223 n.25.
Fried, Michael, 139.
Friedrich, Caspar David, 137.
Friquet, Pierre "Pyaré," *Spaced Out*, 38.
Frontality, 137, 141.
Fuhrmann, August, 128.
Full body ownership illusion, 147.
Futurism, 116, 118, 119, 120, 242 n.32; in opera, 140.

GALATEA, 78, 79, 80; in Weinbaum's "Pygmalion's Glasses," 88–90.
Galeen, Henrik, 50.
Gance, Abel, *Napoléon*, 181.
Garamba National Park (Congo), 190.
Gautier, Théophile, *Avatar*, 150.
Gaze: emanating from images, 135–37, 144; exchanged between devotee and idol, 138; of the filmmaker, 198; in immersive virtual environments, 7, 191, 195, 197, 199; in theater and cinema, 143–45; in Velázquez's *Las Meninas*, 136–37.
Gell, Alfred, 138.
Geminoid project, 93.
Gender swap, 190.
Gestures: in the mirror, 19, 21; in paintings, 135–36; of robots, 93, 97; in *tableaux vivants*, 83; in theater, 142; in virtual environments, 190, 197.
Gibson, James J., "affordances," 105, 205.
Giles, Herbert A., 58, 154.
Gioni, Massimiliano, 84.
Giotto, 107, 241 n.18.
Godard, Jean-Luc, *Passion*, 83.
Goethe, Johann Wolfgang von, 218; *Italian Journey*, 82.
Gombrich, E. H., 108, 125.
Gonzaga, Federico II, 122–23.
GoPro camera, 146, 211.
Gordon, Bert I., *Empire of the Ants*, 211.
Graham, Dan, *Performer/Audience/Mirror*, 63.
Grau, Oliver, 226 n.65.

Great Train Robbery, The (Edwin S. Porter, 1903), 144.
Greco, Emidio, *Morel's Invention*, 184, 185.
Greenaway, Peter, *The Mysteries of Compton House Garden*, 83.
Greimas, Algirdas Julien, 10.
Grisaille, 110.
Grosse Berliner Kunstausstellung, 116.
Groupe μ, 116.
Groys, Boris, 120.
Gunning, Tom, 256 n.39.

HADOT, PIERRE, 19, 33.
Hagen, Charles, 232 n.71.
Halley, Peter, 66.
Hallucinations du Baron de Münchhausen, Les (Georges Méliès, 1911), 54, 55.
Hamilton, Sir William, 82.
Hand, David, 54.
Handprints, 151.
Hannah, Daryl, 94, 95.
Haraway, Donna, 66–67.
Hardcore Henry (Ilya Naishuller, 2015), 146.
Harket, Morten, 162.
Harnett, William, 110.
Hauer, Rutger, 96.
Head, James H., *Home Pastimes, or Tableaux Vivants*, 82–83.
Headsets and helmuts, 7–8, 126–27. See also Virtual reality headsets.
Hearn, Lafcadio, 154.
Hegel, Georg Wilhelm Friedrich, 156, 177.
Heidegger, Martin, 204.
Heil- und Pflegeanstalt Hubertusburg (Leipzig), 30.
Hein, Jeppe, *Mirror Labyrinth, NY*, 64.
Helmholtz, Hermann von, 205.
Hephaestus, 76.
Herder, Johann Gottfried, *Sculpture*, 79–80.
Hikikomori, 42, 226 n.66.
Hirata, Oriza, 93.
Hitchcock, Alfred, 182; *Spellbound*, 144.
Hoffmann, E. T. A.: "A New Year's Adventure," 48; "The Sandman," 86.
Hohokam people, 200.
Holloway, Josh, 259 n.75.
Hollywood, 144, 159.
Holmes, Oliver Wendell, 128.

Holofans, 133.
Holograms, 131–33, 147; march of the holograms, Madrid, *132*, 133.
Holt, Nancy, 59, 60.
Holzer, Jenny, 66.
Homosexuality, 29, 31.
Hopkins, Anthony, as Dr. Robert Ford in *Westworld*, 99, *100*.
Horror films, 211.
Hugo (Martin Scorsese, 2011), 170.
Huizinga, Johan, *The Autumn of the Middle Ages*, 81.
Hull, John, 213–14.
Humanitarian documentary filmmaking, 40–42, 190–95, 199.
Husserl, Edmund, 9, 10.

ICONIC DOUBLING, 70.
Iconoclasm, 81.
Iconology, 9, 10; an-iconology, 12, 15; eco-iconology, 133.
Identity, 36, 215; and otherness, 45, 147.
Ikea Place app, 180.
Iliad, 76.
Illusionistic art, 9, 37, 105, 108–11, 122–26, 218.
Image: case of Narcissus, 20–21, 43; image making, 7, 43, 218; properties of, 7–14; and support, 10–11. *See also* Environmentalization of the image; Frame; Narcissus; Representation; Spectatorship; Unframing.
Immediateness, 7, 10, 11, 37.
Immersion, 37, 40–42, 226 n.65; and emersion dialectic, 128, 133, 153; water metaphor, 157–58.
Immersive dioramas, 68.
Immersive journalism, 191–92.
Immersive natives, 14.
Immersive theater, 141.
Immersive virtual environments, 18, 38, 189, 151; aesthetic and sensory value, 13–14; installations, 40–42, 192–94, 195, 198; precursors, 37–38, 92, 178; properties, 7–11, 37. *See also* Virtual reality.
Immigration. *See* Migrants.
Inanimation of the animate, 80–84, 101; corpses, 84–86.
Iñárritu, Alejandro G., 199; *Carne y Arena*, 125, 192–94, 195, 197–98.

Inception (Christopher Nolan, 2010), 58.
In/out movement, 128, 133, 144, 153, 159–60, 162, 169.
Insects, 107–108, 205, 211.
Installations, 84, 116, 119–20, 122, 242 n.27, 242 n.32; immersive, 38, 40; inanimating the animate, 84; *totale Installation*, 120. *See also Apnea*; Cattelan, Maurizio; Iñárritu, Alejandro G.
Intersubjectivity, 14, 47. 117, 198.
Invention of Morel, The (television film, Claude-Jean Bonnardot, 1967), 259 n.75. *See also* Bioy Casares, Adolfo; Greco, Emidio
Ishiguro, Hiroshi, 93.
Ishikawa, Kōsai, 154.
I/you theme, 137, 138.

"JABBERWOCKY" (CARROLL), 67.
Jackson, Michael, 133.
Jack Tilton Gallery, 66.
Japanese legends, 154–55.
Jensen, Wilhelm, *Gradiva*, 74–75.
Jentsch, Ernst, 91–92.
Jonas, Joan, *Mirror Pieces I and II*, 63.
Joy, Lisa, 99.
Juryfreie Kunstschau (1922 exhibition, Berlin), 116.

KABAKOV, ILYA, 120.
Kaiserpanorama, 127–28, 129.
Kandinsky, Wassily, 116.
Kant, Immanuel, 204; *Critique of Judgment*, 113.
Kapoor, Anish: *Cloud Gate*, 64; *Sky Mirror*, 64.
Kaprow, Allan, 120.
Karina, Anna, 184.
Keaton, Buster, *Sherlock Jr.*, 152, 159–60.
Kemp, Wolfgang, 138.
Keyser, Thomas de, *The Anatomy Lesson of Dr. Sebastiaen Egbertsz de Vrij*, 136.
Kinesthetic ensembles, 65, 108, 125.
Kino-Eye (Dziga Vertov, 1924), 169.
Kittler, Friedrich, 50.
Klüver, Billy, 63.
Knockout, The (Charlie Chaplin, 1914), 144.
Konon, 18.
Koukouti, Maria Danae, 227 n.15.
Kracauer, Siegfried, 50, 153, 158.

Krafft-Ebing, Richard von, *Psychopathia Sexualis*, 29, 75.
Krauss, Rosalind, 59, 60, 61.
Kris, Ernst, 76.
Kristeva, Julia, 20.
Kriszat, Georg, 264 n.48.
Kručënych, Aleksej, 140.
Kubovy, Michael, 108–110.
Kurosawa, Akira, *Dreams*, 164–67, 165, 170.
Kurz, Otto, 76.
Kusama, Yayoi, *Narcissus Garden*, 63.

LACAN, JACQUES, 46–47, 151.
La Ciotat effect, 170. See also *Arrivée d'un train en gare de La Ciotat*.
Lady from Shanghai (Orson Welles, 1947), 58.
Lady in the Lake (Robert Montgomery, 1947), 144.
Lagrenée, Louis-Jean-Francois, *Pygmalion and Galatea*, 80.
Lamarck, Jean-Baptiste, 207.
Lanier, Jaron, 66.
Lasch, Christopher, 35–36.
Lasko, Ann, 66.
Last Year at Marienbad (Alain Resnais, 1961), 259 n.75.
LaTurbo Avedon, 148.
Leibniz, Gottfried Wilhelm, 88, 203.
Leonardo da Vinci: *Bird's Eye View of a Coast*, 200; *Treatise on Painting*, 44.
Levi, Primo, "Retirement Fund," 209.
Leviathan (Lucien Castaing-Taylor/Verena Paravel, 2012), 211.
Ley Mordaza (Gag Law), 132, 133.
Lichtenstein, Roy, *Look Mickey*, 23, 25.
Lindqvist, Sven, 153.
Linear perspective, 67, 120–22.
Liriope, 18.
Lissitzky, El, *Prounenraum*, 116.
Literature, 48, 50, 80, 218; science fiction, 86.
Localization, 202, 213.
Long, Bryerly, 93.
Longhi, Roberto, 22.
Lorrain, Claude, 22.
Lorris, Guillaume de. See *Roman de la rose*.
Lost (television series), 259 n.75.
Lotze, Hermann, 205.
Lucian of Samosata, *Eikones*, 73.

Lum, Ken, *Pi*, 64.
Lumière Brothers, 173, 180; *L'arrivée d'un train en gare de La Ciotat*, 167, 168, 169, 170, 171, 173, 181, 256 n.39; *La Sortie de l'Usine Lumière à Lyon*, 167–69.
Lynch, David, *Twin Peaks*, 57.

MACHINE TO BE ANOTHER, THE (BeAnotherLab, 2013), *188*, 189–90.
Macho, Thomas, 222 n.14.
Mackenzie, David, *Perfect Sense*, 79.
Malafouris, Lambros, 227 n.15.
Malevich, Kazimir, 140.
Manovich, Lev, 196.
Mantegna, Andrea, Bridal Chamber of the Castle San Giorgio, 125.
Man with a Movie Camera (Dziga Vertov, 1929), 169.
Marais, Jean, 57.
Marin, Louis, 135.
Marinetti, Filippo Tommaso, "Il tattilismo," 119.
Mart, the (Rovereto), 65.
Martin, Tony, 64.
Mary Poppins (Robert Stevenson, 1964), 160.
Masaccio, 125; *The Holy Trinity*, 121.
Masson, André, 23.
Matjušin, Mihail, 140.
Matrix, The (Wachowski, 1999), 57.
Matt's Gallery (London), 65.
McLuhan, Marshall, 97; rearview mirror, 35, 177, 257 n.57; *Understanding Media*, 33–35.
Media: awareness, 35; metamedia, 164, 176; reflective and transparent, 61–63; spectacularization, 35; transmediality, 218. See also Transparency.
Media archaeology, 12, 37, 182.
Mediation, 10, 11, 35, 37, 63, 147, 171, 196. See also Immediateness.
Medici, Ferdinand I de', 81.
Mediology, 33, 36–37, 145.
Meeting You (VR documentary, 2020), 198.
Mélenchon, Jean-Luc, 133.
Méliès, Georges: *Les hallucinations du Baron de Münchhausen*, 54, 55; *La statue animée*, 83.
MephistoFiles, 40.
Mephistopheles, 48.
Mérimée, Prosper, "The Venus of Ille," 74.

Merleau-Ponty, Maurice, 47, 228 n.16.
Metamedia, 164, 176.
Metaverse, 14.
Metz, Christian, 59, 171.
Meun, Jean de, *Roman de la rose*, 70–72, 71.
Micker, Jan, *Bird's Eye View of Amsterdam*, 200.
Mickey Mouse: Lichtenstein's *Look Mickey*, 23, 25; *Thru the Mirror*, 54; video game, 54.
Microsoft Hololens 2, 133, 180.
Middleton, Peter, 214.
Migrants, 192, 193, 195, 197.
Milk, Chris: *Evolution of Verse*, 170; VR documentaries with United Nations, 191–92, 194, 197, 199, 262 n.31.
Miller, Lee, 57.
Mimesis, 9, 43, 44, 52.
Minecraft, 145.
Minsky, Marvin, "Telepresence," 126–27.
Mirror neurons, 59.
Mirror people, 51–52.
Mirrors: Alberti on, 44; bidirectional movement through, 52–54; child's experience of, 46, 228 n.16; in cinema, 54–59; dome of Pepsi Pavilion, 62, 63–64; and doppelgänger theme, 47–51; and dreams, 57–58; Eco on, 45–46; estrangement created by, 44–45, 47; as "in-between experience" (Foucault), 43–44; inversion, 45–47, 61; Lacan on, 46–47; Leonardo da Vinci on, 44; in literature, 51–54; and narcissism, 30; otherness of image, 19, 45, 51, 52, Plato on, 4), 15; rearview, 35, 47, 177, 257 n.57; and self-portraiture, 22; symbolism, 43; in visual arts, 59–65; water as, 16, 18–19, 20, 21, 22, 23–26, 28–29, 34, 58, 69–70, 103–104. *See also* Carroll, Lewis: *Through the Looking-Glass*; Narcissus.
Mirror shots, 58.
Mitchell, W. J. T., 138.
"Mixed" reality devices, 133.
Modi, Narendra, 133.
Mondrian, Piet, *Madame B . . . , à Dresde*, 116, 117.
Monet, Claude: *Le train dans la neige, la locomotive*, 167; *Water Lilies*, 23.
Montgomery, Robert, *Lady in the Lake*, 144.
Moreau, Gustave, 23.
Moreau, Paul, 75.

Morel's Invention (Emidio Greco, 1974), 184, 185. *See also* Bioy Casares, Adolfo.
Moretz, Chloë Grace, 170.
Mori, Masahito, 93.
Morris, Robert, *Mirror Cubes*, 63.
Moulin, Félix Jacques, *Female Nude Kissing Her Reflection stereograph*, 129.
Mourey, Jean-Pierre, *L'invention de Morel*, 259 n.75.
Munch, Edvard, 137.
Munhwa Broadcasting Corporation, *Meeting You* (VR documentary), 198.
Münsterberg, Hugo, *Photoplay*, 58–59.
My Mother's Wing (Chris Milk, 2016), 191.
Myst, 145.
Mysteries of Compton House Garden, The (Peter Greenaway, 1982), 83.

NÄCKE, PAUL, 29, 30.
Nagel, Thomas, "What Is It Like to Be a Bat?" 201–203, 213, 215, 263 n.44, 265 n.67.
Naishuller, Ilya, *Hardcore Henry*, 146.
Naivety, 23, 28, 36, 45–46, 169; naive Narcissus, 19–20, 22, 26, 31, 33, 72, 110.
Nakaya, Fujiko, 63.
Nanotechnology, 8, 187.
Narcissism, 18, 22, 23, 29–33, 47, 75; distinguished from egocentrism, 35–36; and *hikikomori*, 226 n.66; and media, 35–36; video art as, 59, 61. *See also* Narcissus.
Narcissus: Alberti on, 17; in Callistratus's *Ekphraseis*, 69–70, 103; in cinema, 48; compared with Pygmalion, 70–72; connection with numbness, 33–34; death of, 18–20, 40; and Echo, 60, 69; gesture of, 21; iconography, 16, 22–26, 103–104; Lasch on, 35–36; legend of, 12, 17–20, 29; McLuhan on, 33–34, 35; and the mirror, 59, 228 n.16; Pausanias on, 17, 20, 26, 33, 47; Plotinus on, 18, 19, 40; as precursor of immersivity, 37, 40, 63; in psychology, 29–33; in *Roman de la Rose*, 72; self-aware vs. naive, 20–21, 22, 23, 26, 28–29, 31, 33, 36, 110; variant legend of twin sister, 26, 47. *See also* Narcissism; Ovid: *Metamorphoses*.
Narcissus at the Fountain (attrib. Caravaggio), 22.
Narcissus flower, 33.
Nature, 97, 206.

Nauman, Bruce, 59; *Corridor with Mirror and White Lights*, 63; *Revolving Upside Down*, 60–61.
Necrophilia, 75.
Nespresso commercia*l, 162–63*.
Nētra pinkama ceremony, 77.
Neubronner, Julius, 201.
New media arts, avatars and, 147–48.
Nicolai, Olaf, *Portrait of the Artist as a Weeping Narcissus*, 16, 22.
Nielsen, Asta, 59.
Nietzsche, Friedrich, 205.
Noé, Gaspar, *Enter the Void*, 146.
Nolan, Christopher, *Inception*, 58.
Nolan, Jonathan, 99.
Nonhuman perspective, 169, 209–11.
Nonobjective art, 13.
Notes on Blindness (2016), 213–14.

OBAMA, BARACK, 194, 261 n.17.
O'Blivion, Professor Brian, 160.
Oculus Rift, 207, 211.
Odorama, 184.
Onomarchus of Andros, "The Man Who Fell in Love with a Statue," 73.
Ontani, Luigi, 23; *NarcisOnfalOnan alla SorGente Del NiEnte*, 23, 24.
Opacity, 10, 20–21, 22, 35, 111. *See also* Transparency.
OpenVR, 207.
ORLAN, 113; *Tentative de sortir du cadre à visage découvert*, 114.
Orphée (Jean Cocteau, 1950), 57.
Osmoticity, 52, 59.
Otherness: and empathy, 189–90; and identity, 45, 147; of mirror image 19, 51, 52; of the other, 196–97, 198.
Ovid: on the fall of the giants, 123; *Metamorphoses*, 18, 19–21, 26, 33, 60, 69; Pygmalion myth, 70, 72, 75, 80, 86.
Ovide moralisé, 22.

PAGE, ELLIOT, 58.
Paintings: entering and leaving, 115–16, *134*, *137*, *138*, 144, 153–58, 186; frames, 7, 80, 113, 135; immersion in, 157–58; mirror, 63. *See also* Alberti, Leon Battista; Environmentalization of the image; Trompe l'oeil.

Palazzo Barberini (Rome), 126.
Palazzo Te (Mantua), 122–25; *Fall of the Giants*, *124*.
Panofsky, Erwin, 9, 10, 43, 121, 241 n.18.
Panorama of Gorge Railway (Edison, 1900), 37.
Panoramas and panopticons, 13, 37, 92, 125, 183, 206; devices, 126–28; Benjamin on, 127.
Paravel, Verena, *Leviathan*, 211.
Parenti, Neri, *Superfantozzi*, 170.
Parmigianino, *Self-Portrait in a Convex Mirror*, 44.
Pasolini, Pier Paolo, *La ricotta*, 83.
Passion (Godard, 1982), 83.
Patchougue, Lord (Jacques Rigaut), 54.
Pathos and ecstasy, 176.
Paumgarten, Nick, 146.
Pausanias, 17, 20, 26, 33, 47.
Peirce, C. S., 9, 90.
Pepper, John Henry, 131; "Pepper's Ghost," 131–33.
Pepsi Pavilion (Expo '70), 63–64; mirrored dome, *62*.
Perfect Sense (David Mackenzie, 2011), 79.
Perrier, François, 57.
Perspective: Alberti on, 120–21, 122; bird's eye view and worm's eye view, 200–201, 203; customization to, 67; grid device, 121; Panofsky on, 121; revolt against, 120.
Perzeption, 196.
Peto, John, 110.
Petroglyphs, 200.
Phantasmagoria, 128–31, *130*.
Phantom rides, 169.
Philidor, Paul, 128.
Philip III, Duke of Burgundy, 81.
Phillips Collection, 194.
Philostephanus of Cyrene, 73, 233 n.7.
Philostratus Major, 241 n.18; *Eikones*, 103–104, 111.
Photography, 11, 90, 107; aerial views taken with carrier pigeons, 201; Barthes on, 197; Benjamin on, 13–14; camera techniques, 126, 138, 143–45, 201; used by Anselmo to enter work, *134*, 138.
Pietro da Cortona, 126.
Pigeons, 107; photography, 201.
Pirog, Jenna, 194.
Pistoletto, Michelangelo, *Mirror Paintings*, 63.
Plato, 9, 43, 45, 72–73, 76, 151.

INDEX

Pliny the Elder, *Naturalis historia*, 33, 104, 105–107, 174.
Plotinus, 18, 19, 40.
Poe, Edgar Allan, "The Pit and the Pendulum," 244 n.49.
Point-of-view shot, 143–45.
Pornographic images, 128.
Porter, Edwin S., *The Great Train Robbery*, 144.
Portraits, 9, 21, 136; self-portraits, 22, 23, 44, 63, 137, 138, 146, 147, 148.
Postcinema, 178.
Poulter, Will, 67.
Poussin, Nicolas, 22, 113.
Pozzo, Andrea, 126.
Pozzo, Paolo, 125.
Praxiteles, *Cnidian Aphrodite*, 73.
Predator saga (John McTiernan), 213.
Presence studies, 126.
Presentness, 7–9, 11, 37.
Profile/frontality antithesis, 137.
Protector, The (Kathryn Bigelow, 2017), 190.
Pu Songling, *Strange Stories from a Chinese Studio*, 154, 155.
Public art, mirror in, 64.
Puni, Ivan, 116.
Purple Rose of Cairo (Woody Allen, 1985), 160.
Pygmalion: in aesthetic theory, 77; animation of the statue, 72, 78–79, 91; compared with Narcissus, 70–72; Freud on, 75, 91; intersection with automaton motif, 86–87, 96, 99; as king of Cyprus, 70; name of Galatea, 78, 89; Ovid's tale, 70, 72, 80, 86; in painting, 80; Philostephanus account, 83, 233 n.7; in psychotherapy, 75; as simulacrum, 73; "Pygmalion's Glasses," 87–89; variations on theme, 73–75, 77–78, 86–87, 94. See also Animation of the inanimate.

QUEST CAMPAIGN (McCann for Nespresso, 2018), 162.

RAFMAN, JON, 148.
Rama (suffix), 127, 135.
Rancière, Jacques, 141.
Rank, Otto, 31–33, 47, 50.
Rauschenberg, Robert, 63.
Reality media, 170–71.
Rearview mirror, 35, 47, 177, 257 n.57.

Reflective media, 61–63. See also Mirrors.
Refugees, 190, 191.
Rembrandt, *The Anatomy Lesson of Dr. Nicolaes Tulp*, 136.
Renoir, Jean, *La bête humaine*, 169.
Representation, 9–10, 20, 80, 92, 164; illusionistic, 181–83; in photography, 90; and reality for animals, 105–107; and trompe l'oeil, 110–11.
Resnais, Alain, *Last Year at Marienbad*, 259 n.75.
Rheiner, Max, 208.
Richter, Gerhard, 137.
Ricotta, La (Pasolini, 1963), 83.
Riegl, Alois, 136.
Rigaut, Jacques (Lord Patchougue), 54.
Rivero, Enrique, 57.
Robertson, Étienne-Gaspard, 128–31; *Mémoires récréatifs, scientifiques et anecdotiques du physicien-aéronaute*, 130.
Robinson Crusoe (Aleksandr Andriyevsky, 1947), 174.
Robison, Arthur, 50.
Robots: Asimov's First Law of Robotics, 99, 101; Björk's "All Is Full Of Love" video clip, 96–97; in cinema, 93–96; research projects, 93. See also Androids.
Rohéim, Géza, 29.
Rohingya Refugees in Bangladesh, 190.
Roman de la rose (de Lorris and de Meun), 70–72, 71.
Romano, Giulio: *Fall of the Giants*, 124; Palazzo Te (Mantua), 122–25, 192.
Rotoscoping, 162.
Rousseau, Jean-Jacques, *Pygmalion*, 78.
Rubin, Bruce Joel, 186.
Rückenfigur, 137–38.
Russolo, Luigi, 118.
Rye, Stellan, *The Student of Prague*, 48–51, 49, 52.

SADGER, ISIDOR, 30, 47.
Saints Michael and Francis rectory (Carmignano), 84.
Samaras, Lucas, *Room No. 2*, 63.
Samsung TV set ad, 105, 106.
Sanderson, William, 94.
Sandrart, Joachim von, *Parrhasius velo*, 102, 105.
Sang d'un poète, Le (Jean Cocteau, 1930), 56.
San Giorgio Castle, Bridal Chamber, 125.
Sant'Ignazio di Loyola (Campo Marzio), 126.

277

Saramago, José, *Ensaio sobre a cegueira*, 214.
Saving Private Ryan (Steven Spielberg, 1998), 38.
Sayonara (play dir. Oriza Hirata), 93.
Schapiro, Meyer, 137, 144.
Schlemihl, Peter, 48, 51.
Schwitters, Kurt, *Merzbau*, 117.
Science fiction, 86–90, 94–96, 99–101, 186, 211–13, 218. *See also* Robots.
Scorsese, Martin, 166; *Hugo*, 170; *Taxi Driver*, 58.
Scott, Graeme, *Aquila Bird Flight Simulator*, 207.
Scott, Ridley, *Blade Runner*, 93–96, *95*, 101.
Sculpture, 22, 79–80, 83, 117, 118, 218; wax, 77. *See also* Statues.
Second Life, 147–48; avatar scene, *149*.
Selbstaufhebungen im Werk, 156.
Self-awareness, 22, 23, 28–29, 32–33. *See also* Narcissus.
Self-empathy, 147.
Self-portraits, 22, 23, 44, 63, 137, 138, 146, 147, 148.
Self-reflexivity, 36, 59–61.
Sensation, 34, 78, 87, 181, 186, 205, 109.
Serra, Richard, 59; *Boomerang*, 60.
Severini, Gino, 116, 118.
Severus of Alexandria, 18–19.
Shakur, Tupac, 133.
Shelley, Mary, *Frankenstein*, 86.
Sherlock Jr. (Buster Keaton, 1924), *152*, 159–60.
Shiryaev, Denis, 171.
Shoulder shots, 138, 145.
Siegert, Bernhard, 255 n.24.
SimCity, 145.
Simmel, Georg, 115, 159, 164; "Bridge and Door," 217.
Simulacra, 51, 73, 87, 111.
Skopas, 76.
Slade, David, 67.
Sloterdijk, Peter, 204.
Smell, 78–79, 88, 119, 184, 186, 193, 205.
Smithson, Robert, *Yucatan Mirror Displacements*, 63.
Soap bubbles, 203, 206, 207, 215.
Somatic effects, 126, 146, 186.
Somniacs, 208, *210*.
Sortie de l'Usine Lumière à Lyon, La (Lumière Brothers, 1895), 167–69.

Space-time, 9, 135, 160, 169, 206, 217.
Spectatorship, 64, 118, 135–38; theatricality, 139. *See also* Gaze.
Spellbound (Alfred Hitchcock, 1945), 144.
Spinney, James, 214.
Split personality, 50.
Stalker (Andrei Tarkovsky, 1979), 57.
Stanislavsky, Konstantin, 142.
Star Wars, 200.
Statue animée, La (Georges Méliès, 1903), 83.
Statues: animation of, 57, 72, 76–80, 83, 91; attacks on, 81; as automata, 86–87; in Greek culture, 76; men who fell in love with, 70–74; Narcissus, 69–70; violation of, 75, 78. *See also* Pygmalion.
Steadicam, 145.
Steensen, Jakob Kudsk, *Aquaphobia*, 38.
Stereoscopy, 127–28, *129*; in cinema, 13, 150, 173–78, 182–83; erotic, *129*; glasses for, 174, 182. *See also* 3-D cinema.
Stoichita, Victor, 72, 89.
Strange Days (Kathryn Bigelow, 1995), 186, *187*, 209.
Student of Prague, The (Stellan Rye, 1913), 48–51, *49*, 52.
Stuhlbarg, Michael, 170.
Subjective biology, 203–206.
Sundance Film Festival, 38, 213.
Superfantozzi (Neri Parenti, 1986), 170.
Super Mario Bros (video game), 145.
Support, 10–11.
Surrealism, 54, 119.
Surround effects, 125, 209.
Sutherland, Ivan, 65–66.
Swimmer, The (Studio Azzurro, 1984), 38, *39*.

TABLEAUX VIVANTS, 80–84.
Tactile dimension, 119, 125, 184, 193, 213; tactilization of the image, 13–14, 157–58.
Tales of the Parrot (*Śukasaptati*), 73–74.
Tarkovsky, Andrei, *Stalker*, 57.
Tatlin, Vladimir, *Corner Counter-Relief*, 116.
Taxi Driver (Martin Scorsese, 1976), 58.
Technophobes and technoenthusiasts, 15.
Technological narcissism, 34–36.
Technological prostheses, 8–9, 34, 174, 206.
Teleportation, 126, 131.
Temple, 140.

Tenniel, John, *Alice Through the Looking-Glass*, 53.
Terao, Akira, 164.
Theater, 81, 139–43; fourth wall, 139–41; immersive, 141; "theatricality" (Fried), 139.
Thorwaldsen, Bertel, 22.
3-D cinema, 12, 170, 173–77, 181–83; contrasted with widescreen, 182; Elsaesser on, 178; forerunners, 128, 131; man watching sharks jump out of the screen, *179*; as precursor of immersive virtual environments, 119, 178. *See also* Stereoscopy; 360-degree shooting.
3-D effects, 133. *See also* Holograms.
360-degree shooting, 143, 178, 183, 191, 195, 197–98. *See also* Immersive virtual environments.
Threshold: in Chinese and Japanese legends, 153; dallying on, 171; door and bridge as, 164–66, 217–18; frame and, 115; between image and reality, 92, 101, 160, 217–18; penetration of, 101, 164, 176, 215; screen as passageway, 158–64, 174. *See also* In/out movement.
Through the Looking Glass (exhibition, Jack Tilton Gallery, 1992), 66.
Titanic (James Cameron, 1997), 38.
Titian, reenactments of, 84.
Tobler, Thomas, 208.
Torec (Total Recorder), 209.
Total cinema, 119, 178–81.
Totale Installation, 120.
Touch screens, 14.
Trains and railroads, 166–71, 173.
Transmediality, 218.
Transparency, 11, 198; and opacity, 10, 20–21, 22, 35, 111; and reflexivity, 61–63; transparent immediacy, 196.
Travers, Jacques-Olivier, 201.
Travolta, John, 58.
Trompe l'oeil, 12, 104, 110–11, 159; Baudrillard on, 111; with insects, 107–110; Kubovy on, 108–110.
Troxler, Fabian, 208.
Truman Show, The (Peter Weir, 1998), 38.
Trumball, Douglas, *Brainstorm*, 186.
Trump, Donald, 194.
Tudor, David, 64.
Tuttle, Richard J., 125.

TV commercials, 162–64.
Twin Peaks (David Lynch, 1990–1991), 57.
Twins, 26, 47, 93. *See also* Doppelgängers.

UBISOFT, 207, 208.
Uexküll, Jakob von, 213, 215; subjective biology, 203–206.
Uffizi Museum, 23–26.
Ultra HD, 171.
Umwelt, 194, 204.
Uncanny effect, 44–45, 91–92; "uncanny valley," 92–93.
Uncle Josh at the Moving Picture Show (Edwin S. Porter, 1902), 169.
Uncle Sam, "I Want You" poster, 139.
Unframing, 37–38, 80, 120, 125, 127, 139–40, 177, 183; unframedness property, 7–8. *See also* Frame.
Unheimlich, 91, 92.
United Nations, 191, 192.
US Border Patrol, 192.

VALCOUR, PLANCHER, 139.
Valéry, Paul, "The Conquest of Ubiquity," 181.
Van Gogh, Vincent, 116; *The Langlois Bridge*, 164, 166; letter to Theo, 166; *Wheatfield with Crows*, 166.
Varallo, shrines of, 77.
Vasari, Giorgio, 121, 123; *The Life of Giotto*, 107.
Velázquez, Diego, *Las Meninas*, 136–37.
Venice Biennale, 68, 116, 214.
Venus (Aphrodite), 21, 70, 73, 78, 86, 233 n.7.
Vertov, Dziga, *Kino-Eye and Man with a Movie Camera*, 169.
Victoria and Albert Museum, 65.
Victory Over the Sun (Russian opera), 140.
Video art, as mirror, 59–61.
Videodrome (David Cronenberg, 1983), 160, 161, 255 n.24.
Video games, 67, 145; *Apnea*, 40; *Eagle Flight*, 207–208.
Vienna School, 136.
Vigo, Nanda, mirror performances, 63.
Villiers de l'Isle-Adam, Auguste, *Tomorrow's Eve*, 86, 90.
Viola, Bill: *The Greeting*, 84; *The Reflecting Pool*, 26; *Submerged*, 23–24; *Surrender*, 26, 27; "water portraits," 23.

Virgin Mary, 74, 84.
Virtual exhibition spaces, 148.
Virtual reality (VR): apps, 207, 214; as autopsy, 198; as catalyst for empathy, 189–91, 195, 196–97, 198, 199, 262 n.31; compared with augmented reality, 117–18; cybersickness, 208; and dream experiences, 68; embodiment virtual reality, 189–90; exhibitions, 65, 66, 68, 232 n.71; experiencing of, 192–93, 194–96, 197–98, 261 n.22; film, 170; and flight, 207–209; gloves, 117, 198; health-related, 213–15; in humanitarian engagement, 40–42, *41*, 199; immersive journalism, 191–92; pioneers, 65–66; political implications, 11, 13, 14; research projects, *188*, 189–90; in science fiction, 87–91; surreptitious ideological conditioning, 195–96; VR turn, 190. *See also* Augmented reality; Immersive virtual environments; Virtual reality headsets.
Virtual reality headsets, 38, 65, 183, 186, 190, 211; and field of vision, 7–8; precursors, 126–28; used in flight simulation, 207, 208, 209.
Vishnu, 150.
Visual perception: field of vision, 7–8; human and animal, 211–13.
Viveiros de Castro, Eduardo, 227 n.15.
Voight-Kampff test, 93–94.
Von Schlosser, Julius, 77.
Vozzo, Vanessa, *Apnea*, 40.
VPL Research, 66.

WALDHAUER, FRED, 63.
Walken, Christopher, 186.
Walk Through Dementia, A (Alzheimer's Research UK), 214.
Warburg, Aby, 77, 81–82, 137; *Pathosformel*, 176.
Water, 37–38, 70; immersion metaphor, 157–58; as mirror, *16*, 18–19, 20, 21, 22, 23–26, 28–29, 34, 58, 69–70, 103–104.
Waves of Grace (Chris Milk, 2015), 191.
Wegener, Paul, 48.
Weinbaum, Stanley G., "Pygmalion's Glasses," 87–90.

Weiss, Josef, 48.
Welles, Orson, *Lady from Shanghai*, 58.
Wells, H. G., "Empire of the Ants," 211.
Welsh, Brian, 187.
Wesselski, Albert, 28.
Westworld, 72; film dir. Michael Crichton (1973), 99; television series, 99–101, *100*.
Wheatstone, Charles, 128.
Wheel, 34.
Whitehead, Fionn, 67.
Whitman, Robert, 63.
Wilson, Richard, *20:50*, 65.
Within (production company), 170.
Wolfenstein 3D, 145.
Wollheim, Richard, 10, 196.
Wonderland, *54*, 47, 65, 66, 67, 68. *See also* Carroll, Lewis.
Woo, John, *Face/Off*, 58.
Wood, Evan Rachel, 99.
Woodman, Francesca, mirror self-portraits, 63.
Woods, James, 160.
World Economic Forum, 192.
Worringer, Wilhelm, "longing to revert," 83.
Wright, Will, *SimCity*, 145.
Wu Tao Tzu, legend of, 153–54, 156, 166; in film, 158.
Wurm, Erwin, *One Minute Sculptures*, 83.

XUAN ZONG, EMPEROR, 154.

YELLOW EMPEROR, 51–52.
Young, Sean, 96.
Youngblood, Gene, 189.
Yourcenar, Marguerite, *How Wang-Fô Was Saved*, 154–55.

ZANKER, PAUL, 21.
Zenobius, 28.
Zeuxis and Parrhasius, 104–105, 110, 174.
Zola, Émile, 169.
Zöllner, Christian, 211.
Zoophenomenology, 203.
Zurbarán, Francisco de, 110.
Zürcher Hochschule der Kunst, 208.